THE
FLOATING
WORLD OF
UKIYO-E

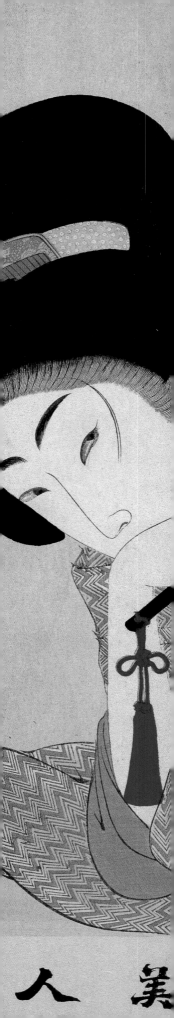

美人

THE FLOATING WORLD OF
UKIYO-E

SHADOWS, DREAMS, AND SUBSTANCE

ESSAYS BY

SANDY KITA

LAWRENCE E. MARCEAU

KATHERINE L. BLOOD

JAMES DOUGLAS FARQUHAR

HARRY N. ABRAMS, INC., PUBLISHERS
in association with
THE LIBRARY OF CONGRESS

CONTENTS

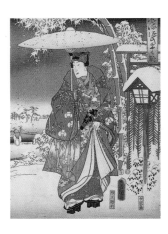

ESSAYS ON THE ART
OF THE JAPANESE
WOOD-BLOCK PRINT

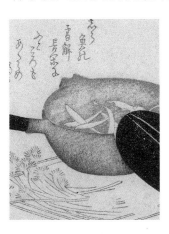

PRE-MEIJI (1868–1911)
BOOKS ON ART IN THE
LIBRARY OF CONGRESS

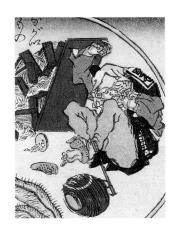

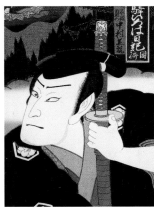

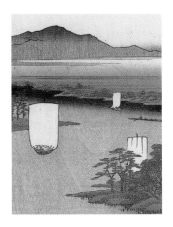

For Harry N. Abrams, Inc.:
Project Manager: Margaret Rennolds Chace

For The Library of Congress:
Director of Publishing: W. Ralph Eubanks
Editor: Iris Newsom
Designer: Linda McKnight

Library of Congress
Cataloging-in-Publication Data

The floating world of Ukiyo-e: shadows,
dreams, and substance./essays by Sandy
Kita...[et al.]. p. cm.
Exhibition catalog.
"In association with the Library of Congress."
Includes bibliographical references and index.
ISBN 0-8109-4169-4
1. Ukiyoe—Exhibitions. 2. Art, Japanese—Edo
period, 1600–1868—Exhibitions. 3. Illustration
of books—Japan—Edo period, 1600–1868
Exhibitions. 4. Art—Washington (D.C.)—
Exhibitions. 5. Library of Congress—Art col-
lections—Exhibitions.

N7353.6.U35 F58 2001
769.952'09'03074753—DC21

2001018144

Published in 2001 by Harry N. Abrams,
Incorporated, New York

Printed and bound in Japan
10 9 8 7 6 5 4 3 2 1

FRONTISPIECE: Chikanobu's *Shin bijin* (True
Beauties), color woodcut book, 1897 (detail of
plate on p. 176)

Harry N. Abrams, Inc.
100 Fifth Avenue
New York, N.Y. 10011
www.abramsbooks.com

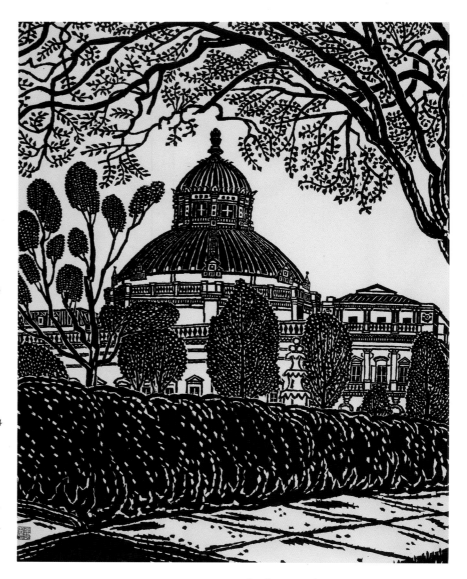

1

Hiratsuka Un'ichi. Library of Congress,
Washington, D.C., 1966. Hiratsuka
(1895–1997) was one of the leaders of the
Creative Print Movement in the 1920s and
1930s in Japan. He emigrated to the United
States in 1962 and spent the second half of
his life as an artist in the Washington, D.C.,
area., where he was famous for his black-
and-white wood-block prints. Most of his
earlier work in Japan was based on his
sketches, so it showed his surroundings:
rural landscapes and traditional Japanese
architecture. Hiratsuka carved into the block
what he saw in his new world as well.
Although the subject matter of his prints
changed to the landscape of the West and
Western-style architecture, Hiratsuka per-
sisted in using the black-and-white wood-
block as the best way to express the world in
which he lived. In this print of the Library
of Congress, Hiratsuka depicted the Main
Building, which was named the Jefferson
Building in 1980. He showed it surrounded
by various trees and a bush fence. His spe-
cial interest in wood and architecture is dis-
played effectively, using the powerful con-
trast of black and white and the compact
construction of the jagged lines.

FOREWORD

JAMES H. BILLINGTON
LIBRARIAN OF CONGRESS

*I*n keeping with its mission to preserve "a universal collection of knowledge and creativity," the Library of Congress collects globally. Gathered here are more than 120 million objects in 460 languages, ranging in format from ancient scroll to digital code. For many areas of the world—including China, Japan, Latin America, and Russia—these collections are among the finest and most comprehensive outside the countries of origin.

This exhibition and catalog—*The Floating World of Ukiyo-e: Shadows, Dreams, and Substance*— showcase the Library's spectacular holdings of Japanese Ukiyo-e (translated as pictures of the Floating or Sorrowful World) and mark the first scholarly analysis of this important and previously unpublished collection. Featured are selected Ukiyo-e prints, books, and drawings from the seventeenth to the nineteenth centuries, and other related works from the Library's collections created by Japanese and Western artists during the same period and into the twentieth century.

The Japanese art form of Ukiyo-e arose from a confluence of social and political forces in early seventeenth-century Japan. A defining moment came with the establishment of the Tokugawa shogunate in 1603 in Edo (now Tokyo), which became a new power base separate from the imperial court in Kyoto. The siege and conquest of Osaka Castle from 1615 to 1616 eliminated opposition to the new ruler, Tokugawa Ieyasu (1543–1616), and marked the beginning of the Edo Period that lasted until 1868. The Edo Period saw fifteen successive generations of shoguns and 250 years of relative peace and was also remarkable for its policy of controlled international contacts. All daimyo (feudal lords with domains awarded by the shogun) were required to maintain residences in Edo and to alternate their time between that city and

their home domains. With this concentration of wealth and power, what had been a small castle town became a thriving urban center.

The Tokugawa shogunate also radically changed the social order. The new hierarchy placed warriors first, followed by farmers and artisans. The wealthiest segment of the population, the merchant class, was on a lower rung. With their social and political power effectively removed, the merchant class turned to art and culture as arenas where they could still participate on an equal basis with the higher classes. Edo's licensed pleasure district, called the Yoshiwara, became the primary focus and incubator for a fresh mode of artistic expression called Ukiyo-e. The term *Ukiyo-e* has multiple connotations suggested by images of the floating world or the sorrowful, ephemeral world of fleeting things. Everyday life in the Yoshiwara became a major theme of Ukiyo-e art, as merchants commissioned Edo artists to depict courtesans of unearthly beauty. The theater districts also generated prints of celebrity actors and climactic scenes from Kabuki plays. At the same time, Ukiyo-e artists portrayed scenes from classical art and literature (traditionally the province of "high" art at the imperial court in Kyoto), such as *The Tale of Genji*, historical figures and events, and folk themes. Another major genre of Ukiyo-e was the landscape, which fed the cultural appetite for travel, for the appreciation of nature, and for the expression of regional pride and identity.

Ukiyo-e art was disseminated largely through color wood-block prints and wood-block-printed books, both of which could be distributed at low cost and in large quantities. Thus, Ukiyo-e art and literature were placed within easy reach of a highly literate, nonelite populace who were at once its creators, consumers, and connoisseurs.

The Library is pleased to present the first major exhibition and catalog featuring its stellar collection of Japanese art and literature, and to publish a new bibliography of pre-nineteenth-century Japanese art books from its collections. We thank Merrill Lynch for its generous support for both the exhibition and this catalog, and our partners in this endeavor: retired Library of Congress Japanese specialist Shôjô Honda and guest scholars Dr. Sandy Kita from the University of Maryland and Dr. Lawrence Marceau from the University of Delaware.

SPONSOR'S LETTER

DAVID H. KOMANSKY
CHAIRMAN AND CHIEF EXECUTIVE OFFICER
MERRILL LYNCH

*M*errill Lynch is pleased to sponsor *The Floating World of Ukiyo-e: Shadows, Dreams, and Substance.* This major exhibition showcases masterworks of Japanese art from the Library of Congress, bringing this world-class collection to the scholarly community and the general public for the first time.

Images of Ukiyo-e, "the Floating World," have long been known for their engaging and beautiful subject matter. A closer look reveals the images also carry deeper cultural meanings. In addition to exploring these meanings, the exhibition clarifies the significant influence of Japanese art on Western art and audiences during the nineteenth and twentieth centuries, while allowing the visitors unprecedented access to hundreds of breathtaking images in a variety of media.

We congratulate the Library of Congress, the world's largest library and the guardian of a universal collection of human knowledge, on *The Floating World of Ukiyo-e.* The Library's ongoing commitment to ensuring that its vast and diverse holdings are accessible to the public will make all of us more informed global citizens.

PREFACE

IRENE U. CHAMBERS
INTERPRETIVE
PROGRAMS OFFICER

*M*ounting *The Floating World of Ukiyo-e: Shadows, Dreams, and Substance* presented the Library of Congress with an unusual challenge. Usually, the organizers of exhibitions at the Library of Congress are called upon to make intellectually powerful material work in a visual way in an exhibition format. The design of the exhibits, the lights, colors, and graphics are, therefore, selected to capture the visitor's immediate interest and provide an effective entry to the intellectual content that is often contained in nonvisual materials, such as written documents, books, and manuscripts.

Additionally, the Library works very hard to make sure that, once the interest of the visitor is piqued or captured, the content of exhibited material can be accessed easily. Thus, for example, we make sure that letters written by Jefferson are readable, that manuscripts prepared by Sigmund Freud are translated and important passages are highlighted, or that the knowledge in pivotal books is summarized and bibliographical information is provided. In short, almost always in its exhibitions, the Library uses visual appeal to ensnare visitor interest and then provides the greatest access possible to the intellectual materials that are the heart of its exhibitions.

With *The Floating World of Ukiyo-e*, the challenge was very different, and that difference says a great deal about the nature of this particular exhibition and the collection which it presents to the public for the first time. The materials in this exhibition are visually stunning. They attract the eye. The colors in the images are dazzling, and each image entices and makes the visitor want to see more.

However, as well as being visually stunning, the images in *The Floating World of Ukiyo-e* are also laden with meaning. They depict fascinating aspects of Japanese history and culture, customs, and traditions. The challenge was to indulge visitors' enjoyment of this visually rich collection while also encourag-

2

Kabukidô Enkyô. Portrait of Nakayama Tomisaburô (1796). This rare print is one of only seven known works, all portraits of actors, by this artist, Sharaku's sole follower. Nothing was known of Enkyô until 1926 when it was discovered that he was the same man as the *kyôgen* author and Kabuki actor Nakamura Jûsuke II (1749–1803). It is likely that the subject here is Nakayama Tomisaburô, the Library's work being identical to the print of this man by Enkyô in the Art Institute of Chicago.

ing them to learn something about Japan, its art, and its past. This challenge was met successfully because of the remarkable contributions of Library staff, particularly in the Prints and Photographs Division, the Asian Division, the Conservation Office, the Publishing Office, and the Interpretive Programs Office. The exhibition director for *The Floating World of Ukiyo-e* was Kim Curry, whose exceptional skills and talents and, especially, her notable enthusiasm for this project benefitted the exhibition immensely. Most of the successful visual and intellectual balance, however, is due to the talents of the three curators: Katherine Blood, Dr. Sandy Kita, and Dr. Lawrence Marceau.

This exhibition is rare not only because it premieres the Library's incomparable and hitherto unknown Japanese print collection. *The Floating World of Ukiyo-e* also represents an unusual collaboration between three Library divisions: the Prints and Photographs Division, the Asian Division, and the Interpretive Programs Office. It should not be at all surprising, of course, that this very visual exhibition is drawn from the collections of the most visual area of the Library's collections: the Prints and Photographs Division. Its collections total more than fourteen million works, including watercolor views, portraits, master prints and photographs, architectural renderings and working drawings, and mass-produced propaganda posters, news photographs, and printed ephemera. The Prints and Photographs Division's collections are featured regularly in Library exhibitions, but this is the first exhibition in more than a decade that focuses on the Asian Division's collections. The Library's Asian collection, the largest and finest outside of Asia, includes about two million items, covering most subject fields and the cultures of China, Inner Asia, Japan, Korea, and South and Southeast Asia. As a result of this exhibition, both of these divisions now will be known as the holders of one of the most important Japanese print collections in the United States.

Finally, for the Interpretive Programs Office, which is responsible for the Library's exhibitions and exhibition-related programs and materials, *The Floating World of Ukiyo-e* is, fittingly, the second exhibition to draw on the incredible non-English-language collections of this unique institution. In 2001, the Library of Congress enters its third century of existence. It seems very appropriate that this first year underscore, through exhibitions featuring its stellar world collections, the breadth and universal reach of the Library's holdings.

ACKNOWLEDGMENTS

Primary thanks for this project coming to fruition go to Shôjô Honda, Research Librarian at the Japanese Section of the Asian Division of the Library of Congress, now retired. He was the guide to the rich Japanese art resources of the Library of Congress. It is chiefly because of his efforts and expertise that the difficult inscriptions on the prints were translated and the bibliography was compiled.

The authors also express their gratitude to Lionel Katzoff. A noted collector of Japanese books, Lionel checked the bibliography for accuracy, made many corrections, and contributed much additional information. Jenny Lee, a graduate student in Asian Art History at the University of Maryland, was the Research Assistant on the project. She tracked down the prints, found enormous amounts of information about them, obtained the crucial comparison materials, and wrote some of the captions. Others who contributed captions include Grayson Lai, Valerie Ortiz, Seojoung Shin, and Elizabeth Nash, graduate students at the University of Maryland, Pat Graham, a colleague in the study of Japanese art, and David McFall from the University of Hawaii, who has a special interest in the Hiroshige sketchbooks. Grayson Lai also typed the Japanese entries for the bibliography, along with Terry Heiner.

The authors also express their appreciation to Iris Newsom, Editor in the Library of Congress Publishing Office, for keeping them on a tight but necessary schedule and for compiling the glossary.

The following individuals from the Library of Congress were also very supportive: Helen Poe (Division Chief), Yoko Akiba, and Beth Katzoff (Asian Division), Irene Chambers and Kim Curry (Interpretive Programs Office), and Ralph Eubanks (Publishing Office); from the Freer Gallery and the Sackler Gallery Library, Smithsonian Institution, Reiko Yoshimura, Lily Kecskes, and David Hogge; from the Japan Information and Culture Center, Embassy

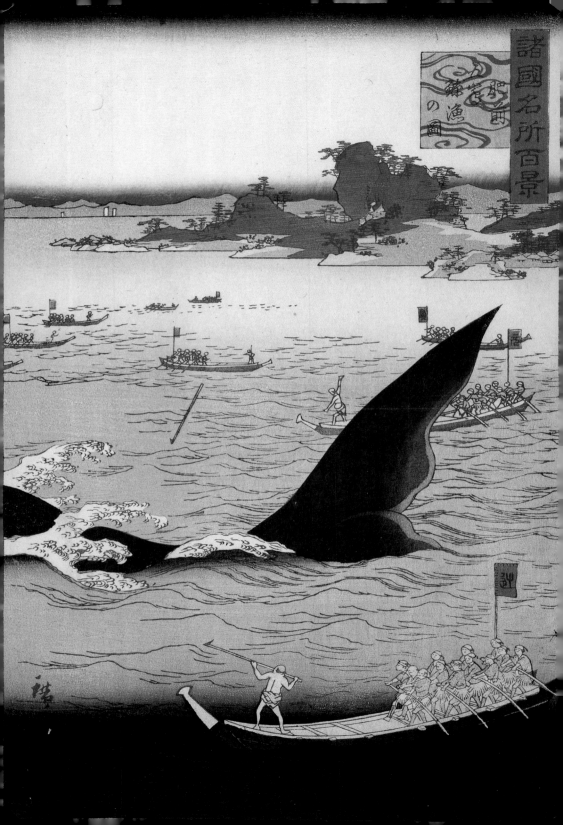

of Japan, Natsume Katsuhiro, Seki Izumi, and Yamamitsu Midori. Special thanks are also due to Norma Baker, Sue Siegel, Amir Pasic, and Mark Conner in the Library's Development Office; and in the Prints and Photographs Division, Prints and Photographs Curatorial Section Head Harry Katz, Poster Curator, Elena Millie, Catalogers DeAnna Evans and Woody Woodis, Technical Services Head Helena Zinkham, Reference Head Mary Ison, Reference Specialist Marilyn Ibach, Technical Services Team Leader Sarah Rouse, former Chief Linda Ayres, and Automated Operations Coordinator Cathy Hoban.

Conservation was a critical element of the exhibition. Senior Conservators Linda Stiber Morenus and Jesse Munn were valued colleagues throughout the project. They and their colleagues gave the objects a new life and informed the scholarly understanding of these works. The authors are grateful to all of the conservators who prepared the objects on display under a tight deadline, including Louise Condon, Sylvia Albro, John Bertonaschi, Terry Boone, Lage Carlson, Elmer Eusman, Ann Grossman, Doris Hamburg, Yasmeen Khan, Lynn Kidder, Holly Kreuger, Maria Nugent, Ann Seibert, Carol Ann Small, Heather Wanser, and Mary Wootton. The Library is also fortunate to have been joined in this effort by Senior Conservator Betty Fiske from Winterthur Museum, who is a longtime specialist in the treatment of Japanese prints.

Library of Congress curators and specialists who helped bring relevant Japanese materials to light from their custodial areas include Marvin Kranz, Alice Birney, and Jeff Flannery from the Manuscripts Division; Elena Millie, C. Ford Peatross, Carol Johnson, Verna Curtis, Beverly Brannan, Mary Ison, and Sam Daniel from the Prints and Photographs Division; Clark Evans and Jerry Wager from the Rare Book and Special Collections Division; and Debra Wynn and Barbara Dash from the Special Materials Cataloging Division.

For the beautiful photographs which appear in this catalog, the authors applaud Library of Congress photographer Jim Higgins and freelance photographer Ed Owen. For the high-quality scans which appear in the online exhibit and Prints and Photographs Division Online Catalog they thank Lynn Brooks, Domenic Sergi, and Michael Smallwood from the Library's ITS Scanning Lab, Phil Michel and Thad Jeffers from the Prints and Photographs Division, Betsy Nahum-Miller in IPO, and Clarke Allen in Publishing.

3 (OPPOSITE)

Ichiyûsai Shigenobu (also known as Utagawa Hiroshige II) (1826–1869). *Hizen Gotô geigyô no zu* (Whale Hunting at Gotô in Hizen Province) from the series *Shôkoku meisho hyakkei* (One Hundred Views of Famous Places in the Provinces), 1859. Publisher: Uoei Eikichi. Vertical *ôban*-size wood-block print in ink and colors on paper. Shigenobu was the pupil and adopted son of Utagawa Hiroshige, famed for his numerous prints which celebrated manmade and natural wonders throughout Japan. As seen in the series to which this print belongs, he drew inspiration in style and subject matter from his mentor. This print portrays whaling, an important Japanese industry since the seventeenth century. At first, catching whales was accomplished with harpoons, as seen in this print; after 1675, whales were trapped in specially designed nets. The Japanese whaling industry peaked between 1810 and 1850. By the time Shigenobu designed this print in 1859, whalers from Western nations had begun hunting in waters off the coast of Japan. Their presence quickly began to deplete the supply of whales for Japanese fishermen, who were prevented by law from searching for their prey far beyond the Japanese coastline. This print may thus be viewed as a nostalgic vision of the glory days of a waning industry.

INTRODUCTION

This book, and its companion exhibition, launch, for the first time, the virtually unknown holdings of Japanese wood-block prints and printed books in the Library of Congress. The Library's collection is rich in historically important prints and books, rare or unusual prints, and in prints that have never before been published. It contains both known masterpieces and new masterworks which have not been seen before or explored in the extant literature. Within the framework of significance and rarity, the objects have been selected with an eye toward the visually impressive. Because the collection has never been exhibited and has rarely been handled, some of the colors are extremely fresh and bright.

In the category of historically important prints are works by the early masters of Ukiyo-e. Only a limited number of these prints existed originally and they disappeared quickly as collectors bought them up. Works of early Ukiyo-e are among the most rare today, and the Library of Congress is fortunate to have both black-and-white prints and the early hand-colored prints of Torii Kiyonôbu, Nishimura Shigenaga, and Nishimura Shigenobu.

Senin Kume Spying on a Girl is an especially interesting work. This print illustrates the story of how a saint, who was so pure that he could fly, spied a girl washing clothes. A glimpse of her white thigh sent him tumbling down from the sky. Also among the Library's examples of early Ukiyo-e is Torii Kiyonôbu I's *Lady Painter and Her Patron*, a rare image of a woman artist.

Even in the West, Hokusai and Hiroshige have become household names. The Library has important prints by both of these great Ukiyo-e masters. This catalog and exhibition include Hokusai's set of five prints, *A Hundred Ghost Stories*, which was recognized early on by collectors and scholars as one of the great masterworks of this premier Ukiyo-e master. One of the treasures in the Library's collection is an album of delicate watercolors by Hi-

4

Katsushika Hokusai. *Hyaku monogatari* (A Hundred Ghosts), title page. Although titled The Hundred Ghosts, this work consists of five *chûban* prints. The Library has all five. They are among Hokusai's rarest and best-known works. (See 92–95.)

roshige which has been reproduced in facsimile by George Braziller in New York in a two-volume set as *The Sketchbooks of Hiroshige.* The catalog and exhibition also include works from Hiroshige's print series One Hundred Views of Edo and his Famous Places of the Provinces, and Hokusai's New Prints of the Eight Views of Omi, the last complete. Finally, the exhibition and catalog introduce a previously unknown book of sixty drawings of figures, birds, flowers, and landscapes in the style of Hokusai and his followers.

Drawings represent yet another important element of the Japanese holdings of the Library. These include *shita-e,* the preliminary drawings for a print used in producing the blocks. They are by nature unique and highly prized. The Library also has sketches, such as the drawings of Kawanabe Kyôsai, the so-called Demon of Painting, for his set of *A Hundred Ghost Stories.* The Library of Congress also has not just one, but three different examples of the finished set of prints based on Kyosai's drawings. It also has many literati, or Chinese-style books and drawings, including some by the famous Ki Baitai.

Certain prints are rare or unusual by virtue of their format, technique, or method of distribution. Within this category are *surimono,* privately commissioned prints made to commemorate special events and given to a select circle as mementos. *Surimono* often carried the cachet of insider knowledge to their cultured and well-educated audience, hidden messages couched in sumptuous visual effects—metallic inks, mica, gauffrage, or lacquering. Other types of unusual prints found in the Library's collection include catfish prints (*namazu-e*), caricature prints (*toba-e*), pillar prints (*hashira-e*), and crepe prints (*chirimen-e*)—the last being prints with the texture of crepe fabric. Within the Library's extensive holdings of multipanel prints (e.g., diptychs and triptychs) is an unusual group of theatrical subjects which provide a fine opportunity to consider repeating visual and literary motifs.

The collection of Japanese wood-block prints in the Library of Congress also encompasses Meiji (1868–1911) and modern works. The Meiji collection includes the work of late masters such as Chikanobu and Tsukioka Yoshitoshi. The Library's collection contains an excellent collection of Yokohama prints—journalistic depictions of Westerners in the port city of Yokohama as well as imagined views of Western cities and subjects, sometimes copied from illustrations in contemporary journals. Political woodcuts by

Japanese artists created during the Sino-Japanese War (1894–1895) and the Russo-Japanese War (1904–1905) constitute another collection strength.

The exhibition also pairs Ukiyo-e prints with the work of such Western artists as Mary Cassatt, Henri de Toulouse-Lautrec, and Bertha Lum, who were directly influenced by this art form. The Library's excellent holdings of Western graphic art reflect this phenomenon, known as Japonisme. Finally, the Library's exhibit showcases some examples from its substantial holdings of prints by modern Japanese artists, including Goyo, Munakata, and Hiratsuka.

This exhibition and catalog elucidate how, together, these various forms of art represent the Floating World of Ukiyo-e. Sandy Kita's essay, "From Shadow to Substance: Redefining Ukiyo-e," not only introduces the reader to the Floating World, but also to the changing ideas on this world. These ideas broaden the concept of Ukiyo-e to include the many objects and subjects covered by this exhibition and catalog. Lawrence E. Marceau, Associate Professor of Japanese Literature at the University of Delaware, follows with an essay on the Japanese book and its relationship to prints. Katherine Blood, Assistant Curator for Fine Prints in the Prints and Photographs Division at the Library of Congress, tells how the Library of Congress formed its collection of Japanese wood-block prints, printed books, and related materials, and also describes some interesting aspects of wood-block printing as applied to Ukiyo-e and discusses the influence of Ukiyo-e on Western art. Finally, Professor James Douglas Farquhar of the Department of Art History, University of Maryland, a noted authority on the Medieval book, provides his impressions of the Japanese book as an introduction to this catalog's bibliography, "Pre-Meiji (1868–1911) Books on Art in the Library of Congress: An Annotated Bibliography."

A key part of this book is the bibliography by Sandy Kita and Honda Shôjô, formerly Research Librarian in the Japanese Section of the Asian Division of the Library of Congress, now retired. It provides a first look at the rich collection of pre-1868 Japanese illustrated books and books on art in the Library of Congress. Thus, it allows readers to judge for themselves the scope and significance of this collection of books that is so important to the Library in general but also to this exhibition in particular.

Japanese wood-block prints and printed books are a natural subject for an exhibition partly because many wood-block prints were marketed first in

5

Nishimura Shigenaga (1697?–1756). *Sawamura Sojurô I (1689–1756) and Ichimura Takenojo Dancing with a Tsuzumi.* Publisher: Nakajimaya of Sakai-machi. This work is a hand-colored print. It bears the seal Wakai-oyaji (Old man Wakai), a reference to Wakai Kanesaburô, assistant manager of one of the first companies to export Ukiyo-e to France.

Anonymous. Hair Dressing. This work is typical of early Ukiyo-e. To the right is a woman, reading a letter. The label above her states "Echizen." To the left is a second woman, identified by inscription as "Kotanko," holding the hair of a man, who is possibly an actor since he sits in front of a mirror, apparently applying make-up. These two figures are identical in pose to ones in Genroku Courtesans in Opposing Mirrors, signed by Okumura Gempachi Masanobu, and based on an earlier work by Torii Kiyonobu I dated 1700.

wrapped series, and early collectors cherished their sets of prints so much that they pasted them into sumptuously bound albums. Furthermore, block-printed books in Japan have always been highly visual, with the exception of a few genres (Chinese philosophy, for example). For some 250 years, Japanese artists, block carvers, printers, and publishers have collaborated in creating some of the most varied and strikingly beautiful picture books in the world. These books include collections of the kinds of prints that typify Ukiyo-e, but feature the full range of painting genres, from literati landscapes, to illustrations from court romances, to the comic *manga* collections made famous by Hokusai. The vast spectrum found in these books makes them ideal companions to a print exhibition, and the fact that they are books makes the Library of Congress the ideal site for exhibiting them: the books inform the prints and drawings, the prints and drawings inform the books, and together they reveal the substance behind the shadows of the Floating World.

Some Technical Information on Japanese Wood-block Prints

Those who are unfamiliar with Japanese wood-block prints may need a brief introduction to them before tackling the essays. Wood-block printing developed in Japan centuries ago, the process having been used to make reli-

gious images and texts as far back as the eighth century. However, wood-block prints were not considered art until the seventeenth century.

The first art prints were called *sumizuri-e* because they were rubbed *(suri)* in ink *(sumi)* alone. Where colors appear, they were applied by hand. When a deep red predominates, the print is a *tan-e*, and where orange, yellow, blue, green, and other vegetable-based colors are used it is called a *beni-e*.

These kinds of prints are found in the work of Hishikawa Moronobu (d. 1694), Torii Kiyomasu I (fl. 1690s), Torii Kiyonobu I (ca. 1664–1729), and many other artists working from about 1600 to 1700. Most of these print-makers specialized in either *bijin-ga* (images of beauties) or *yakusha-e* (prints of actors). They are also known for their *shunga* or erotic works.

During the latter part of the eighteenth century, color began to be printed, producing *benizuri-e*. At first, only one or two colors were used. When a lustrous black is employed, the prints are called *urushi-e* (lacquer prints). *Benizuri-e* and *urushi-e* mark the transition to *nishiki-e,* full-color or brocade prints.

The invention of brocade prints is usually dated around 1741 and is attributed to developments in printmaking begun by Okumura Masanobu (1686–1764). He is credited with creating *hashira-e* (pillar prints) and *uki-e* (perspective prints or prints using a bird's-eye perspective). He should not be confused with Kitao Masanobu (1761–1816) or Santô Kyôden, another Japanese wood-block-print master who had a similar name.

Masanobu was a contemporary of Suzuki Harunobu (ca. 1724–1770),

7

Okumura Masanobu's *hashira-e* or pillar print of Shoki Striding is one of a number of versions of the work which portrays the famous Chinese queller of demons in a walking pose. This is the version with the long signature by the artist: *Hôgetsudô Tanchôsai Okumura Bunkaku Masanobu Baio.* The print is old-fashioned in its imitation of painting. Its printed lines vary in thickness like the calligraphic brushstrokes of ink painters. The work is in a format suitable for framing, which the work in the Library has taken advantage of in being mounted as a hanging scroll.

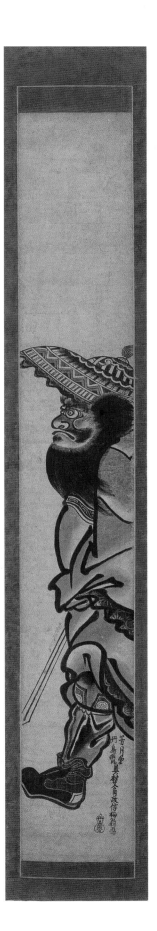

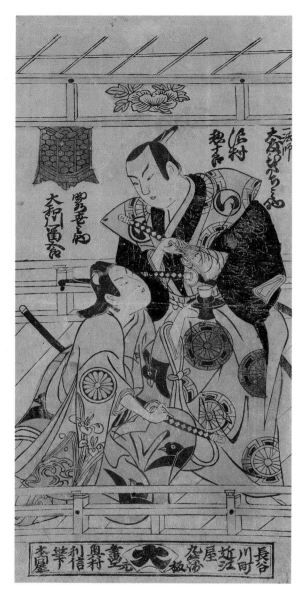

8

Okumura Toshinobu (fl. 1717–1750).
Sawamura Sojurô and Yamatogawa
Tomigoro in the Role of a Samurai and
His Page. According to the title bar of this
hand-colored print, it was printed by
Omiya Kyûbei of Hasegawa-chô and done
by Okumura Toshinobu.

Torii Kiyonaga (1752–1815), and Katsukawa Shunshô (1726–1793?). Shunshô and his student Shunkô (1743–1812) are known for their actor prints. They are said to have transformed the caricaturelike prints of actors of the early Torii masters into true portraits, a development that Margaret Gentles once described as a move from depicting the role not the actor, to the actor not the role. A similar process is thought to be at work in the art of Harunobu and Kiyonaga, who focused on images of beauties. Both turned early, generic pictures of females into more closely observed renderings of individual women with distinctive features. Harunobu is known for his small cute girls, and Kiyonaga portrays tall elegant ladies.

Kitagawa Utamaro (1754–1805) followed up these developments in images of beauties with his psychologically informed portraits of women that he called "physiognomies." Likewise, the changes that Katsukawa made to actor prints are thought to culminate in the "head shots" (*okubi-e*) or close-up portraits of the faces of actors by the enigmatic Tôshûsai Sharaku (fl. 1794–1795). The market for prints had developed greatly by this time, and as it did so, publishers came to play an ever more important role. Sharaku and Utamaro, for example, worked with the famous publisher Tsutaya Jûzaburô.

The need to issue great numbers of prints, however, is thought to have caused a decline in quality. With the advent of aniline and other bright chemical colors, Japanese wood-block prints are seen by some to have become garish. Images of ghosts, demons, and other weird or unusual subjects grow in number during this time, which was that of Utagawa Toyokuni (1729–1825), Kuniyoshi (1798–1861), and Kunisada (1786–1865?). Not surprisingly, their work was not highly valued at one time, though that is not true today. The same may be said of the mad Tsukioka Yoshitoshi (1839–1892), famous for his melodramatic images of slaughter, rape, and other horrors.

An exception to the perceived decline in prints in the period after 1800 is thought to be the great *fukeigakka* or landscape masters Katsushika Hokusai (1760–1849) and Utagawa Hiroshige (1797–1858). They also made wonderful *surimono*, small, richly rubbed prints.

Printmaking took on a new life in the Meiji Period that followed the arrival of Commodore Perry and his black ships to Japan. Yokohama-e—prints that showed foreigners, foreign things, and all the changes that occurred as Japan became a part of a wider world—became popular. With the

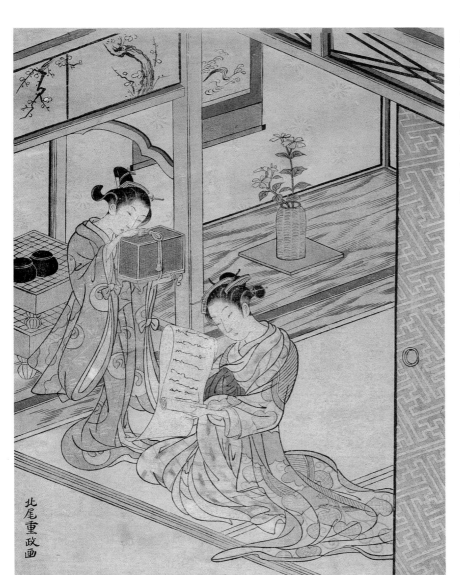

Kitao Shigemasa (1739–1820). Girl with
Insect Cage and Girl Reading a Letter.
This print is in the style of Harunobu,
showing the small cute figures associated
with him. The print bears the seal of
dealer Hayashi Tadamasa (1853–1907), who
was a student of the French language and
who went to Paris to work with Wakai
Kanesaburô exporting Ukiyo-e.

start of the twentieth century, the traditional three-man process by which
prints had been made until then was abandoned and a single artist now de-
signed, cut, and printed the work. These were the masters of *sôsaku hanga* (Cre-
ative Prints) and of *shin hanga* (New Prints). Some of these masters of the
modern Japanese wood-block print brought the art of printmaking in Japan
full circle back to its beginning, for many of them made prints in black and
white, just as the earliest printmakers had done.

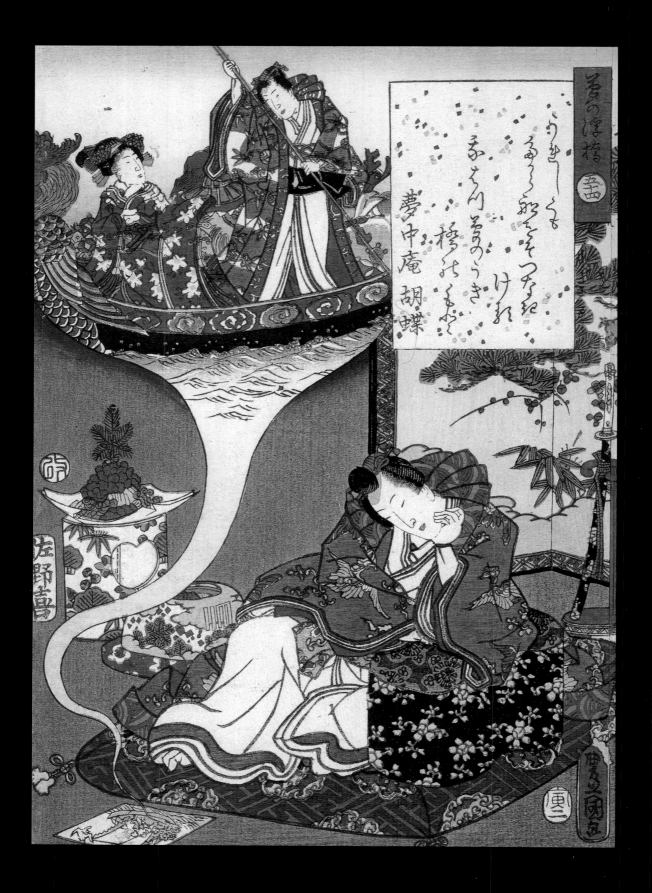

ESSAYS
ON THE ART
OF THE
 JAPANESE
WOOD-BLOCK PRI

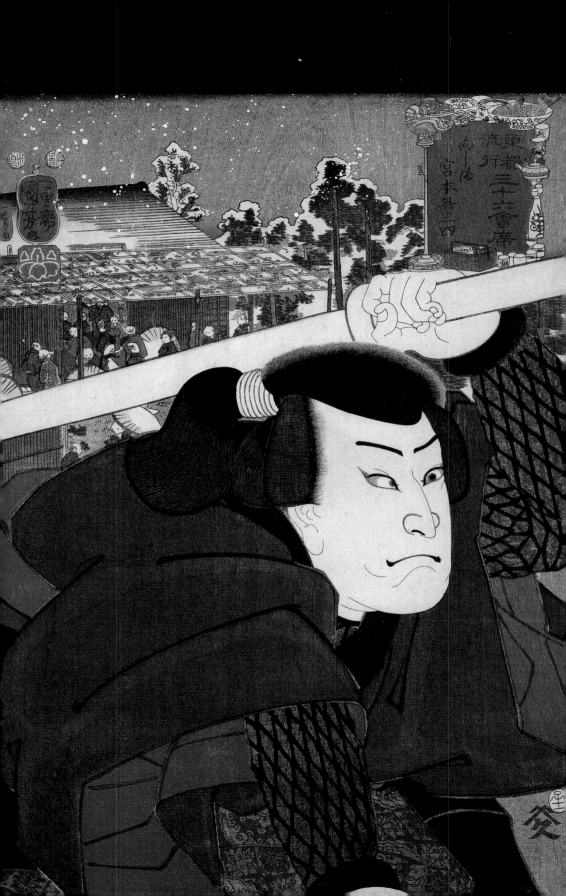

FROM SHADOW TO SUBSTANCE
REDEFINING UKIYO-E

SANDY KITA
UNIVERSITY OF MARYLAND

And by images, I mean, in the first place, shadows, and in the second place, reflections in water...And do you know also that although they make use of the visible forms and reason about them, they are thinking not of these, but of the ideals which they resemble...they are really seeking to behold the things themselves, which can only be seen with the eye of the mind.

That is true.

—Plato's *Republic*

10 (OVERLEAF)

Utagawa Kunisada, *Yume no ukihashi* (Floating Bridge of Dreams). This print, dated 1854, contains a poem that tells how the young man dreams of a treasure ship on New Year's. The poem is a pun on the last chapter of *The Tale of Genji*.

11 (OPPOSITE)

Utagawa Kuniyoshi. *Tôto ryûko sanjuroku kaiseki Mukojima: Miyamoto Musashi* (Thirty-six Current Entertainments of Edo). This work, signed Ichiyûsai Kuniyoshi, is dated 1852. The print is a close-up portrait of Miyamoto Musashi, shown here against the backdrop of Mukojima. It shows how Ukiyo-e masters mixed the illustration of literature, legend, or lore with the depiction of landscape.

*T*here are many ways to define Ukiyo-e. It can be thought of as a school of art—the tradition of Moronobu, the Torii, the Katsukawa, Utamaro, Sharaku, Hokusai, Hiroshige, the Utagawa, and the many other artists represented in the exhibition. It is also possible to consider Ukiyo-e a genre of art, a kind or type of art: wood-block prints in particular or certain kinds of paintings, especially images of actors and courtesans. Finally, Ukiyo-e can be seen as a style of art, a certain way of painting or making prints. Thus, people from different schools of art could produce Ukiyo-e so long as they worked in accordance with its methods. The work of Kawamura Bumpô (1779–1821) is an example. He was a Kishi school painter, specializing in *haiga* or illustrations of *haiku*, who occasionally produced works that could be considered Ukiyo-e.

As a style of art, some see a sense of fashion as key to Ukiyo-e; others see a chic sensuality. Fantasy and play are crucial elements of the Ukiyo-e style in one view of it, and a strict, nearly scientific reporting on reality in another. There are other descriptions of the fundamental nature of the style

of Ukiyo-e, just as there are other ways to define this art than the three given above. But, whatever Ukiyo-e is, clearly it is many things to many people.

Historical Background

One thing that almost all who have sought to define Ukiyo-e will agree upon is that—whether it is a school, style, or genre of art—it developed in the city of Edo (now Tokyo) in the Tokugawa Period (1615–1868). What was that time and place like? There are as many interpretations of Edo in the Tokugawa Period as there are of Ukiyo-e itself. If one were to identify a single common element in all these views, it might be how dominant the shogunate (or warlord government) was.

The Tokugawa Period takes its name from the Tokugawa shoguns who ruled Japan then, and Edo was their city. Before the Tokugawa went there, it had been little more than a fishing village. The Tokugawa made Edo the capital of Japan, as well as the great metropolis of their time. So closely do we identify the city of Edo with the Tokugawa shogunate that another name for these warlords' era of power is the Edo Period (1615–1868). Therefore, when we say that Ukiyo-e is a school, style, or genre of art that emerged in Edo in the Tokugawa Period, what we are saying is that it developed in a world dominated by the Tokugawa shogunate.

For the artists of Ukiyo-e, one crucial aspect of living under shogunal rule must have been the Tokugawa social order. Traditionally, Japan recognized three classes of people: aristocrats, warriors, and commoners. The Tokugawa, following Confucian models, recognized four. Placing aristocrats outside their social order, they categorized the population into warriors, farmers, artisans, and merchants. This system was called *shinôkôshô*, after the Chinese ideograms for warrior (*shi*), farmer (*nô*), artisan (*kô*), and merchant (*shô*).

The four classes of *shinôkôshô* represented not only divisions of society, but also ranks. That is to say, the Tokugawa placed warriors such as themselves on top of their social order, farmers second, artisans third, and merchants last. The usual justification for this ranking is that warriors have pride of place because they defend society. Farmers follow next because they produce the crops that feed the warriors. Artisans make the tools that allow the farmers to grow food. Merchants are last because they create nothing, living only on the exchange of goods. Merchants were some of the richest peo-

ple in Tokugawa-Period Edo, but it can be seen that the shogunate did not regard them highly.

This affected Ukiyo-e because this school differed from others in its focus on making prints. Indeed, as noted, one way to define Ukiyo-e is as prints, and the importance of the print medium to Ukiyo-e is clear in the many books and catalogs that include the phrase "Japanese wood-block prints" in their titles or subtitles.[1]

Prints allow an artist to produce multiple images easily. Thus, by concentrating on making prints, an artist who wishes to sell his work has more to sell. Ukiyo-e was the first school of art in Japan to be composed almost entirely of artists living on the mass sale of their work rather than by serving a select clientele or a single patron. For this reason, the Ukiyo-e artist could be classed not only as an artisan, but also as a merchant.

Consequently, when we define Ukiyo-e as an art developing in Edo in the Tokugawa Period, we must not fail to recognize the impact that the *shinôkôshô* system had on it. Because of the shogunate's prejudice against merchants, Ukiyo-e is not just the art of a certain time and place. It is an art of the lower classes of Edo in the Tokugawa Period. In fact, to many scholars, it is the art of a people suffering under oppression.

The merchant and artisan classes of Edo in the Tokugawa Period, collectively known as "townsmen" or *chônin,* are considered oppressed because of the many sumptuary and other laws directed against them. These limited their dress, housing, and innumerable other aspects of their life. Despite the wealth of the *chônin,* the Tokugawa shogunate was hard on them, so hard that the government saw the need to provide a kind of "safety valve" to release the resentment that would inevitably build among the *chônin* in such a repressive social climate. So the Tokugawa created an area, a limited area, where they would not enforce their sumptuary and other anti-*chônin* laws. There, the *chônin* could be free. This limited realm of *chônin* freedom was the theater and brothel district of Edo, the latter called the Yoshiwara. These places became the center of *chônin* culture. Thus, many of those who see Ukiyo-e as the art of an oppressed *chônin* class see it as an art per se of the brothel and theater district.

In this view of Ukiyo-e the chief subjects of this art are often identified as the handsome actors of the Kabuki or popular theater and the "beau-

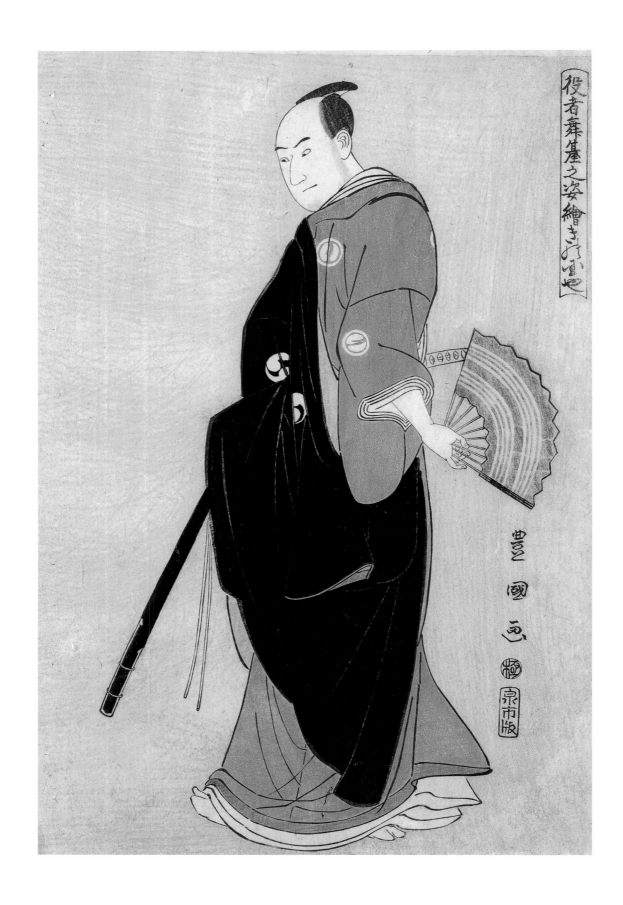

ties" or courtesans of the Yoshiwara. These people and their *chônin* patrons constituted the principal population of the so-called Floating World, which innumerable books and catalogs on Ukiyo-e inform us was the name of the brothel and theater district of Edo in the Tokugawa Period. In Japanese, the characters for Floating World are read *ukiyo*. Thus, in these sources, the compound term *Ukiyo-e* is translated as: "pictures, paintings or illustrations (*e*) of the Floating World (*ukiyo*)." It is with this meaning that the term has come to be used in everything from popular coffee-table books to scholarly works of literature, history, and art. Insofar as this Japanese word can be said to have entered the English vocabulary, it has done so with this meaning.

Although Ukiyo-e is the word now accepted for the art under discussion here, what this art was called in the Tokugawa Period is another matter altogether. Consider, for example, the authoritative *Ukiyo-e jiten* (Dictionary of Ukiyo-e). In it, there are more than a hundred entries on *ukiyo* and *ukiyo-e*. A number of the entries on *ukiyo* are for items dating to the Tokugawa Period. For *ukiyo-e*, there is only a single entry that goes back to that time—Okumura Masanobu's work of art, *Ukiyo-e ichiryû kongen*, from the Kyôhô Era (1716–1736).

Judging from *Ukiyo-e jiten*, therefore, it would appear that the term *ukiyo* was in far more common use in the Tokugawa Period than the compound phrase *ukiyo-e*. Secondly, the vast majority of the entries on *ukiyo-e* in *Ukiyo-e jiten* are for items dating from the late nineteenth to the twentieth century, which would indicate that the word Ukiyo-e came into general use only recently. This word may not be the Tokugawa-Period name for this art then, and we should not blithely assume that it is.

We are not certain what the people in Edo in the Tokugawa Period called the art that we now refer to as Ukiyo-e, but in Kyoto, Osaka, and other cities besides Edo, it may have been known as *azuma-e* (Eastern or Edo art) or *azuma nishiki-e* (Eastern or Edo full-color prints). Such names are logical given that this art came to these people from Edo in the East. Easterners may have referred to the art that we call Ukiyo-e by the names of its more specific products, such as *nishiki-e* (brocade prints), *tan-e* (red pictures), and *urushi-e* (lacquer prints).

It is also possible that, before the nineteenth century, there may not have been just one word in common use for the art we know as Ukiyo-e. This

Utagawa Toyokuni. Kinokuni ya Sawamura Sanjûro III as Oboshi Yuranosuke from the series Yakusha Butai no Sugata-e (Forms of Actors on Stage). The series *Yakusha Butai no Sugata-e* is a famous example of Toyokuni's early work in the genre of the actor print. Each actor in the series is shown full length in a simple, distinctive pose that captures him with a true sense of immediacy. Toyokuni was more famous in his time for his actor prints than was his contemporary Sharaku, whose work was more dramatic, and whose figures showed more exaggerated faces. In this, Toyokuni's actor prints were closer to those of the Katsukawa tradition, especially as represented by Shunei (1762–1819). They are more stable and convey a better sense of individual actors, depicting them as if on stage. This print shows Sawamura Sanjûro III (1753–1801) as Oboshi Yuranosuke from the play *Edo no Hana Akahono Shiokama*, which was performed at the Kiri-za in the spring of 1796. The print bears the subtitle *Kinokuni-ya*, the actor's house name. Sanjûro III, a leading actor at the Nakamura theater, was famous for his large, fat ear lobes and his great round eyes. Toyokuni carefully showed these features of the actor in this print. The expensive gray mica background suggests the commercial success of Toyokuni's work and the popularity of his products in the society of his time.

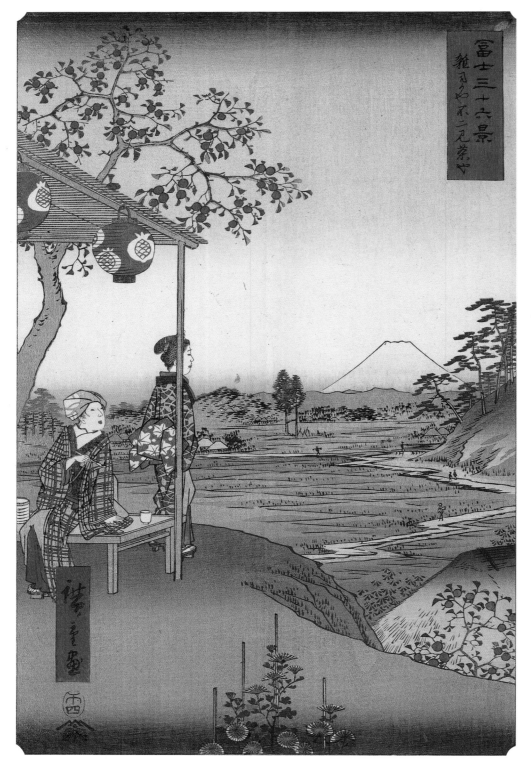

Utagawa Hiroshige. *Zoshigaya Fujimi chaya* (Viewing Mt. Fuji from a Tea House at Zoshigaya) from the series *Fuji sanjûrokkei* (The Thirty-six Views of Mt. Fuji), 1858–1859. Publisher: Tsutaya Kichizô. Vertical *oban*-size wood-block print in ink and colors on paper. Hiroshige designed two sets of prints inspired by the wildly popular set of the Thirty-six Views of Mount Fuji that Katsushika Hokusai published between 1829 and 1833. Hiroshige completed the designs for his second series of Fuji prints shortly before he died in 1858. They were published posthumously by his close friend, the famed publisher Tsutaya, as a tribute. In this print from the series, two young ladies stop for a rest and a chance to admire the distant view of Mount Fuji at an outdoor tea house stall at Zôshigaya, an outlying district of Edo. Tea stalls like this were strategically located throughout the Japanese countryside and within cities so that they could do business along major thoroughfares and at popular tourist destinations. They served simple, common variety cups of steeped green leaf tea to passers-by. The lady seated on the bench beneath the awning is shown smoking tobacco from a slender pipe she grasps with her right hand. Her fine coiffure is concealed beneath a turban to protect it from the elements as she travels to some unknown destination.

Utagawa Hiroshige. *Senju no ôhashi* (Great Bridge at Senju) from the series *Meisho Edo hyakkei* (A Hundred Famous Views of Edo), 1856. Hiroshige, a master of Japanese landscape, created beautiful landscapes of Edo using a wide tonal range with flat surface space. This series was issued between 1856 and 1859. The print shows the great bridge of Senju crossing the Sumida River. The Senju Bridge was built in 1594 and stood for 300 years until it was washed away in the great flood of 1885. Mt. Bukô (4,383 ft.) is depicted.

In looking at the wood-grain markings, color, and detail, we see a superb example of an early edition print. For instance, the wood grain creates a rhythmic pattern in the water, adding a rich texture to its surface. Furthermore, when compared to the print in the Brooklyn Museum, both are identical in color and wood grain.

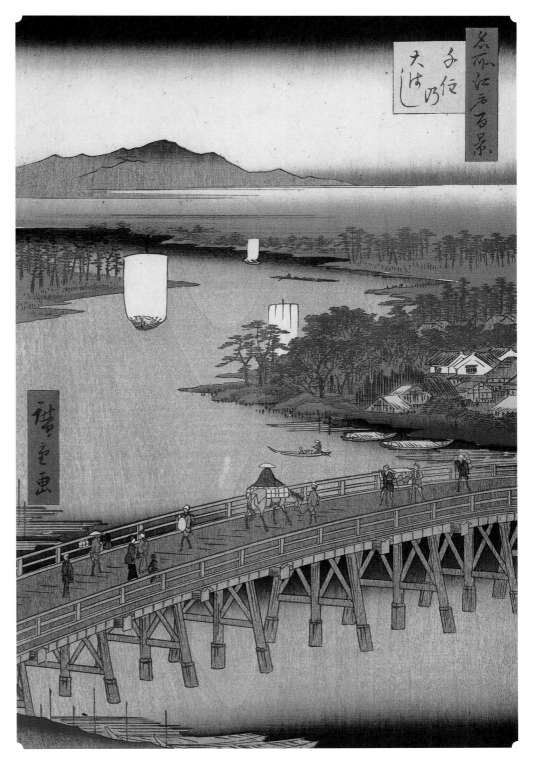

possibility is less strange than it might seem at first. For a school, style, or genre of art to require a name, it must not only develop sufficiently to be different from others, but people must also become familiar enough with it to see its special qualities. This all takes time. Surely the art of Ukiyo-e had an identity of its own by the late eighteenth century, as the development of historical works that examined this art as a discrete tradition suggests.[2] Give or take a century or so for Ukiyo-e to become generally known, and a nineteenth-century date for the appearance of a popular generic label for it does not seem unreasonable. Consequently, the lack of evidence in *Ukiyo-e jiten* for the broad popular use of the term *ukiyo-e* before the nineteenth to twentieth centuries does not particularly bother me. Rather, what disturbs me now is the definition of it, that many have come to accept, as the art of an oppressed *chōnin* class, and so as an art focused upon the beauties of the Yoshiwara and the actors of Kabuki.

A problem with this narrow definition of Ukiyo-e is that two of the best-known, nineteenth-century Ukiyo-e artists are Hokusai and Hiroshige. Who is not familiar with the former's *Great Wave* or the latter's *Ohashi Bridge*? These images decorate billboards in Chicago, houses in Los Angeles, and T-shirts in Washington, D.C. Hokusai and Hiroshige did portray actors and courtesans, but they are unquestionably better known for *The Hundred Views of Edo, The Fifty-three Stages of the Tōkaidō, The Thirty-six Views of Mt. Fuji,* and their other series of landscape prints. In light of the wonderful work that Hokusai and Hiroshige did portraying the scenery of Japan, it is hard to think of them only as specialists in the depiction of the brothel and theater district of Edo. They did so much more. If Ukiyo-e is the art that portrays a Floating World defined as Edo's brothel and theater district, then in what sense are Hiroshige and Hokusai part of it?[3]

In addition, Hiroshige's work has a reputation for being carefully checked against the actual things that his pictures portray. There have been a number of exhibitions that have juxtaposed his prints of *The Fifty-three Stages of the Tōkaidō* with photographs of the places shown. While the match is never exact, it is, at times, quite close. More to the point, Hiroshige and Hokusai filled their prints with detailed renderings of buildings, bridges, trees, rocks, people, and other objects. Their art work suggests a careful observation of things, confirmed in Hiroshige's case by statements in his diaries concern-

ing his habit of sketching as he traveled along the road. We should not think of Hiroshige's work as plein air drawing, for he does alter what he sees when composing his prints. And yet, having said that, it is no less certain that a key element of his art is the degree to which it is checked against the things portrayed. That is also the case for Hokusai.

But, therein lies a problem for current views on Ukiyo-e, for the above aspect of the style of Hokusai and Hiroshige contradicts a key implication of the present definition of this art. You will recall that, in this understanding of Ukiyo-e, the art portrays a Floating World, which, in turn, is seen as a safety valve by which the Tokugawa shogunate releases the pressure building up among the *chônin* under its repressive social system. The shogunate allows the Floating World to exist and to develop because it needs to placate the *chônin* even if it despises them, for these people are, in economic terms, the single most powerful group of their time. The shogunate must dominate and control the *chônin* but it cannot afford to offend them to such a degree that they will rebel. What the shogunate does, therefore, is to issue anti-*chônin* legislation, but then give its victims a place—the Floating World—to vent their anger against these laws. Furthermore, the shogunate disarms the *chônin*'s antishogunal acts or expressions by making it clear that they occur in a realm that stands outside of reality. Thus is *chônin* resistance to authority harmlessly dissipated.

Consequently, for the Tokugawa to tolerate the Floating World, this place must be perceived as unreal or it becomes a breeding ground for the very resistance that the government wishes to suppress. From the perspective of the Tokugawa, the Floating World is—as is the nature of pleasure quarters the world over—a realm of fantasy. This understanding of the Floating World translates in the study of Ukiyo-e into the notion that this art, as one which portrays an unreal realm, must itself have a very basic link to fantasy. Such an interpretation of Ukiyo-e is particularly strong in the writings of those historians who have labored to show us that life in the Floating World was never quite as perfect and glamorous as Ukiyo-e made it seem.

Hiroshige and Hokusai were perfectly capable of creating wonderfully fantastic works of art. And yet, a key feature of their landscape prints is, as noted, how much images in them are true to the things that are portrayed. If fantasy is an element of the art of Hiroshige and Hokusai, it is not its sole

Utagawa Kuniyoshi. *Kada hone o kezurite Kan-u ya-kizu o ryoji suru zu* (Portrayal of the Physician Kada Scraping the Bone of Kan-u to Treat an Arrow Wound). This print depicts the story of how the wounded Chinese Baron Kan-u was so stoic that he could play chess while the famous Dr. Kada operated on his arm. The figure looking on is Baron Shujo. The story is obviously fanciful, but is portrayed in such rich detail as to possess an air of believability.

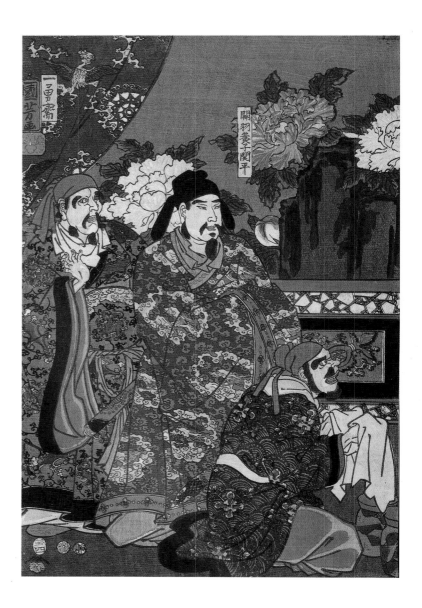

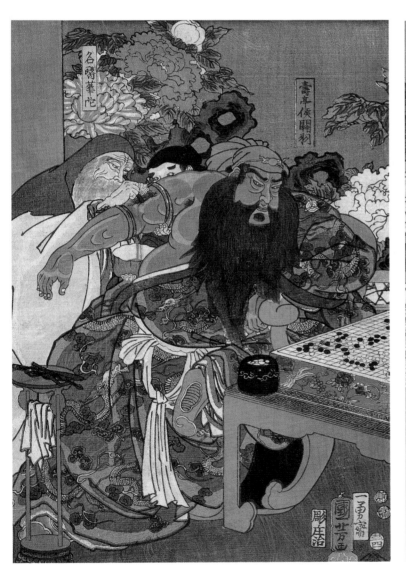
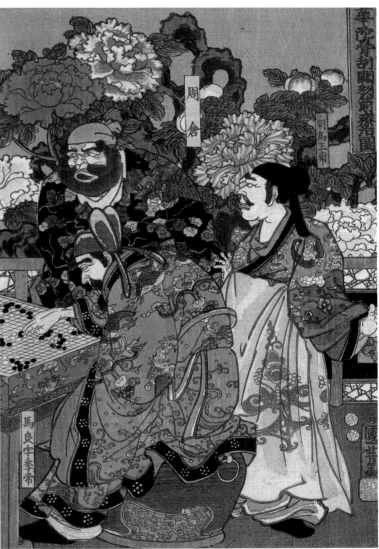

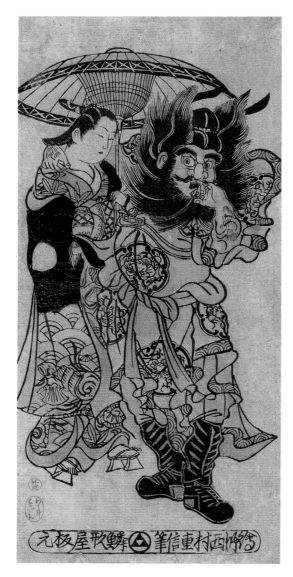

16

Nishimura Shigenobu (fl. 1730s–1740s). [Shoki and Girl]. Publisher: Urogataya. This early, hand-colored print is a typical example of parody. Shoki, the fierce demon queller, has his hand around the shoulder of a cute young lady who has, apparently, quite tamed him. The print bears the seals of the collector/dealers Wakai Oyaji and Hayashi Tadamasa.

constituent. This can be said of Ukiyo-e in general. The art has a rich vein of fantasy running through it, but it is no less about how things actually look. That fact is clear to many collectors, connoisseurs, and museum professionals whose experiences working with prints have shown them how much Ukiyo-e masters checked their images against reality.

Such people are expert in differentiating original Ukiyo-e from fakes, reproductions, and recuts. So many times in discussions over whether such and such a print is "real," the issue comes down to how well a given line captures the object that it portrays. This is the case for even the most fantastic compositions. Compared to fakes, the line of a hand in an original work of Ukiyo-e convincingly renders that hand; the contour of a foot captures its weight; and the outline of a fluttering sleeve depicts its movement in reality. Thus, the assumption that Ukiyo-e is fundamentally linked to fantasy runs counter to the experience of many of those who work most closely with these prints. Accordingly, to define this art in a way that unduly stresses fantasy is too limiting. Such a definition accounts for only part of the complex style of Ukiyo-e and so is neither complete nor satisfactory.

The earlier definition of Ukiyo-e is wanting in another respect. It locates the Floating World in the Yoshiwara, on the one hand, and in the theater district, on the other. Why were these two places chosen? The reason becomes clear when we go back to the idea that the Tokugawa tolerated the Floating World and allowed it to develop because they wanted to alleviate *chônin* frustration with the official social order.

The theater helped placate the most powerful *chônin*, the richest merchants, by allowing them a place to flaunt their wealth. In the world of the theater, *chônin* could patronize actors, support theatrical productions, and do other things to demonstrate their importance. And yet, if merchants were key figures in the theater, they were essentially passive participants, for they were the audience, not the actors, of Kabuki. By contrast, the Yoshiwara gave rich merchants a much more active and, dare we say it, intimate role to play.

It was in the brothel district that money really counted. There, the rich merchants could achieve social positions that were fully in keeping with their great wealth. They could do this, however, only as long as they recognized that things were very different outside the pleasure quarters and that the world beyond was the real one. In the Yoshiwara, *chônin* could even play at

being aristocrats. They could quote the classic literature of the nobility, create poems as aristocrats did, and commission art in upper-class styles. All this was fine with the shogunate, so long as the *chônin* understood that, in so doing, they were just playing. *Chônin* in the Yoshiwara are thus like actors on stage, performing a role that may seem real to us and to them at the moment, but which is ultimately false. That is to say, the Yoshiwara, no less than the theater district, is a realm of theatricality. Therein lies the connection between the two.

But, this view of the Floating World leads us back to the notion that this realm and the art of Ukiyo-e which portrays it do not deal with realities. I have already discussed the problems with this view and now wish to turn to three other problematic corollaries of the above interpretation of Ukiyo-e. These are that references to the classics, to court culture, and to upper-class art in Ukiyo-e are inherently playful, an idea often expressed in the description of these references as *mitate* or parodies. Second is the notion that Ukiyo-e developed largely on its own in the Tokugawa Period. And third and last is the view that Ukiyo-e evolves from a Primitive state to a Golden Age to Decadence.

Parody and Yamato-e

These problematic corollaries of our current understanding of Ukiyo-e all stem from the assumption that Ukiyo-e portrays a Floating World that is like a safety valve created by the Tokugawa to release the pressure building up among the *chônin* in their society. This view of the Floating World leads to the assumption that references to the classics, court culture, and other forms of high art in Ukiyo-e must be parody because otherwise they would challenge the official social order in a way that the government would not tolerate. So, too, if such references are not seriously made, then there can be no real link between Ukiyo-e and the courtly, classical style of painting called seventeenth-century Yamato-e. Seventeenth-century Yamato-e is high art, on the one hand, but genre painting on the other. As the latter, seventeenth-century Yamato-e is Ukiyo-e's most likely ancestor. Accordingly, if one abandons the possibility of a serious connection between Ukiyo-e and seventeenth-century Yamato-e, one has little choice but to conclude that the former developed on its own. The third point—the evolution of Ukiyo-e

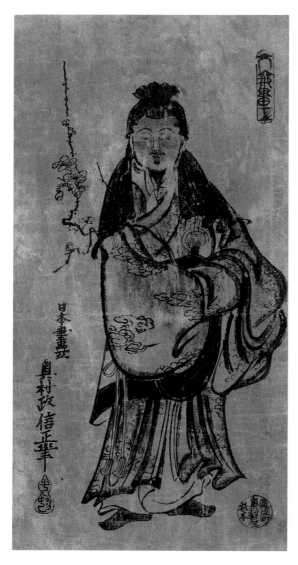

Okumura Masanobu *[Tenjin]*. This print depicts Sugawara Michizane (845–903), a nobleman who became the god Kitano Tenjin. In his deified form, Michizane is said to have flown to China to learn Zen, paying for his lessons with a sprig of flowering plum. This subject matter developed among fourteenth- to fifteenth-century Japanese ink painters and was popular among artists surrounding the *machishu.*

from a Primitive State to a Golden Age to Decadence—I will discuss later. Now, I turn instead to a more detailed examination of the first two corollaries of the safety valve theory of the Floating World and consider the problems that they create for understanding Ukiyo-e.

Before beginning a discussion of parody in Ukiyo-e, I wish to point out that the artists of this school did use the term *mitate* in the titles of their classical or courtly prints. It can also be said that Ukiyo-e artists, including Masanobu, Harunobu, and the Kaigetsudo masters, will state, on occasion, that they make such references "playfully" (*giga-teki*). Finally, it is quite obvious that some references to the classics and to court culture in Ukiyo-e are meant to be funny. I have no doubt that parody is an element of the appropriation of high culture in Ukiyo-e. What is at stake here is only whether all such attempts by Ukiyo-e masters are parody.

That is less likely, given that there are Ukiyo-e in this very exhibition which make such subtle or complex references to the classics or to court culture that it is hard to believe that their creators were not seriously interested in these ancient aesthetic traditions. Wood-block-printed books also make it obvious that there was no lack of publication of the classics and court poetry in the Floating World. The number of Ukiyo-e making classical or court references is, moreover, quite high. If there are Ukiyo-e that label references to the classics, court culture, and high art as "parodies," there are others that do not. Artists such as Moronobu, Kiyonobu, Masanobu, and the Kaigetsudô used signatures such as *yamato gakô, yamato-eshi, yamato gashi,* and *yamato hitsuzu gashi,* all of which mean "painter of Japan" and all of which suggest a link to that most Japanese of Japanese arts: Yamato-e. Finally, we now know that many conventions for painting people, landscape, and other things in early Ukiyo-e derive from those in seventeenth-century Yamato-e. To cite just a few examples, wood-block prints of actors portraying the hero Soga Gorô by Kiyomasu I, Kiyomasu II, and other early Ukiyo-e masters closely resemble paintings of Thunder Gods by Tawaraya Sôtatsu (d. 1643?), Ogata Kôrin (1658–1716), and other seventeenth-century Yamato-e masters. Depictions of *The Beauty on the Verandah (ensaki bijin)* in Ukiyo-e are identical to portrayals of the same subject by Kôrin and Sakai Hôitsu (1761–1828) and their colleagues in the school of seventeenth-century Yamato-e.

As more and more evidence of the relationship between Ukiyo-e and

seventeenth-century Yamato-e has appeared, it has become harder and harder to believe that all references to the classics, the court, and high culture in Ukiyo-e are parodies. Some must be meant seriously. Indeed, that conclusion seems so obvious today that one wonders how it could ever have been questioned. And yet, it was, but for reasons, perhaps, that may have more to do with a larger, related issue: whether or not Ukiyo-e developed suddenly on its own in Edo in the Tokugawa Period or evolved slowly out of seventeenth-century Yamato-e. These two views on the origins of Ukiyo-e, in turn, connect to what *Ukiyo-e jiten* identifies as the two fundamental approaches to understanding this art.

According to *Ukiyo-e jiten*, scholars of Ukiyo-e have traditionally seen it as either prints or painting. *Ukiyo-e jiten* further states that the first view leads to the identification of Moronobu as the founder of Ukiyo-e, and the second, to Iwasa Matabei (1578–1650). Identifying Ukiyo-e as prints and Moronobu as its founder amounts to defining it as a sudden, independent invention of Edo in the Tokugawa Period. So, too, it is my opinion that viewing Ukiyo-e as painting and Matabei as its founder implies that this art emerged slowly out of seventeenth-century Yamato-e.

Viewing Ukiyo-e as prints leads to the conclusion that it appeared on its own suddenly in Tokugawa-Period Edo because, seen thus, the art would have been the first of its kind. Without precedent, then, Ukiyo-e would have no serious connection to an earlier time. Thus, logically, it must have appeared suddenly on its own in Edo in the Tokugawa Period. Moreover, identifying Moronobu as Ukiyo-e's founder confirms this view of this art's origins, given who this artist was. Born at Hoda (Awa Province, now Chiba Prefecture), Moronobu may have studied art under his father. However, we know nothing about Moronobu's father. It is also possible that Moronobu was the student of the printmaker called the "Kambun master." He worked in the Kambun Period (1661–1673), but we know nothing else about him. Thus, given how little we know about Moronobu's teachers, it is clear that, whoever he may be, his lineage is neither long nor distinguished. Thus, the school that he founds is equally without tradition.

Likewise, seeing Ukiyo-e as painting and Matabei as its founder connects this art to seventeenth-century Yamato-e. The first point may require some explanation since the objects that we call Ukiyo-e are so obviously

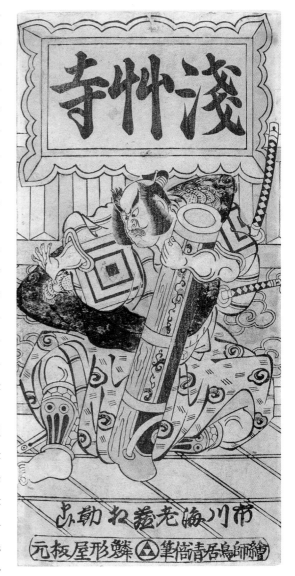

18

Torii Kiyomasu II (fl. 1720–early 1760s). *Ichikawa Ebizô aitsutome moshi soro* (Ichikawa Ebizo on Stage). In the background of the print, a plaque appears bearing the name of the famous Edo temple Sensôji. The print, presumably by Kiyomasu II, shows Ichikawa Ebizô on stage, holding a large gun. He stands in a pose similar to that of Thunder Gods in seventeenth-century Yamato-e.

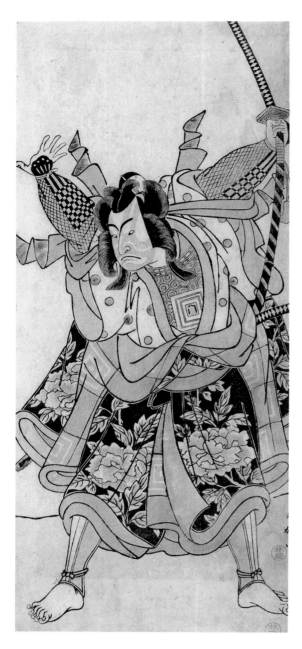

19

Katsukawa Shunkô. Untitled. The actor in this print takes the Thunder God pose.

prints. The tradition of art we know as Ukiyo-e, however, can be considered painting in light of how these prints are made. Unlike Western prints, those of Ukiyo-e are products of the joint efforts of three people. An *eshi,* or painter, creates a composition; a *hori,* or cutter, cuts that image into wooden blocks; and a *suri,* or rubber, makes the actual print. The names that appear in the signatures on Ukiyo-e are those of the *eshi.* The people that we know as the artists of Ukiyo-e, consequently, were not printmakers at all. They were painters, as were the masters of seventeenth-century Yamato-e.

In addition, identifying Matabei as the founder of Ukiyo-e confirms the connection between this art and seventeenth-century Yamato-e, for he claimed to be "The Last of the Line of Tosa Mitsunobu" (1434–1525). Mitsunobu was the second of the Three Great Masters of Tosa, the family and school of artists who specialized in painting Yamato-e. Matabei's art was actually a mix of Tosa and Kanô school elements, for he had also studied with Kanô Naizen (1570–1616). But, as my recent book *The Last Tosa* showed,[4] Matabei served the court, was part of the circle of Sôtatsu, and created a body of signed paintings that are almost entirely classical in subject matter. In all this, Matabei is a typical seventeenth-century Yamato-e painter. His lineage is clear. He is the product of an old and distinguished tradition of art, and so the school that he founds has equally strong historic links—it evolves out of seventeenth-century Yamato-e.

Machishu

What *Ukiyo-e jiten* identifies as the two fundamental approaches to defining Ukiyo-e boil down to whether this art develops out of seventeenth-century Yamato-e or not. That makes me wonder if there is not an even broader issue underlying the questions of how Ukiyo-e evolved and whether its references to high culture are meant as parody. Seventeenth-century Yamato-e is court art, and Ukiyo-e is commoner art.[5] Is it the undeniable gap between aristocrat and commoner that is behind these two problematic corollaries of the safety valve theory of Ukiyo-e? If so, a crucial development for understanding Ukiyo-e is the degree to which the gap between aristocrat and commoner no longer seems unbridgeable. This is the case because of what we know about the *machishu,* or "men of the *machi.*"

Machi is the modern Japanese word for city, but in the seventeenth cen-

Anonymous. Kume Sennin Spies a Girl. This print is unsigned, but typical of the work of early Ukiyo-e masters from Moronobu to Masanobu. The female figure shows the broad cheeks and long jaws associated with Moronobu, a mannerism called *hôkyô-chôi*. This method of drawing faces was supposedly invented by Iwasa Katsumochi Matabei (1578–1650) but is known in hand scrolls back to the twelfth and thirteenth centuries. The print also shows the unusual calligraphic line of Moronobu and other early Ukiyo-e masters, a line also used by Matabei.

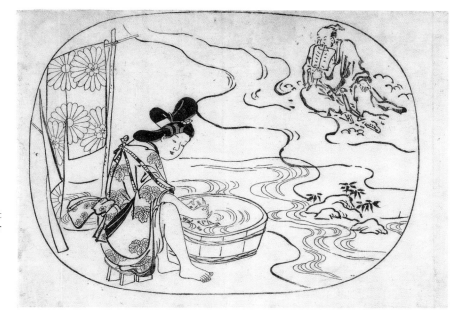

tury it referred to autonomous communities in cities. These little cities within cities formed as the central administration of government collapsed in the Age of Wars (1482–1568). When the government proved increasingly unable to enforce its will, marauding warlords, rebellious peasants, and anyone with the power to do so began to attack cities to plunder them. Their targets were the aristocrats, on the one hand, and the rich merchants, on the other. With no government to help them, these two groups had no choice but to work together to protect themselves. They barricaded their areas, hired mercenaries, and eventually formed private militia. As they became adept at organizing themselves to fight, they also began to take over other aspects of local civic administration. Thus, the autonomous *machi* was formed.

Machi appeared all over Japan, but were especially strong in Kyoto, Osaka, and Sakai. In these places, aristocrats and commoners not only worked together, but also socialized with one another. Court diaries record aristocrats drinking with rich merchants, singing or composing music with them, and even going to the public baths. I do not say that all class distinctions were lost in the *machi* of the Age of Wars, but certainly they loosened in those times of emergency. In this regard, a key fact is that the Age of Wars dragged on for eighty-six years. Accordingly, there was ample time for aristocrats and commoners not only to interact, but also to develop a tradition of interaction.

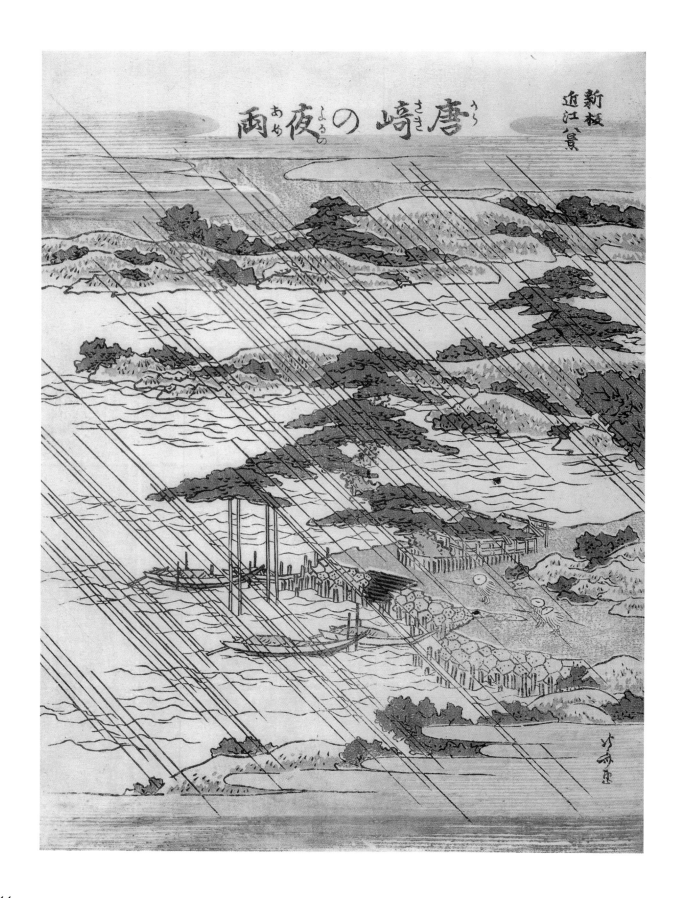

The fruits of the interaction between aristocrats and commoners can be seen in the egalitarian culture of cities such as Kyoto, Osaka, and Sakai during the Momoyama Period (1568–1615). This was the world of the rich merchant Chaya Kiyonobu (1524/45–1596). Leader of his *machi*, he was a friend to both aristocrats and warlords. Among his military-class acquaintances was no less a figure than the founder of the Tokugawa shogunate, Ieyasu (1542–1616). Chaya is a perfect example of a *machishu*.

Another was tea master Sen Rikyû (1522–1591). The son of a warehouse keeper, he became the arbiter of taste in the court despite his low birth. Hon'ami Kôetsu (1558–1637) is a third example of a *machishu*. A commoner, he taught calligraphy to one of the greatest noblemen of his day, Karasumaru Mitsuhiro (1579–1638). Mitsuhiro, in turn, worked with the owner of the Tawaraya shop, Sôtatsu, to make the famous diptych *Bulls*.

I investigated *Bulls* at length in an article I wrote in 1992.[6] The work interested me because I knew that the image by Sôtatsu referred to the story of Sugawara Michizane, but the inscription by Mitsuhiro referred to *The Tale of Genji*. I wondered why the references in the inscription and image did not match. I found my answer in the meaning that the work had for *machishu* when I read the inscription and the image together. Mitsuhiro referred not just to *The Tale of Genji*, but to the Akashi chapter of that story. In this section of the tale, Prince Genji is unfairly forced into exile, but then is vindicated and returned to power. That, in essence, is also the story of Michizane. When the inscription and the image in Sôtatsu and Mitsuhiro's *Bulls* are considered together, then it is apparent that the work contains a hidden reference, most meaningful in Sôtatsu and Mitsuhiro's time when the shogunate, in its efforts to suppress the *machishu*, exiled many of the courtiers associated with the group.

Even more to the point, given that the hidden message in *Bulls* is only apparent when the inscription and image are read together, the work is clear evidence of the degree to which *machishu* calligraphers and painters cooperated in the seventeenth century. It is also to be noted that Mitsuhiro was an aristocrat and Sôtatsu a commoner, so *Bulls* is proof of the degree to which high and low mixed in the world of the *machishu*. Finally, in light of the fact that Sôtatsu and Mitsuhiro did not do just *Bulls*, but also a number of similar works, to question the development of Ukiyo-e out of seventeenth-cen-

21 (OPPOSITE)

Katsushika Hokusai. These prints of *Karasaki no yoru no ame* (Night Rain on Karasaki Pine) from the series *Ômi hakkei* (Eight Views of Ômi), dated circa 1800 to 1802, by Hokusai show beautiful scenes of Lake Biwa in Ômi Province in Japan. They represent a Japanese transformation of a Chinese theme, The Eight Views of the Hsiao and the Hsiang Rivers, established as a set poetic format in the Northern Song Dynasty (960–1127). The popularity of the theme of The Eight Views of the Hsiao and the Hsiang Rivers declined in China after the Song Period but spread to Korea and Japan with Zen Buddhism.

The subject of this print is derived from that of Night Rain on the Hsiao and the Hsiang Rivers. It depicts the Karasaki pine on a rainy night. Hokusai's work differs from Hiroshige's Night Rain on Karasaki Pine, in that where Hiroshige shows a close-up view of the pine, Hokusai creates a wide and flat space that uses the traditional perspective of Chinese-style painting. Some of Hokusai's later landscape prints contain foreground truncation, close-up views, or Westernized perspective.

The Eight Views of Ômi became a popular theme in Ukiyo-e. There was even an erotic Eight Views of Ômi. The nineteenth- and twentieth-century *nihonga* painters chose this theme as the quintessence of the Japanese versus the Western. The Eight Views of Ômi also relates to the concept of *meisho*, or old famous places in Japan.

tury Yamato-e because the former is commoner art and the latter, court, no longer seems valid to me.

That is especially so because the rich merchants of Edo that we call *chônin* came from the rich merchants among the *machishu*. The connection between the two groups is apparent in the terms for them. The word *chônin* can also be read *machinin*, just as *machishu* can also be read *chôshu*. In addition, *machinin/chônin* and *machishu/chôshu* were used interchangeably in the Age of Wars and the Momoyama Era, though that practice seems to have stopped in the Tokugawa Period. It did so because the term *chônin*, which I use in preference to *machinin* because it is better known, began to be used specifically for those lesser *machishu* who accepted the invitation of the Tokugawa shogunate to move to Edo.

I have discussed the implications of this move in my book on Matabei. There I noted how:

> the move had special significance in the early Tokugawa Period. At the time, the shogunate needed merchants, artisans, and other commoners to help populate Edo, which had been little more than fishing village before they made it their base, and then capital. However, this was a move that many upper class *machishu* such as Kôetsu, refused to make.
>
> Their refusal is puzzling for Edo had much to offer. The city was a boomtown. As the new political center of Japan, it was experiencing an influx of lords, their ladies, and their retainers, all of whom needed to furnish their new Edo establishments. This flood of people—regularized once the alternate attendance system was established in 1629 and then formally instituted in 1635—gave Edo an enormous population of consumers, rich enough to buy all the luxuries that they wanted. Edo was thus a place of unrivalled economic opportunity to the great trading houses of Kyoto, Osaka, and Sakai, for the city originally having been, as noted, little more than a fishing village, it had no powerful mercantile establishments of its own. In Edo, there was money to be made, but the elite *machishu* could do so only at considerable personal cost.
>
> These merchants could tap the wealth of Edo only by accepting Tokugawa policies like *shinôkôshô*, and doing that had im-

plications far more devastating than just a humbler place in society. Here the fact that the shogunate had shown—in its dealings with people like Kôetsu—that it would not force elite *machishu* to come to Edo was crucial for if one did not have to go there, those who went could not claim that they did not do so of their own free will. Thus, the shogunate made it clear that those who went to Edo were *willing* to put up with government policies like *shinôkôshô* if they could but partake of the marvelous economic opportunities that the city offered. In other words, the shogunate made a move to Edo connote a preference for money over pride; they made it imply that the *machishu* who went there were not men of principle, above material temptations, but money-grubbers, mere merchants.[7]

And yet, if the richest merchants among the *machishu* did not move to Edo, their competitors who were willing to go there would ultimately eclipse them. The shogunate had the rich *machishu* merchants well and truly trapped and so it neutralized this once powerful group.

In the implications of moving to Edo, then, there lies an explanation for why the shogunate placed the wealthiest people in their society on the bottom of their social order—a curious policy if you think about it. It also suggests how they got away with it. So, too, in the implications of moving to Edo, there is a reason for the shogunate's curious attitude towards sumptuary laws. Everyone knows that the *chônin* disobeyed or circumvented these edicts. But instead of enforcing them consistently, the shogunate satisfied itself with reissuing them or occasionally cracking down. Why did the shogunate act this way? It is hard to say what their motivations might have been, but understood in the above context, their actions are perfectly logical. What I suspect is that the Tokugawa may not really have cared how strictly sumptuary laws were obeyed, for their point was not to control the behavior of *chônin* so much as to damage them politically by representing them as money-grubbers without principles. There was no need then to enforce these laws except in the case of flagrant violations. Far better to reissue them, for that provided yet another opportunity to propagandize against the *chônin*. I wonder if this is not also the motive behind the location of the *chônin's* area of freedom in the brothel and theater district. The choice of these places does

22

Ki Baitei (1734–1810). Woman with Children. Album leaf, ink on paper. Signed Kyûrô-sha. Sealed Baitai. This small, sketchlike painting poignantly captures the essence of motherly love. The main figure is a woman, whose back faces the viewer. She is shown holding a baby to her breast while a small boy sits nearby. Although simply painted, the artist has sensitively imbued the figures with liveliness. The young boy and his mother cock their heads towards one another, deep in conversation. The striped patterns on the woman's robe wrap around her knees creating a sense of volume, and the boy convincingly leans on his outstretched right arm.

The poem to the right of the picture, also by the artist, is written in *haiku* form, a deceptively simple seventeen-syllable verse form of three lines of five, seven, and five syllables, respectively. Such scribbled writing is notoriously difficult to read, but in *haiku* paintings like this, would allude to the illustration.

The artist of this picture was a highly successful professional painter with many pupils and admirers. He specialized in Chinese-style landscapes, figures, and sketchlike *haiku* paintings. His paintings were especially popular among patrons who appreciated Chinese culture and *haiku* poetry.

not seem at all arbitrary or accidental to me, but rather a very deliberate statement by the Tokugawa that, given who *chônin* are, they deserve no better.

Decadence

These thoughts lead me to the third problematic implication of the safety valve theory of the Floating World: the idea that Ukiyo-e develops from a Primitive state to a Golden Age to a period of Decadence. Such organic descriptions of the development of art were once fashionable but have since fallen out of favor as being too deterministic. In addition, the terms *Primitive, Golden Age,* and *Decadent* are particularly deleterious in the case of Ukiyo-e because they occur so often in the context of a comparison of the Floating World to the demimonde of Henri de Toulouse-Lautrec. His shadowy

realm of the lost, the flawed, the addicted, the drunk, and the prostitute is a good metaphor for the Floating World in that it is easy to understand. The comparison, however, may be somewhat facile. It does not take into account the complex political, social, and other factors that made the Floating World such an important center of commoner culture in Japan.

The demimonde interpretation of Ukiyo-e also has a tinge of moral judgment about it that makes one feel that this art ends in decadence because, in essence, that is what it is. Such a view of Ukiyo-e would, I suspect, have found favor among the Tokugawa. The shogunate, after all, benefits from seeing the *chônin* as morally suspect, for that view helps them dominate and control this group. To interpret Ukiyo-e as inherently decadent is thus to take a stance on it that is uncomfortably reminiscent of what one imagines the shogunal position to be. That is uncomfortable because Ukiyo-e is not the art of the shogunate. It is the art of the *chônin*. To adopt too shogunal a perspective on Ukiyo-e is like trying to understand the music of Madonna on the basis of right-wing writings on the proper place of women in our society.

In addition, the Tokugawa may see the *chônin* as money-grubbers who value profit over principle, but would the rich merchants of Edo agree? I suspect that the first or second generation of *chônin* might have had to, but what about the fourth or fifth? They would be old money by then. Would they still remember, or care, how great granddad made the family fortune? The Tokugawa might want the *chônin* to remember the implications of moving to Edo, but I cannot believe that they did not forget over time. If so, the attitude that the *chônin* would take towards everything from the appropriation of high culture to the validity of sumptuary laws would change as generation followed upon generation.

It is here that I find the greatest fault in the Decadence theory of Ukiyo-e: it does not account enough for change. Such a view assumes that we can find a thing—just one thing—to explain this art in all its complexity. As I have noted at the start of this essay, different scholars have defined this essential quality of Ukiyo-e differently; but in my mind, where all such treatments of this art fail is that, in trying to establish its essence, they make it static. Such views suggest that Ukiyo-e does not change—indeed, cannot change—fundamentally.

Ukiyo

The truth may be that Ukiyo-e was much more capable of change than such interpretations would indicate. What we need is a more dynamic definition of Ukiyo-e; one that recognizes how important change was to this art and how greatly it could change. Such a definition is readily at hand in the connotations of the word *ukiyo*.

You will recall that this word is currently understood to be the name of the brothel and theater district of Edo in the Tokugawa Period. As such, it is used in writings back to the time of Ihara Saikaku (1642–1692). If Japanese people as early as the seventeenth century employed the word *ukiyo* as a name, it must be noted that the Japanese language does not have capitalization. As a result, it is sometimes difficult to tell what is a common noun and what is a proper noun in Japanese writings.

Here, it is important to note that the term *ukiyo* is not, as is sometimes mistakenly assumed, a Tokugawa-Period invention. Hashimoto Mineo has traced it back at least to the *Taketori monogatari* of circa 850 to 950,[8] so that the term *ukiyo* existed long before there was a brothel and theater district in Edo. Consequently, it could not originally have been the name of that place. Rather, as Narazaki Muneshige and many others have pointed out, it was a common noun, the word for "the here and now."[9] The term was essentially equivalent in meaning to the modern Japanese *ima* (the present).

What seems to have happened is that the common noun *ukiyo* was used to refer to the brothel and theater district of Edo to the point where it was identified, albeit mistakenly, as the name of that place. Such a situation is not so hard to understand. Something similar happened to the word *xerox*. This term, too, was originally a common noun designating copies produced through the technical process of xerography. Later, the Xerox Corporation adopted this common noun as a brand name, transforming it into a proper noun.

To be precise, the word *ukiyo* is not a proper noun at all but a common noun that has become a proper noun. Making that distinction is not just splitting hairs. It is important because the common and proper nouns *ukiyo* do not mean the same thing. The proper noun is the name of the brothel and theater district of Edo in the Tokugawa Period. The common noun is

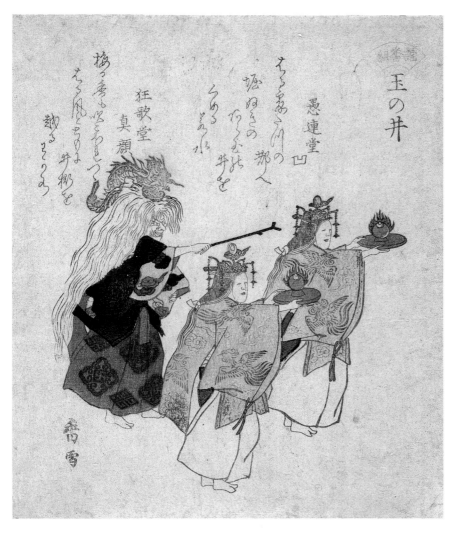

Kosetsu (active 1823–1824). *Tama no I* (The Jewelled Well). This *surimono*, dated 1823, is one of a set of fifteen scenes from *Nō* and *kyōgen* plays, designed by the painter Kosetsu for the Yomo group. Roger Keyes, in his *Art of the Surimono*, notes that (p. 254) "1823 was a Goat year (so) the Yomo group commissioned… a series of *Nō* play scenes because the *utai*, the chanted accompaniment to the *Nō* dances, could also be pronounced *yo*," a Chinese homonym for goat. The play pictured here is Kojiro's The Jewelled Well, which, according to Keyes, concerns the God Hohodemi who entered the sea to retrieve a lost fish hook for his brother. Hohodemi met two princesses and their father, the Dragon King, and lived in an underwater palace with them for three years. In the scene shown, Hohodemi leaves the palace. The Dragon King is at the left and returns the fish hook to him. The two princesses present jewels to him on lacquered trays. Although the print is on somewhat thick yellowish paper, it still shows delicate designs and colors.

the word for the here and now.[10] When we define Ukiyo-e as the art of the brothel and theater district of Edo in the Tokugawa Period, we are considering it only in terms of the meaning that the word *ukiyo* has as a proper noun. Why can we not also use its meaning as a common noun in defining the art of Ukiyo-e?

Such a definition would be most interesting because the common noun *ukiyo* refers to a here and now that is constantly changing. The concept of *ukiyo* is thus akin to that of the contemporary. What is contemporary today is not so tomorrow. It changes with the changing times. Defining Ukiyo-e as pictures, paintings, or illustrations of an *ukiyo* understood in terms of this word's meaning as a common noun, therefore, produces a most dynamic de-

finition of this art indeed. Ukiyo-e becomes the art that shows its artist's here and now when that present is understood to be moving forward forever.

This definition of Ukiyo-e has distinct advantages over the old one. First of all, it solves the problem of what to do with Hokusai and Hiroshige. As noted before, these two artists present a problem in the old view of Ukiyo-e in that they are among the most famous masters of this school but did not limit themselves to portraying the brothel and theater district of Edo. Thus, in the old view of Ukiyo-e, Hokusai and Hiroshige had to be considered somehow exceptional, but we do not have to resort to such expedients if we define Ukiyo-e via the common noun *ukiyo*. In this definition, it is no longer a portrayal of the brothel and theater district of Edo per se. It can show those areas, of course, if the artists in question saw them as their here and now—as Moronobu, the Torii, and the other early masters of Ukiyo-e apparently did. But, Ukiyo-e does not have to portray the brothel and theater district. If its artists moved out of those areas and entered the broader outside world, there would be no reason why we could not include them in the tradition of Ukiyo-e so long as they saw their new, larger realm as their here and now and portrayed it as such. In this respect, Hokusai and Hiroshige could be thought of as doing exactly what Moronobu, the Torii, and the other early Ukiyo-e masters did. They depicted their here and now. It is just that the here and now that they knew was so very different from that of the earlier artists. It had changed with the changing times.

Second, defining Ukiyo-e via the common noun *ukiyo* provides a better way to understand its relationship to seventeenth-century Yamato-e, simultaneously connecting it to and separating it from seventeenth-century Yamato-e more strongly than ever before. The new definition of Ukiyo-e separates it from seventeenth-century Yamato-e by making change fundamental to Ukiyo-e. Understood thus, this art would differ strongly from seventeenth-century Yamato-e in that the latter is an essentially conservative art, as is clear from its very name. We call seventeenth-century Yamato-e that to distinguish it from twelfth-century Yamato-e, to which it harkened back. Literally hundreds of years old, seventeenth-century Yamato-e had traditions ancient enough that they could not help but have affected its artists' attitude towards change. Seventeenth-century Yamato-e masters could never be as committed to the new as were the artists of Ukiyo-e, and therein lies a good reason to separate the two schools.

However, if the new definition of Ukiyo-e separates it from seventeenth-century Yamato-e in terms of content, it also links it to it in terms of style. The court, the classics, and the high culture of Japan were all essential parts of the world of Sôtatsu, Matabei, and the masters of seventeenth-century Yamato-e. In making their conservative paintings, therefore, these artists can be said to have portrayed their here and now no less than the artists of Ukiyo-e did. Their style was much the same as that of Ukiyo-e in this regard. It was just that the here and now that they portrayed was so very different in character from the Floating World.[11]

Moreover, what I have said above about Ukiyo-e and Yamato-e holds true for Meiji-Period or even later prints. Where Meiji and Modern artists portrayed their here and now, their work would be relevant to any discussion of Ukiyo-e.[12] This art need not end with the close of the brothel district of Edo and the collapse of the shogunate. It can extend beyond those events because it is not centered in a certain period or place, but in the attitude that an artist takes towards his world.

Terms to Describe the New Ukiyo-e

What is the nature of this distinguishing attitude of the artist of Ukiyo-e that identifies his work as part of this tradition of art? Before any answers to this key question can be suggested, we need terms for describing Ukiyo-e as seen in this new understanding of it. One such term is *fashionable.*

This is a good word for Ukiyo-e when defined via the common noun *ukiyo* because it means "following the prevailing mode." Thus it captures well the commitment to change that is the essence of Ukiyo-e in the new definition of it. *Chic* is another excellent description of Ukiyo-e as defined above. It implies current, but also suggests elegance and sophistication, which Ukiyo-e certainly had, especially in its later stages. *Popular* describes well an Ukiyo-e defined via the common noun *ukiyo,* for this term implies something in vogue but destined to pass out of favor. Popular also fits the origins of Ukiyo-e among the commoner class of Edo in meaning "of the people."[13] Current, fashionable, chic, and popular—these are good descriptions of Ukiyo-e in our new definition of it, but they are not the only features of this art. That is clear when we consider another meaning of the term *ukiyo,* one that appears with regard to the various ways that this word is written.

Kunisada and Hiroshige. *Fûryû genji yuki no nagame* (Modern Genji: Viewing in Snow). This triptych is a joint work by Utagawa Kunisada and Utagawa Hiroshige. The signature *Toyokuni-ga* (Painted by Toyokuni) appears on the left and right prints, while the center piece is signed in the middle *Hiroshige hitsu* (Brush of Hiroshige). The male figure delicately holding an umbrella above him and the female figure elegantly brandishing a broom show the heightened importance that things—material objects—can have in Ukiyo-e.

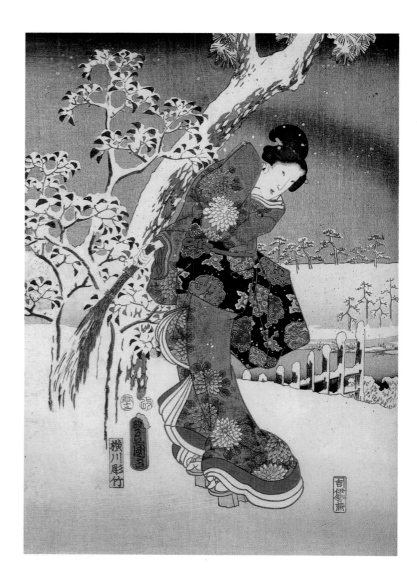

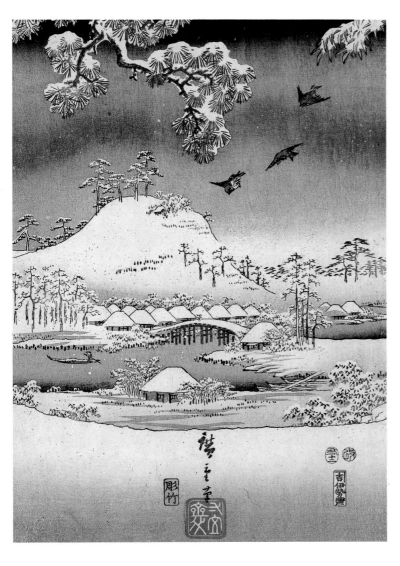

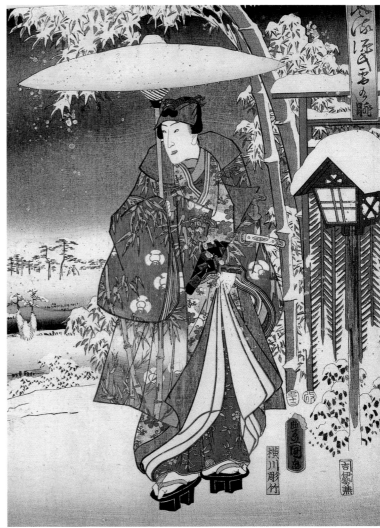

As innumerable books and catalogs on Ukiyo-e will inform you, the term *ukiyo* can be written either *floating world* or *sorrowful world*. These sources also frequently state that the latter is an older way of writing the word. Both these assertions, however, may be wrong. My research suggests that *sorrowful world* and *floating world* are not two ways of writing a single term, but are two quite different words, each with its own separate etymology.[14] The two were conflated in Japan from very early on and have long been used interchangeably. Eventually, the characters for *floating world* did come to predominate, but I do not think that the one word can be dated any earlier than the other.

Certainly, the characters for *floating world* started to be used more frequently than *sorrowful world* before the end of the Tokugawa Period, but I am not certain when this happened, and not knowing exactly when the change occurred creates a small difficulty for me. If the characters for *sorrowful world* and *floating world* were used interchangeably at the time that the word *ukiyo* was applied to the brothel and theater district of Edo, as I suspect, there is something that I do not understand. I can see calling the brothel district the Floating World, but not the Sorrowful World. Such a dark and dolorous name does not seem appropriate for the pleasure quarters.

One way to resolve this is to consider a third statement often made about the term *ukiyo* in books and catalogs on Ukiyo-e: that it is Buddhist. This assertion seems to me quite right, and so, I believe that a logical way to investigate the concept of the *ukiyo* is via Buddhism.

One feature of Buddhism that I find striking is how directly the Buddha confronted the question of death. Instead of positing an afterlife by which to escape death, the Buddha warned against clinging to the ephemeral, such as life. Buddha said that sorrow inevitably results from the unwise desire to maintain what must disappear. An excellent metaphor for the inconstant nature of existence in the Buddhist view of it is the Floating World, a world where nothing is fixed. That may be why Buddhists used this term for the here and now.

What is then crucial to understanding the concept of *ukiyo* is the close relationship between the ephemeral and sorrow in Buddhism. Life may be ephemeral, but who does not cling to it? Our world, understood as a *floating world*, therefore, is inherently a *sorrowful world*. That may explain why Buddhists called the here and now the Sorrowful World and it suggests a reason

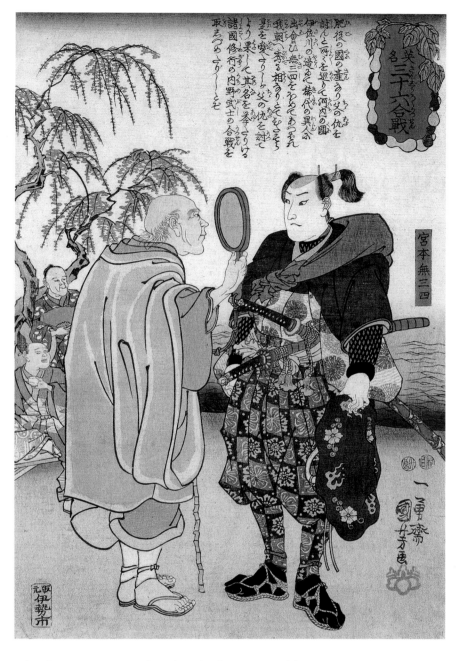

Utagawa Kuniyoshi. *Eimei sanjûroku kasen* (Thirty-six Famous Battles). These three prints show how Ukiyo-e developed conventions of its own. The first, signed Ichiyûsai Kuniyoshi, shows a man holding up a magnifying glass to look at the features of Miyamoto Musashi (1584–1645), the famous swordsman, better known as Niten or "Two Swords." Musashi was a painter as well. He represents the phenomenon called *ronin bunka* (the culture of the masterless samurai) that developed as warriors lost their masters and turned to art to support themselves.

why this term was conflated with Floating World.

There may be more to it than that, however, and here the troubling in-appropriateness of naming the pleasure quarter the Sorrowful World leads to something more significant. I believe that the Sorrowful World and Float-ing World are one in the same because they are both the world that we ex-perience in life. The Sorrowful and Floating Worlds are equally the world that we know in the flesh. For that reason, I would like to posit something

Utagawa Kunisada. *Tôkaido gojûsan tsugi no uchi: Kambara zu* (One of the Fifty-three Stages of the Tôkaidô: Picture of Kambara). Here Kunisada uses Hiroshige's famous print of *Kambara* from the series The Fifty-three Stages of the Tôkaidô as a backdrop for a portrait of a beauty riding a bull, a possible reference to Kitano Tenjin. The print reveals the extent to which the artists of Ukiyo-e could borrow images from one another as the traditions of this school developed. Not only did Kunisada use Hiroshige's landscapes in this series, but he also made a second set of half-length portraits of actors paired against these same landscapes.

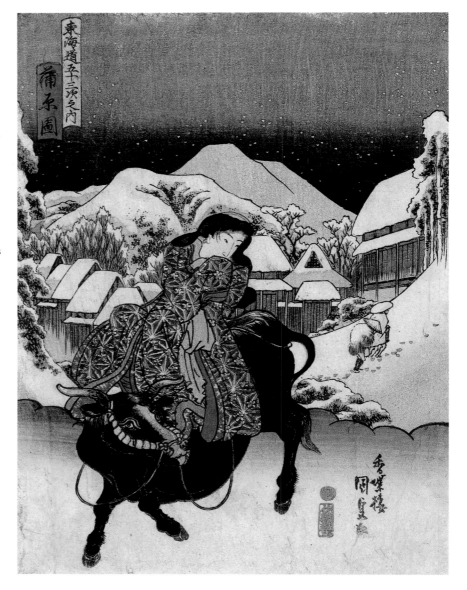

like a concept of a "flesh world" behind that of the Floating World and the Sorrowful World. This explains to me how the term *Sorrowful World* was applied to the pleasure quarters, for its underlying implication of flesh would be most appropriate to a brothel district.

More importantly, positing a flesh world behind the Floating World and the Sorrowful World explains something else. Earlier, in discussing Hokusai and Hiroshige, I noted their tendency to check their images against the things that they portrayed. So, too, in commenting on how experts differentiate fakes, copies, and recut prints from originals, I remarked that this

Adachi Ginkô (fl. 1874–1897). This set of prints dated 1886 shows a connection to Ukiyo-e in both subject matter and style. The style is the detailed, colorful manner found in innumerable *musha-e* or Ukiyo-e prints of warriors. Its subject matter is the classic war story *Heike monogatari* (The Tale of Heike). In the first print, the forces of the Taira clan have taken to their ships in retreat. One of the Taira women places her fan on a pole fixed to the bow of her boat and challenges her Minamoto enemies to shoot it. Archer Nasu no Yoichi then rode his horse into the waves and hit the fan square in the middle. The second print is the story of how the tough old warrior Kumagai Naozane pursued and killed the young Taira no Atsumori. So brave was the boy that no one regretted the killing more than Kumagai himself.

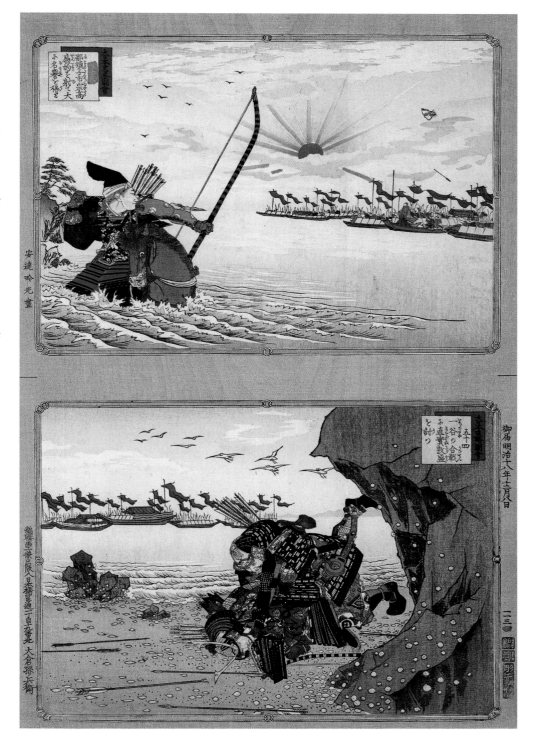

This single sheet and set of four prints by Kunisada and this triptych by Kuniyoshi all show a figure with a sword and wearing an ankle-length costume with a fringe of tassels. The figure stands in the same pose in both Kunisada's four-part work and Kuniyoshi's triptych. In the triptych, he is identified as Nagata no Tarô Nagamune, and in the four prints as Akugenta Yoshihira. Thus, these prints attest to the prevalence of set forms in later Ukiyo-e. The single sheet, once owned by Oliver Wendell Holmes, shows the figure in the same costume, though in a different pose. The Holmes print is of interest because it is known to exist in two states. In the first state, the print showed Ichikawa Danjûrô VIII, but then the head was changed so that the figure represented Nakamura Fukusuke, who can be recognized by his closed mouth, the addition of two downward curved ridges next to the eyebrows, and the lack of a fold above the eyes. The Holmes print, which shows Danjûrô VIII, has a label indicating that it is a scene from the play *Raigô ajari kaisoden*, an adaptation of Kyokutei Bakin's (1767–1848) famous 1808 novel.

quality of the art of Hokusai and Hiroshige might be a feature of Ukiyo-e as a whole. I now wish to strengthen this initial suggestion and assert that the above aspect of Ukiyo-e is, in fact, an essential quality of this art, at least when this art is defined as a portrayal of an Ukiyo-e that is, in turn, understood via the word's meaning as a common noun.

My thinking here is that to the extent that the common noun *ukiyo* refers to the world that we experience in the flesh, it follows that it also refers to the world that we know through the flesh. Thus, we might define *ukiyo* as a here and now perceived via the physical senses; for the artist this would mainly be sight. As that art which portrays such an *ukiyo*, therefore, Ukiyo-e would logically be an art in which artists rely on what they can see for themselves with their own two eyes.

What are we to call this feature of Ukiyo-e? I can think of no one word that perfectly describes it. However, one term that has often been used for this feature of Ukiyo-e is *realism*.[15] I have tried to avoid that term because the dictionary definition of realism in art is picturing things or people as they really are. I am not sure that we can ever know anyone as they really are, and maybe not things either. And yet, we must think on the nature of things in thinking about what Ukiyo-e is, for the *ukiyo* is the world of things. It is to be noted that this word was applied to all sorts of things. Thus, we have *ukiyo kan* (*ukiyo* pipes), *ukiyo bôshi* (*ukiyo* hat), *ukiyo kasa* (*ukiyo* umbrellas), and *ukiyo motoyui* (*ukiyo* hairstyle). Beautiful pipes, neat hats, clever umbrellas, special hairstyles, and all sorts of material objects, moreover, fill the prints, paintings, and books of Ukiyo-e. Insofar as these objects were often referred to via the word *ukiyo*, one way we can define Ukiyo-e is as a portrayal of the many things called *ukiyo*.

Taking that thought a step further, we might then consider Ukiyo-e a portrayal not just of these specific things, but of things in general. That would follow logically from defining Ukiyo-e via the common noun *ukiyo*, for to the extent that this word refers to the world that we perceive through our physical senses, any art that is a portrayal of it must concern itself with material objects. After all, we can only perceive physically what exists materially. Yet another word to describe Ukiyo-e in our new definition of it, then, might be "material."

But if the content of Ukiyo-e is material, is its style realistic? Here,

Set of four prints by Kunisada.

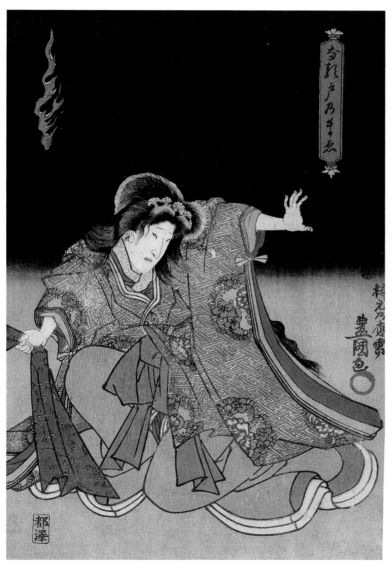
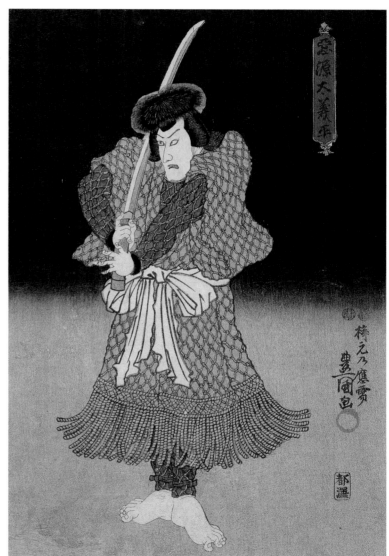

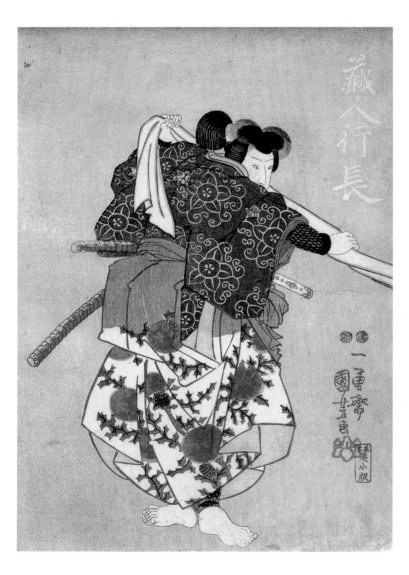

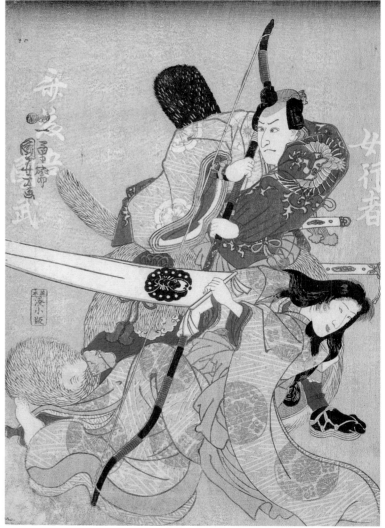

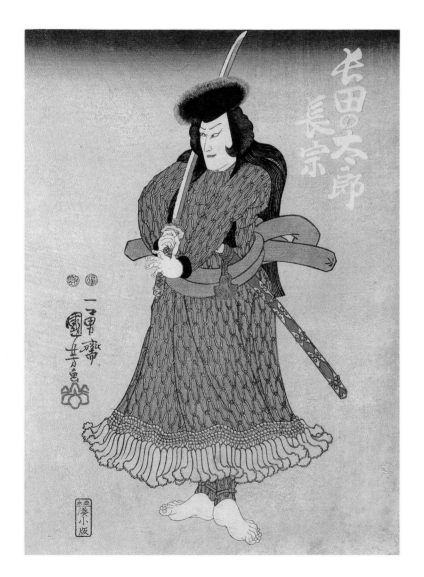

30 _____

Triptych by Kuniyoshi

Utagawa Hiroshige. *Meisho Edo hyakkei: Yotsuya, Naitô Shinjuku* (Yotsuya: The New Station at Naitô from the series A Hundred Views of Famous Places in Edo), 1857. Among the prints of Hiroshige, this shows one of his most unusual views, a row of shops seen through the legs of horses. Not only does the composition display Western-style perspective in drawing the road, but also in the trimming of the horse's legs. The print is thus an example of Hiroshige's strong personal vision of art, something he intentionally applies to all his works. The Brooklyn Museum of Art has a comparable print, which bears the same red cartouche and titles, but has different colors. The general tone of the brown, red, blue, and yellow is clearer, and green is applied all over the ground. The horse droppings are in totally different colors.

one must consider the work of Thomas Kasulis, for he gives us good reason to say no.[16] Kasulis notes that Buddhist thinkers such as Kukai (774?–835) posited a difference between the doctrine of the Buddha of our time, Shakyamuni, and that of the Mahavairocana Buddha, a kind of manifestation of all Buddhas across time. Kasulis says that when Shakyamuni spoke his doctrine, he did so as a man to men. When Mahavairocana spoke his teachings, he did so for his own pleasure. Thus, we might say that Mahavairocana spoke God to God. To Kasulis, the difference between the discourse of Mahavairocana and Shakyamuni is that there are doctrines in Buddhism that are beyond logical human understanding. That does not mean that these doctrines cannot be understood. It is just that human logic is not entirely up to the task. How one goes about understanding such difficult doctrines is a problem that I leave to Kasulis, my point being only that he sets up a universe that proceeds on two levels: the absolute one of Mahavairocana and the human one of Shakyamuni.

The world implied by the term *ukiyo* is the here and now of human experience and not the absolute reality of divine knowledge. It is for this reason that it is inappropriate to label the tendency of Ukiyo-e masters to check their images against the things that they portray realism, for there may well be no implication that what is shown is real in any absolute sense. Rather, what Ukiyo-e portrays may only be what its artists see or believe that they have seen, and for this reason there is no contradiction between the drive to record things accurately in this art and its rich tradition of fantasy.[17]

Reportage

In this regard, a much more appropriate term for the tendency of Ukiyo-e artists to closely compare their images with the objects that they portray is reportage. This word is free of the baggage of realism and implies only a straightforward reporting upon things. However, the word is not perfect either in that it does not account enough for the importance of the conventions of Ukiyo-e.[18]

I have remarked earlier on the many conventions for depicting people, places, and other subjects in early Ukiyo-e that derive from seventeenth-century Yamato-e. My point then was to connect Yamato-e and Ukiyo-e. My point now is simply to observe that there are many conventions in early

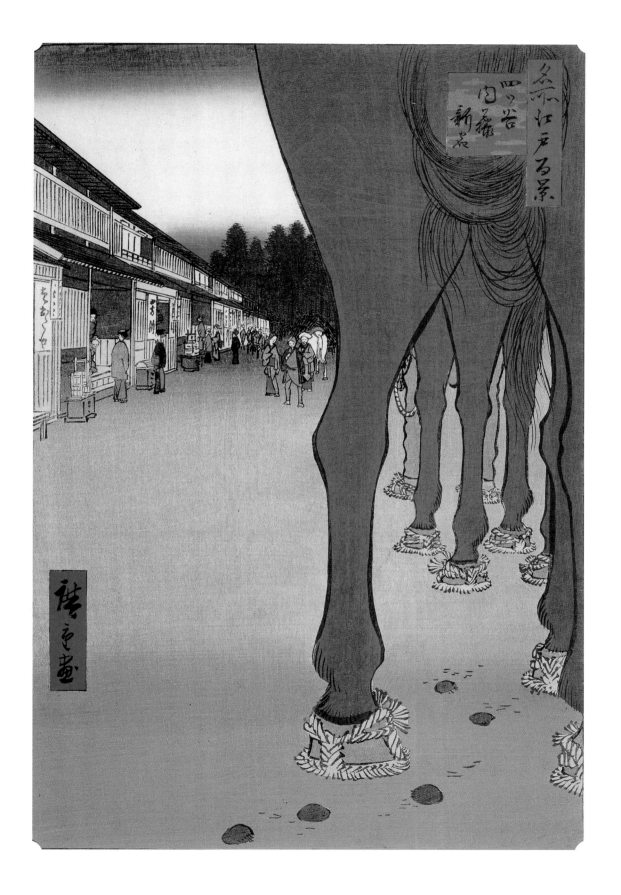

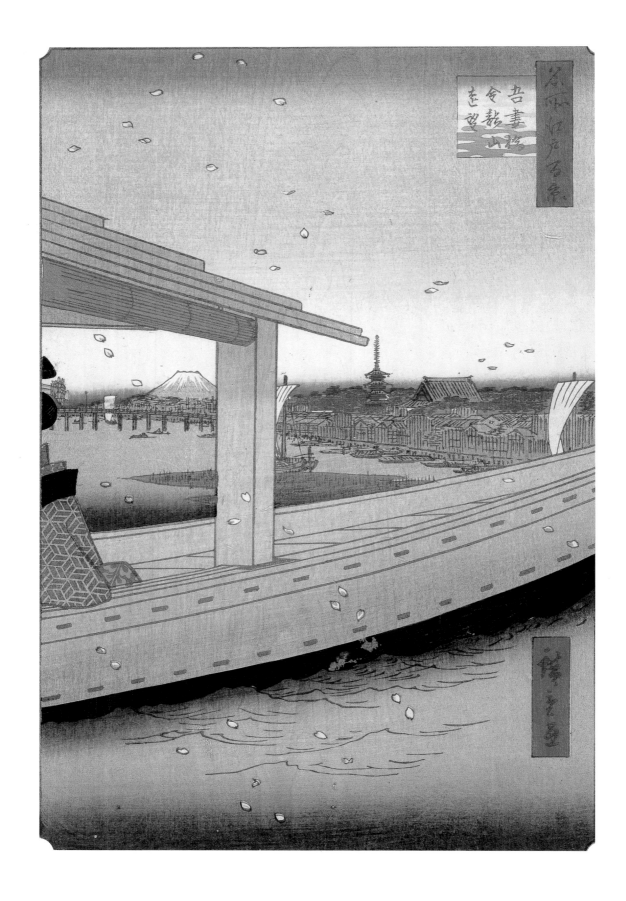

Utagawa Hiroshige, *Azumabashi kinryûsan enbô* (Distant View of Kinryûsan from Azuma Bridge) from the series *Meisho Edo hyakkei* (A Hundred Famous Views of Edo). This series was issued in 1856. In the background we see the Azuma Bridge, built in 1774, stretching in front of Mt. Fuji. To the right stands a five-story pagoda with the golden hall of the Kinryûzan Temple. Here, Hiroshige creates an unconventional landscape by playing with the composition. First, he immediately captures the viewer's eye by cropping the boat and placing it in the extreme foreground. He then depicts the city as an unobtrusive background. Moreover, he plays with the eye level of the viewer by placing it at an awkward level with the water and the bottom side of the boat. By juxtaposing a large, geometric image with strong diagonals and color in the foreground with small-scaled monochrome city detail, Hiroshige plays with the viewer's curiosity as to the content and theme of the print.

When compared to a first-edition print in the Brooklyn Museum, the wood grain in the Library's work is identical. More importantly, both prints have similar vertical "scratch marks" made by natural imperfections in the wood. These marks are located in the water below the boat. However, additional imperfections found on the bottom and roof of the boat are a result of overworking the woodblock, making this print a later edition. Identical prints with these markings are found in the Tokyo National Museum and the Elvehjem Museum of Art of the University of Wisconsin.

Ukiyo-e. This is also obvious in the overall simplicity of these images and in how much they resemble one another.

The importance of conventions in Ukiyo-e never died out. It remained a feature of the art even in its later stages. We can see it in the degree to which we can recognize types of actors or beauties in the prints. For example, there are the short cute girls of Harunobu and the tall, elegant women of Kiyonaga. Both are clearly conventions for drawing women.

So, too, nearly every major Ukiyo-e master had a distinctive personal style. To have a manner of one's own, an artist cannot just report on reality: he must improve upon it, manipulate it, and otherwise change it. Where such changes were successful, they quickly became conventions. We can see this in the many subschools of Ukiyo-e where the innovations of a master fast become standard practice among his students. If reportage was an important element of Ukiyo-e, then set forms, patterns, and conventions were no less crucial.

Individuality

These formalized ways of seeing are all the more remarkable in that, if the history of Ukiyo-e shows us anything, it is that Ukiyo-e artists evolve from anonymity into individuality. Earlier, we saw the anonymity of the first Ukiyo-e masters in the problems with establishing Moronobu's identity, but it is no less apparent among the early Torii. Howard A. Link has shown this fact in his highly detailed and elaborate studies of whether Torii Kiyomasu I and II and Torii Kiyonobu I and II are two, three, or four people.[19] That Dr. Link can debate such issues reveals how little we know of these artists.

Later, our knowledge of Ukiyo-e masters improves. As I noted, we have Hiroshige's various diaries. We also have his letters and other correspondence. We can write the story of his life much more fully than that of any early master of Ukiyo-e. The same might be said of Hokusai, Kuniyoshi, and their contemporaries. The survival of better biographical information on the later Ukiyo-e masters, moreover, occurs so consistently that it cannot be a historical accident. It seems more likely that people were more interested in the later Ukiyo-e artists as individuals, and so they took the time to record information about them. Certainly, what we know of these later Ukiyo-e artists suggests that they were, in fact, quite interesting people. Hokusai, for example, seems to have been a real character. Innumerable sto-

Toyohara Kunichika (1835–1900). Scene in a Villa. When found, these two prints by Kunichika were separated. However, given that a screen painting runs across both works, their relation is obvious. The screen in the print is signed by the female artist Sakurai Kiku. The print shows an elegant patron of a brothel, wearing a gorgeous garment decorated with a design of a dragon in gold. The garment painting is signed Inchûan Rigyoku. The great blue-and-white bowl in which children are floating paper figures, the man's finely decorated fan, the elegant clothing of the women, and the handsome boxes in the background all attest to the wealth of the Floating World.

ries exist about his eccentricities. He constantly changed his name, assuming more than fifty different epithets. He is said to have lived in ninety-three different houses, never cleaning up and leaving when the place got too dirty or when the back rent, which he never paid, grew too large. When he lost everything in a fire, Hokusai is reputed to have said, "I came into the world without much."[20]

In addition, Hokusai's art attests to his strong personality. He and Hiroshige often portray scenes from odd angles—Mt. Fuji through a great barrel, a town between the legs of a horse, or the land from beneath the roof of a houseboat. Such unusual views were necessitated, in part, by the need to produce something different to ensure sales; however, they also make it clear that these artists do not portray objective reality, but rather the world as seen through their eyes. Their work makes us as aware of them as of the things that they portray.

Hiroshige also had the habit of including small portraits of himself in his prints. He put his name or initials on houses, clothing, baggage, and all sorts of other things in his works of art. Hokusai laid equal claim to his art by his distinctive manner of drawing. His style, if hard to describe, is instantly recognizable. What Hokusai draws is never the world, but his vision of it.

The Complexity of Defining Ukiyo-e

I suppose that any tradition of art that takes the artist's physical perception of his world as its basis will eventually develop a tradition of individuality, for what are we if not our flesh? To focus on the world that artists see in the flesh is to focus on them. But, in this regard, Ukiyo-e is a most complex tradition of art, for it moves in the direction of ever greater individuality at the same time that it maintains an interest in conventions, patterns, and other set visual forms. The latter asks an artist to keep things unchanged, whereas the move towards individuality drives him in exactly the opposite direction. Likewise, reportage encourages an artist to question conventions by having him check them against the things that are portrayed, just as set forms and patterns oppose fashion, stylishness, and the chic. The various features of Ukiyo-e that have come up in this essay are thus singularly contradictory. How can one tradition of art embrace such opposing artistic features?

Here, again, the work of Kasulis is relevant. He provides a means of

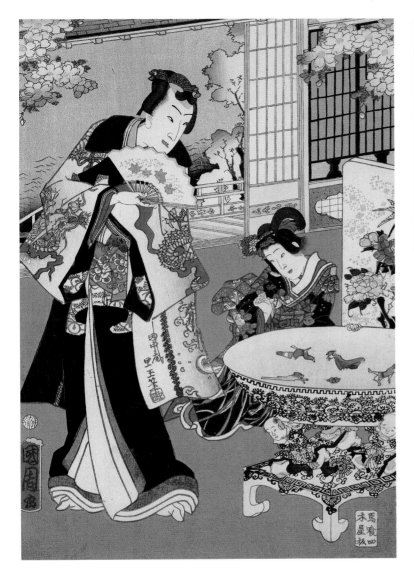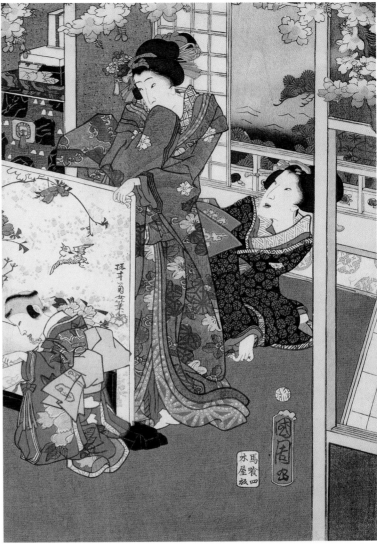

resolving the conflict between the various aspects of Ukiyo-e in his treatment of the relationship between the doctrines of Mahavairocana and Shakyamuni. Kasulis makes the point that the Song of Mahavairocana is the Song of the Universe. Mahavairocana's thought is present in all things and everything. The doctrine of Mahavairocana Buddha may be beyond human logic, but it is certainly not impossible to understand, for we know it inherently just by being. Thus, Kasulis places the doctrines of Mahavairocana and Shakyamuni in opposition and on a continuum.

What I suggest is that we do the same with Ukiyo-e. Let us not fall into the old trap of trying to find one feature, one quality, one word that de-

scribes the essence of this art. Instead, let us recognize the inherent complexity of Ukiyo-e and define it neither as reportage nor convention, fashion nor set form, individuality nor pattern, but as all these things together. This may be the only way to understand this art in all its complexity.

The attitude that the Ukiyo-e artists take to their here and now would have to be just as complex as the art itself. It would involve a reliance on what one sees for oneself with one's own two eyes balanced against a real respect for conventions, set forms, patterns, and other established ways of seeing. It would be down-to-earth and practical, doing for art what the *chônin* did when they chose profit over principle in moving to Edo. And yet, it could involve an appreciation of fantasy. It would be highly individualistic, while creating schools, subschools, and traditions of art. It would love the new, the fashionable, the chic, and the popular, but still see the value of old traditions. So we see that the attitude of the Ukiyo-e artist constitutes all these things and more which I have either not thought of or not had the time to discuss.

But whatever the individual elements of the vision of art of the Ukiyo-e artists may be, the need to balance very different things would be fundamental to that vision. That brings me to my final point, one I make as I return to the problem of play in Ukiyo-e. It seems to me that any tradition of art wherein there is so fine a balance between contradictory elements as there is in Ukiyo-e will eventually develop a tradition of play. Moreover, play is a particularly useful description of Ukiyo-e in that it brings to mind theater. It also reminds us of the key principle underlying this definition of Ukiyo-e: change.

A Tradition of Play and Change

The importance of change in the study of Ukiyo-e is nowhere more apparent than in the role of play. I believe that play and its related quality of parody function very differently in early and late Ukiyo-e. Parody and play imply humor, but humor can come from many sources. It can result from not taking things seriously, but it also can come from telling the truth—from realizing the artificiality of a situation and exposing it. The first method of being funny seems to me revealing of early Ukiyo-e, the second, late. The difference has to do with the differing nature of the world of the *chônin* in these two times.

At the start of the Tokugawa Period, *chônin* were under the thumb of the shogunate. Having just won the wars, the Tokugawa were busy estab-

lishing their power. They would brook no resistance from the likes of the rich merchants of Edo, who, in any case, hardly had the spirit to fight back. It is easy to believe that parody in Ukiyo-e in this time was self-deprecating, a tacit admission by *chônin* that they no longer had a right to the high culture that they had once enjoyed as *machishu.*

By the end of the Tokugawa Period, that would not be the case. *Chônin* would have grown enormously in power by then, as the economy itself developed. We call these people merchants but we should not think of them as mere shopkeepers. The most powerful of the *chônin* were more akin to the great financiers of Wall Street than to mom and pop at the corner store. They could support an entire season of Kabuki plays or, on a whim, provide public lighting for the Yoshiwara. They controlled the wealth of the nation. So the warriors, even the shogunate, eventually had to come to them for loans.

So, too, the warriors had changed by the end of the Tokugawa Period. Herman Ooms has spoken of the great silent processions of samurai marching back and forth across the country as they fulfilled their *sankin-kôtai* obligations. These military parades were unquestioned signs of Tokugawa power when they started. They were clearly an effective means of enforcing the peace, as we can see by the fact that no wars occurred during the Tokugawa Period. As the peace lasted and lasted, however, samurai became soldiers who never fought. They continued to look as impressive as ever with their great helmets and their two swords, but their armor was lacquer-covered paper, and their weapons were light and for show.

Despite these changes, the official Tokugawa model of the social order remained in effect. Only in the brothel and theater district could merchants rise to a social position that was equivalent to their wealth. Only there were they superior to the warriors. But what did it mean when those same warriors sought loans from the rich merchants? What did it mean when the shogunate itself asked *chônin* for financial help? Who had the power then— merchant or warrior?

If one looked at reality in the late Tokugawa Period, *shinôkôshô* no longer made sense. The reverse social order of the Yoshiwara, that supposed realm of fantasy, was becoming a better model of how things actually were. When fantasy is more real than reality, and when the real is more fantastic than fantasy, we are in the realm of parody and play.

34 _____

Utagawa Kunisada, *Fukigusa sono yuran* (Visiting a Flower Garden). This color wood-block-print triptych is from the same blocks as the work in the Van Gogh Museum. Van Gogh collected more than four hundred Ukiyo-e. Among these are 159 works by Kunisada. The Van Gogh Collection has only the center and right side of this triptych. The Library of Congress has the complete set. Compared with the print in the Van Gogh Collection, the triptych in the Library of Congress shows the delicate kimono design of the villa's rich guest better, even though the blue and purple colors have faded.

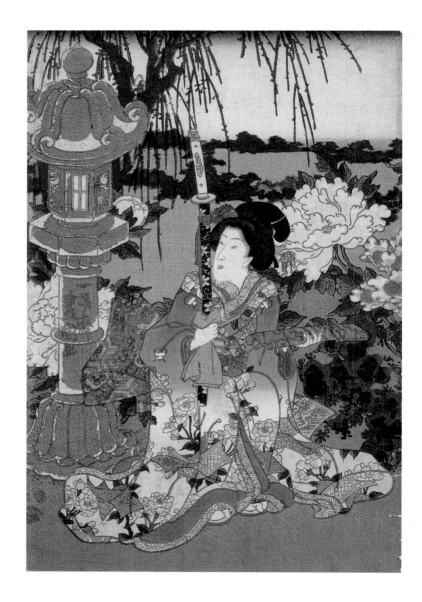

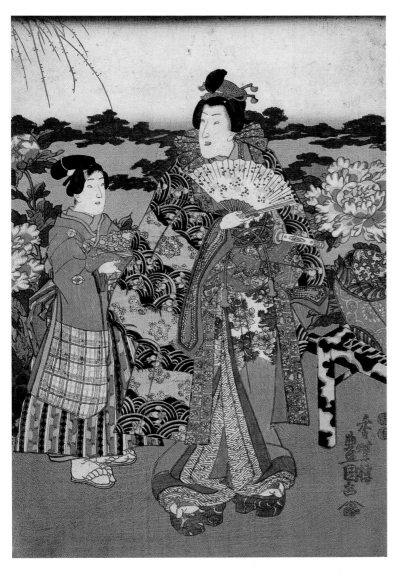
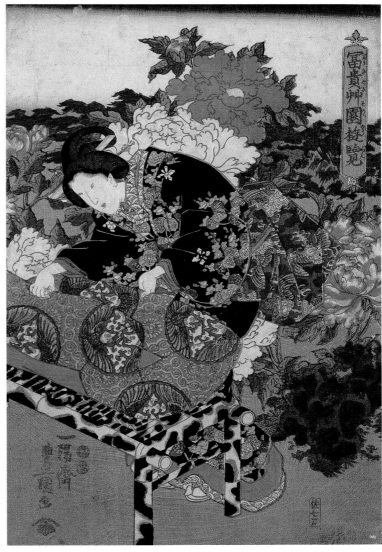

Conclusion

Thus, it seems to me that the humor of late Ukiyo-e stems from a very different source than that of this art in its early period. One must not forget the importance of change in understanding play in Ukiyo-e, and I would say the same for all the features of this art that I have defined here. They were all subject to change, and change they must have as the world of the *chônin* itself changed. Defining these changes is crucial to writing the history of Ukiyo-e, but that is a task for a future book; for now, I end with an observation.

I find it striking how relevant Ukiyo-e is to my everyday life. For example, I have defined humor in late Ukiyo-e as essentially subversive in character, stemming from the conflict between the official, established view of reality and the *chônin*'s practical experience of things. This conflict between how the establishment sees things and how things really are is one we all know; so that there are clearly things in Ukiyo-e that fit current American sensibilities. So, too, the bloody prints of Yoshitoshi challenged conventional morality in the Tokugawa Period no less than our own shocking works of twentieth-century art question the morality of today. When Hokusai or Hiroshige drew Mt. Fuji so that it protruded beyond the frame of the composition, though they may never have heard of the word "deconstruction," they deconstructed their picture nonetheless. When Ukiyo-e masters made *harimaze* or prints that gather together the various different things associated with a site, they defined those places as the composite of what they implied in a way as relevant to us today as it was common in Japan back then.

I do not say that the masters of Ukiyo-e invented such theories as relativity and deconstruction. The issue may be more one of, to quote something that Mark Sandler once said, Japan being a "naturally deconstructed culture."[21] But what I do say is that there is much in Ukiyo-e to appeal to us today. Here is a sensual, physical art of beautiful things. Here is a balance between reportage and convention, fashion and set forms, change and pattern. Here is a truly dynamic art, one in which forward movement was its essence. Finally, here is a Japanese art in which individuality and personal style are valued, and that in a land famous for its emphasis on the group. When the artists of Ukiyo-e took all these things and created lasting powerful images from them, they produced masterworks indeed. This book is full of them, and it is to these art works that we should now turn.

Notes

1. The Japanese for "Japanese wood-block prints" would be *nihon moku hanga.* Thus, "Japanese wood-block print" is not a literal translation of Ukiyo-e, though many book titles and subtitles might make one think it is.

2. An example is Ôta Nampo's *Ukiyo-e ruiko*, written sometime in the Kansei Era (1789–1801). Still used today as a standard source for information on the lives of Ukiyo-e masters, this work has a long and troubled history detailed in Juzô Suzuki's *Sharaku* (New York: Kodansha International, 1968), pp. 16–19.

3. We can regard Hokusai and Hiroshige to be somehow exceptional figures in the history of Ukiyo-e, but that is merely begging the question. How can two of the most famous masters of this school not be fully representative of it?

4. Sandy Kita, *The Last Tosa: Iwasa Katsumochi Matabei, Bridge to Ukiyo-e* (Honolulu: University of Hawaii Press, 1999).

5. There is good reason to see Ukiyo-e as Japan's first true commoner art in the nature of the city of Edo. To populate Edo after they had made it their capital, the Tokugawa encouraged commoners from all over Japan to go there. Immigration did tend to favor certain areas, but the population of Edo was a better mix of commoners from various parts of Japan than any other comparable city of its time. For that reason, the culture that grew up among the common people of Edo differed from that of commoners in other areas and times in not being regional. It represented the common people of Japan as a whole much better.

6. Sandy Kita, "*The Bulls of the Chômyô-ji*: A Joint Work by Sôtatsu and Mitsuhiro," *Monumenta Nipponica* 47, no. 4 (winter 1992): 495–519.

7. Sandy Kita, *The Last Tosa*, pp. 242–243.

8. Hashimoto Mineo, *Ukiyo no shisô* (Tokyo: Kôdansha, 1975).

9. In C. H. Mitchell's adaptation of Muneshige Narazaki's *The Japanese Print: Its Evolution and Essence* (Tokyo and Palo Alto, California: Kodansha International, 1966), on page 21 it states that: "the word *ukiyo* first appeared in popular fiction in a book by Asai Ryoi, published around 1661." However, it is apparent that Narazaki knows that the word existed far earlier, since he discusses it at length in his studies of Iwasa Matabei. This artist was known as Ukiyo Matabei. He died in 1650.

10. Thus, when writers such as Asai Ryoi (d. 1691) spoke of *ukiyo* as "living only for the moment, gazing at the moon, snow, cherry blossoms, and autumn leaves, enjoying wine, women, and song, and, in general, drifting along with the current of life, like a gourd floating down a river," was he trying to define the nature of the Floating World or just describing his here and now? See Narazaki, *The Japanese Print*, p. 20.

11. In differentiating style and content in defining the relationship between seventeenth-century Yamato-e and Ukiyo-e, one must be careful not to forget about change. Change affected the expression of the link between seventeenth-century Yamato-e and Ukiyo-e. At the start, this link involved mainly Ukiyo-e borrowing conventions for drawing people, places, and other subjects from seventeenth-century Yamato-e. As time passed and

Ukiyo-e developed conventions of its own, such borrowing was needed less. However, as the conventions of Ukiyo-e themselves became established traditions, the Ukiyo-e master began to confront a situation similar to that which the seventeenth-century Yamato-e master experienced. Later Ukiyo-e artists are thus more like seventeenth-century Yamato-e masters in having to balance innovation against tradition. Thus, the link between late Ukiyo-e and Yamato-e is more one of style.

12. Thereby, we can acknowledge connections between Ukiyo-e and certain, specific, individual works of art by Yoshitoshi, Kawanabe Kyôsai (1831–1889), and Meiji printmakers, on the one hand, and modern masters such as Hiratsuki Un'ichi, on the other. At the same time, we need not accept all their work into Ukiyo-e, but only that which is genuinely similar in style. We can broaden out the pool from which the works called Ukiyo-e are chosen at the same time that we gain tighter criteria of selection than those sometimes seen today, which lump Ukiyo-e, Meiji, and Modern prints together just because they are all prints.

13. Current, fashionable, and popular are characteristics of Ukiyo-e that many other scholars have commented on previously. There is nothing new here then in terms of the qualities identified as being key to Ukiyo-e. Rather, what is new is how these features are linked to this art. They now derive from the meaning of the word *ukiyo* instead of being based just on the observations of scholars. However, this does not mean that the qualities of Ukiyo-e discussed here were attributed to this art by Edoites of the Tokugawa Period. I am fully cognizant of the fact that Ukiyo-e may not have been the word for this art in that time. All I am saying is that whenever this label is applied to this art, the label is most appropriate when the word *ukiyo* is understood in its full range of meanings.

14. I have discussed this issue at more length in *A Hidden Treasure: Japanese Prints from the Carnegie Museum of Art* (Pittsburgh: Carnegie Museum of Art, 1996), p. 31.

15. Another word for this quality of Ukiyo-e that has been used is *sensual*. I like this word in that it brings to mind the important role played by the physical senses in Ukiyo-e. I also like it because the term can describe the effect of a work of art as well as the processes by which art is made. What I mean by this is that the term *sensual* can refer to the way in which certain prints, paintings, or books evoke strong physical reaction in their viewers. Creating these feelings seems to me a key feature of Ukiyo-e. We see it in the striking compositions so common in this art. While such images are often carefully checked against the things that they portray, they also depict things with more drama, intensity, and power than simple recording can achieve. So, too, I would understand the rich colors and fine detail of Ukiyo-e in this way. Such methods of drawing increase the physical reactions viewers have to these works of art. That might also be said of the use of metallic powders, mica, gauffrage (negative printing), and all those other techniques by which Ukiyo-e so delights the eye. These things are not just tricks of the trade in this view of them, but the crucial means by which such works identify themselves as Ukiyo-e. Subject matter could be involved as well. Erotic themes, by their very nature, evoke strong physical reactions. Thus, *shunga* or erotica could be seen as something that

the masters of Ukiyo-e did, not just because it was profitable but also because it was part and parcel of what their art as a whole was about. The sad tales of the heroines of *setsuwa*, or sermon stories, would function similarly. These subjects in and of themselves evoke such feelings as pity and sorrow. The *Gunki monogatari*, the brave tales of the great warriors of Japan, would arouse very different emotions, but in eliciting physical reactions that are no less strong, would be no less a part of the tradition of Ukiyo-e as defined here.

16. Thomas Kasulis, "Reality as Embodiment: An Analysis of Kûkai's Shokushinjôbutsu and Hosshin Seppô," in Jane Marie Law, *Religious Reflections on the Human Body* (Bloomington and Indianapolis: Indiana University Press, 1995), pp. 166–185.

17. Whether things perceived in dreams are any less valid or real than things perceived while awake is a notoriously knotty problem in Buddhism.

18. Another term for this aspect of Ukiyo-e is *empirical*. The dictionary definition of empiricism is the dependence of a person on his own experience and observations, rather than on some theory, accepted wisdom, or other authority. If we add conventions, set patterns, and established forms of seeing to the above list, empirical would describe perfectly the tendency of Ukiyo-e masters to compare their images with what they portray.

19. Howard A. Link, *The Theatrical Prints of the Torii Masters* (Honolulu: Honolulu Academy of Arts, 1977). See also his *Primitive Ukiyo-e from the James A. Michener Collection in the Honolulu Academy of Arts* (Honolulu: University of Hawaii Press, 1980) and his various articles on the subject.

20. Michener's highly entertaining account of Hokusai's life, full of anecdotes about the painter's eccentricities, should be compared to Lane and Forrer's meticulously documented biographies. The image of Hokusai as the great eccentric fades somewhat in the light of the true facts of his life, but the powerful personality that lies behind this master's work, which Michener strove to emphasize, does not change. See James A. Michener, *The Hokusai Sketchbooks* (Tokyo: Charles E. Tuttle, Co., 1958), p. 19; Richard Lane, *Hokusai: Life and Work* (New York: E. P. Dutton, 1989); and Matthi Forrer, *Hokusai* (New York: Rizzoli, 1988).

21. That would explain such a phenomenon as Roland Barthes's book on Japanese culture, *Empire of Signs*. Barthes was not, as he himself admits, an expert on Japan, but he was a semiotician and literary critic whose writings helped make structuralism one of the leading intellectual movements of the twentieth century.

HIDDEN TREASURES FROM JAPAN

WOOD-BLOCK-PRINTED PICTURE BOOKS AND ALBUMS

LAWRENCE E. MARCEAU
UNIVERSITY OF DELAWARE

*J*apan currently enjoys one of the most active and vibrant publishing cultures in the world. Major publishing houses in Tokyo, Osaka, and Japan's other metropolitan areas produce a vast array of books, monthly and weekly magazines, newspapers, and even thick *manga*, or comic book collections that sell in the hundreds of thousands with each issue released.

Early Japanese Printing and Publishing

This dynamic and diverse industry is by no means a modern phenomenon, but traces its roots back over four hundred years to the 1590s, when the Japanese states were just emerging under the hegemony of Toyotomi Hideyoshi (1537–1598) from over a century of civil warfare. A small production of block-printed books, mainly Buddhist sutras and their commentaries, had been in existence at various monastic compounds in Kyoto and other sites for several centuries, but their output was limited, both in scope and volume. Foreign influences from two directions, south and west, in the 1590s changed the face of Japanese publishing forever.

From the south, Jesuit missionaries moving into Japan from Batavia (present-day Djakarta), Macao, and Manila set up movable-type presses at their missions in Amakusa, Nagasaki, Kyoto, and other locations, producing, in romanized fonts, a number of dictionaries, Christian tracts, and even a translation of Aesop's *Fables*. The mission also published a few titles in Sino-Japanese script, approximating the flow of calligraphic writing through the use of metal movable-type characters that often connected in a column. The Jesuit mission presses exerted little influence on Japanese publishing, however, due as much to the fact that their publications in romanized script were

35

Issai. *Shinpan bijo-zukushi* (New Impression: An Assortment of Beauties) (right) (Tôkyô: Izutsuya, circa 1870). Utagawa Kunisada. *Shinpan yakusha-zukushi* (New Impression: An Assortment of Actors) (left) (Tôkyô: Izutsuya, circa 1870). These are actual woodblocks made of wild cherry and used to print single-sheet prints. The block on the right shows thirty women engaged in various occupations, such as tea vendor and shrine priestess. The second woodblock, which shows twenty-four portraits of actors, is another example of the same series, this time by the famous Ukiyo-e artist Kunisada.

not legible to the contemporary reader as to the complete suppression of Christianity in the early seventeenth century.

More enduring was the impact of printing technology that was looted from Korea to the west of Japan in the aftermath of two disastrous invasions of the peninsula in the 1590s. The presses and bronze movable type that were taken to Japan at that time produced a series of historical works in Chinese, the written language of Japan's ruling elites, roughly analogous to Latin or ancient Greek in Renaissance Europe. These early publications appeared in limited editions and are considered to be rare today. However, the use of wooden movable type based on the bronze type of the Korean presses took hold in Japan as it never had before and led to the publication of further works, not only in Chinese, but in Japanese, which employs a combination of several thousand Chinese *kanji* characters and several dozen phonetic *kana* syllables.

One private press in particular demonstrated how the *kana* syllabaries as well as illustrations could provide aesthetically pleasing results in printed works. The Saga press, named for its location in the western suburbs of the capital, Kyoto, was a private collaboration between a merchant and intellectual, Suminokura Soan (1571–1632), and the most prolific artist of his age, Hon'ami Kôetsu (1558–1637), who excelled as a calligrapher, potter, and lacquerware artist. Among other works coming from the collaboration between these two gifted individuals, their press produced some thirteen titles, most of them multivolume compendia, in a total of thirty-eight distinct editions, between 1608 and 1624. Titles published were far different from the Buddhist, Christian, Confucian, historical, or other ideologically based works that had appeared from the other presses. Kôetsu and Soan focused mainly on the belles lettres, such as poetry collections, classical prose narratives, and Nôh libretti. Printed on multicolored and embossed papers, in many cases with covers lavishly decorated with patterns in mica and other special materials, the *sagabon*, as these books are called, proved that Japanese literary works could attain the heights of the calligraphic quality of their manuscript counterparts through the careful selection of paper, ink, font (based on Kôetsu's own hand), and illustrations.

Japanese publishing houses—official, commercial, and private—continued to thrive through the first half of the seventeenth century, reaching a

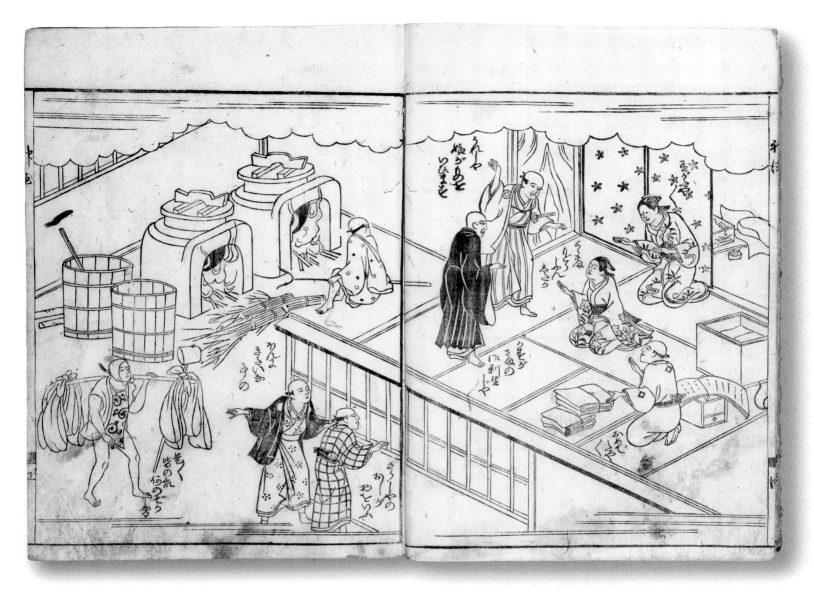

point at which the massive amounts of wooden movable type necessary to have on hand could not keep up with the demand, not only for new publications, but for reprints of long-running titles. As Peter Kornicki, in his masterful *The Book in Japan*, writes, "(B)lockprinting proved better able to handle the growing market for books in the seventeenth century: reprinting movable-type books required resetting the type, while blockprinting simply required taking the blocks out of storage."[1] Once the publishers—who also served as the block carvers, printers, bookbinders, and retailers—had committed to publication by means of block printing, there then occurred an explosion in all kinds of publishing that continued unabated until the trans-

36

Anon. *Shintoku Nara miyage* (Shintoku's Souvenirs from Nara). Kyôto: Nakajima Matabei, 1713. In this previously unknown work, the itinerant monk Shintoku cures a girl of her mute condition.

fer to mechanical offset printing in the late nineteenth century. Inoue Takaaki's compendium of publisher-booksellers counts an astounding 6,747 distinct establishments active at some point or other during the Early Modern Period (between 1603 and 1868).[2] While many of these lasted only long enough to publish a single title, the number of established firms that survived at least a generation or two is in the thousands.

Another advantage of block printing, whereby two pages of text and/or illustrations are printed from a single block that has been carved directly from the handwritten manuscript, is that—because the same technique is employed for carving and printing illustrations as is used for the text—illustrations can easily accompany text, and text can be embedded in illustrations. As Kornicki points out, "By the end of the [seventeenth] century, it had become the norm for almost all books in Japanese to include some form of illustration, including not only literary works but also, for example, mathematical and botanical studies, encyclopedias, cooking manuals and guide books."[3] Wood-block illustrations became, in other words, an expected, even demanded, element in Japanese books of nearly all varieties.

We can see the possibilities of the integration of text with illustration in one of the few examples of a literary work in this collection otherwise devoted to *ehon*, or picture books. In the book, Shintoku's Souvenirs from Nara (*Shintoku Nara miyage*), published in Kyoto in 1713, the itinerant monk Shintoku returns the power of speech to a formerly mute girl. This story, which is narrated over several pages, features a two-page illustration of the instant the girl has regained her speech. On the right leaf the girl, seated at the center, raises her hand and says, "Papa, have you come back home?" Behind her, her mother rises up on both knees and declares, "Halleluja, halleluja!" while her father, standing in the striped kimono, gestures, saying, "I'm so glad, my daughter has spoken!" Shintoku, in black clerical attire, explains, "It is due to the grace of the deity at Kasuga." Probably from the narrative itself the illustration would "make sense" without the inclusion of the simple dialogue by the various characters pictured. However, the ease by which text can be included in pictures makes it possible for a reader with limited literacy to appreciate the illustration separately from the text proper.[4]

The Physicality of the Wood-block Book

While Westerners tend to think of the rolled hand scroll as an ancient or medieval artifact, in Japan, as in other East Asian countries, scrolls, specially illustrated hand scrolls, called *emaki*, continued to play an important role in literary culture through the nineteenth century. While hand scrolls lack the ease of use and quick random access that bound volumes feature, they take advantage of their linearity to provide the reader with a sequence of texts and images. This sequential nature of the hand scroll generates suspense and anticipation on the part of the reader and allows for a temporal transition through images and text in addition to the physical transition. Another advantage of the scroll format is that it allows secrets to remain so. The illustrated hand scroll, Ikuma School Illustrations on Preparing Fish and Fowl (*Ikuma-ryū denshin uo tori no kirikata zu*) contains vivid hand-drawn illustrations on how to carve, debone, and otherwise dress a wide variety of species of fish and fowl for culinary appreciation. The Ikuma school, one of several schools of food preparation, zealously guarded its secrets, just as gourmet master chefs do today. We find here illustrated the technique for carving a pheasant (*kiji*) on the right, and for preparing a sea bass (*suzuki*) on the left. The inscription at the end of the scroll, dated Kansei 12 (1800), states that

37A AND B

Miyazaki Shikin. *Ikuma-ryû denshin uo tori no kirikata zu* (Scroll for Preparing Fish and Fowl According to the Ikuma School). Copied in 1800. This illustrated hand scroll provides graphic visual aids for preparing numerous varieties of fish and fowl, including pheasant (*kiji*) and sea bass (*suzuki*).

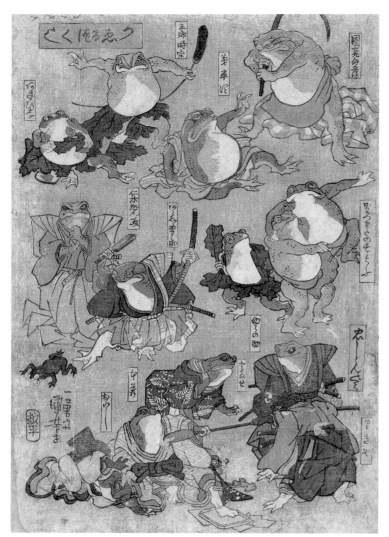

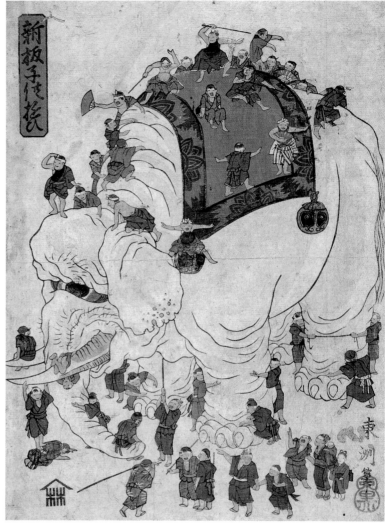

38

Various artists. *Omocha-e, Kodomo-e harimazechô* (Album of Toys and Children). Meiji Era (1868–1912). This album of large *ôban*-size prints provides a window into the types of images small children were exposed to in the Meiji Era. The print *Shinpan: Kodomo no asobi* (New Impression: Children at Play) features boys engaged in a number of festive activities over New Year's and the four seasons.

a member of the school is allowed to copy the scroll's contents, but must keep those techniques secret.

The block-printed book contains many advantages over the scroll, not least of which is the ease of access to any section the reader wishes to examine. As we have seen above, woodblocks are extremely versatile compared to movable type, in that both text and images can coexist in the same space on the page. The late nineteenth-century woodblock New Impression: An Assortment of Beauties (*Shinpan: Bijo-zukushi*) by the artist Issai provides us with an example. The block itself, a single cut of Japanese wild cherry (*yamazakura*), features a hardwood surface that can withstand hundreds of impressions.[5] At the same time, the wood is not so hard that it is difficult to

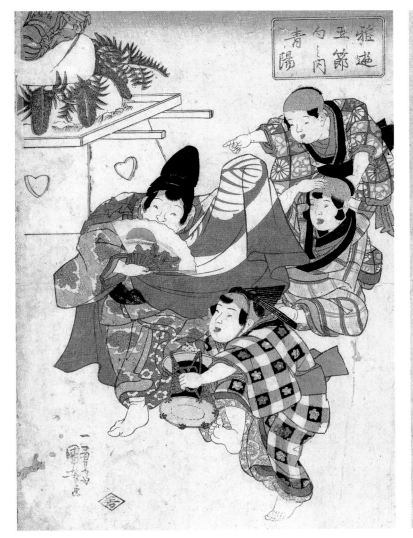

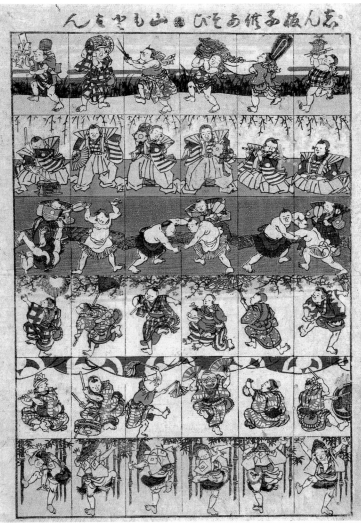

carve, and not so soft that the ink applied to it is absorbed into the surface itself. To the lower left of the block, and along the left edge, are ridges that serve as a guide for the absorbent mulberry paper as it is placed upon the inked surface of the block and rubbed with a flat circular tool called a *baren* to create the image. In order to create the carved block in the first place, the artist draws his image on paper, in this case thirty images of women in various walks of life, such as the servant girl with the umbrella in the fourth row, or the girl at writing practice in the second row. The sheet of paper with the images is then moistened and applied to the woodblock. A separate artisan, a professional wood-carver, then cuts away the empty space around the ink on the moistened paper, revealing the image and text that appear in

relief on the block. The carved block is then ready for printing.

Prints from this particular block of beautiful women involved in various occupations may have been pasted to cardboard, cut, and used by children as treats or prizes when purchasing a small bag of sweets. They may also have been attached to the wall of a room for practice in reading and gaining knowledge about the world. We can see a similar example of this in a wood-block print that has survived from this time period by being preserved in a large and rare collection of prints of toys, games, and children, called the Album of Toys and Children (*Omocha-e, Kodomo-e harimazechô*). One of these prints, New Impression: Children at Play (*Shinpan: Kodomo no asobi*), features full-color images of thirty-six scenes of young boys at play over the course of the year. The boys engage in a lion dance (New Year), a Nôh performance (spring), a *sumô* competition (summer), a Kabuki parody (autumn), a masked dance (winter), and yet another festive New Year dance. Again, these images would likely have been cut up for young children to collect and trade with their friends.

Japanese-published, wood-block books often came in envelopes or wrappers, called *fukuro*. These wrappers were especially common in smaller-sized works of illustrated fiction, such as *hanashibon* collections of humorous stories, popular romances, and action adventures. These books often came in packets of several thin volumes, usually only ten or fifteen pages each. Since the individual volume was too small or fragile to market easily, several were combined in a wrapper that was often attractively designed and printed itself. Such wrappers were usually discarded when the book was read and are quite rare today. The Library of Congress possesses two large albums, each containing scores of these wrappers, dating from the 1830s through the 1870s. One wrapper, illustrating two figures in travel gear, originally covered issue number 4 of Kanagaki Robun's serial novel, On the Road through Western Countries (*Seiyō dōchū hizakurige*, Tokyo: Mankyûkaku, preface, 1871), a highly popular sequel to Jippensha Ikku's *Hizakurige*, which itself has appeared in English translation as *Shank's Mare*. The hapless heroes of *On the Road*, Kita and Yaji, become some of the first Japanese actually to see the West with their own eyes, embarrassing themselves and their country at nearly every turn. The wrapper depicts the two in a manner reminiscent of a photograph that has been transferred to print as a ferrotype or copperplate etch-

Various artists. *E-zôshi harimaze jô* (Album of Wrappers from Illustrated Fiction). Meiji Era (1868–1912). This is an album of wrappers or envelopes (*fukuro*) that originally covered published works of popular illustrated fiction. Many wrappers only survive today in albums such as this. One wrapper, from Kanagaki Robun's *Seiyô dôchû hizakurige* (On the Road through Western Countries, Tôkyô, Mankyûkaku, preface 1871), depicts the two protagonists as though they had appeared in a photograph that had then been printed as a ferrotype or copperplate etching.

ing. Robun's novel was based on other reports of the West and is wrought with inaccuracies, but, just as with the pseudophotograph on the wrapper, he uses all of the techniques at his command to entertain his readers, who could never be satiated with his fantastic stories of foreign lands and wanted nothing more than to be led astray by his seductive words and images.

Language and Humor in Block-printed Books

Illustrated books seemed especially suited to humor, and in the nineteenth

Yoshiume (illustrator). *Kotowaza: Heso no yadogae* (Proverbs: The Navel's Change of Address). (Ôsaka: Wataya Kihei, circa 1830s.) This work is a series in twelve installments of various figures of speech taken literally and illustrated. This particular wrapper graphically expresses the notion of "breaking open the piggy bank," or in Japanese, "digging up those savings you've tucked away in your navel."

century there was no lack of demand for books that relied on parody, word-play, and visual humor to entertain readers. Such humor, which thrives on exaggeration, naturally found its way into the Library of Congress collection, given the inherent fascination American collectors of a century ago would have had in the forms that Japanese humor might take. One good example of this is the collection, Proverbs: The Navel's Change of Address (*Kotowaza: Heso no yadogae*, Osaka, ca.1830s), illustrated by a certain Yoshiume. The title refers to the notion that, when you are laughing uncontrollably, your belly shakes so hard that it seems as though your navel is trying to find

another place to live. The Library of Congress set of this work is rare, not only in that few collections anywhere include all twelve volumes, but also in that no collection includes the wrappers as well. The wrapper for number 11 in the set, for example, is as over-the-top as the contents it originally enclosed. In the illustration, we see a man and a woman busily using Japanese swords to make some sort of a hole larger. Upon closer inspection, however, we realize that they are actually digging into the belly of a giant who is stretched out on his back, perhaps taking an afternoon nap. To the uninitiated observer this would just seem bizarre and grotesque, but, when we are reminded that, in Japanese, a person's hidden stash of saved-up money is referred to as *hesokuri-gane*, or "money dug out of one's navel," then we see that this wrapper is actually taking a figure of speech and illustrating it literally, to humorous effect. Across the top of the illustration, we see the title, issue number, and author (Hansui) displayed in bold calligraphy. The potential buyer's interest is drawn, not to the title, however, but rather to the illustration itself. In this case, at least, you *can* tell a book by its wrapper.

One of the pages in the section, most of which are now separated, but which seem originally to have been pasted together at the edge of each page, depicts a portly man striding down the street with both arms outstretched. On the right, a vendor with a basket hanging from a pole has to duck to get under his arm, while on the other side, a woman seems to be using his sleeve, instead of her own umbrella, to ward off the rain. Behind him several people are pointing and gesturing in apparent vexation at the man's audacity. Above the group, the text provides the saying, "The person who fills the Great Way," meaning someone of great virtue who has nothing to hide. This title is followed, however, with dialogue explaining that the owner of the wide sleeves actually has them filled with money that he uses to bribe those around him into doing what he desires. Furthermore, if anyone wishes to get past him, he or she must bow down in order to get by, thus demonstrating supplication to him. In this case, when the proverb is illustrated, its didactic meaning becomes reversed, and the notion is subverted to present an image of corruption and someone who literally throws his weight around.

Most of the illustrations in this collection provide a couple of proverbs or figures of speech on a single open page. On the left side of the page we see a young boy frolicking with a flowering cherry branch in his hand

41

Yoshiume (illustrator) *Kotowaza: Heso no yadogae* (Proverbs: The Navel's Change of Address). (Ôsaka: Wataya Kihei, circa 1830s.) Here a man is demonstrating the notion of "following the great and broad Way," while in fact he can throw his weight around by keeping money to bribe others in his sleeves or "deep pockets."

and jumping up to catch some fluttering butterflies. This is accompanied by the proverb, "A child raised with butterflies and cherry blossoms," or, as we might say, a child born with a silver spoon in its mouth. The dialogue following the proverb makes it clear that such a child, rather than growing up to lead a carefree life, wishes to emulate his dad and make his living by manipulating others underhandedly. Again, the expectations that were raised by the proverb are subverted, in this case, by the dialogue.

Japanese visual humor comes in many varieties, and one of the most well known in the West is that provided in Katsushika Hokusai's massive collection, the *Hokusai manga*, or Hokusai *Sketchbooks*, that were published in Edo (Tokyo after 1868) in fifteen volumes between 1814 and 1878. Hokusai (1760–1849) was perhaps the most prolific artist of the school of genre painting and prints known as Ukiyo-e, composing, especially late in his long life, literally thousands of drawings that have come to make up some of the most

well-known prints in the world. His series of prints, Thirty-six Views of Mount Fuji (*Fugaku sanjûrok-kei*, early 1830s), includes not one, but two, renowned masterpieces—Fine Wind, Clear Morning (*Gaifû kaisei*, the so-called Red Fuji), and Beneath the Wave off Kanagawa (*Kanagawa-oki namiura*, ubiquitous as, The Wave)— while, in book illustration, Hokusai in his prime was the most sought-after artist of the early nineteenth century, illustrating dozens of popular narratives.

The Library of Congress possesses three complete sets of the *Hokusai manga* (hereafter referred to as the *Manga*) and several volumes from additional incomplete sets. The richness of this collection provides the researcher and student alike with the means to compare editions and document the process of printing, reprinting, and block recarving for new editions over a period of several decades. Matthi Forrer has conducted an exhaustive survey of the *Manga*, confirming that the first impressions of all fifteen volumes are from the press of Eirakuya Tôshirô of Nagoya, not from an Edo publisher, as had long been assumed.[6] While the act of bibliographical research can often be tedious, it is a joy to compare and contrast editions of the *Manga* and come to an appreciation of the popularity and broad reception of this remarkable compilation. Even the covers of each volume of the series feature a distinctive color. One of the most striking images in the collection is found in Volume 8 (first issued in 1819) and illustrates the well-known Buddhist parable of Blind Men Examining an Elephant ("*Gunmô zô wo naderu*"). This story, found in various forms in a number of sutras, describes a king who sends a number of blind men to examine an elephant and report back. Based on their limited perspectives, they report that an elephant is shaped like a broom (tail), a cane (base of the tail), a drum (belly), a polished gemstone (eye), a depression atop a hill (back), a grain scoop (ear), a giant ladle (head), a horn (tusk), and a thick rope (trunk). This allegory directs us to the notion that our comprehension of reality is at least as limited as that provided by each of these blind men. While such a realization should humble and sober us, Hokusai cannot resist having fun with the image of numerous men examining a massive elephant. Elephants are not native to Japan, so depictions of the creatures were based on Buddhist portrayals, especially those of the Bodhisattva Fugen (Sanskrit, Samantabhadra), who is typically depicted riding a white elephant. Given the fact that he himself never saw a

Katsushika Hokusai. *Hokusai manga* (The Hokusai Sketchbooks), 15 vols. (Nagoya: Eirakuya Tôshirô, 1814–1878.) The renowned wood-block print artist Hokusai created a massive collection of sketches of nearly unlimited scope. Even the covers of theses sketchbooks were designed to attract the consumer's eye, being issued in a variety of distinctive colors.

live elephant, Hokusai is free to allow his imagination to create a truly impressive creature. The printer provides a peach-colored ink to the flesh of the eleven blind acolytes, to the surface of the framing pine tree, and as a shadow to the black outlines of the seemingly bemused elephant. The background is executed in a printed wash of grey, thereby revealing that the image itself underwent a total of three impressions—in black, peach, and grey. The abbreviated figures lack noses, fingers, toes, and often mouths, but share their earnest desire to understand the creature, each from his own perspective. In sum, the effect is humorous and at the same time allows the viewer to appreciate Hokusai's ability to depict the human figure in a variety of poses.

We find this same theme depicted in another block-printed album, Itchô's Freestyle Album (*Itchô kyôga shû*). This album, which is undated, but seems to date from the mid- to late-nineteenth century, provides a retrospective on the work of the seventeenth-century genre painter, Hanabusa Itchô (1652–1724). Itchô, who incurred the displeasure of the military *bakufu* authorities and was exiled to distant Miyake Island for eleven years, returned to Edo in 1709 and created the highly animated and upbeat images for which he is best known today. A collection of his paintings did not appear in woodblock form until several decades after his death, when a disciple named Ippô compiled several monochrome collections starting in the 1750s. However,

Itchô's Freestyle Album, a later compilation, features a faithful rendering of Itchô's vibrant style, and provides the viewer with an Itchô anthology in full-color splendor. In Blind Monks Examining an Elephant ("*Gunmô zô wo naderu*"), Itchô provides a creature more closely resembling that which carries Fugen, and also scales it down to the size of an ox. Eight monks are shown engaged in an almost frenzied attempt to solve the puzzle of the elephant, which, in this version, seems intent on shaking them away.

The Fantastic Given Form

Humor was certainly not the only form that block-printed picture book consumers enjoyed. Another popular form that caught the public's imagination was that of collections of ghosts and other fantastic creatures. Seventeenth-

43

Hokusai manga (The Hokusai Sketchbooks), 15 vols. (Nagoya: Eirakuya Tôshirô, 1814–1878.) In Volume 8, we see illustrated the Buddhist proverb on "blind monks examining an elephant." However, both Hokusai's elephant and his monks play with the notion of limited perspective in a fanciful and memorable image.

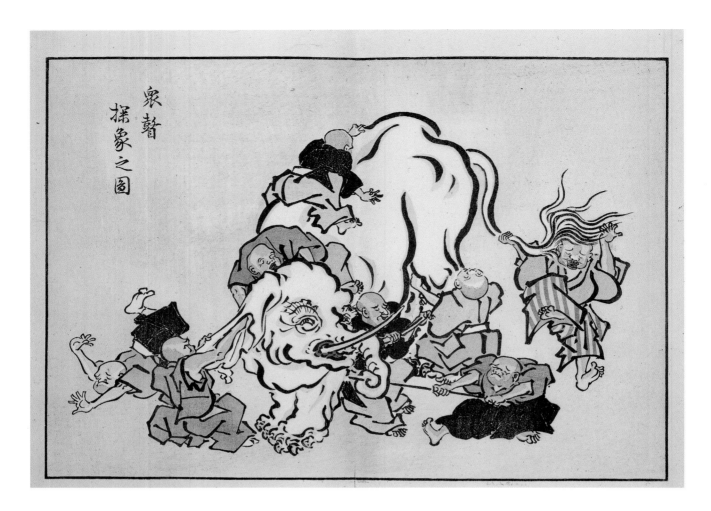

衆瞽
揉象之図

44

Hanabusa Itchô. *Itchô kyôga shû* (Itchô's Freestyle Album; Niigata: Meguro Jûrô, 1888). This fine album presents major works in Itchô's oeuvre, some 175 years after his death. Itchô's interpretation of the elephant and monk parable displays even more animation and levity than that of Hokusai, his later successor.

century collections of ghost stories, some of them translations of Chinese originals and some homegrown tales, often included relatively simple monochrome illustrations of ghosts, goblins, and other inhabitants of the netherworld, but, starting in the latter decades of the eighteenth century, block-printed books began to appear with compilations and categorizations of the various types of spirits, magical beasts, and haunting images. Together with these books, prints, drawings, and plays, the practice of telling "One Hundred Tales" (*hyaku monogatari*) grew in popularity. One Hundred Tales does not refer to the specific number, but rather indicates a storytelling genre. On certain nights, especially in the summer (when the spirits of the dead come back to their homes for the *Bon* Festival), people would gather together in someone's home and tell ghost stories by the light of one hundred string wicks burning in an oil lamp. As each story is told, one of the wicks is extinguished, making the room darker and darker, until, at the conclusion of

the hundredth story, the room is thrown into darkness and a spirit appears. We can see this practice in a wood-block-printed album by an artist who in many ways serves as Hokusai's successor, Kawanabe Kyôsai (1831–1889). In Kyôsai's Illustrated Talks on a Hundred Demons (*Kyôsai Hyakki gadan*), published in Tôkyô in August 1889, four months after Kyôsai's death that April, the album opens with a scene of a one-hundred-tale session in full swing. Since the book is folded in the accordion style, the viewer can actually open it completely to spread it across the room like an unrolled hand scroll. If we view only the first two double pages, however, we find a group of several men and women (and a child) huddled around a charcoal brazier listening to a man in the foreground tell a ghost story by candlelight. One figure cringes at the accentuated gestures of the storyteller, and seems to cling to the figure next to her, not realizing that the figure is either a ghoul itself, or someone wearing a ghoulish mask. To the far left we see the recorder of the tales gingerly approaching the lamp with all the wicks to extinguish one. Beyond that is another world where, in addition to much more, an army of skeletons battles a regiment of goblins.

Several decades before Kyôsai's Illustrated Talks appeared, a certain Tôkaen Michimaro, inspired by the explosion of ghost stories, pictures, and plays on the Kabuki and puppet stages, collaborated with the print artist Takehara Shunsen (ca. 1775–post 1850) to create a collection of forty-four short tales with full-color wood-block illustrations, entitled Illustrated Hundred Tales (*Ehon Hyaku monogatari*, Kyôto, 1841). Shunsen in his youth studied landscapes as a disciple of the renowned artist Takehara Shunchô, and illustrated the gazetteer, Illustrations of Famous Places along the Tôkaidô (*Tôkaidô meisho zue*, Kyôto, 1797). In his Illustrated Hundred Tales, however, Shunsen demonstrates his strengths in portraiture and his ability to bring the world of the fantastic to life. In tale number 11, "Yama-chichi," we see two men asleep with travel gear next to them. The man on the left is scratching his head and seems about to wake up, while, on the right, his companion is sleeping contentedly, a pleased smile on his face. We can imagine that he is dreaming about his wife or lover, especially given the fact that some sort of hairy creature has bent over his head, cradled it in its hands, and has pressed his lips against the man's! The caption above the figures briefly describes the creature as follows:

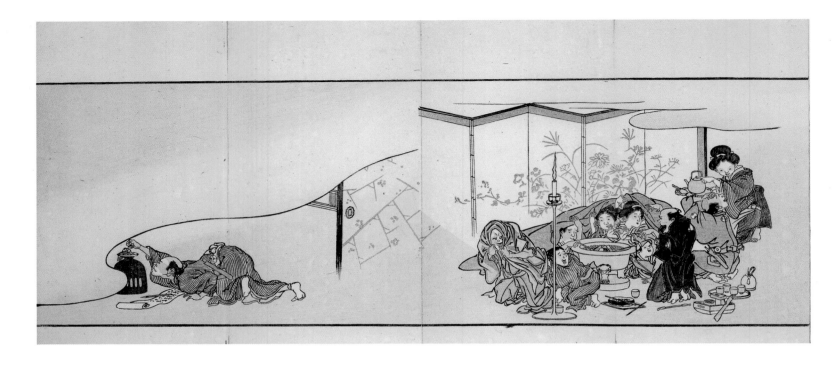

45

Kawanabe Kyôsai. *Kyôsai Hyakki gadan.*
Kyôsai's (Illustrated Talks on a Hundred
Demons). (Tôkyô: Inokuchi Matsunosuke,
1890.) This block-printed album, bound
accordion style, provides Kyôsai's version
of the famous One Hundred Fantastic
Creatures on a Night Parade (*Hyakki yagyô*)
motif. Preceding the parade depiction,
however, we are treated to an accurate
portrayal of a "Hundred Tales" ghost
story gathering, complete with the removal
of a wick from an oil lamp after each
ghost story is recounted.

Yama-chichi: This creature inhales people's breath while they are
sleeping and pounds their chest until they are absolutely dead.
However, if it happens to rouse its victim's companion, then the
victim will be blessed with long life. It is said that many live in
Michinoku Province.

Tales of the Abominable Snowman (Yeti, Sasquatch, Bigfoot) seem to
be universal in lands with rugged, hilly regions. These creatures are consid-
ered to be deadly if encountered. However, for some reason, in spite of the
caption, Shunsen has presented Yama-chichi's appearance more as resembling
a character out of Dr. Seuss, who might come and enhance our dreams, than
as a fearsome beast out to assume the breath of our life.

In tale number 43, we are a bit more disturbed. This is one of the few
illustrations that lacks a running caption, but, perhaps this is because the
title, Backstage at Night ("*Yoru no gakuya*"), speaks for itself. The puppet the-
ater, now known as Bunraku, developed its current form early in the eigh-
teenth century. Puppets are about three-fifths human size, and three pup-
peteers are required to manipulate one of the main characters. Much of the
Bunraku repertoire consists of vendettas, beheadings, and other gruesome
plays, designed to take full advantage of the fact that puppets, not people,

are doing the fighting. Magic swords and ghosts returning from the dead abound in these plays, so it is not too far-fetched to imagine that these puppets, designed from the start for bloodshed, would continue their atrocities long after the lights have gone out and the audience has returned home. The tale itself, next to the illustration, identifies the two figures engaged in a life-and-death struggle as the infamous villain Kô no Moronao and the lord of the forty-seven Rônin samurai En'ya Hangan, as they are known in the stage versions of the real-life vendetta.

Returning to Kawanabe Kyôsai—whose printed depiction of a Hundred Tale ghost-story-telling session helped us frame our discussion of Shunsen's Illustrated Hundred Tales—we find that he often employed fantastic creatures to suit his own ends. In the series Kyôsai's Hundred Pictures (*Kyô-sai Hyakuzu*, Edo, 1863), we encounter a male and female creature that are both characterized by their long necks. At the top of the image, a noodle vendor who had been selling prepared bowls at night, as we see by his paper lantern, has dropped everything and cringes in fear while a pair of stray dogs make the most of the spilled noodles. The two long-necked goblins—known as Potter's Wheel Head (*"rokuro-kubi"*) for the female, and The Overlooker Lay-Priest (*"mikoshi nyûdô"*) for the one-eyed male, have bound a helpless noodle customer and, judging by their opened mouths and extended tongues, are about make him their personal plaything. It is unlikely he will survive the ordeal. The caption expresses a famous saying, "Let yourself get bound up by whatever is long" (*"Nagai mono ni wa makarero"*), which roughly translates as "Don't resist the ones in control."

This collection survives in a series of forty-nine separate sheets, kept in six *fukuro* wrappers. The impression is crisp, and the colors vibrant, leading us to believe that possibly this is the form in which the first edition appeared . Another edition exists, though, with exactly the same image, but colored quite differently. In this bound edition, the blocks are the same, but the pigments that have been used to color the image are much thicker, lending the illustration an overall sense of excess. Neither edition is dated, but the existence of the wrappers, as well as the general care taken to provide tasteful, light colors, lead us to conclude that the loose-leaf edition preceded the bound edition.

The Library is extremely fortunate to possess an album, in Kyôsai's

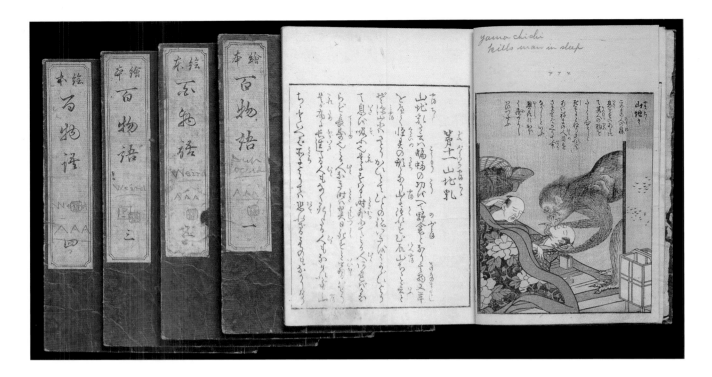

46

Tôkaen Michimaro (text), Takehara Shunsen (illustrations). *Ehon Hyaku monogatari* (Illustrated Hundred Tales). (Kyôto: Ryûsuiken, 1841.) Takehara Shunsen illustrates a collection of forty-four short vignettes identifying well-known fantastic creatures and several "true" tales made famous on the stage. The Yama-chichi, illustrated here, is a Yetilike creature believed to inhale the life force from travelers who spend the night in its territory.

own hand, of preliminary studies for his Hundred Pictures and other collections. Done in ink with touches of pigment perhaps applied by someone else, Kyôsai provides in a horizontal format the image that we eventually find redrawn, carved, and printed in a vertical format. The outlines of the caption in pink may be an editor's instructions, over which Kyôsai provided the text in black. The translucent mulberry paper upon which Kyôsai has drawn the image is typical for the kind of paper used as a *hanshita*, or final copy that will be overlaid onto the woodblock and sacrificed to create the carved block. Appropriately, the title slip on this album, Kyôsai Hanshita Drawings (*Kyôsai Hanshita*), reflects the purpose for which these drawings were intended. While it is not clear whether drawings of exactly the same size and layout ever found their way into print, those that survive in this album provide us with fine examples of Kyôsai's range of style, versatility, and mastery of his artistic medium.

Gafu *Anthologies and* E-dehon *Painting Manuals* —*Education or Appreciation?*

Many block-printed picture books were created and published for the purpose of providing to an audience, beyond one's circle of direct disciples, a

range of models of line, theme, and technique that represent a particular artist's or school's lineage. An unusually rich array of schools of drawing and painting coexisted in Japan throughout the Early Modern Era. We can identify the Tosa school, heir to the Yamato-e tradition related to the literary classics of the Heian Period; the Kanô school, which developed fine monochrome ink techniques imported from China during the Muromachi Period; the Rimpa, or decorative school inspired by Tawaraya Sôtatsu and Ogata Kôrin; schools of *Ukiyo-e* genre painting of contemporary tastes; the Nagasaki school of *kanga* (Chinese-style) landscapes and bird-and-flower mo-

47

Tôkaen Michimaro (text), Takehara Shunsen (illustrations). *Ehon Hyaku monogatari* (Illustrated Hundred Tales). (Kyôto: Ryûsuiken, 1841.) In this image from the Hundred Tales, Backstage at Night (*Yoru no gakuya*)—the universal motif of dolls, wax museum figures, and puppets coming to life—is given a vivid portrayal as warrior puppets from the *bunraku* theater continue their struggles backstage each night.

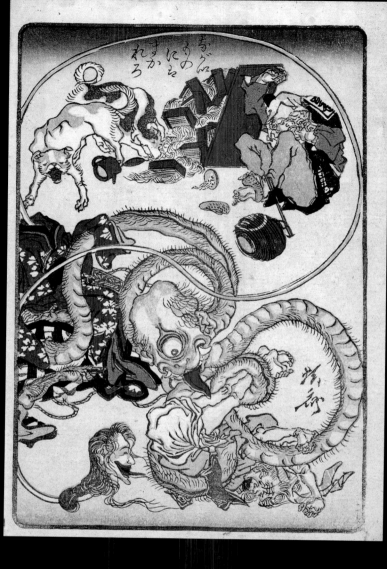

48

Kawanabe Kyôsai (illustrator). *Kyôsai Hyakuzu* (Kyôsai's Hundred Pictures). (Edo: Wakasaya Yoichi, 1863(?).) This collection of humorous illustrations of proverbs and figures of speech originally appeared in loose-leaf form, with each packet of eight or nine illustrations wrapped in a single *fukuro* sheet. This print of two long-necked creatures accosting a helpless noodle-shop customer illustrates the dictum that "resistance is futile."

49

Kawanabe Kyôsai (illustrator). *Kyôsai Hyakuzu* (Kyôsai's Hundred Pictures. (Edo: Wakasaya Yoichi, 1863(?).) This is another printed version of the Hundred Pictures, but in bound-volume format. The content is the same, but the coloration is noticeably different.

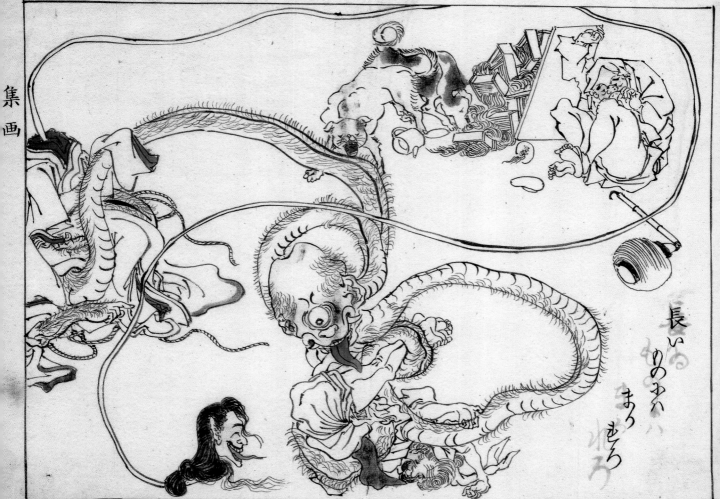

集
画

長いものゝ
あやしき
ハ
まろ
せろ

tifs transmitted to the Japanese by seventeenth-century émigré Chinese of the Ôbaku sect of Zen Buddhism; domestic adaptations of *kanga* styles known as "Southern school" (*nanga*) or "literati" (*bunjin-ga*) drawings; abbreviated sketches inspired by *haikai* (*haiku*) poems and linked verse, called *haiga* (*haiku* paintings); the Maruyama-Shijô school of painting in Kyôto, which combined European techniques of perspective and three-dimensionality with a combined *nanga* and *haiga* sensibility; and numerous other schools, styles, and influences. It is remarkable that, for each of these traditions, the publication of painting manuals and album anthologies in block-printed form served as an important means for documenting the work of a particular master, promoting and advertising a certain artistic approach, and transmitting images and techniques to posterity.

Kawamura Bunpô (1779–1821) stands as one of the most gifted promoters of *kanga* painting in the Kamigata (Kyôto-Ôsaka) area in the early decades of the nineteenth century. His Instructions in *Kanga* Painting: Second Edition (*Kanga shinan: ni-hen*, Kyôto, 1811) provides fine examples of Chinese figures in a variety of poses and settings. Printed using three blocks—one for the drawing in black ink, one for the highlights in light blue, and one for the details in beige—this painting manual derives its name from an earlier manual, by eighteenth-century polymath Takebe Ayatari (1719–74), published posthumously in 1776. Compared to Ayatari's manual, which may have been assembled from sketches and notes after his death, Bunpô's provides mature and well-digested images that clearly illustrate various techniques students might apply in their own work. The illustration Returning Home (*Ki kyorai zu*) is based on a verse by the mid-T'ang Dynasty poet Po Chü-yi (772–846). In the illustration, we see a man being ferried to his home on the riverbank, where his wife and children joyously greet him. The season is spring, and the flowering tree in the foreground both frames the upper right side of the image and provides a sense of new life and growth. The artist is not afraid to leave great portions of the image blank, but utilizes this space to provide depth to the scene. We see a very different scene, simply labeled Fishmarket ("*Uoichi zu*"), in which the background is completely nonexistent, but a number of fisherfolk gather to hear one of them recall "the one that got away." Behind the speaker lie several varieties of the bounty of the sea.

Bunpô also published his collected anthology, *Bunpô gafu*. The first part

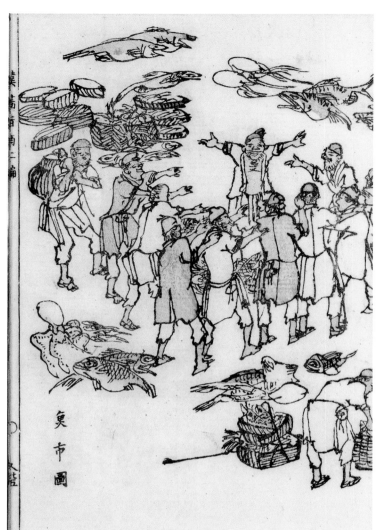

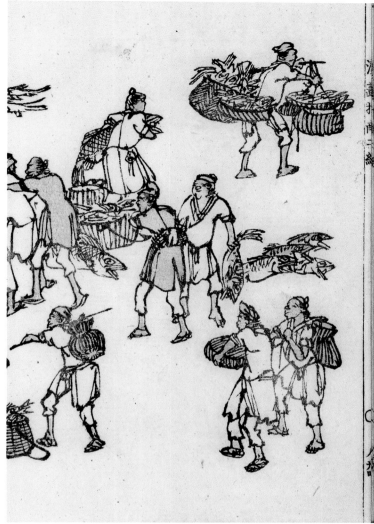

appeared in 1807, when the artist was only twenty-eight, while the second and third parts appeared in 1811 and 1813, respectively. In the first illustration, we see very little on the right except a stream with a small waterfall, while, on the left, the scene is filled with trees, a path, a gate, and a woman bent with age approaching it. Probably this image alludes to a Chinese poem, but even without the literary source, we can still appreciate this scene, executed so effectively. In Part 2, the artist takes us under water where we can observe a pair of turtles in action. The water itself is limited to a few wavy strokes, allowing the viewer to focus on the turtles as one swims while the other makes its way with some effort onto terra firma.

Another Kamigata artist, whose work is known almost exclusively by

51

Kawamura Bunpô. *Kanga shinan: ni-hen* (Instructions in Kanga Painting: Second Edition). (Kyôto: Hishiya Magobei, 1811.) In this image, men dressed in Chinese costume are gathered at the fish market discussing the catch and the ones that got away.

52

Kawamura Bunpô. *Bunpô gafu* (The Bunpô
Painting Manual). (Vol. 1: Ôsaka:
Yanagihara Kihei; Kyôto: Yoshida Shinbei,
1807. Vol. 2: Ôsaka: Kawachiya Kihei;
Kyôto: Yoshida Shinbei, 1811/1813.) In
another example of Bunpô's recognition as
a leader of the Shijô school of painting,
his anthology includes such images as that
of a woman climbing a hill toward a gate.

the book illustrated here, is Saitô Shûho (also, Aoi Sôkyû, 1769–1859). His
Mr. Aoi's Album of Charm (*Kishi enpu*, Kyôto and Ôsaka, 1803) is considered
a minor masterpiece that combines the intent toward verisimilitude charac-
teristic of the Shijô school (where Shûho was trained) with a *haiga*-like ab-
breviated touch, and applies these stylistic elements to a record of the four
seasons as they could be experienced at the licensed pleasure quarters in
Ôsaka. In the first illustration, a courtesan is being helped onto a boat on
which a dinner party is being held while it travels along one of Ôsaka's many
waterways. The delicacy of the courtesan is accentuated by the rough, but

文鳳画譜二

〇廿三

53

Kawamura Bunpô. *Bunpô gafu* (The Bunpô
Painting Manual). (Vol. 1: Ôsaka:
Yanagihara Kihei; Kyôto: Yoshida Shinbei,
1807. Vol. 2: Ôsaka: Kawachiya Kihei;
Kyôto: Yoshida Shinbei, 1811/1813.) In this
image, Bunpô brings a pair of turtles in
the water to life with just a few details.

respectful demeanor of the boatman, for whom the act of taking the cour-
tesan's hand may be the closest he can ever approach the world of the plea-
sure quarters. In the second illustration from this book, for which only a few
complete copies exist in Japan (the Library of Congress alone possesses two
copies, we should note), the scene has shifted to a chamber concert featur-
ing the three-stringed *shamisen* and the *kokyû* (a type of *shamisen* played with a
bow). We are able to appreciate the musicians as they play. As night deep-
ens, a matron provides more candlelight, while a courtesan with her back to
us serves beverages to the male patrons, who, conveniently, are outside the

Saitô Shûho (also known as Aoi Sôkyû). *Kishi enpu* (Mr. Aoi's Album of Charm). (Ôsaka: Ueda Uhei, Murakami Sakichi, preface, 1803.) In this fine example of an extremely rare album of life and activities in the Shinchi licensed pleasure quarters of Ôsaka, we see a courtesan being helped onto a boat by an uncultured but gentle boatman.

frame of view. The general impression provided by this series contrasts sharply with the sense of contemporary chic we tend to find in depictions of the Yoshiwara or Fukagawa pleasure quarters of Edo, and, even though the scenes of *Mr. Aoi's Album of Charm* are not captioned, we can almost hear the melodic lilt of the Ôsaka or Kyôto regional cadences coming from the men and women portrayed in this delightful work.

Of course not all picture books are wood-block-printed. Many sketch-books, albums, and notebooks have been transmitted from artist to disciple through the years, and some of them eventually end up in public and private collections. The Library's collection is no exception and, in fact, it houses many hand-drawn albums of exceptional beauty. Chôkô's Album of Paintings (*Chôkô gajô*) is a fine example. The artist, Nagayama Kôin (1765–1849), a merchant's apprentice, was discovered in Akita in the northern provinces by the scholar and poet Murase Kôtei and, with Kôtei's introduction, Kôin traveled to Kyôto and entered the Shijô school of painting there.[7] In the album, we

55

Saitô Shûho (also known as Aoi Sôkyû).
Kishi enpu (Mr. Aoi's Album of Charm).
(Ôsaka: Ueda Uhei, Murakami Sakichi,
preface, 1803.) In this image, we encounter
courtesans engaged in a chamber concert,
in a scene that strikes the viewer
simultaneously as both engaging and
charming.

can easily appreciate the image of the elderly woman seated alone on a straw mat under the moonlight, using a fulling mallet to soften the cloth she has just woven. We can also see that Kôin sketched this scene directly into his notebook, since he had to paint across the crease in the middle of the book.

Another fine album is one that comes down to us untitled and with no clue as to the identity of the artist. With the provisional title of Sketchbook (*Shasei jô*), we have little recourse but to examine and appreciate the images contained within the sketchbook's covers. One image, labeled "Ômi-hachiman," is particularly striking. Composed with a dry brush, or perhaps charcoal, the image shows us the main street of the post town of Ômi-hachiman, along the Nakasendô Highway just east of Lake Biwa. The characters just above the building on the right page label the street as the Tôkaidô, but this particular scene lies on the northern, mountain route to Edo from Kyôto. The sketch employs a vanishing point and horizon in the European manner, as well as a low perspective, leading the viewer to suspect that the artist may have been trained

Nagayama Kôin. *Chôkô gajô* (Chôkô's Album of Paintings), before 1850. This bound collection of multicolor paintings shows the Shijô artist Nagayama Kôin at his finest, in an intimate album format. In the image, Woman Fulling Cloth, we encounter a woman fulling cloth in the moonlight. The picture provides a sense of calm refinement, due as much to what is omitted as to what is included in the image.

in the Shijô school. From the thick-walled warehouse in the foreground to the inns lining the road ready to feed, entertain, and provide rest for travelers, the sketch draws us in and beckons us to explore the town further.

The Library's collection of prints and drawings provides a taste of some of the treasures that Japanese books and albums have to offer. For the scholar of Japanese books, Japanese art, comparative graphic design, and a host of other fields, this collection offers a new addition to the world-class resources at our disposal. For the artist and designer interested in gaining a fuller understanding of the rich and varied traditions Japan has to offer in both wood-block-printed and hand-painted formats, the Library's collection can help to provide new ideas and inspirations that might lead to a further enrichment of our future heritage.

57 ———

Anon. *Shasei jô* (Sketchbook), circa 1830-1843 (Tenpo Era). This album of various scenes, studies, and other images is anonymous, but intrigues the viewer all the more with the artist's clear mastery of line and form. The street scene in the post town of Ômi-hachiman, east of Lake Biwa, illustrated here, immediately attracts the viewer. The use of a vanishing point and a horizon provide this monochrome sketch with a high degree of realism, derived from Western perspective techniques.

Bibliography

Bessatsu Taiyô: Nihon no kokoro (The Separate Volume Sun: The Heart of Japan) 89 (spring 1995). Issue devoted to *Tsutaya Jûzaburô no shigoto* (The Work of Tsutaya Jûzaburô).

Brown, Yu-ying. *Japanese Book Illustration*. London: British Library, 1988.

Chibbett, David. *The History of Japanese Printing and Book Illustration*. Tokyo, New York, and San Francisco: Kodansha International, 1977.

Edo bungaku (Edo Literature Journal): Special Issue on *Edo no shuppan* (Edo Publishing) 15 and 16 (1996).

E-iri baisho to sono gakatachi (Illustrated Haikai Collections and Their Artists). Itami: Kakimori Bunko, 1992.

Forrer, Matthi. *Eirakuya Tôshirô, Publisher at Nagoya: A Contribution to the History of Publishing in 19th Century Japan*. Amsterdam: Giebens, 1985.

Hillier, Jack. *The Art of Hokusai in Book Illustration*. London: Sotheby, Parke, Bernet; and Berkeley and Los Angeles: University of California Press, 1980.

—. *The Art of the Japanese Book* (2 vols.). London: Sotheby's, 1987.

—. *The Japanese Picture Book: A Selection from the Ravicz Collection*. New York: Abrams, 1991.

—, and Lawrence Smith. *Japanese Prints: 300 Years of Albums and Books*. London: British Museum, 1980 (1983).

Hironiwa, Motosuke, and Nagatomo Chiyoji. *Nihon shoshigaku wo manabu hito no tame ni* (For People Learning Japanese Bibliography). Kyôto: Sekai Shisôsha, 1998.

Holloway, Owen E. *Graphic Art of Japan: The Classical School*. Rutland, Vermont, and Tokyo: Tuttle, 1971 (reprint of London: Tiranti, 1957 edition).

Honda, Shôjô, comp.; Jin'ichi Konishi, annot. *Pre-Meiji Works in the Library of Congress: Japanese Literature, Performing Arts, and Reference Books: A Bibliography*. Washington: Library of Congress, 1994 (Asian Division Bibliographic Series, No. 2).

Ikegami, Kôjirô, adapted by Barbara B. Stephan. *Japanese Bookbinding: Instructions from a Master Craftsman*. New York and Tokyo: Weatherhill, 1986 (1998).

Inoue, Muneo, Oka Masahiko, Ozaki Yasushi, Katagiri Yôichi, Suzuki Jun, Nakano Mitsutoshi, Hasegawa Tsuyoshi, and Matsuno Yôichi, eds. *Nihon kotenseki shoshigaku jiten* (Bibliographic Dictionary of Japanese Classical Books). Tôkyô: Iwanami Shoten, 1999.

Inoue Takaaki. *(Kaitei zôho) Kinsei shorin hanmoto sôran* (Revised and Expanded: Catalogue of Early Modern Publishers and Booksellers). Nihon Shoshigaku Taikei series 76. Musashi-Murayama: Seishôdô Shoten, 1998.

Kinsei Nihon kaiga to gafu/e-dehon ten: Meiga wo unda hanga (Exhibition of Early Modern Japanese Paintings and Albums/Painting Manuals: Woodblock Prints that Gave Birth to Famous Pictures) (2 vols.). Machida: Machida Shiritsu Kokusai Hanga Bijutsukan, 1990.

Kornicki, Peter. *The Book in Japan: A Cultural History from the Beginnings to the Nineteenth Century*. Leiden: Brill, 1998.

Lee, Sherman. *The Sketchbooks of Hiroshige* (2 vols.). New York: Braziller, 1984.

Michener, James A. *The Hokusai Sketchbooks: Selections from the* Manga. Rutland, Vermont, and Tokyo: Tuttle, 1958 (1989).

Mitchell, C. H., with the assistance of Osamu Ueda. *The Illustrated Books of the Nanga, Maruyama, Shijo, and Other Related Schools of Japan: A Biobibliography*. Los Angeles: Dawson's Book Shop, 1972.

Mizutani, Futô (Yumihiko). *"Kohan shôsetsu sôga shi"* (A History of Illustrations of Early Published Narrative Fiction). In *Mizutani Futôchosakushú* (Collected Writings of Mizutani Futô) 5. Tôkyô: Chûô Kôronsha, 1973 (reprint of Tôkyô: Ôokayama Shoten, 1935 edition).

Nakano, Mitsutoshi. *(Shoshigaku dangi) Edo no hanpon* (Bibliographic Sermons: The Woodblock-printed Books of Edo). Tôkyô: Iwanami Shoten, 1995.

Nakata, Katsunosuke. *Ehon no kenkyû* (Research into Picture Books). Tôkyô: Bijutsu Shuppansha, 1950.

Smith, Henry D. II. "The History of the Book in Edo and Paris." In McClain, James L., John M. Merriman, and Ugawa Kaoru, eds., *Edo and Paris: Urban Life and the State in the Early Modern Era*. Ithaca: Cornell University Press, 1994: 332–55.

Suzuki, Jûzô. *Ehon to ukiyoe* (Picture Books and Ukiyo-e Prints). Tôkyô: Bijutsu Shuppansha, 1979.

Tenri hizô meihin ten (Exhibition of Hidden Masterpieces in the Tenri Collections). Tenri: Tenrikyô Dôyûsha, 1992.

Yoshida, Kogoro. *Tanrokubon: Rare Books of Seventeenth-century Japan.* Tokyo and New York: Kodansha International, 1984.

Notes

1. Kornicki, 1998: 135.
2. Inoue, 1998: 38.
3. Kornicki, 1998: 57.
4. This work in the Library's collection has yet to be identified elsewhere and may well be a unique publication of which only this, unfortunately incomplete, copy survives.
5. For a fuller explanation of the Japanese wood-block-printing process, see Chibbett, 1977: 33–35.
6. See Forrer, 1985: 195–224.
7. Biographical information found in *Kokusho jinmei jiten* 3:516.

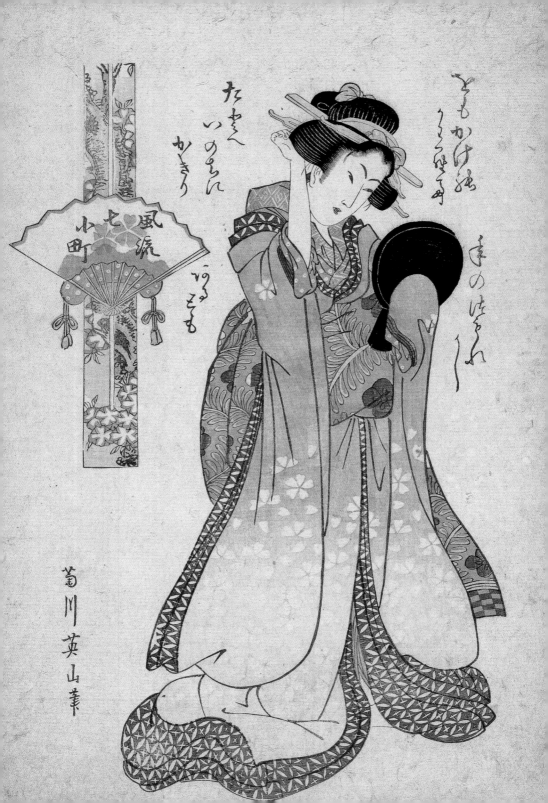

UKIYO-E AND ITS ORBIT

THE LIBRARY OF CONGRESS COLLECTIONS IN CONTEXT

KATHERINE L. BLOOD
PRINTS AND PHOTOGRAPHS
DIVISION

Elegant things:

A white coat worn over a violet waistcoat.

Duck eggs.

Shaved ice mixed with liana syrup and put in a new silver bowl.

A rosary of rock crystal.

Snow on wisteria or plum blossoms.

A pretty child eating strawberries.

Sei Shônagon
The Pillow Book of Sei Shônagon
Tenth-century Japan

Whenever I see it (mind you, it should be the best Ukiyoye art in original) at my friend's house by accident or in the exhibition hall, my heart and soul seem to be turning to a winged thing fanned by its magic; and when my consciousness returns, I find myself narcotised in incense, before the temple of art where sensuality is consecrated through beauty.

Yone Noguchi
The Spirit of Japanese Art
London, 1915

My Dear Sir:

The collection of Japanese pictures, engravings, illustrated books, etc., which I hereby tender to the Congressional Library, Washington, D.C. will, I think, serve to supply in some degree an illustration of the extraordinary variety in Japanese art and an instructive and timely insight into the history, legends, religions, industries, amusements, folklore, fauna and flora, scenery, drama, and all the wide range of art motives of the wonderful people who are just now the center of world interest.

Crosby Stuart Noyes
Excerpted Letter
October 17, 1905

58

Kikugawa Eizan (1787-1867). *Fûryû nana komachi* (The Modern Seven Komachi). Komachi was a celebrated ninth-century poet, famed also for her spectacular beauty and its decline in her old age. The inscription reads: "Even if we say life is limited/ The accumulating years would not matter/ if one's appearance did not change."

*L*ong appreciated and studied by Western artists, scholars, and collectors, the Japanese art of Ukiyo-e (translated as pictures of the Floating, or Sorrowful World) first captures the eye by its sheer force of physical beauty and captivating subject matter—exquisite courtesans, stunning landscapes, the baroque world of the theater. A closer look yields complex layers of meaning, issuing in part from the dual function of Ukiyo-e art as accessible images by and for everyday people, and as the new, spirited progeny of a long and highly literate courtly tradition.

The objects and essays in this catalog show that an understanding of this art can only be approached through many layers of textual and visual language, history, philosophy, aesthetics, and thought. However, the impact of Ukiyo-e reaches far beyond its original time (1615–1868), place (the Japanese city of Edo, now Tokyo), and intent. That so many major museums and libraries in Europe and the United States have assembled substantial collections of Japanese Ukiyo-e is a testimony to its influence[1] and also reflects the shared histories of these countries.

Western appreciation for Japanese graphic art and culture reached a crescendo during the nineteenth century when Japanese-influenced style irrevocably entered the lexicon of Western artistic expression. Around the same time, and on a very different trajectory, exposure to the West began to have an increasing impact on Japanese artists and audiences. The results of these cultural exchanges are extensively chronicled in the Library's matchless holdings of graphic art. Particular strengths include Japanese Ukiyo-e of the seventeenth to the nineteenth centuries,[2] nineteenth-century Yokohama-e (primarily images of Westerners in the port city of Yokohama), and Japanese-inspired artworks known by European and American artists from the nineteenth century forward as *Japonisme* (a term used to describe the taste for and artistic appropriation of Japanese style). The collection also includes Japanese political prints from the Sino-Japanese and Russo-Japanese wars, and modern Japanese prints.

Some Background on Ukiyo-e

Among the many physical shapes Ukiyo-e can take are prints in various standard sizes (including multipanel works and series), books, albums, and scrolls. The Library's Ukiyo-e collections are richest in wood-block-printed images,

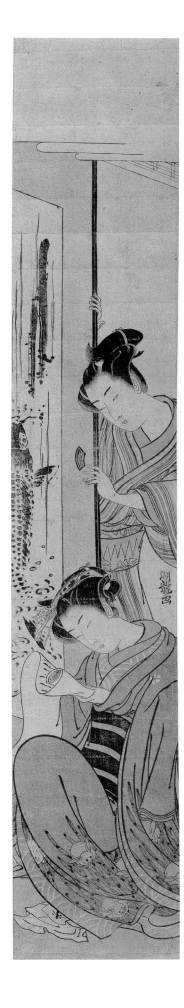 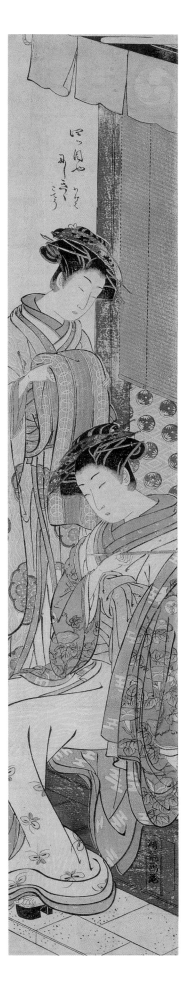

59 AND 60

Attributed to Isoda Koryûsai. Two color wood-block pillar prints, circa 1764 to 1788. Pillar prints were intended for display on support pillars or *hashira*. It has been estimated that Koryûsai created over a quarter of all known pillar prints, many of which are counted among the masterpieces of Ukiyo-e. On the left, a woman is engrossed in reading a scroll, perhaps a love letter, while a young man emerges from behind a painted screen. The next image shows two willowy beauties; one holding sumptuous kimono fabric, and the other a long-stemmed pipe which extends beyond the border of the image.

Detail from Ryûsai Shigeharu (illustrator).
Yakusha sangoku shi (The Three Kingdoms of
Actors' Customs). This illustration from a
wood-block-printed book has been
photographed in raking light to emphasize
the three-dimensional effects achieved by
embossing.

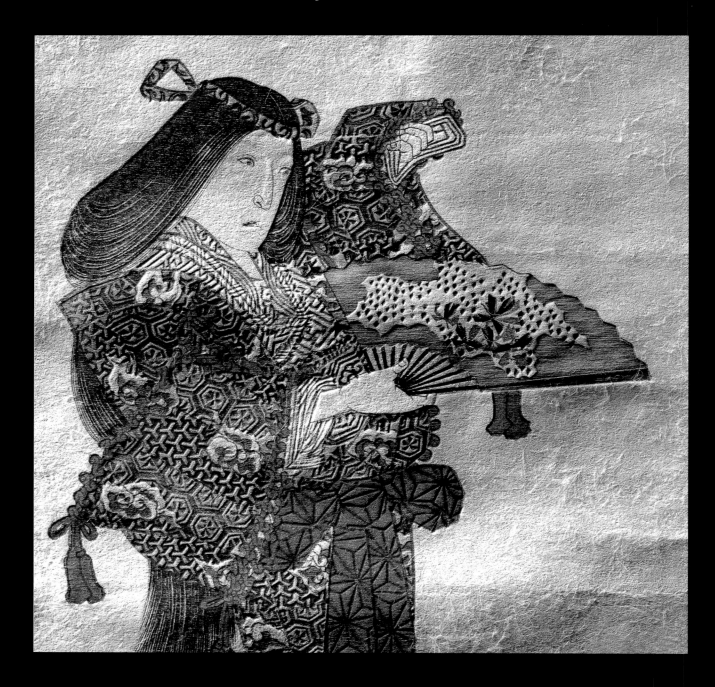

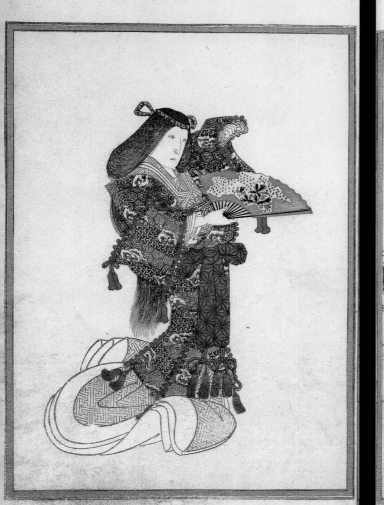
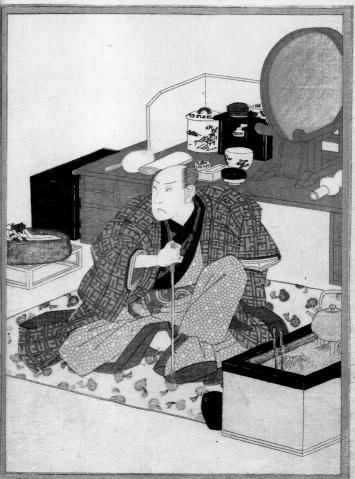

the primary vehicle for this art, and drawings are also held in strength. These holdings demonstrate the breadth and depth of Ukiyo-e; including such major genres as beauty and actor prints, landscapes, and *surimono* (privately commissioned prints, made to commemorate special events, and given to a select circle as mementos). Also found in the Library's collections are unusual types of Ukiyo-e including catfish prints (*namazu-e*), caricature prints (*toba-e*), pillar prints (*hashira-e*), and crepe prints (*chirimen-e*).

The art of the woodblock is exemplified in Ukiyo-e, which exploits the full potential of this printmaking medium. The interplay of wood grain and paper texture are often key elements in composition and design. Since the process involves the transfer of ink from woodblock to paper under pressure, wood-block prints often display three-dimensional qualities. Embossing is a common design device. Papers vary in degree of opacity or transparency, and paper surfaces (plain and printed) sometimes glitter with flecks of ground metal or mica. Some images, especially early examples of Ukiyo-e, are spare and monochromatic. At the other end of the spectrum are lavish images built up in multiple layers of color. Colors and textures are seen in a dazzling array of combinations, from organic hand-applied pigments to later aniline dyes and from metallic inks to highly polished lacquerlike passages.

Scholars continue to debate the chronological boundaries of Ukiyo-e, but it is generally thought to have come of age and flourished during Japan's Edo Period—from 1615 to 1868. This corresponds roughly with the two-hundred-year rule of the Tokugawa shogunate, a time of relative peace and limited international contacts. During this period, the imperial court retained its base in Kyoto, while the city of Edo became the shogunal seat of power. The social hierarchy of the day placed those with the most spending power, the merchants, at the lower end of the scale. It was the collaboration among the merchants, artists, publishers, and townspeople of Edo that gave Ukiyo-e its unique voice. In turn, Ukiyo-e provided them with a means of attaining cultural status outside the sanctioned realms of shogunate, temple, and court. The result was an art that was both populist (of and for the people, readily accessible, plentiful, affordable) and highly sophisticated. Conventional themes include the life of Edo's pleasure and theater districts, especially beautiful women and equally splendid Kabuki actors. Ukiyo-e

frequently referred back to historic, mythic, and literary sources from the near and distant past. Landscapes were used to express delight in natural beauty, pride of place, and the importance of travel. Interest in natural beauty also extended to the depiction of birds and flowers. Text and poetry were essential components in many Ukiyo-e artworks. This was particularly true of *surimono*, which were intended to carry the cachet of "insider knowledge" for a cultured and well-educated audience. *Surimono* texts and images might contain nuanced or emblematic meanings, literary references, and indirect allusions to an event or celebration.

Western exposure to Ukiyo-e only happened on a grand scale with the close of the Edo Period. Since both literal and cultural languages were so integral to this art, the subject matter often suffered in translation. But the sheer visual allure of the images performed an alchemy in the Western imagination that has had profound and long-lasting effects. Through selected works from the Library's collections, this essay celebrates the universal appeal of this art form and its wide sphere of influence.

The Crosby Stuart Noyes Gift

The Library of Congress owes its extensive holdings of Ukiyo-e prints and printed books to a host of different collectors, including Oliver Wendell Holmes, William Howard Taft, A. J. Parsons, Leicester Harmsworth, and Donald D. Walker. However, the most extensive collection of Ukiyo-e at the Library was assembled by one person, Crosby Stuart Noyes (1825–1908). Noyes came to Washington, D.C., in 1847 with less than two dollars in his pocket[3] and rose up through the ranks as a young journalist. He worked for a number of papers and journals including the *Washington News*, the *Yankee Blade*, and the *Saturday Evening Post.* From 1855 until the end of his career, Noyes worked at the *Washington Evening Star.* During the Civil War, Noyes was acquainted with Abraham Lincoln and Secretary of War Edward Stanton. The *Star* was the first newspaper to publish Lincoln's inaugural address, and official announcements were often made through the paper during his administration. In 1867, Noyes purchased the paper along with several associates and became its editor-in-chief. By 1908, the paper was hailed in the *New York Tribune* as "the most influential newspaper in Washington . . . which shapes more legislation than any other paper in the United States."[4]

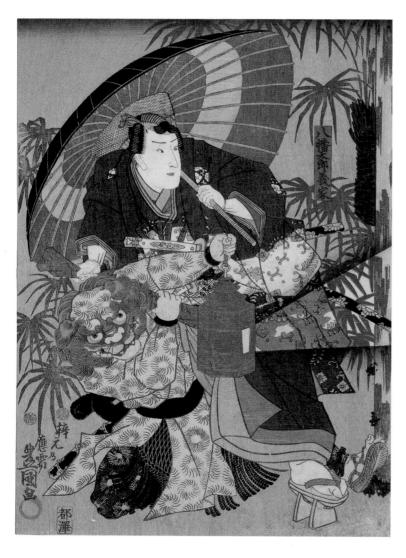
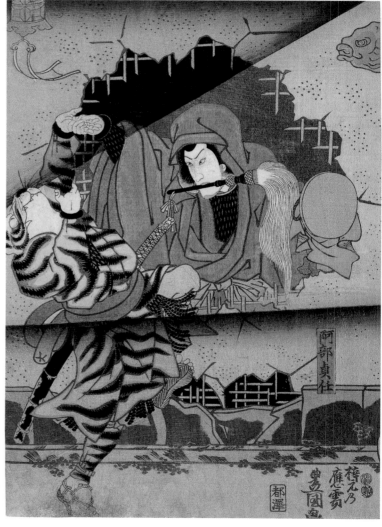

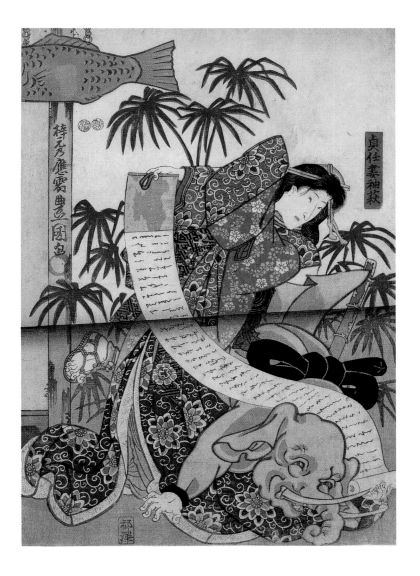

Utagawa Kuniyoshi. Signed *Motome ni oji Toyokuni* (Painted on Demand by Toyokuni). This triptych depicts a night scene lit by a lantern in which six actors appear, three dressed as a tiger, elephant, and lion. The figures are identified as *Hachiman Tarô Yoshiie* (left, with parasol), *Abe no Sadato* (center, holding tiger), and *Sadato no tsuma* (Sadato's wife) *Sodehagi* (right, holding long letter). Kabuki theater was a major source of inspiration for Ukiyo-e artists, and Kuniyoshi's triptych conveys some of the energy of this art form. Edo actors were known for a bombastic style of Kabuki known as *aragoto* (rough stuff) which originated with the great actor Ichikawa Danjûrô. Theatrical prints often focused on climactic scenes in the play and moments of epiphany for its actors.

Shinsai. Wood-block *surimono* print with metallic inks. Undated. The poem reads: "Icefish (cooking) like melting snow/Peacefully the wine warms my breast/I feel like a spring of a thousand gold coins." *Shirao* is a kind of small white fish, called icefish or salangid (Salanx microdon).

Over the course of his life, Noyes traveled widely and visited Japan several times. He assembled a remarkable collection of Japanese art which he gave to the Library of Congress in 1905. The gift consisted of 1,304 works, including: "12 water-colors, 145 original drawings, 331 wood engravings, 97 lithographs, 658 illustrated books, and 61 other items."[5] Most of the major schools, genres, and masters of Ukiyo-e are represented in Noyes's collection. Because he was acquiring Japanese prints at a time when such collecting was still in its infancy, he was able to acquire a large number of so-called Primitives by early Ukiyo-e masters of the seventeenth century. Such prints were originally issued in limited numbers and are extremely rare today. Noyes also collected Japanese wood-block prints related to the Sino-Japanese and Russo-Japanese wars.

In his 1905 letter accompanying the gift, Noyes punctuates his own opinions of Japanese art with the words of contemporary Western writers on Japanese art, including Edward F. Strange, Sir Rutherford Alcock, and Basil Hall Chamberlain. Noyes alternately invokes and lambasts these critiques; lauding Miss E. R. Scidmore as a "thoughtful and acute observer of Japanese life and character," and calling Alcock's *Art and Art industries of Japan* "supercilious and superficial." On the subject of Japanese artists, Noyes wrote:

> Their art, as well as character, is notable for its diversity and strong contrasts. In its different schools—academic, realistic, and impressionist—it is by turns vigorous, graceful, grotesque, weird, decorative, refined, intense, dainty, and poetic. It is distinguished by the exquisite beauty of its color harmonies, delicate gradations of tone, subtle fineness of touch contrasted with bold directness of method; for the delicacy, accuracy, and at the same time the vigor of its line "ranging from hairbreath to the width of an inch." It has been well described as "a combination of delicate grace, infallible accuracy, and unostentatious verve, the same brush wielded with admirable strength, and reveling in microscopic elaboration of detail."

He ended the passage by writing: "Japanese art, as well as character, has been misunderstood and misrepresented."

64

Unknown photographer. Portrait of Crosby Stuart Noyes (1825–1908). Silver albumen photograph. Undated.

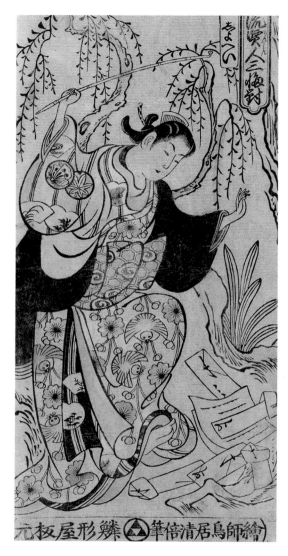

65

Signed Torii Kiyomasu. Actor Sanjô
Kantaro as a Peddler of Love Letters. Title
bar states: *Eshi Torii Kiyomasu hitsu; Urogataya
hangen*. Wood-block print with hand-
applied color, circa 1690s to 1720s. The
earliest Ukiyo-e prints were monochrome
with the main design laid out in bold black
lines. Beginning in the late seventeenth
century, artists began to add colors, such
as red lead, yellow, and orange; and light-
catching textures, such as metallic powder,
and lacquerlike passages made of *sumi* ink
and glue (*urushi*).

Noyes's gift to the Library came just one month after the official close
of the Russo-Japanese War, in which Japan effectively blocked Russia's ex-
pansionist policy in the Far East. Noyes alluded to the political climate of
the times in this passage toward the end of his letter: "What is to be the
future of this remarkable people? This is the great problem now before the
world. The pursuit of this inquiry will necessarily lead to a close study of
the antecedents of the Japanese; their history, life, manners, and customs, in-
dustries and arts, and it is believed that this collection will afford the inquirer
a considerable amount of information." Beyond the beauty, charm, and
artistry of its images, Noyes anticipated the research potential of his col-
lection as a window to Japanese history and culture, and as a source for both
appreciation and understanding.

Early Encounters

The 1853 arrival of Commodore Perry in Japan has sometimes been painted
as a kind of klieg-light moment, suddenly revealing a hidden civilization after
200 years of seclusion. Though Perry's arrival would prove to be a crucial
event, the earliest encounters between Japan and the West date back to the six-
teenth century.[6] Japanese artistic influence in the West can be traced to the
seventeenth century, when the Dutch East India Company began exporting
Japanese lacquerware and porcelain to Europe. European collectors responded
with a ravenous appetite, and "japan" quickly became the catchword for lac-
quer, just as "china" became synonymous with porcelain. Among the nu-
merous manuals for emulating Japanese methods of production was John
Stalker's *A Treatise of Japaning and Varnishing . . . for Japan, Wood, Prints, Plate, or Pic-
tures*, published in London in 1688. In his preface Stalker wrote:

> We have laid before you an Art very much admired by us, and
> all those who hold any commerce with the Inhabitants of Japan;
> but that Island not being able to furnish these parts with work
> of this kind, the English and Frenchmen have endeavored to im-
> itate them; that by these means the Nobility and Gentry might
> be compleatly furnisht with whole setts of Japan-work.

The manual included copperplate engravings of suggested "Japanese" de-
signs in a style known as *Chinoiserie*: a hybrid aesthetic in which Chinese,

Unknown artist. Untitled (shows wounded warrior drinking from a shallow bowl). Ink drawing, Meiji Period. The Library's collection of Japanese art is rich in original drawings, including this preliminary sketch that may have been intended for a wood-block design. The style is reminiscent of Yoshitoshi's work, especially in the graphic portrayal of the warrior's wound. The ultimate "decadent," Yoshitoshi created a series of prints known as "bloody prints" (*chimagusai-e*) because of their concentration on gore. He also used the same nervous brushstroke to create multiple outlines for his forms. At the base of the image is a separate drawing of a head, carefully shaded in red and black washes.

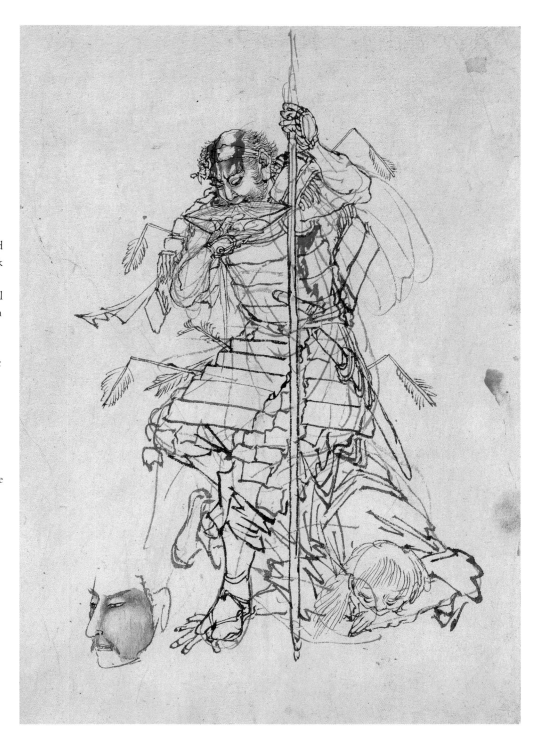

67

John Stalker. Engraving from *A Treatise of Japaning and Varnishing . . . for Japan, Wood, Prints, Plate, or Pictures*, London, 1688.

These design patterns appeared in Stalker's how-to manual for emulating Japanese lacquerware. Early Western interest in Japanese art was based largely on export goods, such as lacquer, porcelain, and textiles. In the preface to his book, Stalker waxes rhapsodic: "Let not the Europeans any longer flatter themselves with the empty notions of having surpassed all the world beside in stately Palaces, costly Temples, and sumptuous Fabricks; Ancient and modern Rome must now give place: The glory of one Country, Japan alone, has exceeded in beauty and magnificence all the pride of the Vatican at this time, and the Pantheon heretofore."

Japanese, and European motifs were swirled together with sheer fantasy. On the connection between *Chinoiserie* and the later phenomenon of *Japonisme*, Siegfried Wichmann has written:

> It has been asserted that chinoiserie—the fashion for Chinese art—merely exploited the charms of the exotic, and that there was no real progress in the understanding of China during that period; this claim also casts its shadow over the study of *Japonisme*.[7]

Fascination with cultural "otherness," or exotica for its own sake runs throughout the long history of visual representation and this impulse is clearly at work in *Chinoiserie* and *Japonisme*. Both were stimulated by a wide array of objects—lacquer, porcelain, textiles, ivory, and jade. It would not be until the nineteenth century that Western attention began to fasten on Japanese graphic art.

Inquiring Eyes and Reportage

U.S. Commodore Perry arrived in Japan in 1853 with a fleet of armed ships and a presidential mandate to open trade with Japan. Responses by the Japanese authorities were mixed; there were those who wanted to oust the Americans and others who wished to develop a relationship with the West. Confronted by a thinly veiled threat of force (Perry was under orders to use threat as a last resort) the Tokugawa government decided not to engage in conflict with the Americans. It was also thought that contact with the West might help Japan in becoming an international power in its own right. By 1858, trade agreements were in place between Japan and five foreign nations, including the United States, Russia, Great Britain, France, and the Netherlands. The following years saw an unprecedented flow of travelers and material goods between Japan and the West, giving rise to artistic cross-fertilization on both sides.

For Japanese artists, the port city of Yokohama became a primary incubator for a new category of images that straddled convention and novelty. Because travel was still restricted for both Japanese and foreigners in Japan, Edo print publishers sent their artists to Yokohama to sketch foreigners in situ. The resulting prints, called Yokohama-e (literally "Yokohama pictures"),

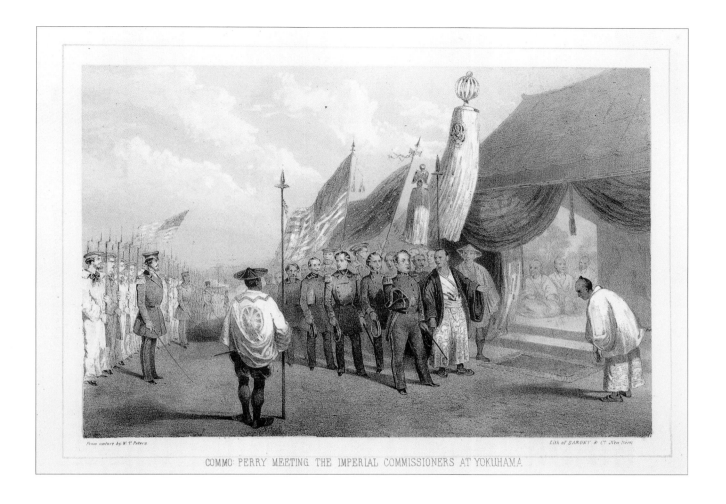

COMMO PERRY MEETING THE IMPERIAL COMMISSIONERS AT YOKUHAMA

were sold in Edo, and also by print vendors in Yokohama.[8] They were often issued in five-panel sets symbolizing the five treaty nations, or six to include China, which was also a longtime trade partner with Japan.

At first glance, Yokohama-e seemed a radical departure from the woodblock-print tradition of Ukiyo-e in terms of subject matter and a general decline in artistry and craftsmanship. However, Yokohama-e and Ukiyo-e shared an essential function, as Julia Meech-Pekarik points out:

> Woodblock prints, which satisfied the demand of the rising masses for an inexpensive art form, had always featured documentary of topical subjects—whether a new Kabuki play, a gorgeous courtesan complete with name and address, or popular beauty spots of interest to travelers. Now foreigners were news and the Japanese eagerly bought their pictures .[9]

68

Commo. Perry Meeting the Imperial Commissioners at Yokuhama, from nature by W. T. Peters. Lithograph of Sarony & Co., New York, 1856. That this image was taken "from nature" suggests that a first-person sketch was the source for this lithograph.

Hashimoto Sadahide. *Yokohama kôeki seiyôjin nimotsu unsô no zu* (Picture of Western Traders at Yokohama Transporting Merchandise). Color woodblock, 1861. Publisher: Yamaguchiya Tôbei. Although Yokohama prints have been widely maligned for not being up to the standards of Ukiyo-e, this image by Sadahide has both technical and artistic strength. Bustle and change are implied by every rippling wave, and the repeated lines of oars, stripes, planks, rigging, and pleats— punctuated by the wave crashing at the base of the ship. While he was sketching the scene this print is based on, the artist is reported to have dropped his brush in the water and borrowed a pencil from a foreigner to continue drawing. This image is part of a pentaptych.

Edo publishers of Ukiyo-e had always been in the business of representing the "here and now" concerns of their subjects and customers, and this became the driving force behind Yokohama-e. Like Ukiyo-e, the primary vehicle for Yokohama-e was the color, wood-block print. Most Yokohama print artists, including Yoshiiku, Yoshikazu, Yoshitora, and Sadahide, had been reared in the traditions of the Utagawa school associated with Ukiyo-e. Brilliant colors were a hallmark of this school, and Yokohama artists took frequent advantage of high-volume aniline dyes to heighten the impact of their images. The Western foreigners were depicted almost as zoological specimens. Bewhiskered men and crinolined women strode through the city, clamored on and off ships, enjoyed local entertainments, and were seen at every turn interacting with an endless array of things. Light fixtures, locomotives, and wine glasses were all painstakingly recorded.[10]

In addition to eye-witness accounts, Yokohama-e often borrowed imagery from secondary sources, such as wood engravings in Western journals and newspapers. At the same time, Western journals offered American audiences reports of their "new neighbors," most strikingly on the occasion of the first Japanese diplomatic delegation to Washington, D.C., in May of 1860. It is telling that 80 percent of all Yokohama scenes were published between 1860 and 1861.[11] The central purpose of the Japanese mission was to ratify the U.S.-Japan Treaty of Amity and Commerce (Harris Treaty) of 1858. Leading the delegation were commissioners of foreign affairs Shimmi Masaoki and Muragaki Norimasa, and intelligence agent Oguri Tadamasa. While in Washington, they met with President Buchanan and visited the nation's capitol, the Library of Congress, and the Navy Yard. They were photographed by Mathew Brady and were portrayed in sketches and wood engravings that circulated throughout the popular press. In June of 1860, *Harper's Weekly* published a wood-engraved portrait of the foreign affairs commissioners along with this account of a ball held in their honor:

> We publish herewith portraits of the two Japanese ambassadors, Sim'mi Boojsen no-Kami, and Mooragaki Awajsi no-Kami. They are the chiefs of the embassy now at Washington, and have just concluded the ratification of our treaty with Japan. We are, of course, unable to give any biographical sketch of these distin-

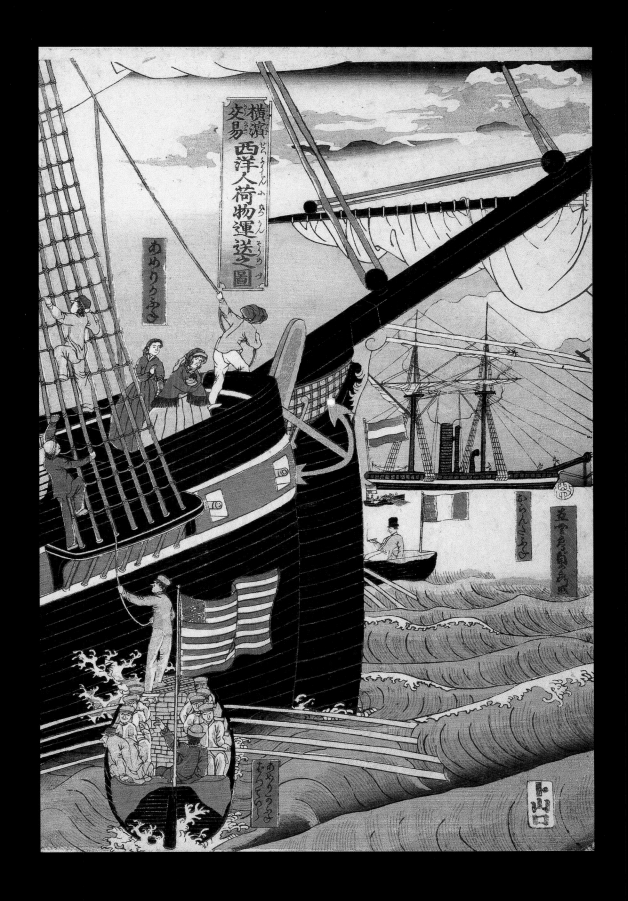

70

Ando Hiroshige (II or III). *Amerika nigiwai no zu* (Picture of Flourishing/Prosperous America). Color woodcut, 1861. Scholar Julia Meech-Pekarik has traced the source for the architecture seen here to an illustration of Fredericksburg Castle (near Copenhagen) in the March 7, 1860, issue of the *Illustrated London News*.

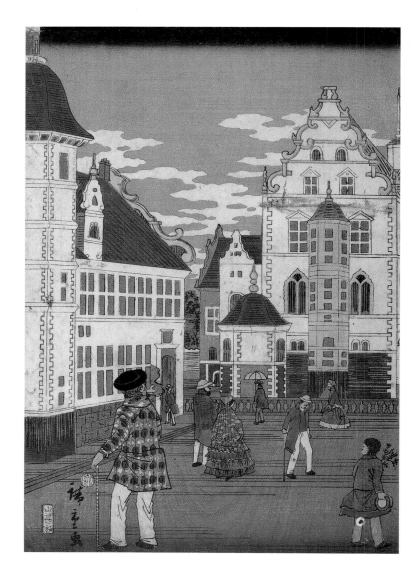

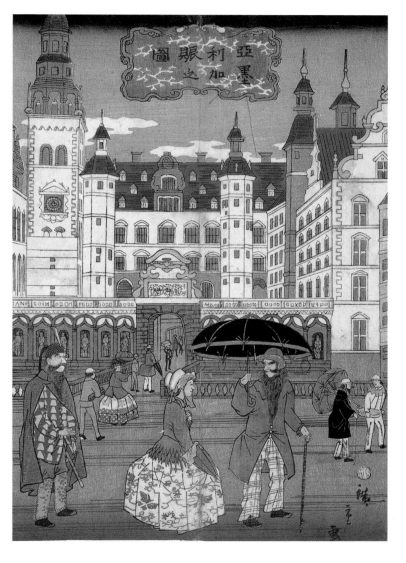

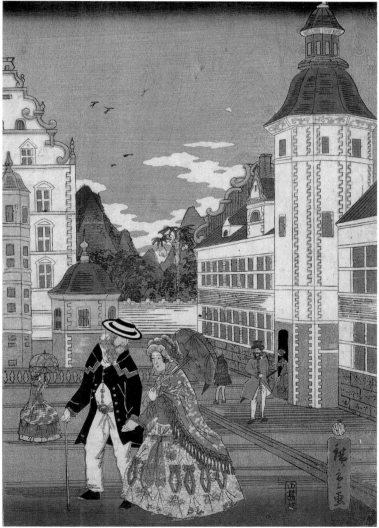

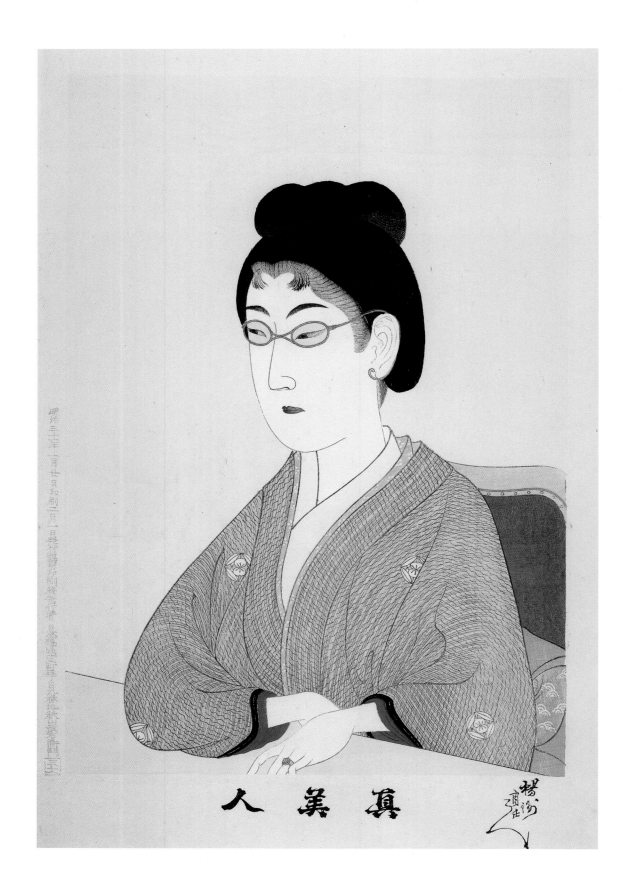

71 (OPPOSITE)

Chikanobu. *Shin Bijin* (True Beauties).
Color woodcut book, 1897. Some artists,
such as Yoshitoshi and Chikanobu,
produced both Yokohama-e and more
traditional Ukiyo-e. For the latter they
tended to stay close to conventional
themes, although their beauties, historical
scenes, and heroes often exhibited a
distinctly Western flavor. Here Chikanobu
blends the Ukiyo-e tradition of beauty
prints with a Western twist, topped off by
the fetching wire spectacles worn by this
beauty. This book came from the library of
William Howard Taft.

72 (RIGHT)

Tsukioka Yonejirô (known as Yoshitoshi).
Yoshitoshi musha-burui: Han Gaku-jo
(Yoshitoshi's Incomparable Warriors: The
Woman Han Gaku). Color woodblock,
circa 1883. Artist, Tsukioka Yonejirô.
Publisher, Tsunajima Kamekichi. Cutter,
Hori-yû. This image combines Meiji and
Ukiyo-e sensibilities. Yoshitoshi's dashing
woman warrior was a historical figure who
lived around the year 1200. She is
considered one of the three woman
warriors of Japan, along with Empress
Jingû and Tomoe Gozen. She lived in the
province of Echigo (present-day Niigata)
and fought (unsuccessfully) against the
Kamakura shogunate. She was sent to
Kamakura for execution, but was instead
saved by a warrior who asked for her to be
spared and took her as his wife.

73

Cover of *Harper's Weekly*, vol. 4, no. 179,
New York, Saturday, June 2, 1860, "The
Japanese Embassadors."

guished persons. They are both members of the Council of Six, who are understood to administer the Government of Japan, and to hold a rank corresponding to that of Prince in Europe. We glean from the daily papers some gossip about their movements at Washington. Speaking of the ball at General Cass's, at which they were present, the *Tribune* correspondent writes:

AT A BALL

The party visiting the Secretary of State was composed of three Princes, and the five officers next in rank, and the two interpreters. For nearly an hour these ten gentlemen sustained unflinchingly the unaverted gaze of as many scores of people as could draw near to them. Their self-possession then, as it always is, was marvelous. The haughtiest stare, with intensest eye-glass concentration, could neither move them to embarrassment nor rouse them to the least defiant glance in return. Directly personal remarks—not always uttered, I am afraid, in the best taste, and sometimes unworthy of the fair lips whence they proceeded—were listened to by those who perfectly understood them with no sign of discomposure, except perhaps a slight compression of the mouth, showing that insensibility was no cause of their immovable calmness.

Accounts by members of the Japanese embassy and sketches from the trip have survived in their diaries, including this account of Secretary of State Cass's ball by Muragaki:

We arrived at Cass's residence. I wondered about the nature of the ceremony we were going to perform on this occasion since it was an invitation from the Prime Minister. To our great surprise, however, we found that the hall, passages, and rooms were all packed with hundreds of men and women. Innumerable gas lamps were hanging from the ceilings, and the glass chandeliers decorated with gold and silver were reflected in the mirrors. It

View of the U. S. Capitol from *Meriken kôkai nikki ryakuzu* (Journal and Sketches from the Voyage to America). Watercolor, 1860. This is thought to be a hand-drawn copy (*shahon*) of an eye-witness sketch made by a member of the Japanese delegation of 1860. The labels in the image identify the subject as "View of Washington from the Harbor" (top center); "The Capitol" (top right); and "Alexandria" (bottom).

Centennial Photographic Co. Philad'a International Exhibition, 1876. *Japanese Vases, Japanese Sec.* Silver albumen stereographic photograph, 1876. When seen through a special viewer, these side-by-side photographs appear three-dimensional. This image focuses on two spectacular, oversized ceramic Satsuma ware urns. World's fairs were important catalysts for the popularization of Japanese style and culture in the West.

Shop interior (filled with Japanese objects including samurai armor, weapons, carvings, lacquer, ceramics and porcelain, dolls, and paintings) from Stillfried and Andersen's *Views and Costumes of Japan by Stillfried & Andersen*. Yokohama, albumen silver photographs with hand-applied watercolor, circa 1877.

was as brilliant and dazzling as day. Though we did not know what was happening, we somehow managed to make our way through the crowd to the room where Cass and his family stood, and were greeted by them. Even his grandchildren and daughters came to shake our hands. Since there was no interpreter around, I did not understand at all what was being said. The crowd was extremely dense. DuPont took my hand and led me to an adjoining room, where a large table was laid with gold and silver ware. At the center of the table were the Japanese and American flags to express friendship. We had some drinks and food at the table. Soon we were led away to another large room; its floor was covered with smooth boards. In one corner, there was a band playing something called "music" on instruments that looked like Chinese lutes. Men were in uniform with epaulets and swords, and women with bare shoulders were dressed in thin white clothes. They had those wide skirts around their waists. Men and women moved round the room couple by couple, walking on tiptoe to the tune of the music. It was just like a number of mice running around and around. There was neither taste nor charm . . . Admittedly, this is a nation with no order or ceremony [*rei*], but it is indeed odd that the Prime Minister should invite an ambassador of another country to an event of this sort . . . The only way to exonerate them is by recognizing that all this absence of ceremony issues from their feeling of friendship.

All is strange
 Appearance and language,
 I must be in a dream-land.[12]

Threads of ambivalence run through much of the visual and textual commentary on all sides, reflecting the complex social and political climate in which these observations were made. On a basic level, the wide range of responses, from admiration to bewilderment, from wonder to repugnance, must have stemmed from the relatively slender margin of shared language and sense-based discovery evident in the artwork of this period.

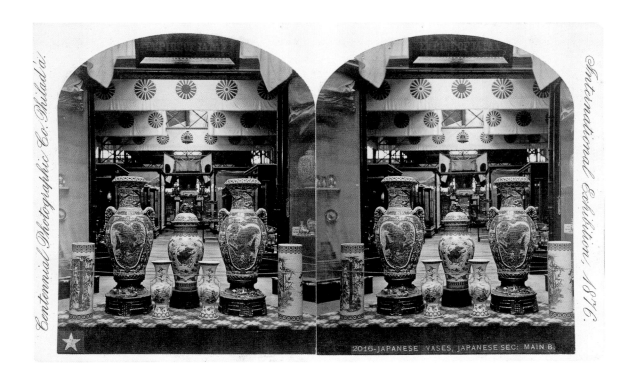

2016—JAPANESE VASES, JAPANESE SEC. MAIN B.

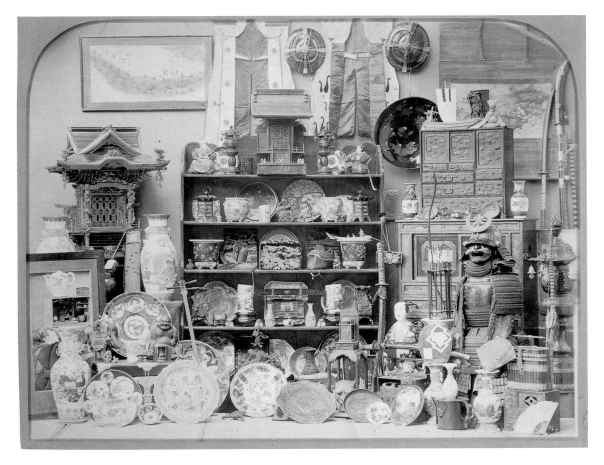

Japonisme *During the Meiji Period (1868–1911)*

The story of Ukiyo-e's influence in the West really begins during the transition from the Edo Period to the Meiji Period and the transfer of power from the Tokugawas to Meiji Emperor Mutsuhito in 1868. Major prongs of the imperial program for "civilization and enlightenment" included consolidation of power, modernization through reform policies and technological development, and promotion of Japan within the international community. These programs would unfold during the golden era of international expositions and world's fairs, ideal venues for the advancement of Japanese culture and commerce. Japanese arts and crafts were major standard bearers in this regard, and graphic art played a major role. Japan mounted displays at the Vienna World Exhibition in 1873, the Philadelphia Centennial Exhibition in 1876, the Paris Universal Exposition in 1878, the Nuremburg International Metalwork Exhibition in 1885, the Paris Universal Exposition in 1889, the 1893 World's Columbian Exposition in Chicago, the Paris International Exposition in 1900, and the Belgian Universal and International Exposition in 1905. During the same time, there were Domestic Industrial Expositions held in Tokyo in 1877, 1881, 1890, and 1907; in Kyoto in 1895; and in Osaka in 1903.

Within Japan, the arts and art education were considered an important part of the government quest for modernization. The government-sponsored Technical Art School was established in 1876 and it was staffed with Italian instructors of painting, sculpture, and architecture. Teachings included the modernization of traditional Japanese art and the introduction of Western methods. In 1880, the Kyoto Prefectural School of Painting was established. Around the same time a widespread reaction against Westernization welled up among many Japanese. Two of the leading proponents of this movement were American professor Ernest Fenollosa and his associate Tenshin Okakura at Tokyo Imperial University. A revival of national pride in traditional arts led to the development of *nihonga*, Japanese-style paintings on paper using water-based pigments. The Tokyo Art School (founded in 1889 and now the University of Fine Arts and Music in Tokyo) focused on instruction in *nihonga* and traditional Japanese techniques. As principal of the school, Okakura continued his advocacy for classical Japanese tradition as well as Western style.

77

Portrait of Beauty from Stillfried and Andersen's *Views and Costumes of Japan by Stillfried & Andersen*. Yokohama, silver albumen photographs with hand-applied watercolor, after 1877. This portrait is evocative of Ukiyo-e *bijin-ga*, or pictures of beautiful women.

Meanwhile, Western exposure to Japanese arts and crafts was stimulating widespread interest and admiration, with France and England leading the way. Paris-based dealers Tadamasa Hayashi,[13] Wakai Kenzaburô, and Samuel Bing were pivotal figures in this movement. Hayashi reported in his record book that between 1890 and 1901 he exported 860 cartons to Paris, including 156,487 prints. These shipments also included 10 picture scrolls, 9,708 illustrated books, 846 paintings, and 97 drawings.[14]

Prints were ubiquitous in Hayashi's inventory, and this was generally true of the Japanese market since they were available in large numbers and at relatively cheap prices. Buyers thronged to importers and "curio" shops that specialized in oriental art and objects—including L'Empire Chinoise and Mme Desoye's in Paris, and Farmer and Roger's Oriental Warehouse (later Liberty and Company) in London. French artist Félix Bracquemond is reported to have seen Hokusai's *Manga* (Hokusai's Ten Thousand Sketches, 1814) at Auguste Delâtre's Paris print shop in 1856, a famous early encounter. American artist John La Farge was another early collector and devotee of Japanese style, and it quickly became the rage to collect, or at least admire Japanese art. Artists, dealers, and literary figures were its most ardent and vocal consumers, among them James McNeill Whistler, William Morris, Edmond and Jules de Goncourt, Charles Baudelaire, and Emile Zola. Fast behind the objects themselves came a flurry of published responses, both popular and scholarly, while at the same time Japanese art was circulating through public exhibitions at museums and art academies.

America was slower to respond, although Perry himself had returned from Japan with gifts of Japanese lacquer, porcelain, textiles, and art in various forms. Francis L. Hawk's 1857 narrative of Perry's journey to Japan commented specifically on Japanese wood-block prints:

> Another example of Japanese art before us is a species of frieze, if we may call it, cut in wood and printed on paper in colors. It presents a row or line of the huge wrestlers of whom we have spoken on a previous page. The chief point of interest in this illustration, considered in an artistic sense, is that, apart from its being a successful specimen of printing in colors—a process, by the way, quite modern among ourselves—there is a breadth and

78

Félix Hilaire Buhot. *Japonisme: Dix Eaux-Fortes*, 1885. This is the title page from a suite of ten etchings based on objects from the collection of French art critic Philippe Burty, who is credited with coining the term *Japonisme* in 1872.

vigor of outline compared with which much of our own drawings appear feeble, and above all things, undecided. Whatever the Japanese may lack as regards art, in a perception of its true principles, the style, grace, and even a certain mannered dexterity which their drawings exhibit, show that they are possessed of an unexpected readiness and precision of touch, which are the prominent characteristics in this picture of the wrestlers.[15]

The flurry of interest sparked by Perry's visit and rekindled at the time of the 1860 delegation, was suspended until after the Civil War and Reconstruction. By then, American audiences had been primed by European regard for Japanese art and with widespread exposure at the 1876 Philadelphia Centennial Exhibition, American *Japonisme*[16] began to catch fire.

Conceptually, *Japonisme* is both tantalizing and problematic, with nearly as many theories about its meaning as physical forms of expression. The term itself was coined by French critic and collector Philippe Burty in 1872, an important advocate for Japanese art during the nineteenth century. From its beginnings, Western *Japonisme* was imbued, to some degree, with an aura of exotica. As we have seen, this was an essential ingredient in many of the works by Japanese artists that portrayed things Western, and this exotic aura was equally apparent when Westerners portrayed things Japanese.

Most scholars agree that commercialism played a key role in the development of *Japonisme*. Gabriel J. Weisberg provides this overarching analysis:

> Japonisme must be situated within the matrix of political and, most notably, commercial history in order to comprehend it as a social phenomenon. This suggestion implies not only that Western nations were eager to find new markets for their products, but also that they quickly learned to capitalize on what Japan had to offer, especially within the domain of art and industry. The West soon took advantage of the budding interests that were fed by the sense of discovering a new and alien culture. This growing fascination was nurtured by importing objects and promoting the taste for the "new" through public exhibitions, sales, gallery displays, and publicity, from simple advertisements to scholarly articles and books. Dealers and man-

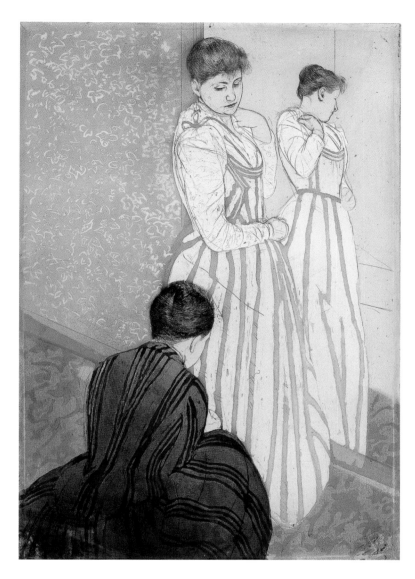

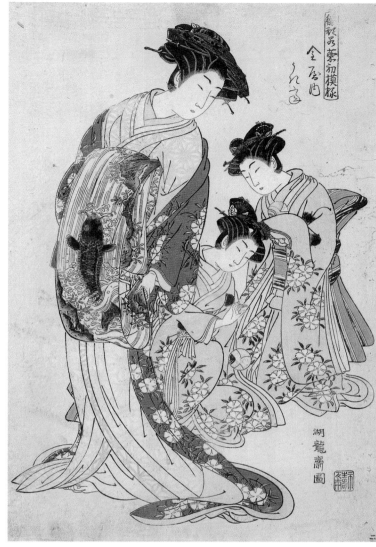

79

Mary Cassatt. *The Fitting*. Color drypoint
and aquatint with monotype inking, circa
1893. After seeing an exhibition of Japanese
prints in 1890 at the École des Beaux-Arts,
Cassatt wrote to her friend and colleague
Berthe Morisot: "Seriously, you must not
miss that. You who want to make color
prints you couldn't dream of anything more
beautiful. I dream of it and don't think of
anything else but color on copper . . . You
must see the Japanese—come as soon as
you can."

80

Isoda Koryûsai (ca. 1764–1788). *Hinagata
wakana no hatsu moyô: Kanaya uchi Ukifune* (First
Designs of the Young Plants, in Pattern
Form: Ukifune of the Kanaya House).
Cassatt's print *The Fitting* bears a striking
resemblance to this composition by
Koryûsai. Cassatt's subject glances over her
shoulder at the woman near the hem of her
dress, while Koryûsai's beauty strikes a
similar attitude above the two young
attendants (*kamuro*) who play behind her.
Both prints are concerned with costume
and fashion.

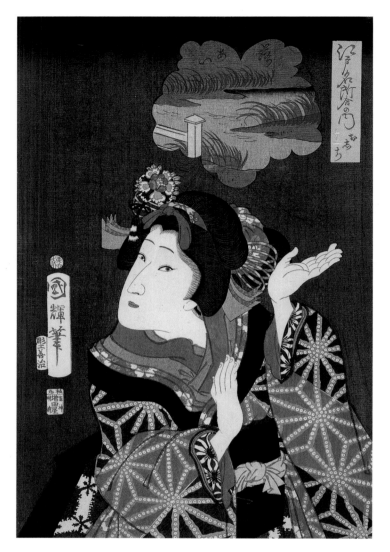

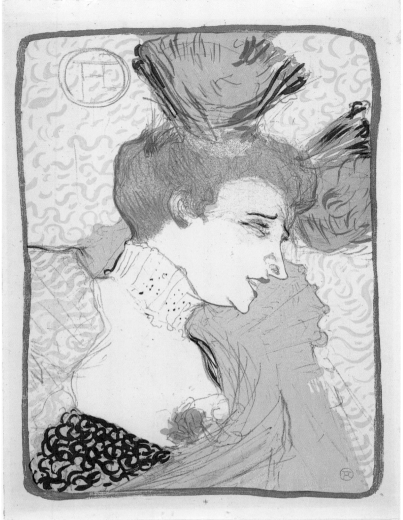

ufacturers encouraged the nascent captivation with the East by supporting Western artists who utilized Japanese art. Commercial interests consistently moved in tandem with purely aesthetic concerns. As the West recognized Japan's importance, so Japan valued the West for its technical and commercial proficiency. Japanese artists and manufacturers, eager to profit from Western enrapture with their art, responded by producing objects specifically for Western markets.[17]

These cultural and commercial exchanges gave birth to a new crop of hybrid forms as *Japonisme* became an essential part of the language used to

develop a number of artistic styles in the West. It inspired the Pre-Raphaelite and Impressionist movements and gave definition to Art Nouveau. By the time the following passage was written by a New York picture dealer, *Japonisme* was a well-entrenched mainstream idea in the West:

> . . . so powerfully have artists, and especially French artists, been impressed by the extraordinary quality of the composition of line and mass which characterizes the works of the Japanese masters, that it is not too much to say that many of the rapidly successive innovations through which Western Art, led by French genius, has passed during the present generation, have been largely due to conscious study of Oriental masterpieces.
>
> (*W. H. Ketcham,* Japanese Color Prints, *1895*)

When Ketcham wrote this, Mary Cassatt had recently created her virtuoso series of intaglio color prints under the direct inspiration of Japanese Ukiyo-e wood-block prints. In looking at Japanese-inspired works by Western artists, it is not always possible to parse out exactly where Japanese inspiration begins and innovation emerges. In the works seen here by Mary Cassatt and Henri de Toulouse-Lautrec, both artists chose asymmetrical compositions and bold design lines reminiscent of "key block" outlining in Ukiyo-e woodcuts. Interestingly, neither chose the medium of the woodblock. Flattened modeling and highly patterned passages are characteristic of much Ukiyo-e. The color palettes for these works are very different from one another, but both suggest different aspects of Ukiyo-e. Cassatt's print shows delicate colors similar to those often used by Ukiyo-e masters Eizan (see 58), Utamaro, and Koryûsai. Cassatt also shares with them a primary concern—the portrayal of women in the course of their daily lives. Toulouse-Lautrec's more robust palette evokes the brilliant colors of Utagawa school artists and the opulence of brocade prints (*nishiki-e*). His lines tend to be calligraphic in a way that recalls brush-applied ink. The depiction of individual actors in close-up was common in Ukiyo-e, and the prints shown here by Kuniteru and Toulouse-Lautrec focus on charismatic actors.

Over time, legions of Western artists have drawn inspiration from Japanese precedents, among them Edgar Degas, Pierre Bonnard, Walter

Utagawa Kuniteru (1808–76). *Edo meisho ai no uchi: Oshichi* (Famous Places in Edo: Ai no Uchi matched to Oshichi). Signed Kuniteru hitsu. Seal of carver Hori Yoshiharu and seal reading *Masudaya hanmoto Shiba myojin mae.* Publisher: The Masuda Shop before the Temple of the Shiba Myojin). This portrait of the incendiary Oshichi includes a vignette image. This type of secondary image called *koma-e,* shows a famous place in Edo known as Ai no Uchi.

Henri de Toulouse-Lautrec. *Mademoiselle Marcelle Lender, en buste.* Crayon lithograph in eight colors, 1895. Like Cassatt, Toulouse-Lautrec was one of the major pioneers of *Japonisme.* This portrait draws on many of the conventions seen in Kuniteru's actor print—the highly stylized pose, bold colors and patterning, and oblique, asymmetrical composition. Toulouse attended Lender's performance as the fandango-dancing Queen Galswintha at the Théâtre des Variétés nearly twenty times, making sketches for a series of paintings and prints including this one, which is one of his masterworks.

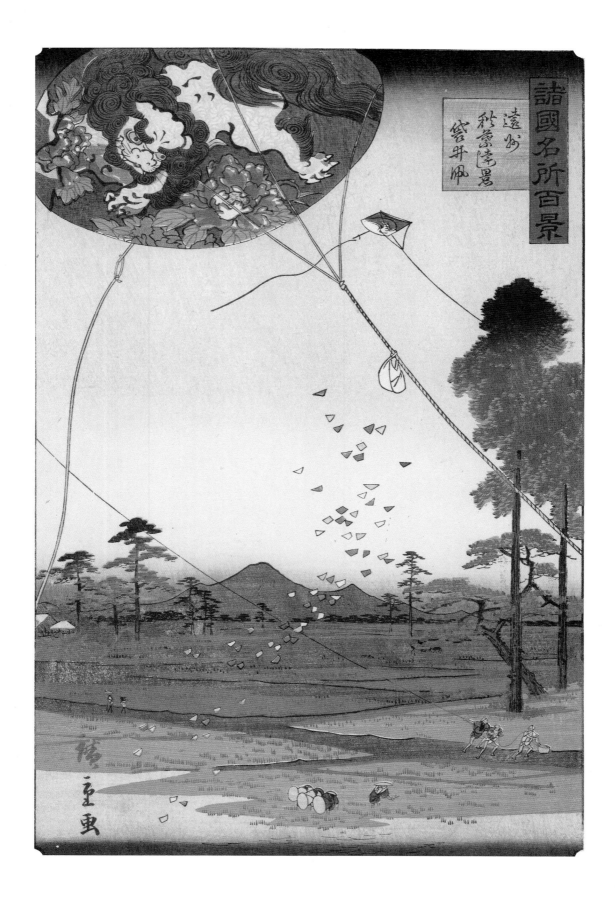

Crane, Paul Gauguin, Félix Bracquemond, Aubrey Beardsley, Helen Hyde, Bertha Lum, Arthur Wesley Dow, Edna Boies Hopkins, and Blanche Lazzell, to name just a few. All are represented in the Library's extensive collections of fine and popular prints, posters, illustrated books and journals, and photographs. Their works show how Japanese style, spearheaded by the graphic art of Ukiyo-e and applied arts and crafts, provided creative infusions that have carried forward into the twentieth century and up to the present day.

Modern and Contemporary Japanese Prints

During the twentieth century, the Library of Congress continued to collect graphic art by modern Japanese artists, including such masters as Azechi, Goyo, Hasui, Munakata, Sekino, and Hiratsuka. Through their work, these artists pioneered the *hanga* movements that dominated Japanese printmaking up through the 1960s. *Shin-hanga* or "new prints" were given their name by publisher Watanabe Shōzaburō in 1915, and they were produced in the time-honored way of Ukiyo-e, with a publisher commissioning designs from

83 (OPPOSITE)

Ichiyûsai Shigenobu, known as Utagawa Hiroshige II (1826–1869). *Enshû Akiba takkei Fukuroi-dako* (View of Akiba and Fukuroi-kite, Enshû) from the series *Shôkoku meisho hyakkei* (A Hundred Views of Famous Places in the Provinces), circa 1859–1864. This image of kite-flying at Enshû (also called Tôtômi) was made by Hiroshige II, the pupil and adopted son of Utagawa Hiroshige (1797–1858). The artist's rendering of a Chinese lion on the large kite in the foreground creates a playful, almost trompe l'oeil effect.

84 (ABOVE)

Bertha Lum. *Kites.* Color woodcut, 1912. *Kites* was published in the December 1912 issue of the *International Studio*, the same year Bertha Lum was the only foreigner to show work in the Tenth Annual Art Exhibition in Uyeno Park, Tokyo.

Hashiguchi Goyo (1880–1921). *Woman after Bath* (The Model Tomi after Bath). Color woodcut with mica ground, July 1920. One of the premier *shin-hanga* (new prints) artists, Goyo was influenced by Kano-school painting and studied at the Hakuba-kai (Western Painting Institute) and the Tokyo School of Art. His interest in Ukiyo-e is clear in this wood-block image, which recalls the work both of Utamaro and Ingres.

the artists, and the actual printing being done by professional carvers and rubbers. *Sôsaku-hanga* or "creative prints" were produced by the Western method, whereby the artist closely followed the design and printmaking process, either personally or through direct supervision. Many lines have been drawn between *shin-hanga* and *sôsaku-hanga* regarding their relative integrity and quality as artworks. However, the creative choices for *hanga* artists were incredibly diverse. Cumulatively, their work ran the gamut of traditional and cutting-edge styles, including abstraction, expressionism, folk and naive forms, and ideas and techniques related to classical traditions in both Japan and the West. Whereas *shin-hanga* often referred back to traditional subjects, such as beauties and landscapes, the overriding concern of *sôsaku-hanga* artists was toward the new and original. Still, Ukiyo-e continued to resonate on a basic level, as Roger Keyes explains: "The hanga artists consciously broke with the past. They rejected the forms and craft of ukiyo-e. But when we look more deeply, we see how much tradition they preserved."[18]

When six *sôsaku-hanga* artists were asked in a 1965 interview what aspects of the Ukiyo-e tradition had value for them, they had this to say:

HAGIWARA: The point that it is closely related with the life of the common people.

KITAOKA: It is true that we have adopted the tools and materials of Ukiyo-e, as they have been handed down to us in their finished state. As for the technique or expression, we owe practically nothing to the Ukiyo-e artists, since modern printmaking started as a negation of this tradition. The techniques used by Ukiyo-e artists are still worthy of study though, for one might yet find methods that can be utilized in the making of modern prints.

KIDOKORO: For me, the only significance the Ukiyo-e has is that the medium is the wood block. Its subject matter is apart from my interest.

TAJIMA: My question is how to deny the Ukiyo-e tradition.

AZECHI: That part of the Ukiyo-e tradition that reflects the feeling of the common people.

YOSHIDA: Only the tradition of its tools and materials has value for me. When considered as a pictorial art, Ukiyo-e has noth-

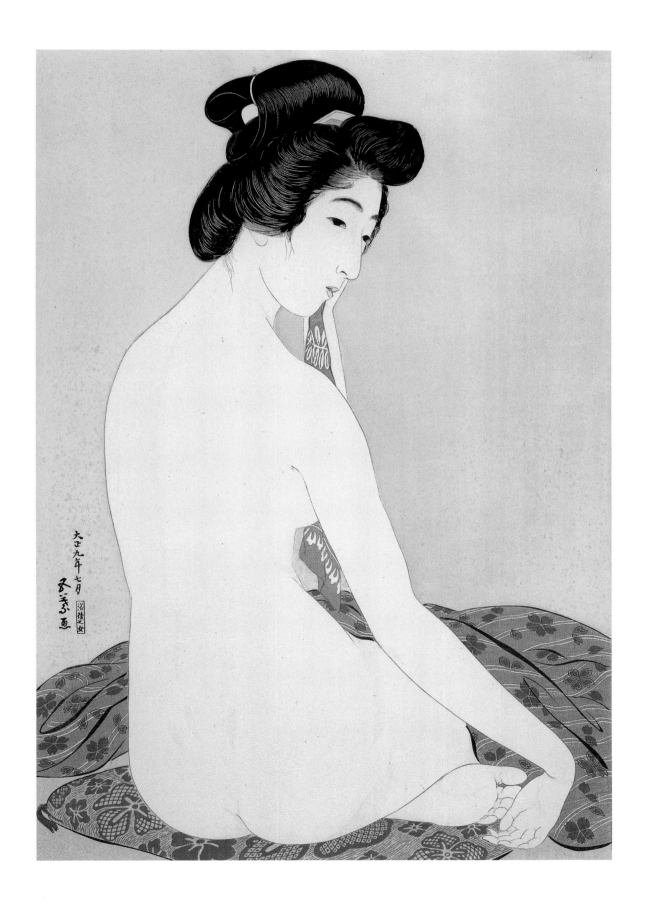

Hagiwara Hideo. *Circus*. Color woodblock, 1959. As a *sôsaku-hanga* (creative prints) artist, Hideo Hagiwara explored abstract forms and experimental printmaking techniques.

Azechi Umataro. *Yamaotoko I*. Color woodblock, 1963. Azechi's naive, folklike forms are also very modern, verging on abstraction. This is another example of *sôsaku-hanga*.

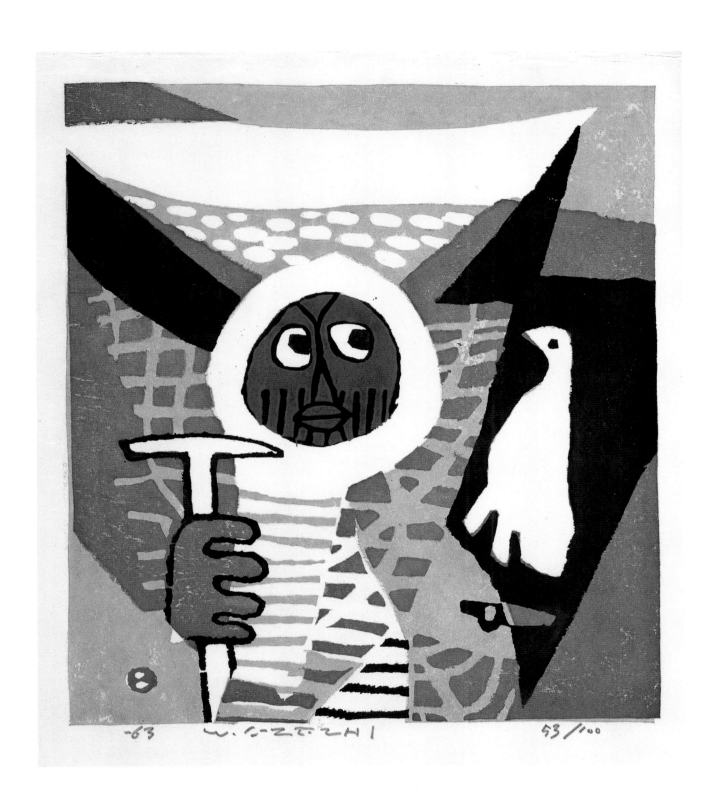

'63 W. OZEKHI 53/100

10/20 Junichiro Sekino

[Objects of the Sea. 195-]

88 (OPPOSITE)

Sekino Jun'ichiro. *Objects of the Sea*. Color woodblock, circa 1950s. This *sôsaku-hanga* still life invokes a multitude of associations including the depiction of shells and sea creatures common in pre-nineteenth-century Japanese art, surrealism, and the treatment of natural forms by such artists as Georgia O'Keeffe.

89 (RIGHT)

Keiji Shinohara. *Imagined Landscape*. Color wood-block monoprint, from an intended series of three variants, 1999. Keiji Shinohara's work, as exemplified in this highly sculptural landscape print, updates and personalizes the spirit of Ukiyo-e. Shinohara first studied the traditional woodcut technique of Ukiyo-e in his native Japan, under renowned printer Uesugi Keiichirô. Unlike Ukiyo-e artists of the past, Shinohara shepherds the creative process through from start to finish and has made each impression of this print unique through variant inking and printing. The result is an image of depth and beauty. Shortly after attaining the status of Master Printer in 1981, Shinohara moved to the United States where he continues to promote the art form through his own work and teaching, and through collaboration with such artists as Sean Scully, Balthus, and Chuck Close. The Library's fine print collection currently includes a superb example of Shinohara's collaborative work with Chuck Close in the 1992 woodcut portrait *Alex*.

ing in common with our work. Nevertheless, if we should take it in a more abstracted sense of the word, such as racial trait in regard to sensibility or feeling, it can be said that Ukiyo-e, as well as other classical arts of Japan, has definite significance.[19]

Today, the collections at the Library of Congress continue to grow, encompassing the glorious past of Ukiyo-e and modern incarnations of its spirit by contemporary creators. The objects in these pages represent just a small sampling of these collections, and it is hoped that they will provide seeds for future research by scholars, students, artists, and historians.

Notes

1. William Green, founder and first president of the Ukiyo-e Society of America, has compiled an extensive bibliography titled *Japanese Woodblock Prints: A Bibliography of Writings from 1822–1992* (Leiden, The Netherlands : Ukiyo-e Books, 1993) that includes substantial sections on collectors and collections, collecting and connoisseurship, reports and reviews of exhibitions, *Japonisme* in the West, and the influence of Western art on Japanese printmaking. Also see Gabriel P. Weisberg and Yvonne M. L. Weisberg, *Japonisme: An Annotated Bibliography* (New York and London: Garland Publishing, Inc., 1990).

2. Ukiyo-e and related collections at the Library of Congress are held in a number of different custodial divisions. The Asian Division is the primary custodian for bound items, such as books and albums; most unbound works are found in the Prints and Photographs Division.

3. Biographical information related to Noyes is available in numerous biographical dictionaries, including *Dictionary of American Biography* (New York: Charles Scribner's Sons, 1928–1936); *Concise Dictionary of American Biography* (New York: Charles Scribner's Sons, 1980); *American Newspaper Journalists 1873–1900* (Detroit: Gale Research Company, 1983); *American National Biography* (New York: Oxford University Press, 1999); *The National Cyclopaedia of American Biography*, vols. 5 and 28 (New York: James T. White & Co., 1891 and 1940); and *Who Was Who in America*, vol. 1, 1897–1942 (Chicago: A. N. Marquis Co., 1943). Another good source of biographical information is "Crosby Stuart Noyes: His Life and Times" by his grandson, Newbold Noyes, published in the *Records of the Columbia Historical Society of Washington, D.C.* in 1940.

4. Quote from the *New York Tribune*, February 22, 1908, p. 7.

5. *Annual Report of the Librarian of Congress* (Washington, D.C.: Library of Congress, 1906).

6. Many scholars have explored the complex history of artistic encounters between Japan and the West, including Chisaburo Yamada in "The Exchange of Influences in the Fine Arts Between Japan and Europe," published in *Japonisme in Art: An International Symposium*

(Tokyo: Committee for the Year 2001 and Kodansha International Ltd., 1980).

7. From Siegfried Wichmann's *Japonisme: The Japanese Influence on Western Art Since 1858* (New York: Thames & Hudson, 1999).

8. The Library of Congress holds more than two hundred Yokohama prints, most of which were given to the Library in 1930 by Mrs. E. Crane Chadbourne. The Prints and Photographs Division has created an item-level finding aid for the Chadbourne Collection.

9. From Julia Meech-Pekarik's *The World of the Meiji Print: Impressions of a New Civilization* (New York: Weatherhill, 1986), pp. 13–14.

10. Among the novelties the Westerners introduced to Yokohama were the first gas lights, a railway, a daily newspaper, and a Western brewery.

11. From Meech-Pekarik's *The World of the Meiji Print*, pp. 13–14.

12. Quoted from: Masao Miyoshi, *As We Saw Them: The First Japanese Embassy to the United States* (Berkeley: University of California Press, ca. 1979), p. 71.

13. The collector's seals of Hayashi and/or Wakai appear on a number of prints in the Library of Congress collection.

14. Segi Shinichi, "Hayashi Tadamasa: Bridge Between the Fine Arts of East and West," in *Japonisme in Art: An International Symposium* (Tokyo: Committee for the Year 2001 and Kodansha International Ltd., 1980).

15. Francis L. Hawks, *Narrative of the Expedition of an American Squadron to the China Seas and Japan, Performed in the Years 1852, 1853, and 1854, under the Command of Commodore M. C. Perry, United States Navy, by Order of the Government of the United States, Compiled from the Original Notes and Journals of Commodore Perry and His Officers, at His Request and under His Supervision* (New York: D. Appleton and Company, 1857), p. 528.

16. Julia Meech-Pekarik and Gabriel P. Weisberg, *Japonisme Comes to America: The Japanese Impact on the Graphic Arts 1876–1925* (New York: Abrams, 1990) is a valuable resource on this subject.

17. Gabriel P. and Yvonne M. L. Weisberg, *Japonisme: An Annotated Bibliography*, p. xi.

18. Roger Keyes, *Break with the Past: The Japanese Creative Print Movement, 1910–1960* (San Francisco: Fine Arts Museum of San Francisco, 1988), p. 14.

19. Ronald G. Robertson, *Contemporary Printmaking in Japan* (New York: Crown Publishers, 1965), p. 114.

鞦 腰成

遠の脚まき女

や〳〵遠〳〵

わつゝけるる

ちのゝ鞦ひ

石燈樓

庭住

惟一枚なられふを殺は

あふ玉の年のゆよ

かるかんさ

杉旭舎

撑蛤玉の

えこし

くちぬこ成

さ〳〵

かう斈

もゝ京

もゝの雑ひ

蓬莱

英信

画

THE PORTFOLIO

This portfolio illustrates some additional important Japanese wood-block prints and drawings. It provides a look at some very famous works and a significant new discovery, and includes a few rare or unusual prints. The particularly strong holdings that the Library has in the late Utagawa tradition are represented by works chosen for their visual power. Also shown are a *surimono*, some Yokohama-e, a Russo-Japanese War print, and a modern Japanese print.

Horai Hidenobu (active 1805–1825). Hair Ornaments and Toilet Articles. Signature: *Horai Hidenobu ga.* This *surimono* was a picture calendar. This print is very similar to a print in the Chester Beatty Library. Roger Keyes classifies the print in the Chester Beatty Library, Dublin, Ireland, as an elaborate copy, made in the early 1890s, often mistaken for the original *surimono* printed in 1818. However, having said that, this print has wonderfully delicate pressed lines and an elegant gradation of colors.

Torii Kiyonobu I. Courtesan Painting a Screen. Known from examples in the Art Institute of Chicago, the Riccar Museum of Art in Tokyo, and many other collections, this famous print is the frontispiece of a set of twelve erotic prints, the last sheet of which gives the date 1771 and the publisher Takeda Chôemon of Dobôchô in Yokohama. The print bears the signature and seal of Kiyonobu on the screen painting in the print.

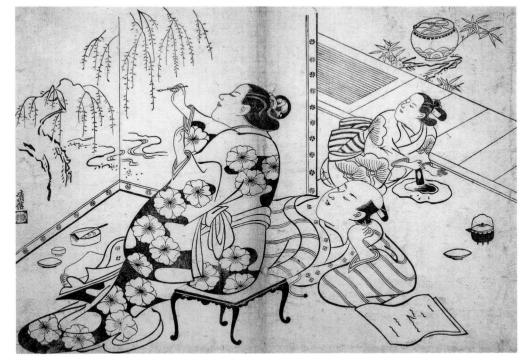

Katsushika Hokusai. *Hyaku monogatari* (The Hundred Ghosts). Although titled The Hundred Ghosts, this work consists of five *chûban* prints. The Library has all five. They are among Hokusai's rarest and best-known works.

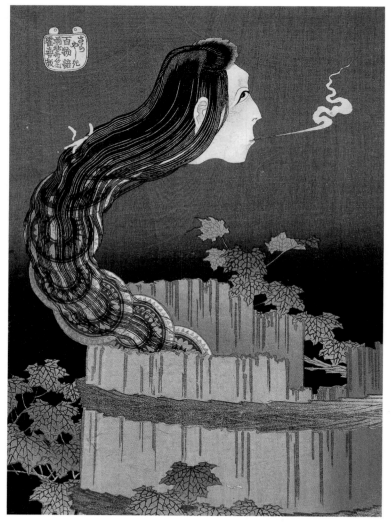

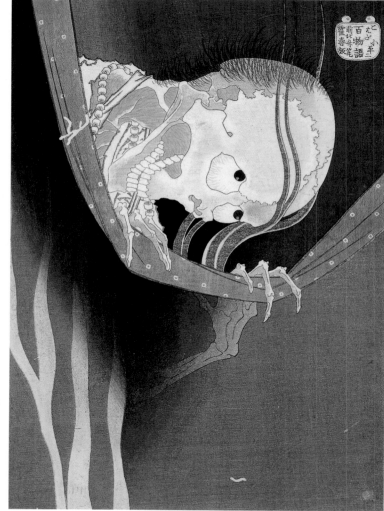

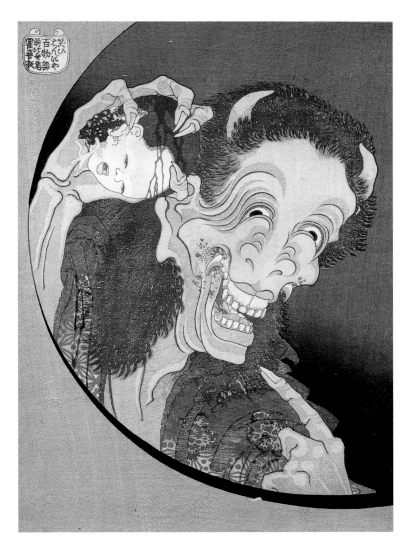
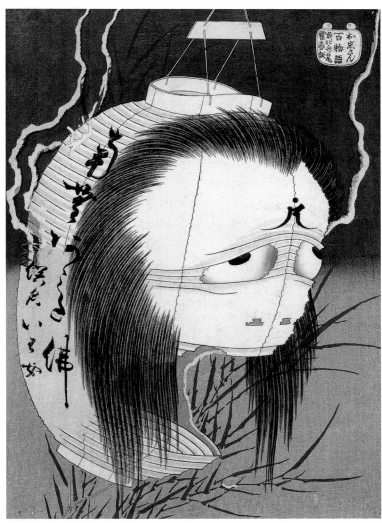

96 AND 97

Utagawa Hiroshige. The Hiroshige Albums. These two albums in the Library of Congress feature examples of Hiroshige's poetic vision of the Japanese landscape. In addition to his mastery of landscapes, the brushwork in these albums also demon-strates his ability to portray characters from Japanese history and folklore, famous roles from the Kabuki stage, and scenes of everyday life. The album leaf reproduced here represents the side of Hiroshige as the landscape artist who depicted the beauty of Japan through the eyes of the traveler, as opposed to the Edoite who portrayed the courtesans and actors of the Floating World. In the illustration, a solo boatman poles his raft down the Hozu River past cherry trees in full bloom that appear to float cloudlike above the river. Down-stream, a woman, parasol in hand, leads a child as they cross the Togetsu Bridge in Arashiyama. A sense of serenity envelopes the scene even as the characters hurry about their business. It is Hiroshige's ability to convey the atmosphere of a scene, whether in a crowded Kabuki theater or drifting down a river admidst the splendor of blossoming cherry trees, that marks his genius.

98 AND 99

Unknown. Book of Drawings. A very important find in the Crosby Stuart Noyes Collection is a delightful group of approximately sixty drawings. The drawings are all similar in size, measuring approximately 10 1/2 (height) by 7 1/2 (width) inches, and bear discoloration, holes, and the remnants of page numbers that indicate they were once a book. We do not know who did the drawings, although they are reminiscent of Hokusai and his students.

Utagawa Kuniyoshi. *Meiyo migi ni teki nashi Hidari jingoro* (The Famous, the Unrivalled Hidari Jingoro). The title of this print, which appears in the box in the upper right, involves a pun. The phrase for "unrivalled" literally means that there is no enemy on the right, which plays against the name of the famous left-handed carver Hidari Jingoro. He was a Buddhist sculptor, involved in the Tôshôgû project that produced this temple to the deified Tokugawa Ieyasu. In this triptych, Kuniyoshi may be showing himself as Jingoro since the sculptor has the artist's flower seals on his robe and cushion. The cat in the scene is also a reference to Kuniyoshi, who was known for drawing cats. In addition, the sculptures around him are thought to bear the faces of well-known Kabuki actors, some of whom Kuniyoshi showed in his other prints. For instance, he put the faces of actors that he showed in other prints on images of Otsu-e that he showed coming alive in his portrayal of Ukiyo Matabei, the so-called founder of Ukiyo-e.

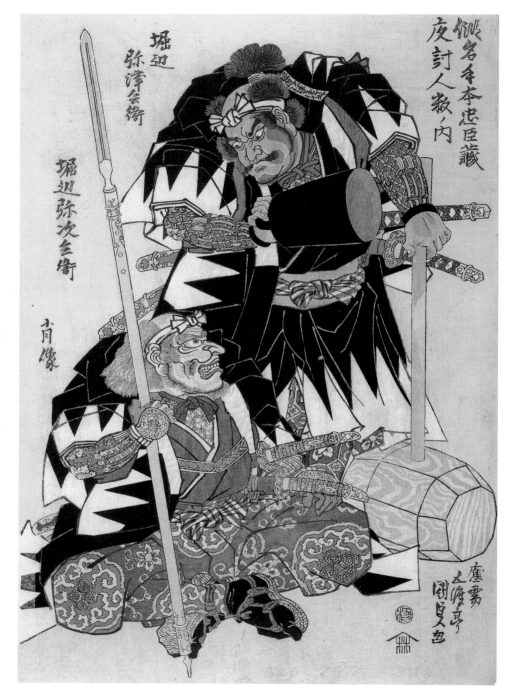

Utagawa Kunisada, *Kanadehon chûshingura: youchi ninzu no uchi* (A *Kana* Version of the Tale of the Storehouse of the Loyalties: The People Involved in the Night Attack). Signed: *Motome ni oji Gototei Kunisada ga* (Painted by Kunisada, On Request). Utagawa Kunisada specialized in actor prints. He won the Toyokuni name in recognition of his superb technical skill and achievement. Labels state that this work has portraits of Horibe Yatsubei (Yasubei) and Horibe Yajibe. Powerful themes of loyalty and revenge make up the classic tale of The Storehouse of the Loyalties, which was first produced for the puppet theater and is based on events which occurred in 1701. A young, inexperienced lord named Asano fails to bribe an official named Kira, who provokes Asano until, enraged, he draws his sword. Asano is ordered to commit *seppuku*, suicide, as a result of his improper actions. Forty-seven of his loyal band of retainers, now *ronin*, or samurai without a master, bide their time until they are able to attack Kira's mansion and behead him, avenging their master's death. Here we see two *ronin* dressed in the black-and-white patterned robe which has traditionally been used to identify them as Asano's retainers. One holds up a black lantern, ready for the night attack. He also holds an enormous mallet with which he will break into Kira's mansion. The forty-seven *ronin* were to be executed for the crime they committed this night, but in recognition of public sympathy for them, were allowed to commit *seppuku* instead.

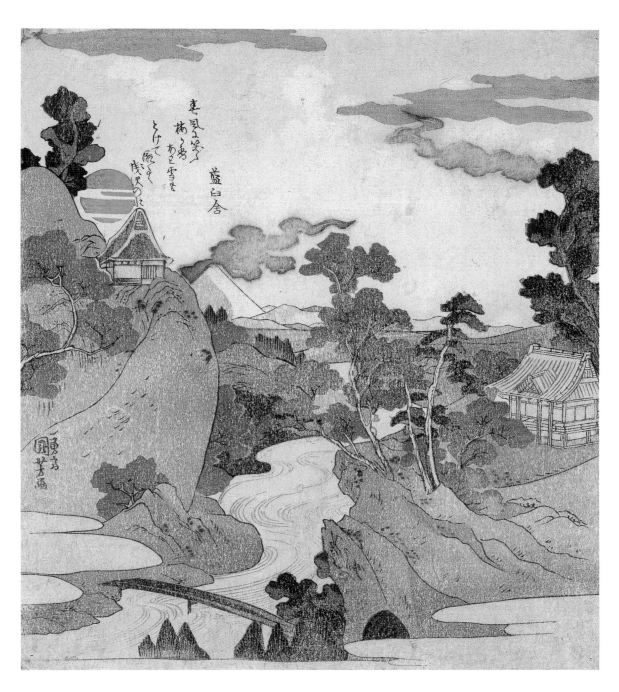

Utagawa Kuniyoshi. The Stream of
Asazawa in Spring 1828. Signature: *Ichiyûsai
Kuniyoshi ga* (Painted by Ichiyûsai Ku-
niyoshi). Kuniyoshi produced several *suri-
mono* after 1828, including this view of Mt.
Fuji from the hot springs at Hakone. The
poem reads: In the spring wind/There is

the scent of the laughing plum/The soft
snow melts to be/The waters of the
Asazawa. This print exists in two states. The
print in the Library is the same as that in
the Merlin C. Dailey collection. It has a
poem to the right. The other is darker in
color and has different shaped clouds in the
sky. An example is in the Springfield Mu-
seum of Art, Springfield, Massachusetts.

The Springfield print does not have the
poem. The composition of this print shows
both traditional Japanese and Western influ-
ence. The print is traditional in the white
horizontal clouds covering the foreground,
which are like standard Tosa-school clouds.
By contrast, the rhythm of the clouds
higher in the sky and the chiaroscuro on the
hills are quite Western in style.

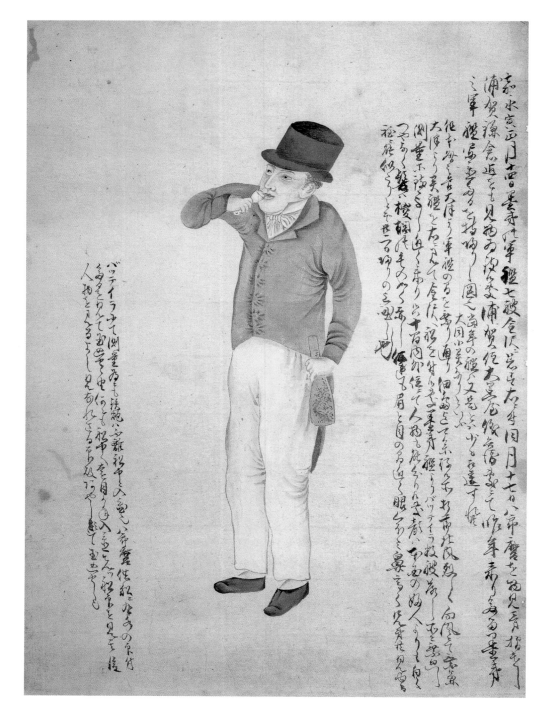

Anonymous. [American Sailor Drinking]. This work bears a long, very significant inscription that describes Perry's visit from the Japanese point of view. It tells how one Hachiromaro saw the American fleet on January 1, 1854, noting how the Americans were "so much alike that one would have thought them to be brothers." It also notes how, when approached, the Americans "did not take their hands off their guns" and how when "our markings were not familiar to them...they must have become suspicious and loaded their guns."

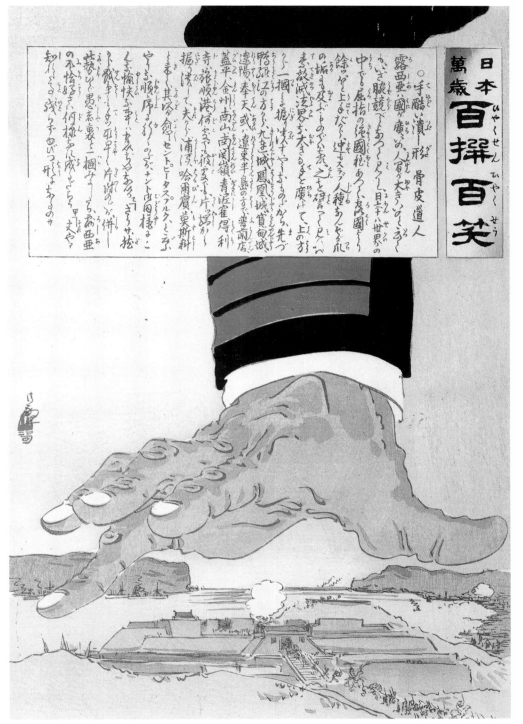

104

Kobayashi Kiyochika (1847–1915). The Ruthless Crusher, July 25, 1904, from the series Long Live Japan: One Hundred Selections, One Hundred Laughs. Color wood-block print. Historian Henry D. Smith II says the title of the series is a pun on "One Hundred Battles, One Hundred Victories," the two phrases being homonyms in Japanese. In the series, Kiyochika depicts comic, but imperialistic views of late-nineteenth- to early-twentieth-century Japanese wars. Such images flourished during the war with China in 1894 to 1895 and were revived during the war with Russia in 1904. Kiyochika published over sixty comic views of the Russian war. According to Smith, when this print was published, the Japanese were filled with confidence and considered the war a laughing matter. The picture shows a huge Japanese hand crushing Port Arthur.

Tsukioka Yoshitoshi. This Yokohama-e
bears the title *Furansu Eigirisu sanpei daichôren
no zu* (Picture of Grand Maneuvers by the
French and English). Censors' seals on the
print in the Library establish it as an 1879
variant by a different publisher of a work
that first appeared in 1867 to 1868 under a
slightly different title.

Ikkesai Yoshiiku. *Gokakoku gankiryô ni okeru sakamori no zu* (Picture of a Drinking Party among People of Five Countries at the Gankiryô Tea House). This triptych depicts foreigners drinking at the Gankiryô Tea House. The Gankiryô was a famous pleasure-seeking place for foreign merchants in Yokohama, scenes of Westerners partying in a Japanese setting becoming popular after the arrival of Perry in 1853 and the treaty between the United States and Japan of 1858. The treaty provided for the opening of Yokohama. England, France, Russia, and the Netherlands also gained the same treaty concessions. These four nations, along with the United States, are often referred to as the Five Nations, and the people of these five nations were often depicted in Yokohama-e. The popularity of prints depicting people of the Five Nations may reflect the curiosity of the Japanese towards outsiders, a reflection, in turn, of the importance outsiders have in Japanese folk religion and myth. Beauties and actors appearing in Ukiyo-e are also figures outside the reality of daily life. Sometimes Chinese were included in pictures of the Five Nations. Here a Chinese, labelled "Nankin," is in the centerpiece of the triptych, wearing black and making some kind of kung fu-like gesture. The word "Nankin" or "Nanjing" is often used to indicate people from China in depictions of the Five Nations. Besides the Chinese and Westerners appearing in the print, there are two Japanese courtesans and some children in the party.

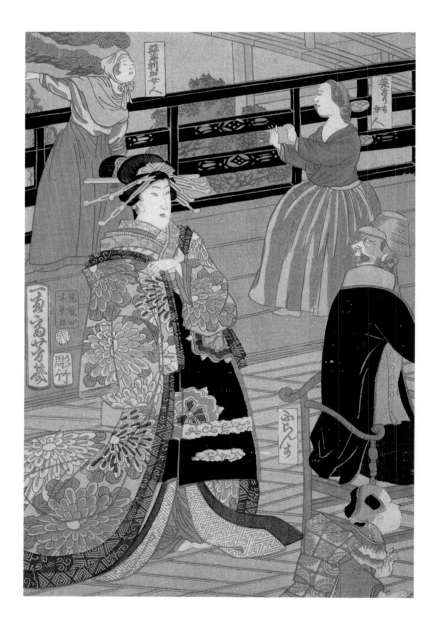

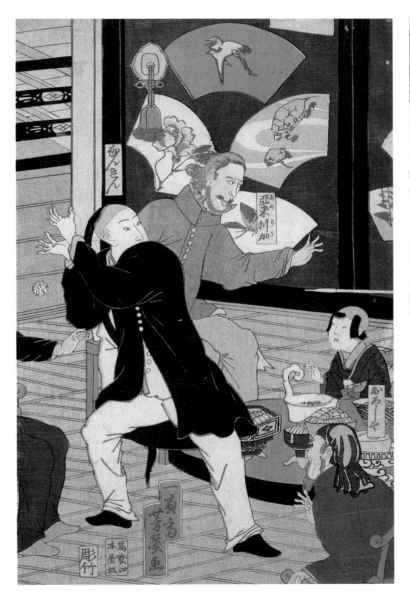
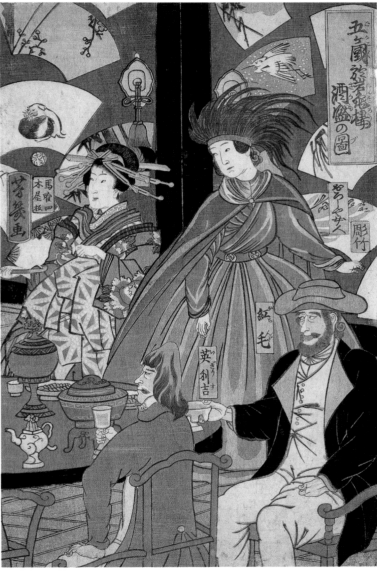

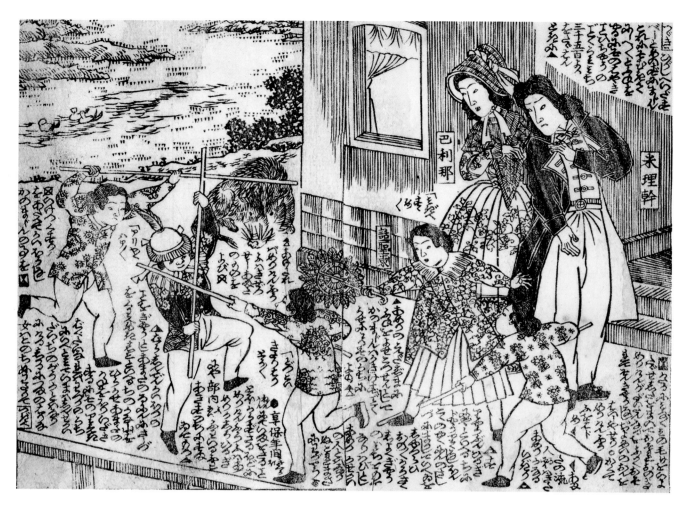

107

Utagawa Yoshitora (fl. ca. 1850–1880).
Scenes of the Life of George Washington.
Another surprising example of Japanese
knowledge of the West is prints about
George Washington, such as this one by
Utagawa Yoshitora. He, like his famous
contemporary Yoshitoshi, was a student of
Kuniyoshi. A man of Edo, Yoshitora is not
known to have traveled outside Japan.
Notwithstanding his lack of personal
knowledge of the West, Yoshitora made
many images of foreigners, foreign places,
or foreign things. He is believed to have
based these on Western engravings.

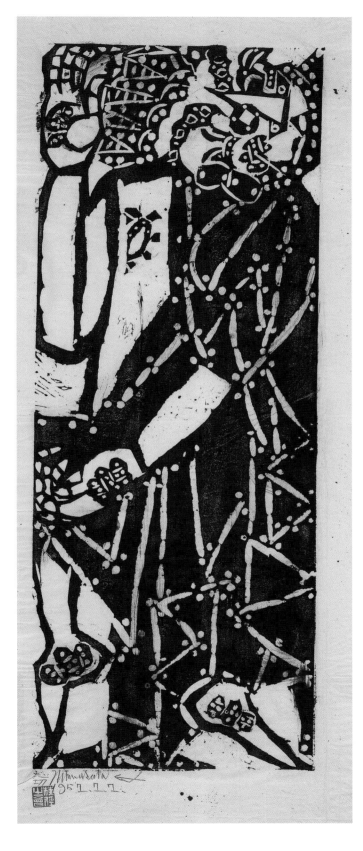

Munakata Shiko. Untitled from the series The Twelve Apostles of Jesus, 1953. Munakata Shiko's famous black-and-white prints always contain religious or literary narratives. However, the stories never dominate him. Instead, he recreates them on the woodblock in an improvised and expressionistic manner. Munakata carves his designs directly on the block with a knife, working as a painter does with a brush on canvas. Here he does a Christian theme. In *The Way of the Print* (1956), Munakata notes that he had no particular knowledge of Christianity, having only discussed the religion with his friends and read a Bible that his children had around. However, he states that he thinks there is something of Leonardo Da Vinci's *Last Supper* somewhere in this work. He also notes that he was disappointed in the Twelve Apostles of Jesus, making only three or four that took his fancy. But these prints, he says, did have something not in his earlier The Ten Disciples of Buddha (1939) and The Sixteen Gods and Goddesses (1941), a "solidity of composition and an enjoyable decorativeness." Indeed, the simple, angular, and powerful figures of the earlier sets have become decorative, rhythmic, and humorous in this particular series. Munakata also notes how he randomly named two of the prints Peter and John when he later submitted them to international exhibitions.

Toyohara Chikanobu et al. *Scroll of Actors*
(details). This is an unusual example of a
set of twenty prints mounted onto a hand
scroll.

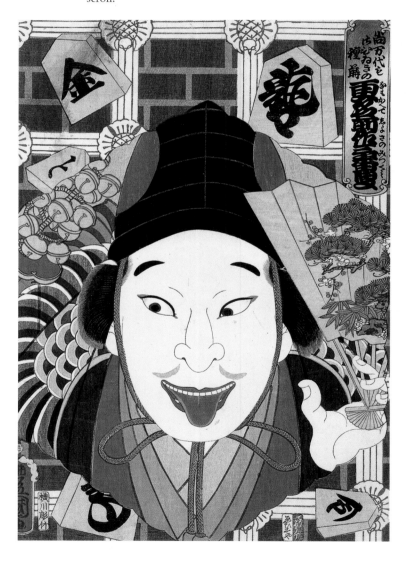
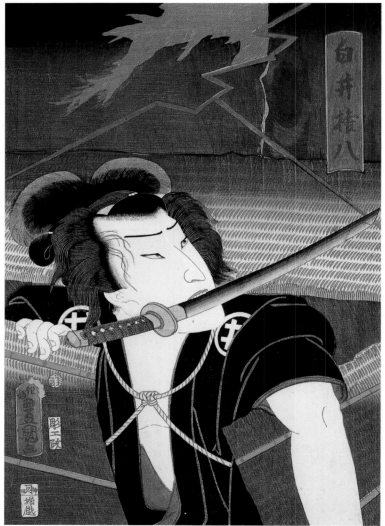

174

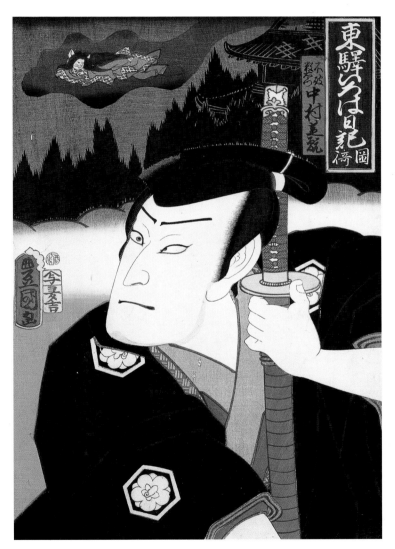
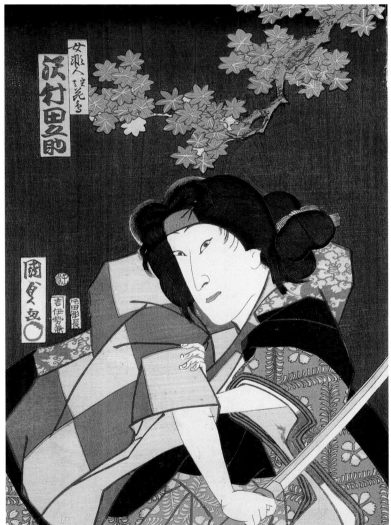

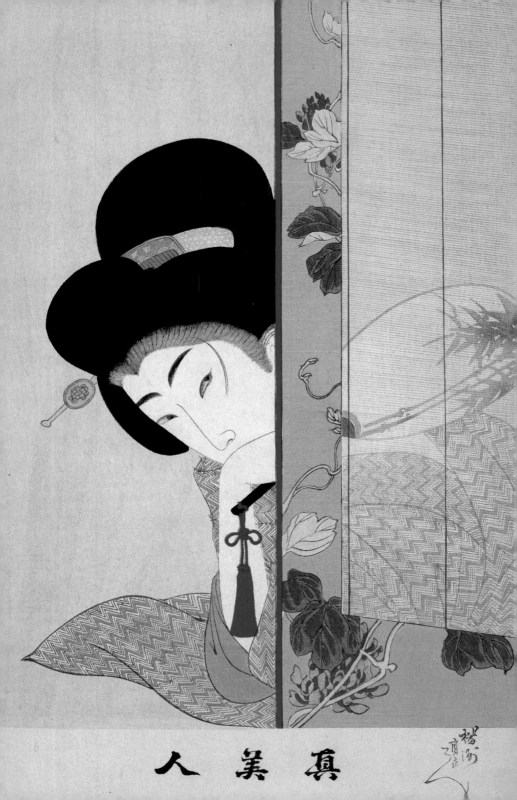

真美人

PRE-MEIJI (1868-1911) BOOKS ON ART
IN THE LIBRARY OF CONGRESS

An Annotated Bibliography

SANDY KITA

HONDA SHÔJÔ

*I*n 1905, Crosby Stuart Noyes, owner of the *Washington Star*, donated his extensive personal collection of Japanese art and books to the Library of Congress. This collection is called the "Noyes Collection." The Library divided the collection between books and loose-leaf prints. The books are housed in the Japanese Section of the Asian Division and the prints are in the Prints and Photographs Division. The offices of the Japanese Section are located in the Thomas Jefferson Building with stacks in the Adams Building. The Prints and Photographs Division is located in the James Madison Building.

The works listed in this bibliography number 309 titles. These consist of wood-block-printed books and freehand drawings. The bulk of these materials date from the middle of the eighteenth century to the end of the Meiji Era (1868–1911). This bibliography focuses on works about art, although some literature, history, and other subjects have been included, either because they are so fully illustrated as to qualify as art books or for some other reason that links them to the art works.

This bibliography provides an initial look at these materials and is only an introduction into the rich collection in the Library of Congress. Complete bibliographical information in English and Japanese and the location of the web site for the collection are available through the Japanese Section, Asian Division, Library of Congress, (202) 707–5430.

Where titles are uncertain, they appear in brackets. Reference is made to the following sources: Matthi Forrer, *Eiryakuya Toshio*: Publisher at Nagoya, J. C. Gieben Publisher, Amsterdam: 1986; H. Kerlen, *Catalogue of Pre-Meiji Books and Maps in Public Collections in the Netherlands*, J.C.Geiben Publisher, Amsterdam, 1996; C. H. Mitchell, *The Illustrated Books of the Nanga, Maruyama, Shijô, and Other Related Schools of Japan: A Bibliography*, Dawsons Book Shop, LA, CA, 1972; Kenji Toda, *The Ryerson Collection of Japanese and Chinese Illustrated Books*, Art Institute of Chicago, Chicago, IL, 1931; Richard Lane, *Images from the Floating World: The Japanese Print*, Dorset, New York, 1978. Standard sources such as *Kojien, Kokusho so mokurou*, and *Nihon gakka jiten* were also used and there is occasional reference to Laurence P. Roberts, *A Dictionary of Japanese Artists*, Weatherhill, New York, 1976, and *A Dictionary of Japanese Art Terms*, Tokyo Bijutsu Co., Ltd., Tokyo, 1990.

A special problem is presented by the Japanese method of indicating three-volume sets with the characters *jô* (upper), *chû* (middle), and *ge* (lower) and two-volume sets, with *jô* (upper) and *ge* (lower). This means that a volume marked *ge* can be either the second or third volume of a set. For this reason, the terms *jô, chû,* and *ge* are not translated.

110

Chikanobu's *Shin bijin* (True Beauties), color woodcut book, 1897

1

Akegarasu sumie no uchikake (No translation). The Library has volumes 5 and 6 of this popular novel written by Ryûtei Tanehiko and illustrated by Nisei Kunisada, or Kunisada II (1823–1880). The work was published in Edo from blocks owned by Tsutaya Kichizô. Volume 5 appeared in 1862 and volume 6 in 1863.

2

Azuma nishiki-e (Full-color Prints). This book consists of eighty-nine single-color, wood-block- prints, one diptych, three triptychs, and one set of five prints, all bound together.

3

Banbutsu hinagata gafu (An Art Book of Miniatures of All Sorts of Things). These four black- and-white wood-block-printed books are by Sensai or Eitaku (1843–1890). Eitaku was once official painter to the Ii clan of Hikone. He lost his position upon the assassination of his master, became a wanderer and eventually an illustrator for the *Yokohama Mainichi Shinbun* (The Yokohama Daily Paper). This book was published by Etô Kihei in Tokyo across a range of time and it consists of miniature illustrations of scenery, figures, animals, and other things. The Library has volumes 2 to 5, dated 1880–1882. H. Kerlen knew the work as *Sensai eitaku senga banbutsu hinagata gafu.*

Banbutsu zukai isai gashiki
See *Isai gashiki*

4

Banshoku zuko (Design Manual). This work by Katsushika Taito or Hokusai was published in Edo by Suwaraya Shinbei and in Osaka by Kawachiya Mohei and one other pubisher. It is a compilation of designs for craftsmen to use as source book. The Library has three volumes of the work. Volumes 1 and 5 of the sets in the Library of Congress are later reprints *(atozuri)*. Volume 2 is the 1898 edition.

5

Banshoku zushiki (A Design Manual for Artisans). This black-and-white wood-block-printed book compiled by Noda Fumiyuki was published by Sanyûshoro in Kyoto. The publication date is not given. The work is a collection of miniature designs of birds, flowers, scenery, and other things for the use of craftsmen. The Library owns only the *chû* volume.

6

Beisen man'yû gajô (Sketchbook of Beisen's Travels). Kubota Beisen (1852–1906) went to Paris to see the World's Fair of 1889. As he travelled, he sketched the scenery that he saw. The Library has one fascicle of the multivolume set of wood-block-printed books of sketches that he made and which Tanaka Jihei published in Kyoto in 1889. The work in the Library consists solely of depictions of Chinese scenery.

7

Bijutsu sekai (World of Art). This wood-block-printed work was compiled by Watanabe Shôtei and published by Wada Tokutarô in Tokyo between 1889 and 1890. C. H. Mitchell (p. 223) notes a *Bijutsu sekai* published in Tokyo, 1891–1894, in his bibliography. The Library work is a collection of reduced-size, wood-block-print reproductions of paintings by prominent Edo artists. They show various printing techniques, including *karazuri* (gauffrage) and *tsuyadashi* (lacquering). The Library owns numbers 1–3, 8–11, 14, 17,18, 20, 23–24.

8

Bijutsukai (A Sea of Art). Yamada Geisôdô published this wood-block-print book by an unknown artist in Kyoto in 1896. The work is a collection of designs to be used in dyeing fabric and it may be a sample book. The Library has only volume 7.

9

Bikô zukan (Mirror of Beautiful Craft Work). Torii Matashichi published these two wood-block-printed books in Kyoto in 1894. The work is a collection of designs for *nishijin*, the kind of rich fabrics that were named after the area of Kyoto where they were produced. It was possibly meant to serve as a sample book. The Library owns the complete set of two books.

10

Boku-ô shinga (New Paintings by Ôoka Shunboku). *Tsunogaki* states *Wakan koji* (Ancient Chinese and Japanese Events). These five wood-block-printed books by Ôoka Shunboku (1680– 1763) illustrate Japanese and Chinese myths *(shinwa)*, traditional stories *(densetsu)*, and tales about heroes, wise men, philosophers, priests, and poets. Nishimura Genroku of Edo and Tsurugaya Kyûbei of Osaka published the work in 1753. Shunboku is the artist of the famous *Minchô seido*, one of the rarest of all Japanese color-print books. He never used the name

Boku- ô. Rather this name is a combination of the last character of Shunboku and o, the word for old. Thus, Boku-ô means Old man Shunboku. The Library has the complete set of five books.

Bokusen soga
See *Shashingaku hitsu*

11

Bunchô gafu (Drawings by Bunchô). This set of two wood-block-printed books bears the seals and signatures of Tani Bunchô (1763–1840); the signatures are in several styles. The work contains drawings of birds and flowers, figures, animals, and landscapes, some in color. The publisher and place of publication are not known but the book appeared in 1805. The Library owns the complete set of two books.

12

Bumpô gafu (Drawings by Bumpô). Bumpô is also spelled Bunpô. The Library has only two volumes of this famous set of wood-block-printed books by Kawamura Bumpô. The books consist of pictures of birds and flowers, figures, and landscapes. They are printed in light blue and orange colors. Yanagihara Kihei and Yoshida Shinbei published volume 1 in Osaka in 1804. Kawachiya Kihei (in Osaka) and Yoshida Shinbei (in Kyoto) published volume 2 in 1811.

13

Bumpô gafu (Drawings by Bumpô). This work is a Meiji-Period edition of the previous entry. It consists of three wood-block-printed books. Yanagihara Kiheii published the work in Kyoto and Fukui Genjiro published it in Osaka. The work is printed in black ink alone, without the light blue and orange colors found in the above work. The pulp paper that was used suggests a Meiji date. The title sheet bears the same dates of 1804 and 1811 as are indicated in the volumes listed above, which may imply that the original blocks were used in making this edition.

14

Bumpô sôga (Rough Sketches by Bumpô). This single-volume, wood-block-printed book published by Eirakuya Tôshirô in Nagoya in 1800 consists of simple, rough drawings of genre subjects by Kawamura Bumpô (1779–1821).

15

Buyû sakigake zue (A Picture Book of Heroes).

These two wood-block-printed books by Keisai Eisen, that is Ikeda Yoshinobu, were published in Edo by Suwaraya Mohei and five others, in Kyoto by Fugetsu Shôzaemon and one other, in Osaka by Kawahchiya Kihei and three others, and in Nagoya by Eirakuya Tôshirô. Their publication date is not given. They portray various heroes and other great men from history, literature, and lore. The Library has two *hen*, two volumes, as in the first edition, as listed in Kerlen, pp. 48–49.

16

Chiharu gajô (Sketchbook of Chiharu). This *oribon* book consists of twenty-eight freehand paintings in ink and color. The works are by Chiharu. Two artists are known to have used this name: Arai Chiharu (1733–1826) and Takashima Chiharu (1777–1859). The latter was a Tosa school artist, also called Teiko and Yûsai. He seems a likely candidate for the author of this work since it shows a knowledge of court and military practices (*yûsoku*) common in the Tosa school. But, no clear evidence exists one way or the other as to who did the work.

17

Chôjû ryakuga-shiki (Simple Drawings of Birds and Animals). This single-volume, wood-block-printed book is by Kuwagata Keisai (1764–1824). The blocks were owned by Suwaraya Ichibei in Edo when the work was first published in 1797. It consists of simple drawings of birds, animals, and insects in a plain brush style. Keisai was a student of Kitao Shigemasa (1739–1820), in turn a pupil of Nishimura Shigenaga (1697?–1756?). He designed Ukiyo-e under the name of Kitao Masayoshi up until 1797 when he entered the service of the Lord of Tsuyama, changed his name to Kuwagata, and became a Kanô-style painter.

18

[*Chôkô gajô*] [Sketchbook of Nagayama Kôin]. The word *chôkô* in the title of this single-volume book of forty-six freehand drawings is composed of the character *naga* from Nagayama, which can also be read *chô*, and the *kô* of Kôin. Nagayama Kôin (1765–1849) , the pupil of Matsumura Goshun, *kyoka* poet and Confucianist, is the artist better known as Bokusai. This sketchbook reproduces his drawings of figures, flowers, and birds, all in color. The work bears the signature Chô Kôin.

19

Chûgata harimazechô (An Album of Mid-size Prints). There is no artist or publication infor-

mation on this album of *chûban* wood-block prints. The title noted above is written on the cover. The album consists of wood-block prints by Kachôrô, Kunitora, and five other artists. The prints have been pasted together into a home-made album. Utagawa Kunitora was a pupil of Toyokuni, who died in the Ansei Period (1854–1859). Not much work by him survives, so that his prints are very rare, which adds to the value of this book. Kachôrô called himself an Utagawa and there is a painting of a nude (*ratai bijinga*) by him from the Kaei Period (1848–1853). There is a theory that "Kachôrô" is the childhood name of Kunichika (1835–1900).

20

[*Daikai gajô*] [Sketchbook of Daikai]. This book of twenty-one freehand drawings is by the little-known artist Maruyama Daikai (1820–ca. 1890). It is dated 1867 in the *okugaki.* It shows flowers, mostly chrysanthemums, and smaller blossoms, mostly plums.

21

Dôchu gafu (Drawings on the Road). This single-volume, wood-block-printed book by Katsushika Hokusai was published by Eirakuya Tôshirô in Nagoya. The work depicts the various stations, or stopping places (*shukuba,*) along the Tôkaidô or Eastern Sea Road from Edo to Kyoto. The book in the Library is probably a Meiji-Period reprint.

22

Edehon (Picture Handbook). This book of eleven color, freehand drawings of flowers and figures in color is by some unknown artist or artists. The production date is not given.

23

Edehon (Picture Handbook). There is no publication or author information. This is clearly a practice book since critical comments appear on the drawings.

24

Edehon (Picture Handbook). This practice book consists of drawings of animals, figures, landscape, birds, and flowers, some in color and some in black and white. The work bears a pair of seals which can be read as Nomoto. There is an artist named Nomoto Fumio (1887–?), but whether he is the artist in question is not clear.

25

Edehon jô (Picture Handbook). The Library has two fascicles of this title by the same unknown artist. One contains thirty-eight freehand drawings in color and the other has twelve. These show flowers, birds, figures, and other subjects.

26

[*Edo meisho dôge zukushi*] [A Humorous Compilation of the Famous Places of Edo]. This work is a collection of wood-block prints that were originally published separately but are now bound together as a book. It is not known who bound the works together or when they were bound. The prints themselves include works by Utagawa Hirokage (fl. 1855–1865) and Utagawa Yoshiiku (1833–1904). Hirokage was a student of Hiroshige, but little else is known of him. Yoshiiku is also little known. The title given to this work is taken from Hirokage's set of prints, which appear first in the compilation. It consists of forty-eight humorous depictions of Edo's famous places. The work in the Library lacks numbers 33 and 40. Yoshiiku's contribution is his *Edo sunago kodomo asobi* and three prints of his *Dokei Chushingura*.

27

Edo meisho zue (Famous Places in Edo). This famous black-and-white, wood-block-printed book was written by Shôtôken or Saitô Chôshû and illustrated by Hasegawa Settan (1778–1843). There is no other publication information on the Library work. However, Kerlen, p. 88, gives the publisher as Suwaraya Ihachi, the place of publication as Edo, and the date of publication as Tenpô 5–7 (1834–1836). Kerlen notes that there were twenty volumes in the set , but the Library has only one. Settan, a pupil of Toyokuni, lived in Edo. Edo customs are shown in this book.

28

[*Edo meisho*] [Famous Places in Edo]. This wood-block-printed book of uncertain title shows famous places in the city of Edo and, more broadly, in Musashi Province. Each famous place is shown with a *waka* poem that relates to that place. The work includes nine illustrations, but there is no publication or artist information.
Edo Saijiki
See *Tôto saijiki*

29

Ehon azuma asobi (Amusements of the Eastern Capital). This wood-block-printed book is by Katsushika Hokusai, with text by Sensôan, that is Asakusa-an Ichindô (1755–1820). There is no publication information; however, the Library's copy seems to date to the Meiji Period and is presumably a reprint of a three-book set published under this title in 1802 by Suharaya Ihachi of Edo. According to Richard Lane (pp. 270–271), that set is a reissue of the original, published in 1799. The Library owns only the

chû volume. Kerlen (pp. 91–92) has an example of the 1802 edition.

30

Ehon Edo miyage (A Picture Book: Souvenir of Edo). These three wood-block-printed books by Utagawa Hiroshige were published in Edo from blocks owned by Kikuya Kôsaburô. Its publication date is not given. It comprises drawings of famous places in Edo. The Library has only numbers 1, 3, and 8. These appear to be later reprints or *atozuri*.

31

Ehon fuji no yukari (Picture Book: An Affinity to Wisteria). This work has an alternate title of *Ehon genji monogatari* (Picture Book: Tale of Genji). This wood-block-printed book was published in 1751 by Urokogataya Magobei in Edo and by Kamibishiya Shojirô in Kyoto. It consists of illustrations of the fifty-four chapters of the Tale of Genji, with short summaries of the stories.

32

Ehon fujibakama (The Picture Book: Thoroughwort). This wood-block-printed book was edited by Hôzan Shôfu (1759–1826), also known as Saeda Shigeru. It was illustrated by Yanagawa Shigenobu II, and published in Edo in 1823. The publisher is not given in the Library work. Kerlen (p. 99) notes that the publisher was Kadomaruya Jinsuke. The work provides portraits of fifteen women from Japanese history and tells their stories. *Fujibakama* is a flower, the *Eupatorium fortunei*, which is known in the West as thoroughwort, boneset, or augeweed. The Library owns the complete set of the *jô* and the *ge* volumes bound together as one book. For more on Yanagawa Shigenobu, see *Yanagawa gajô* (Album of the Art of Yanagawa.)

33

Ehon fûzoku kagami (Picture Book: Reflections on Manners and Customs). There is no artist or publication information for these two woodblock-printed books. They show seasonal festivals. The Library owns the complete set of two books.

34

Ehon hayamanabi (A Picture Book for Quick Learning). This wood-block-printed book by the little-known artist Urakawa Kôsa (?–ca. 1859) was published by Sakaiya Sadashichi (Teishichi) and two other Osaka publishers in 1848. The work consists of very scientific depictions of fish, shells, and crustaceans. The Library owns only one book from part 3.

35

Ehon hayamanabi (Picture Book for Quick Learning). This wood-block-printed children's book by Ikkôsai was published in 1857. There is no other publication information. Ikkôsai is the Edo artist Taguchi or Miki Yoshimori (1830–1884). He is the student of Utagawa Kuniyoshi, and so is also known as Kuniharu. The work shows figures, famous places, birds, and flowers. Kerlen notes another work , published in 1848, by the same title but by the artist Issensai, also called Uragawa Kosa (?–ca. 1859). See Kerlen, pp. 101–102, and Mitchell, p. 245.

36

Ehon hyaku monogatari (Picture Book of a Hundred Ghost Stories). This color wood-block-printed book written by Momo Sanjin and illustrated by the unknown artist Takehara Shunsen (?–?) was published in Kyoto in 1841 from blocks owned by Ryûsuiken. The work is a collection of forty-four illustrated ghost stories. The Library owns the complete set of five books.

37

Ehon isaoshigusa (An Illustrated Book of War Stories). *Tsunogaki* of *Zôho* (Additional). These two wood-block-printed books consist of selections out of such war stories as the *Soga monogatari*, *Taiheiki*, and *Hogen monogatari*. There is no artist or publication information. The Library owns only two volumes from this set of ten.

38

Ehon joruri zekku (An Art Book of Chinese Quatrains from Puppet Plays). This single-volume, wood-block-printed book was published in Edo in 1815 by Kadomaruya Jinsuke and in Nagoya by Yorozuya Tôhei. The work was by Hokusai and edited by Hokutei, that is Maki Bokusen. Hokusai worked with Maki in Nagoya after 1812. The upper part of the pages of this book contain sections of text from puppet plays or *joruri*. Below are illustrations of the puppet play or pictures otherwise appropriate to the text. The illustrations are only in black, a technique called *sumizuri*.

39

Ehon kitsune [no] yomeiri (Picture Book: The Fox's Wedding). This single-volume, black-and-white, wood-block-printed children's book by Kazantei Shôba (?–?) was published in Kyoto from blocks owned by Minôya Heibei. The publication date is not known, nor is it clear who Kazantei Shôba might be. The work shows foxes performing human activities, in this case getting married. The text accompanying the illustrations is not a narrative of the story but consists of the foxes' conversations.

40

Ehon kôkyo (Picture Book of Filial Piety). Alternate title of *Ehon kobun kôkyô* (Picture Book of Old Tales of Filial Piety). This wood-block-printed book by Katsushika Hokusai is signed Zen Hokusai Manji Rôjin and has an introduction dating 1834; the work probably appeared in 1850. Lane (p. 255) notes Hokusai is not generally thought to have called himself Manji until 1831 and is believed to have continued to use the name until about 1849. The work consists of Takai Ranzan's commentaries on the paragons of filial piety, with illustrations by Hokusai. There is no publication information on the work in the Library. However, Kerlen (p. 111) gives the publisher as Suwaraya Shinbei and the place of publication as Edo. More importantly, he gives the date of publication as 1850.

41

Ehon kotori zukai (A Picture Book: All about Birds). Alternate title: *Kotori zukai* (All about Birds). In 1805, Imazuya Tatsusaburô published these three wood-block-printed books in Edo and Kawachiya Kihei and two others published them in Osaka. The books contain satiric drawings by Jichôsai, each picture being accompanied by some jesting but pointed comment. Jichôsai, or Nichôsai, is another name of the sake brewer, curio dealer, writer, and artist Matsuya Heizaburô (fl. 1781–1788). It is not known how many books were in the set but the Library owns three.

42

[*Ehon kyôkun kotowazagusa*] [An Illustrated Book of Moralistic Proverbs]. There is no author or publication information on this wood-block-printed book. The upper part of each page in the book presents a proverb meant to convey some moral or ethical teaching. The lower part provides an illustration of that proverb, drawn in the style of Nishikawa Sukenobu (1671–1751).

43

[*Ehon makuzu ga hara*] [Picture Book: Kuzu Field]. This wood-block-printed book is the same type and size (22 by 16 cm.) as *Ehon masukagami*. It is also similar in content, its subject being the customs of women, drawn in the style of Nishikawa Sukenobu. The Library has only the *chû* volume and lacks the *jô* and *ge* volumes. The *daisen* (or title on the cover) and the imprint page normally appear in the *jô* volume. The character for *kuzu* (the name of the plant *Pueraria thunbergiana* or arrowroot) appears in the

hashira or the space between two printed pages left open to accommodate the binding. *Ehon masukagami* has the character *masu* (to increase) in the same position. This character must be an abbreviation of *masukagami*, the title of the book that appears properly written in Manyogana in the work's *daisen*. Assuming, therefore, that the character *kuzu* is similarly an abbreviation of the title of this work, the book is *Ehon makuzu ga hara*. See Toda, p. 143.

44

Ehon masukagami (Picture Book: A Clear Mirror). This wood-block-printed book is possibly by Nishikawa Sukenobu (1671–1751). There is no publication information on the Library work. The Library owns only the *chû* volume, which shows wedding customs of the Edo Period. Kerlen notes that the work was published by Kikuya Kibei in Kyoto in 1748.

45

[Ehon nijûshi kô] [Picture Book of the Twenty-four Paragons of Filial Piety]. There is no publication information on this single-volume, wood-block-printed book by Ryûsai Shigeharu. The work depicts the Twenty-four Paragons of Filial Piety based on the compilation of these didactic stories by Kuo Chû Ching. The illustrations are printed using chemical colors on the kind of thick Japanese paper called *hôsho*. For more on Ryûsai Shigeharu, see *Yakusha fûzoku sangokushi* (Customs of Actors from the Three Kingdoms).

46

Ehon nishiki no fukuro (Picture Book: Brocade Bag). This wood-block-printed book is by Keisai Eisen, another name for Ikeda Yoshinobu. It was published by Kawachiya Moheii in Osaka in 1828. The introduction to the work contains the following statement: "This book is not meant to teach you art but is to serve craftsmen who seek inspiration for their designs." The work is thus a source book of designs for metal carvings, lacquer work, and ceramics. For more on Eizen, see *Shinji andon* (Decorations for Festival Lanterns).

47

Ehon nishiki no fukuro (Picture Book: Brocade Bag). This wood-block-printed book by Keisai Eisen (Ikeda Yoshinobu) was published in Osaka by Kawachiya Moheii, but when it appeared is not given. The contents of this work are different from that cited above. Each page of this book bears a didactic admonition in its upper part, written in the form of a *waka* poem. The lower part of each page has an illustration for each poem.

48

Ehon sakigake (Picture Book of Warriors). *Tsuno-gaki* states *Wa-kan* (China and Japan). These wood-block-printed books are by Hokusai. The blocks were owned by Suzuki Chûzô when the work first appeared in Tokyo in 1877. Kenkyusha's *New Japanese-English Dictionary* defines *sakigake* as "the lead, the initiative, the first." Thus the term is often used in the titles of books to indicate a pioneering work. This picture book, however, is only a compilation of traditional heroes from Chinese and Japanese history. It is debatable to what extent it is pioneering and Lane (p. 275) translates the book's title as we do here, Picture Book of Warriors. There are two editions, the first was published in 1836. The Library owns the complete three-book second edition.

49

Ehon shahô bukuro (Picture Book: Bag of Copies of Treasures). This wood-block-printed book is by Tachibana Yûzei, that is Tachibana Morikuni. The work was published in Osaka in 1720 by Shibukawa Seieimon and contains illustrations of, and commentary on, various animals. The Library has only one book from the set, the *ge* volume of part. 9. For more on the artist, see *[Un'pitsu soga]* [Rough Brushwork Sketches].

50

Ehon shûyô [Picture Book of Miscellaneous Figures and Animals]. This set of two wood-block-printed books is by Sesshôsai, the artist who was also known as Terai Shigefusa (fl. 1744–1764). He is little known but may have been a student of Nishikawa Sukenobu, given how much his work resembles that of this master. This book consists of simple drawings of animals and figures that are printed in black and white. The figures are mostly gods, poets, and other people from Chinese and Japanese history. The word *shûyo* in the title is not a standard term. It consists of the characters for to pick up *(hirou)* and leaves *(ha)*. Thus, the title could have been translated more poetically as A Picture Book: Gathered Leaves. However, rather than do so, we have chosen a translation that reflects the book's contents. The Library owns the *jô* and *chû* volumes but is missing the *ge* . Kerlen notes that the second edition, *Ehon shûyô, nihen*, appeared in 1784.

51

Ehon shûyô (A Collection of Picture Books). These two black-and-white, wood-block-printed books by Sesshôsai, or Terai Shigefusa (?–?), were published by Kashiwaraya Seiuei-

mon in Osaka in 1751. The work depicts birds and flowers, various people from history, the Seven Gods of Good Luck, and similar subjects. It has the same title as the work cited above but the date of publication differs. The Library owns the *jô* and *chû* volumes and is missing the *ge*.

52

Ehon shûyô: nihen: ge (A Collection of Picture Books: Book 2, Volume 3). This work is another of the set by Terai Shigefusa discussed above, but published in Edo by Yamazaki Kinbei and in Osaka by Kashiwaraya Yozaemon in 1784. The Library owns only the *ge* volume.

53

Ehon sôshi (An Art Book Miscellany). This wood-block-printed, black-and-white book by some unknown artist shows figures, landscapes, and other things. There is no publishing information.

54

Ehon Takauji kunkoki (An Illustrated Tale of the Bravery of Takauji). These two wood-block-printed books by Kuwagata Keisai were published in 1800. There is no other publication information. The work purports to be an *ehon*, but is in fact a *kibyoshi*. The illustrations are printed in black ink only. The introduction to the work is by writer and poet Kyokutei, also known as Takizawa Bakin (1767–1848). The Library owns only volumes 1 and 3.

55

Ehon takaragusa (Picture Book: Treasure Grass). This work consists of detailed drawings of flowering grasses, insects, animals, fish, and other subjects. Both black-and-white and color compositions are included. There is no author or publication information, but the work appears to be a product of the Meiji Period. The work consists of eight volumes, of which the Library has only volume 4.

56

Ehon teikin ôrai (Picture Book: Home Education). This single-volume, wood-block-printed book by Hokusai was published in Nagoya by Eirakuya Tôshirô, but the publication date is not given. The book consists of models for letters to be written in *nihon kambun*. In addition, the work describes society, the judicial system, medical treatments, and other matters. The introduction to the work gives the author of the original text as Genkei (or Gen'e, 1269–1350). The work has 162 illustrations by Hokusai. Lane (p. 284) notes that the work was published in three series, the first issued in 1828, the

second circa 1830, and the third around 1848. *Teikin orai* is a common term for official, Confucian-influenced, hortatory writing; hence the translation of the title as Home Education. See also Kerlen, p. 137.

57

Ehon tengu [no] tawamure (Picture Book: The Play of the *Tengu*). These two picture books by an unknown artist appear to date to the Meiji Period, but there is no publication information on the work. It is a children's book, containing simple illustrated stories about the goblinlike figures called *tengu*. The Library owns the complete set of two books.

Ehon tôto asobi
See *Ehon azuma asobi*

58

Ehon Yamato shikyô (Picture Book of Japanese Verse). There is an alternate title of *Ehon Yamato shikyo* (Picture Book of Japanese Verse), written with different characters. These wood-block-printed books were published in 1770 and were compiled by Banzan Shôfu and illustrated by Yanagihara Genjirô, the poet and calligrapher who was also known as Shitomi Kangetsu (1747–1797) and who was an admirer of Sesshû Tôyô (1420–1506). No other publication information is provided. Kerlen (p. 149) notes a work by this title that he considers to be a Meiji reprint. At the far right of each page of the Library work, some ethical precept from the Chinese classics is quoted. At the top of the page, there are poems composed by the Zen Priest Bankei that relate to the ethical precept in question. At the bottom of the page is an appropriate illustration.

59

Ehon yûsha chikara awase kagami (The Picture Book: Mirror of Contests of Strength Between Brave Men). There is no publication or author information on this wood-block-printed book. The Library has only the one volume. This work concerns brave men from the Kamakura Period, such as Hôjô Tokimasa (1138–1215). The work is anachronistic, the architecture and other things in the story of Tokimasa being those of the much later Edo Period.

60

Eiri hokku shû (Collection of Illustrated *Hokku* Poems). This book of ninety-eight colored, freehand drawings is by an unknown artist. It was compiled by Uoichiba Washiya in Tokyo in 1870. The pictures are enclosed by 9 by 13.5 cm. boundary lines. The pictures may have been meant to provide poetic inspiration.

61

Eisen gafu (Art of Eisen). There is no publication information on this wood-block-printed book by Keisai Eisen (Ikeda Yoshinobu). The book comprises miniature sketches of people, scenery, birds, flowers, and other subjects and is almost identical to Hokusai's *manga*. It is lightly printed in pale blues and reds. The Library owns volume 1 of this work.

62

Eisen'in ga (Art of Eisen'in). The title of this single-volume book of drawings of undated drawings implies it is by the artist Eisen'in, who is also known as Kanô Furunobu (1696–1731). He was head of the branch of the Kano school in Edo at Kobikichô and, after 1711, official painter to the shogunate. The work itself, however, is a simple sketchbook by some apparently amateur artist. It shows birds, people, and animals, all drawn in black ink.

63

Eiyû zue (Pictures of Heroism). This single-volume, wood-block-printed book is by Genryusai Taito, that is Taito II (fl. 1810–1853). It was compiled by Nanrite Kiraku (act. 1804–1835) and published in Osaka in 1825 by Kawachiya Chôbei. Taito was from a samurai family, but became the student of Hokusai, who gave him his own name of Taito in 1820. Thereafter, Taito signed his work Genryûsai Taito or Katsushika Taito. He is sometimes also called Dog Hokusai *(Inu Hokusai)* for having forged his master's signature on some of his own prints. This work consists of pictures of the great war heroes of Japan from the Age of Myth to the Warring States Period. The images are accompanied by short biographies. The Library book is a later reprint of the original work by Taito. See the version in Kerlen, p. 154.

64

Eiyûga shi (An Illustrated History of Great Heroes). This black-and-white, wood-block-printed book purports to be by Keisai Eisen. The work was published by Suwaraya Sasuke in Edo in 1854, six years after Eisen died. It comprises pictures of famous Japanese war heroes. The Library owns volume 1 of the work.

65

Ekuchiai fukube no tsuru (A Comparison of Pictures and Poems about Growing Vines). This wood-block-printed book was compiled by Unwatei Koryû and illustrated by Matsukawa Hanzan (see *Matsukawa hanzan gahon*). The work was published in 1850 in Edo by Suwaraya Mohei and four other houses, in Kyoto by Izumoji Mon-

jirô, in Osaka by Itamiya Zenbei and two others, and in Bizen by Kamiya Sôeimon. It contains *haikai* poetry, accompanied by twenty-seven illustrations.

66

Ezôshi-bukuro harimazechô (An Album of Pasted-up Bags for *Ezôshi*). There is no publication information for this collection of *Ezôshi bukuro*, that is the bags or cases for *sharehon*, *kibyoshi*, *gokanbon*, and other books published in series. The cases are about 6.5 inches by 5 inches in size and usually enclose several volumes, serving to keep them together. The case normally bears a design or an illustration appropriate to the book it contains. These pictures are called *fukuro-e* (bag pictures.) The work in the Library contains *fukuro-e* by such noted masters as Hiroshige, Toyokuni, Kunisada, and forty others, for a total of 130 images. *Fukuro-e* are very rare, making this work and the one which follows among the most significant holdings in the collection.

67

Ezôshi-bukuro harimazechô (An Album of Pasted-up Bags for *Ezôshi*). This work is the same as the one above. It contains a hundred items by ten artists, including Kunisada and Toyokuni.

68

Fude no chikara (Power of Brush). The artist of this book of freehand drawings is not given. There is no publication date, but the work appears to have been produced in the nineteenth century. It contains *waka* and *hoku* that are suitably illustrated. The work is of poor quality.

69

Fugaku hyakkei (A Hundred Views of Fuji). The Library owns two complete reprint sets of this work. Each set consists of three wood-block-printed books by Hokusai that show Mt. Fuji from various different angles. The work was published in Nagoya by Katano Tôshirô in 1875. Hokusai is thought to have made the work around 1835 when he was seventy-five. The work develops his earlier interest in Mt. Fuji which was shown in his Thirty-six Views of Mt. Fuji *(Fugaku sanjûrokkei)*.

Fuso meisho zue
See *Kyôka fuzô meisho zue*

70

[Fûzoku nenjû gyôji] [Common Manners, Customs, and Yearly Events]. This little-known, single-volume wood-block-printed book of uncertain title and unclear publication history is

attributed to Hokusai. It contains twenty-two black-and-red illustrations of the manners, customs, and yearly events of common people.

71

Gafu (Art Book). There is no publication or author information on this wood-block-printed book. It consists of sixteen color illustrations of birds and trees.

72

Gafu: kihin, ihin (An Art Book of Odd Articles and Strange Things). There is no publication or author information on this wood-block-printed book. It contains eighteen color depictions of curious flowers and odd animals.

73

Gahin hippô (Graceful Art, Sharp Brush). This black-and-white, wood-block-printed book has the alternate titles of *Edehon* (Handbook) and *Ehon tekagami* (Picture Book: Calligraphic Exemplars). There is no publication information on this collection of miniature sketches by Ôoka Shunboku of paintings by Kakuyû or Toba Sôjô (1053–1140), Ikkyû Sôjun (1394–1481), Minchô (1352–1431), Shûbun (fl. 1414–1463), Oguri Sôtan (1413–81), Sesshu, and other famous artists. The Library has only the third volume of the work.

74

Gaiban yôbô zue (Pictures of Foreigners: Their Looks and Customs). There is no artist or publication information on this wood-block-printed book. Kerlen (pp. 175–176) gives the author as Tôshundô Rôjin, who also owned the blocks. The book is known to date from 1854 and it contains illustrations of twenty-one different kinds of people from the Far east, South East Asia, the Near East, and Europe. It describes their customs, products, and land. It also discusses the regions in which these people live, the climate there, and other geographical issues.

Gojunin isshu kyôka sodekurakago
See *Kyôka sodekurakago*

75

Gokinai sanbutsu zue (Illustrations of the Products of the Five Regions of West Central Honshû). This single-volume, color, wood-block-printed book was compiled by the Osaka artist, originally from Nara, Ôhara Tôya (Minsei). He also illustrated the work, along with a number of other artists. Shiono Heisuke, Shiono Chôbei, Kawachiya Kihei, and Kawachiya Tasuke published the work in Osaka in 1813. It

contains illustrations of textiles, medicine, stationery, food, and other famous products (*meibutsu*) of Settsu, Kawachi, Izumi, Yamato, and Yamashiro provinces. Each illustration is accompanied by a poem. The Library owns the complete set of five volumes. Mitchell (pp. 272–274) has the title *Gokinai sanbutsu zukai* (Illustrations of Products of the Five Provinces in the Vicinity of Kyoto). Kerlen, p. 190, has the same title.

76

Goshozakura baishoroku (No translation). The Library has two volumes of this popular novel by Kakutei Shûga with illustrations by Kunisada. The work was published by Yamadaya Shojirô in 1861. The Library owns only the *jô* volume from part 2 and the *ge* volume from part 3.

77

Gunchô gaei (Hanabusa Itcho's Art Book). *Tsunogaki* states *Manga zukô* (Manga Pictures). These three wood-block-printed books by Hanabusa Itchô (1652–1724) were published by Ejima Iheii and Aono Tomosaburô in Tokyo. The work shows birds and flowers, customs and festivals of the people, and scenery. These are all simply printed in black and white. The work was originally issued in 1778, but the version in the Library dates to the Meiji Period. The word *gunchô* in the title of the work is a combination of the second character of Itchô's name and an alternate reading (*ei*) of the character also read as *hanabusa*. Itchô is an artist usually considered to be a member of the Ukiyo-e school although, unlike other artists of this tradition, he did not design prints. However, he did make printed books. The Library owns the complete three-book set.

78

Gyokai ryakuga-shiki (Sketches of Fish and Shells). This single-volume, wood-block-printed book by Kuwagata Keisai was published in 1802 in Edo from the blocks owned by Suwaraya Ichibei. The title refers to sketches, but the drawings are, in fact, quite finished. The Library owns two copies of this book housed in one case. Lionel Katzoff notes that this book appears as *Tatsu no miya tsuko* (Servants of the Palace of the Dragon) in Kerlen (p. 517), who notes this as the work's original title.

79

Gyôsai gadan or *Kyôsai gadan* (Art of Kyôsai). *Tsunogaki* states *Kokon* (Old and New). The Library owns two versions of this wood-block-printed book, illustrated by Kawanabe Kyôsai (1831–1889), with text by Uryû Masakazu. Tim

Clark, Laurence Roberts, and Brenda Jordan all read the name of the artist as Kyôsai with a K, not a G. However, the character for *dawn (akatsuki)* that is used to write the artist's name is usually read *gyô.* This work consists of four books from the earlier version, published by Iwamoto Shun in Tokyo in 1887. The first of the four books concerns the painting techniques (*gahô*) of various eminent Japanese artists and then explains Japanese-style painting or *nihonga* in both Japanese and English. The second book focuses on the work of the artist Kyôsai and gives various anecdotes concerning his life. The third book consists of copies of works of the Kose, Tosa, Shijô, Ukiyo-e, and Chinese schools by Kyôsai. In the fourth book, Kyôsai renders in pictures and text the things that he saw or heard about on a trip to Shinshû (Nagano prefecture). The Library owns two books from the *jo* volume and two books from the *ge* volume for a total of four.

80

Gyôsai gadan (Art of Kyôsai). This set of four books is the second of the two works with this title owned by the Library. It is the same in content as the other work but is printed on cheap pulp, rather than on Japanese *washi* paper, which would suggest a later publication date.

81

Gyôsai hyakki gadan or *Kyôsai hyakki gadan* (A Hundred Demons by Kyôsai). This wood-block-printed book was published by Inoguchi Matsunosuke in Tokyo in 1890. It contains an inscription that states: "Kawanabe Kyôsai painted this work after A Hundred Demons by Tosa Gyôbu daiu." According to Tim Clark, there is a hand scroll in the Shinju-an, Kyoto, once attributed to Tosa Mitsunobu (1434–1525), of this subject. Another famous example of a painting by this theme is by Toriyama Sekien (1712–1788).

82

Gyôsai manga shohen or *Kyôsai manga shohen* (*Manga by Kyôsai: Part 1*). This wood-block-printed book was published by Chikira Sadahei in Tokyo in 1881. It consists of drawings in light black and orange of festivals, birds, animals, skeletons, mountains, trees, masks, and other subjects.

83

[Buson-fû haiga] [Buson-style *Haiga*]. This is a book of free-hand drawings illustrating *haiku* poetry. A note on the book states that the work is in the style of Buson but it is clearly by some other unknown artist.

84

[Hakai shû] (A Collection of *Haikai*). This work is a collection of *surimono* that includes *surimono* by Toyokuni and Satake Eikai (1803–1874).

85

[Haikai shû] (A Collection of *Haikai*). This wood-block-printed book of *surimono* is dated sometime between 1853 and 1855. There is no other publishing information. The work is a collection of *haikai* by various poets. The poems are dated and were composed in the period from 1853 to 1855, hence the date given to the book. The work has colored illustrations by forty-three different artists. Shikô produced the most, four. Roberts lists ten artists who used this name, but none employed the characters used by the man in question here. Ryôsai provided the next largest number, three. Who the artist Shikô might be is not clear. Ryôsai is Yoshimura Kôbun (1793–1863), a little-known Kyoto painter who was the son of Yoshimura Kôkei (1769–1836) and the pupil of Maruyama Ôkyo.

86

[Hakai shû] (A Collection of *Haikai*). This work is another collection of *surimono*. The works are by forty-three different artists. The most are by an unknown artist named Jindai. There is also a work signed Suieidô Hanzan, also known as Matsukawa Hanzan. The work is very similar in size and format to that described above in *[Haikai shû]* (A Collection of *Haikai*).

87

[Haikai shû] (A Collection of *Haikai*). This work is another collection of *surimono*. The works are by thirty-three artists, including Hanzan, .who produced the most, with six to his credit. An unknown artist named Chôsui did four. The work is similar in size and format to that in the previous entry.

88

[Hakai shû] (A Collection of *Haikai*). This wood-block-printed book was published by Rokôsha (?) in the period between 1860 and 1864. The work is a collection of *hokku* with illustrations by Matsukawa Hanzan and fifty-one other nineteenth-century artists.

89

Harikae andon (A Change of Pictures for Lamps). This single-volume, wood-block-printed book is by the artist Matora, one of the artists of *Shinji andon*. The work was published in Nagoya by Eirakuya Tôshirô and in Edo and Osaka by twelve other houses. The publication date is not given. The work consists of simple line drawings in ink with some color. The drawings are of common people and their customs and manners. This work is the same in content as *Soka hyakubutsu*, but of inferior printing and color quality.

90

Hengaku kihan (Wooden Tablet Models). This wood-block-printed book is by the Kishi school Osaka artist Aikawa Minwa (?–1821) and the unknown artist Kitagawa Shunsei. It was compiled by Hayamizu Shungyôsai (1760?–1823). There is no publication information. Mitchell (pp. 293–294) notes a *Hengaku kihan* (Model Pictures from the Temples of Kyoto) published in 1819 in Kyoto. Kerlen (pp. 213–214) gives the place of publication as Kyoto and the publisher as Fukuroya Sashichi. *Hengaku* are rectangular wooden tablets that are decorated with calligraphy or paintings. They are hung in gates on the cross bars over the entrance way, or on the inside walls of buildings. The Library. has only volume 2 of this book that concerns the tablets dedicated to Shinto shrines and Buddhist temples in Kyoto. It describes the art work on the sites and the artists who made them.

91

Hiroshige gajô (The Sketchbooks of Hiroshige). This famous work in the Library was published as a two-volume, boxed facsimile by George Braziller in New York in 1984 as *The Sketchbooks of Hiroshige*. Volume 1 shows twenty-five landscape scenes, mainly from Eastern Japan, drawn in light color. Volume 2 consists of illustrations from fairy tales, scenes from Kabuki, historical personages, and the manners and customs of the people. The works are unsigned but each drawing—except for one that shows a monk, perhaps Saigyo (1118–1190), before Mt. Fuji—bears seals reading Hiroshige or Ryusai. The year of production is not absolutely certain, but Hiroshige began using the name Ryusai around 1842. The lord of Tendo prefecture also commissioned Hiroshige to do freehand drawings in and around the early 1850s. Thus, a logical place to the put the work is between the mid-1840s and the early 1850s.

92

Hôgajô (An Album of Japanese Pictures). Yamada Geisôdô published this wood-block-printed work by an unknown artist in Kyoto in 1901. It contains *nihonga* prints of scenery, people, birds, and flowers. The Library owns two books from the set, parts 2 and 4.

93

Hôkashû (Collection of Precious Poems). This important work is a collection of 143 *waka*, *haikai*, and *kyôka*, each by a different poet. The work was compiled in the Bunsei Period (1818–1829), but by whom and where are not known. It also includes forty-four freehand drawings by Hokuba, Hokuju (1810–1824), and thirty-five other prominent early-nineteenth-century artists. Kazumasa Hokuju, an Edo Ukiyo-e artist, was reputedly the best of Hokusai's students. Among the drawings in *Hôkashû* are two bearing Hokusai's seals. One is signed Genpo and the other, Tatsumo. The introduction is by Rokujuen, that is Ishikawa Masamochi (1753–1830).

94

Hokku-e shû (Collection of Illustrated *Hokku* Poems). This single-volume work, very similar to the one cited above, consists of thirty-eight freehand, colored drawings of various subjects by an unknown artist. This work is also enclosed in 9 by 13.5cm. boundary lines as in *Eiri hokku shû* (Collection of Illustrated *Hokku* Poems). There is no publication information, but it appears to be a Meiji product.

95

Hokku-iri shukuzu (Miniature Pictures with *Hokku* Poems Added). This single-volume book is composed of sixty-eight colorful, freehand drawings of various subjects by some unknown artist. There is no publication information, but the work appears to date to the Meiji Period.

96

Hokusai gaen (A Garden of Drawings by Hokusai). These two wood-block-printed books by Hokusai were published by Kinkôdô in Edo in 1843. The Libary has two books, numbers 1 and 3, both of which are probably Meiji-Period reprints.

97

Hokusai gafu (Drawings by Hokusai). *Tsunogaki* states *Nihon bijutsu taito* (Japanese Art by Taito). These two books are a Meiji-Period reprint of a wood-block-printed book by Taito, also known as Katsushika Hokusai. The original was published by Okada Kôshin and one other publisher in Osaka. It is a work of historical fiction with black-and-white illustrations. The work is classified as a *mitate-e*, that is a parody. In this case, the parody involves depicting ancient legends or stories in contemporary guise. The Library owns one book each from parts 2 and 5.

98

Hokusai garoku (A Record of Hokusai's Art). This single-volume, wood-block-printed book was made from the blocks of Hishiya Kyûbei of Nagoya. Its publication date is not given and it is not listed in *Kokusho sômokuroku* or in *Ukiyo-e jiten*. The work comprises black-and-white images, mostly of legendary heroes, but it also shows birds, animals, and flowers. The work was edited by Bokusen, Taiso and others. Bokusen could be either Maki Bokusen (1736–1824) or Shimada Bokusen (1867–1943). Taiso is the name that Tsuioka Yoshitoshi (1839–1892) used after 1873, but he is not likely to be the person meant since he wrote his name with different characters.

99

Hokusai gazu: shohen (Hokusai's Pictures: Volume 1). *Tsunogaki* of *Denshin kaishu* (Transmitting True Images). This wood-block-printed book by Hokusai was published in Nagoya by Eirakuya Tôshirô. The publication date is not given. The work shows mostly people and flowers and is printed in light black ink and pale colors.

100

Hokusai manga (Random Sketches by Hokusai). *Tsunogaki* states *Katushika Iitsu iboku* (Inheritance of Katsushika Iitsu.) The term *iboku* refers to the works that a deceased artist has left us. This is one of Hokusai's most famous works. It was issued in several series, the first of which bears a preface dated Autumn, 1812. However, the work is thought to have appeared in the early spring of 1814, when it came out under the title *Denshin kaishû* (Transmitting True Images). The blocks used for this edition differ from those used in the general offering. A second series of *manga* appeared in 1815, and more followed. Lane (pp. 273–275) lists publications in 1816, 1817, 1819,1834, and 1849. Fifteen volumes of *manga* by Hokusai were published; volume 13 was published the year of his death, and volumes 14 and 15 were posthumously published. The Library's two complete fifteen-volume sets were published by Katano Tôshirô in Nagoya and appear to be Meiji-Period reprints. The Library has other incomplete sets as well.

101

Hokusai onna imagawa (Hokusai's Admonitions to Women). This single-volume, color, wood-block-printed book by Hokusai was published in Nagoya by Eirakuya Tôshirô. The term *onna imagawa* is common in Ukiyo-e and refers to admonitory writings for women. The usage is in memory of the admonitions that Imagawa Ryôshun (1326–?) gave his younger brother

Chushu and they are based on the *Imagawa-jo* (Imagawa Admonitions), a kind of admonitory writing also called *oraimono*.

102

Hokusai onna imagawa (Hokusai's Admonitions to Women). This single-volume work is another copy of the book discussed in the previous entry, but this one was printed without color. The publishers are Eirakuya Tôshirô in Nagoya and ten others in Edo and Osaka.

103

Hokusai shashin gafu (Life Drawings by Hokusai). This single-volume, wood-block-printed book was published by Meguro Isaburô in Tokyo in 1891. It is a reprint of the original published in 1814 that depicts persons, imaginary creatures, scenery, birds, flowers, and other subjects—all in rich colors.

104

Hokusai shin hinagata (New Patterns by Hokusai). *Tsunogaki* states *Katsushika Tamekazu iboku* (Inheritance of Katsushika Tamekazu). This single-volume, wood-block-printed book by Katsushika Tamekazu, that is Hokusai, was published by Eirakuya Tôshirô in Nagoya and by twelve other houses in Kyoto, Osaka, and Edo. The date 1836 appears in the introduction to the book, which consists of architectural drawings, including plans for buildings, along with designs for carvers. The pictures are drawn in thin red ink.

105

Hokusai shin hinagata (New Patterns by Hokusai). *Tsunogaki* states *Katsushika Tamekazu iboku* (Inheritance of Katsushika Tamekazu). This is the same book as is described in the previous entry, but this one was published by Katano Tôshirô in Nagoya and by fourteen other publishers in Kyoto, Osaka, and Edo in the Meiji Period.

106

Hokusai shûga tehon (A Copy Book of Drawings by Hokusai). This single-volume, wood-block-printed book was published by Inoguchi Matsunosuke in Tokyo in 1892. It provides examples of drawings of figures, landscape, flowers, birds, fish, and a variety of other subjects. The pictures are printed in light black and red ink on cheap pulp paper.

107

Hokusai ô gajutsu hayagaten (No translation). This work has the alternate title of *Katsushika Hokusai gakujutsu chô* (Album of the Art of Katsushika Hokusai). When and where this book of draw-

ings was made is not clear. It is richly mounted with a brocade cover, the inside of which is gilded. The title of the book appears alongside a 9 by 9.2 cm. red seal reading *Azuma-eshi Katsushika Hokusai Ô* (The Edo Artist: Old Man Katsushika Hokusai). Thus, the work purports to be by Hokusai himself. It shows his compositional method, wherein initial contours are drawn in light red lines that are followed by a final outline in light black. Thirty-five of the compositions in this book, however, closely resemble those in a two-volume wood-block-printed book by Hokusai entitled *Rakuga hayashinan*. Volume 1 of this work has a colophon dated 1812 and volume 2 states 1814. The existence of this work raises the possibility that the book in the Library is not by Hokusai, but a copy by some student or follower. The lack of assurance in the brushstroke supports this possibility.

108

Honchô hyakushô den (A Hundred Famous Japanese Heroes). This is a book of drawings by Yamamoto Tauemon (?–?), reproduced in 1853. It shows a hundred famous heroes from Japanese history. These include such legendary figures as Yamato Takeru but also the historical Taira no Kiyomori (1118–1181), Minamoto Yoshitsune (1159–1189), Oda Nobunaga (1534–1582), and Toyotomi Hideyoshi (1536–1598). These detailed, colorful works are drawn in a fine line. Little is known about the work of Yamamoto Tauemon. Whether this work is actually by him is unclear, it seems to have been done by an amateur artist.

109

Hyakki yakô shûi (The Night Procession of a Hundred Ghosts). This black-and-white, wood-block-printed book by Toriyama Sekien (1712–1788) was published by Naganoya Kankichi in Ise in 1805. The Library version has three volumes bound together as one. Among these, possibly by mistake, is volume 3 of *Konjaku zoku hyakki*. Sekien was the Kano painter and Ukiyo-e master who was one of the teachers of Kitagawa Utamaro (1754–1806). He is known for his drawing of ghosts, which he also portrayed in his famous *Sekien gafu* of 1773.

110

Hyaku monogatari (A Hundred Ghost Stories). Alternate title of *Hokusai hyaku monogatari* (A Hundred Ghost Stories by Hokusai). This set of five famous wood-block prints by Katsushika Hokusai was published by Tsuruya Kieimon in 1830. The works in the Library are bound as a book. On the insides of the front

and back covers, there is a label that indicates the name of the binder: Endô Tokujiro, Kyoto, Oike-dôri, teramachi, nishi-iru.

111

Hyakumenso shita-e (A Hundred Sketches of Faces). Despite its title, this single-volume book of drawings contains only sixteen images of different kinds of facial expressions. Just as the word eight in India can mean many, the number 100 in Japan sometimes signifies only a large number of things. So, too, in general usage, a*shita-e* is an underdrawing or a preliminary drawing and thus the same thing as a *shita-gaki*. The word is so defined in the dictionary *Kojien*. However, art historians often distinguish between *shita-e* and *kojita-e*. The latter is closer to what we would call a sketch. Hence, *The Dictionary of Japanese Art Terms* defines a *shita-e* as a more detailed and exact rendering of a sketch done to the same dimensions as the final painting. It is with this meaning that the word *shita-e* is used for those copies of Ukiyo-e masters' preliminary drawings that professional copyists made to be pasted down on wooden planks and cut away to create the key blocks for prints. That cannot have been the purpose of the drawings in this book, given that they survive. Hence, the term *shita-e* is clearly being used here only in its most general sense.

112

I-ro-ha gana kane no sashimono kamagabuchi futatsu tomoe (No translation). This work is an illustrated program for a Kabuki performance at the Nakamura-za in Edo in 1857. The illustration is by Kiyokawa Taneharu, that is Ikkôsai (fl. 1848–1864). According to *Ukiyo-e jiten*, p. 17, he is a little-known master of *shibai-e* (theater prints.)

113

I-ro-ha kaisei kyôiku hayamanabi (A Revised Edition of Education in the Quick Study of I-ro-ha). The work has the alternate title *I-ro-ha kaisei hayamanabi* (A Revised Edition of Quick Study of I-ro-ha). This single-volume, wood-block-printed book was published by Fukuda Kumajirô in Tokyo in 1892. The work is a textbook for learning *kana*, I-ro-ha being a traditional way of organizing the syllabary into an easily memorized form.

114

Ichirô gafu: sansui (Painting Style of Ichirô: Landscape). This wood-block-printed book was published in 1824. There is no other publication information on the Library work. Kerlen (p. 264) gives the place of publication as Edo and

the owner of the blocks as Gasendô. He gives the date as 1823. Ichirô is the pseudonym (or *go*) of Gakutei (1786?–1868), also known as Yashima Harunobu. He was a follower of Hokusai. Although born in Edo, he was an Osaka artist. He is better known for his writings, which he did under the name of Horikawa Tarô. Among other things, he adapted The Journey to the West *(Hsi-yu Chi)* from Chinese into Japanese. This art book contains pictures of figures and landscapes, drawn in pale green and orange colors.

115

Ippitsu gafu (One-stroke Drawings). *Tsunogaki* of *Denshin kaishu* (Transmitting True Images). The introduction to this single-volume, wood-block-printed book states: "Fukuzensai of Nagoya made this book. A year later, Hokusai saw it and decided he wanted to introduce it to the world. Therefore, he copied it." The book is signed: Fukuzensai, copied by Katsushika Hokusai. Eirakuya Tôshirô published Hokusai's book in Nagoya. It comprises drawings of people, birds, and various other subjects, each done in a single stroke of the brush. Matthi Forrer (p. 226) dates the work 1824 and Lane (p. 274) has it as 1823.

116

Isai gashiki (Isai's Style). *Tsunogaki* states *Banbutsu zukai* (Explanations of Pictures of Myriad Things). This wood-block-printed book by Katsushika Isai was printed from blocks owned by Yamatoya Kihei in Edo in 1864. The work consists of depictions of the customs and manners of different times, illustrations of each of the chapters of The Tale of Genji, portrayals of heroes from Japanese history, and pictures of various musical instruments.

117

Itchô kyôga shû (A Collection of Crazy Pictures by Itchô). This single-volume, color, wood-block-printed book by Itchô was published by Meguro Jûrô in Nigata in 1888. The book is a collection of Ukiyo-e and genre pictures by Itchô.

118

Itchô gafu (Art of Itchô). This wood-block-printed book was published in Edo in 1770 by Kariganeya Seikichi. Kerlen lists the work under *Hanabusa Itchô gafu* and gives the publisher as Nishimura Sôshichi. In it, Suzuki Rinshô (?–1802) publishes his reduced-size copies of paintings by Hanabusa Itchô, who was also called Rinshôan (1652–1724). The pictures are

accompanied by highly refined, delicate freehand drawings of heads *(kubi-e)* in the Ukiyo-e style. The Library owns the complete three-book set bound in one volume.

119

Jinbutsu chô (Figure Sketchbook). This *oribon* of twenty-one freehand genre paintings in ink and color has no seal or signature; however, the cover says Figure Sketchbook by Chiharu. Concerning the artist Chiharu, see *Chiharu gajô*.

120

Jinbutsu gajô (Sketchbook of Figures). This single-volume *oribon* consists of seven freehand drawings of figures in pale colors. The first two seem different in style from the rest, suggesting that this work may represent the efforts of a teacher and his student or students. There is no publication information.

121

[Jinbutsu gajô] (Album of Figures). It is not known when this single-volume book of freehand color drawings was made. It consists of eight images of figures. The cover is made of brocade. A previous owner of the work has written the name of the artist, Hokuba, on the cover in pencil, providing a tentative attribution to Arisaka, that is Teisai Hokuba (1771–1844), the student of Hokusai.

122

Jinbutsu ryakuga shiki (Figures Drawn Simply). This wood-block-printed book is by Kuwagata Keisai. The work was published in Osaka in 1813 from blocks owned by Ômiya Heisuke. However, Mitchell (p. 316) and Kerlen (p. 287) give Edo, 1799, Suwaraya Ichibei instead. The work in the Library consists of simple, color drawings of people. It is a later reprint. On Keisai, see *Chôjû ryakuga-shiki* (Simple Drawings of Birds and Animals).

123

Jinbutsu ryakuga-shiki (Sketches of Figures). This single-volume, wood-block-printed book by Kuwagata Keisai was published in Edo in 1799 from the blocks owned by Suwaraya Ichibei. It consists of simple drawings of people done in pale color.

124

Jinbutsu shukuzu (Miniature Freehand Drawings of Figures). This is a beautiful single-volume book of drawings in black outlines with corrections made in red ink. The artist is unknown, but the work appears to be a practice book.

125
Jinbutsu shukuzu (Miniature Figure Drawings). This book of freehand brush paintings of figures is by the unknown artist Shika (?–?). It appears to date from the Meiji Period.

126
Jinbutsurui (Various Kinds of People). This is a book of freehand drawings of various types of people by some unknown artist. There is no publication data for it, but many of the drawings appear to be copies of Chinese paintings.

127
Joruri zue (Pictures of Puppet Plays). This work, dated 1901, is a Meiji-Period reprint of the wood-block-printed book *Ehon joruri zekkui* by Hokusai. It is in the album style; the page on the right side provides a section of *joruri* text, while that on the left has a light blue and red illustration. The Library owns the *ken* volume of the two-volume set and is missing the *kon*.

128
[Jûjitsu shinan] [Illustrated Instructions on *Jûjitsu*]. This *oribon* consists of freehand drawings of seven *jûjitsu* techniques. There is no publication or author information on this work.

129
[Kachô fûgetsu gajô] [A Drawing Book of Birds and Flowers and of the Wind and Moon]. This is a single-volume work comprising sixteen freehand drawings of scenery, animals, birds, and flowers. Most are done in ink, although some show traces of color. The boneless style of wash drawing is used for the most part. The brushwork is refined, but the artist or artists are unknown. An attached loose-leaf note attributes the drawings to Nishikawa Hoen, presumably meant to be Nishiyama Hoen (1807–1867), a Shijo painter. No other evidence supports this attribution.

130
Kachô gafu (Bird and Flower Art Book). This color, wood-block-printed book of birds and flowers is by Fukui Kôtei (1856–1938). He was the Western-style *(yoga)* painter who became a Japanese-style *(nihonga)* painter. He was also the student of Kawabata Gyokushô (1842–1913). The work was published by Yoshida Kinbei and three other houses in Tokyo in 1896. Kerlen (p. 300) notes a *Kachô gafu*, undated, published in Edo by Bunkaidô.

131
[Kacho gafu] [Album of Birds and Flowers]. This wood-block-printed book by an unknown artist depicts birds and flowers. The work in the Library lacks the title slip on the cover, the title page, and the imprint. For that reason, the publisher of the work and the date and place of publication could not be identified. For the same reason, the title of this work is also uncertain.

132
[Kacho ehon] [Art Book of Birds and Flowers]. This single-volume book of twelve colorful, freehand drawings of birds, flowers, and insects on silk is by some unknown artist and appears to date to the Meiji Period.

133
Kachô gyojû zu: Jinbutsu Gesshô gafu (Pictures of Birds, Flowers, Animals, and Fish: A Picture Book of Figures by Gesshô). This *oribon* of freehand drawings is divided into two parts. The first part, entitled *Kachô gyojû zu* (Pictures of Birds, Flowers, Animals, and Fish), consists of black-and-white drawings. The second part, *Jinbutsu Gesshô gafu* (A Picture Book of Figures by Gesshô), is in ink and color. On the verso of the pages, there are skillfully executed freehand drawings of bamboo in ink. Gesshô, also called Chô Yukisada (Gyôtei), is the painter and book illustrator who worked with Matsumura Goshun and Nagasawa Rosetsu (1754–1799). Among his other books are *Zoku koya bunko* and *Fugyo Gaso*.

134
Kachô jô (Book of Birds and Flowers). This book of fifteen freehand drawings of flowers and birds is by some unknown artist. There is no publication information on it. The drawings are amateurish and were probably done as practice pieces. One work, a painting of a crane, bears the inscription Seisen'in Hôgen. Seisen'in is another name for Kanô Yasunobu (1796–1846). He was granted the title of *hôgen* in 1819. The drawings appear to be a copies of his work.

Kachô sansui saiga zushiki
See *Saiga zushiki*

135
Kachô sansui zushiki (Pictures of Landscapes, Birds, and Flowers). There is no publication information on this work by Katsushika Isai that consists of wood-block prints that depict scenery, birds, flowers, and other subjects. It also includes design motifs. The Library owns only volume 2.

136
[Kachô-zu gajô] (Album of Bird and Flower Paintings). This set of seventeen color, freehand drawings is by an unknown artist. It depicts flowers that are associated with the months. Some appear with birds. The work may be a sample book of kimono designs.

137
Kaibutsu ehon (A Picture Book of Ghosts). This wood-block-printed book by the unknown artist Rikan Kôken was copied by Nabeta Gyokuei; it was published by Yasuda Kôtarô in Tokyo in 1883. The book depicts *kaibutsu* (monster), *yokai* (weird creatures), and *yurei* (ghosts.) According to the imprint statement, the first edition appeared in 1802, but the work in the Library was published later.

138
Kaiga hansho (Painting Models). *Tsunogaki* of *Tomei gain* (Tomei Art Studio). These two books of rough, freehand sketches of flowers, birds, and people are by Shunka. They also explain how to make line drawings and apply color. Shunka's identity is not known. Yamada Bunkô (1846–1902) used the name, but with different characters. The Library owns numbers 1 and 7 of the set.

139
Kaigajô (Book of Paintings). Okura Yasugorô published this wood-block-printed book in Tokyo in 1887. It contains twenty-two paintings by Kawabata Gyokushô, Araki Kampo (1835–1913), Takeuchi Seihô (1864–1942), and nineteen other prominent modern artists. The Library owns only volume 2. Kerlen (p. 325) notes a *Kaigacho*, two volumes, published in 1892 in Tokyo.

140
Kai'I shinga (Hearty Laughter: New Pictures). This single-volume book of twenty-three freehand drawings in color is by Tamate Tôshû (1795–1871). He was an Osaka painter, the student of Nakai Tadashi, also known as Rankô (1766–1830). Translating the title of this work is a problem. *Kai'i* is an unusual word meaning to laugh heartily.

141
Kakuchu enpu. Alternate title of *Ki Shi enpu* (Charming Depictions by Mr. Aoi). The contents of this work are the same as *Ki Shi enpu* (Charming Depictions by Mr. Aoi), except for the *kana* introduction. The *kana* introduction in this case is by an unidentified person named Chinu-ô. Since the work in the Library lacks

the imprint page, the year of production is unclear. The Library owns the *jô* and the *chû* volumes.

142

Kakuryû Sekai Hakurankai bijutsuhin gafu: Daisan shû (Drawings of Art Objects in the World Columbian Exposition: Volume 3). This woodblock-printed book by Kubota Beisen, published by Okura Yasugorô in Tokyo, is an album of very detailed sketches in ink and color of the paintings, design works, and everyday goods that Japan sent to the World Columbian Exposition in Chicago in 1893. These include a complete Japanese room. It is not known how many books comprise a complete set but the Library has only the third volume.

143

Kanga shinan (Proper Instructions as to the Chinese Method of Drawing). This set of three wood-block-printed books by Kawamura Bumpô were published in Kyoto by Hishiya Magobei. The books contain 180 drawings of trees, landscape, and figures. The last page bears the date 1810, but Mitchell (p. 335) states that the work was published in 1811. The books contain 180 drawings of trees, landscapes, and figures. The work was purportedly made to teach readers how to draw these things in the Chinese manner. The first book is concerned principally with trees, the second, with scenery, and the third, with people and landscapes. The Library owns only three volumes from the second part of th

144

Kansai gafu (The Art work of Kansai). These three wood-block-printed books by Kansai were published by Meguro Jinshichi in Tokyo in 1891. The works show deities from Japanese myth, imaginary animals, famous Buddhist priests, scenery, and other subjects, all drawn in delicate detail in thin black and red lines. Honda identifies the Kansai who made this book as Ichikawa Raijiro. Rajiro. The Kansai in question here is unknown, but apparently is not the same as Ishikawa Kansai (fl. late 18th c.), Koma Kansai (?–1792), or Mori Kansai (1814–1894), all of whom wrote the name Kansai with different characters. The Library owns only numbers 1, 3, and 5.

145

Kasen eshô (Illustrations of the Poetic Immortals). This single-volume, wood-block-printed book was compiled by Fujiwara Masaomi with illustrations by the Edo literati painter Kita Busei (1776–1856). It was published by Suwaraya

Mohei in Edo in 1810. The work consists of pictures of the Thirty-six Poets and their poems. The name of the poet appears in the upper part of each page followed by a commentary on his poem. The poem appears in the middle of the page, and a color portrait of the poet is provided at the bottom.

146

Kasshi heisen zu (1864 Skirmish and Conflagration). Tanaka Jihei published these two woodblock-printed books in Kyoto in 1893. The work has drawings by Mori Yûzan, reduced from the originals by Maekawa Goryô. These artists are unknown. The name Yûzan was used by Imaôji Genshû (1790–1849), but it was written with different characters. The book depicts the disastrous fire that occurred in Kyoto in 1864, as a result of the Hamaguri Gomon Incident in August of that year. The Hamaguri Gomon or Palace Gate (Kimmon) Incident involved the attempt by the forces of Chôshû (now Yamaguchi Prefecture) to reenter Kyoto, from which they had been expelled the year before after a failed coup. It is estimated that 28,000 houses burned. The incident is recorded through text and in colored pictures. The Library owns the complete set of two books.

Katsushika Hokusai gajutsu chô
See *Hokusai-ô gajutsu hayagatten*

147

Katsushika shin so gafu (Drawings in the Formal and Informal Style by Katsushika Hokusai). This set of wood-block-printed books by Katsushika Hokusai was printed from blocks cut by Egawa Sentaro. It was published in 1890 in Tokyo by Matsumura Magokichi. It contains Hokusai's work in his Formal and Informal styles. The work is notable for its excellent use of *gauffrage* or negative printing (*kara zuri*). The Library owns the complete set of two books.

148

[Kawabata Gyokushô gafû] [Art Book of Kawabata Gyokushô]. This color, wood-block-printed book by Kawabata Gyokushô was published by Geisôdô in Tokyo in 1898. It contains prints of figures, landscapes, birds, and flowers, all by Gyokushô. The Library work has no cover, hence no title. For more on Gyokushô, see *[Nôgaku]* [Noh].

149

Kayaragusa (No translation). This work has the alternate title of *Fuyu no mado nihyaku- sanjûsan kan* (Winter Window: Number 232). This *origami* textbook by Adachi Masayuki demon-

strates how to make decorative wrappings, dolls, flowers, and other things. Some illustrations are in color. The alternate title suggests that the work is part of a series. The Library's work is signed Adachi Masayuki, but with characters different from those usually used to write this name.

150

Keibun sensei hitsu [gajo] (An [Art Book] by the Brush of Master Keibun). This book of twenty-three freehand drawings in color is by Keibun, that is Matsumura Naoji, the brother of Goshun. See *Kôcho gafu* (Drawings by Kôchô). Some of the drawings have suffered damage that has been repaired carefully.

151

Keihitsu toba guruma (*Toba-e* in a Rhythmic Style). This wood-block-printed book is by some unknown artist. It consists of comic figures in the exaggerated *Toba-e* manner. The work was published by Kawachiya Kihei and Kawachiya Eisuke in 1793. The Library has the complete set of three books. Katzoff notes that there is an earlier edition of this work, listed as *Keihitsu tobaguruma* in Kerlen (p. 315) and Toda (p. 342) dated 1720.

152

[Keikoga tsuzuri] [A Group of Practice Drawings]. This book of freehand drawings by some unknown artist appears to date to the Meiji Period. It consists of sketches that were presumably made to practice painting. The work seems to be that of an amateur or beginner.

153

[Keinan gajô] [Sketchbook of Keinan]. This *oribon* of freehand color drawings is by the unknown artist Keinan (?–?). There is no publication information. The drawings depict people and genre subjects. Among the latter are portrayals of festivals and stage shows. There is an inscription at the end of the book stating, "Drawn playfully by Keinan." His seal also appears. There is a handwritten English description of each of the paintings. The handwriting on this document resembles that in the English description of *kyôga*, which is dated 1875.

154A

Keisai jinbutsu ryakuga-shiki (Sketches of Figures by Keisai). The work has the alternate title of *Keisai ryakuga shiki* (Sketches by Keisai). This single-volume, wood-block-printed book by Kuwagata Keisai was published in 1795 from the blocks owned by Suwaraya Ichibei in Edo. It consists of simple drawings in ink with slight

color. These show figures, scenery, fish, insects, birds, and flowers.

154B

Keisai ryakuga-shiki (Sketches by Keisai). This book is a later edition of that discussed above but with a different title. Its title is the same as that of the following entry.

155

Keisai ryakuga-shiki (Sketches by Keisai). This single-volume, color, wood-block-printed book by Kuwagata Keisai was published in Edo, but there is no other publication information on it. It consists of simple drawings that illustrate proverbs. The book has the same title as the one cited above, but its contents are totally different.

156

Keisai soga (Rough Sketches by Keisai). These five wood-block-printed books by Keisai, that is Kitao Masayoshi were published in Nagoya by Eirakuya Tôshirô. They consist of wood-block-print reproductions of rough sketches in color of landscapes, people, animals, birds, and flowers. For more on Masayoshi, see *Chôjû ryakuga-shiki* (Simple Drawings of Birds and Animals). Kerlen (p. 347) gives the title of the work as *Sanryô gato keisai soga* and notes that it appeared in 1815. Mitchell (p. 355) assigns the work to Kuwagata Keisai and others. Kuwagata Keisai is another name for Kitao Masayoshi.

157A

Keisai ukiyo gafu (Ukiyo Drawings by Keisai). There is no publication information on this wood-block-printed book by Keisai Eisen (Ikeda Yoshinobu). Toda (p. 303) gives the publisher as Eirakuya Tôshirô, Nagoya. See also Kerlen, p. 756. There is a handwritten label on the B volume of the Library set stating: "Title: *Keisai ukiyo gafu*, vol. 1, A Few Glances into the Floating World: Artist: Yeisen Keisai; Publ. Suuokaraya (Nagoya): Date: unknown." The work contains examples of how to draw people, landscape, birds, flowers, and other things.

157B

Keisai ukiyo gafu (Ukiyo Drawings by Keisai). There is no publication information on this wood-block-printed book by Keisai Eisen (Ikeda Yoshinobu). The work is a sketchbook showing people, animals, insects, birds, flowers, and other subjects.

158

Kenzan iboku (Inheritance of Kenzan). This famous wood-block-printed book by Sakai

Hôitsu (1761–1828).was published in 1823. It is also known as *Kenzan iboku gafu* (The Inheritance of the Art of Kenzan). Hôitsu, also known as Sakai Tadamoto, was part of the family that supported Ogata Kôrin (1658–1716) after 1707. Hôitsu then spent the last twenty-one years of his life studying the life and art of Kôrin and his brother Kenzan (1663–1743). He published two important books on the Rimpa or Kôrin and Kenzan tradition of art, this one and *Korin hyakuzu* (A Hundred Works by Kôrin). *Kenzan iboku* consists of reduced-size, color, wood-block-print reproductions of the paintings and calligraphy of Kenzan. The Library's work has a postscript by Hôitsu.

159

Ki Shi enpu (Mr. Aoi's Album of Charm). *Tsuno-gaki* of *Kakuchû enpu*. Alternate title of *Kakuchû enpu*. This set of wood-block-printed books is by Saito Shûho (1786–1859). It was published in Osaka by Ueda Uhei and Murakami Sakichi. The publication date is not known, but the work has a preface dated 1803. The Library has the complete three-volume set. The work is a humorous depiction of the manners and customs of the red-light district of Osaka. Volume 1 has twelve illustrations, volume 2 has eleven, and volume 3 has twelve. Each volume also contains pages of *hokku* verse. There is an introduction in *kambun* by someone named Seisei Zuiba and in *kana* by Kien. Who Seisei Zuiba might be is not clear. Kien is not Yanagizawa Kien or Minagawa Kien (1734–1807) but a *haiku* poet of the same name who died in 1834. The *Ki Shi* (Mr. Aoi) of the title presumably refers to the artist Sôkyû or Saito Shûho, since he was also known as Aoi Mamoru and *ki* is a phoneme of *aoi*.

160

Kihô gafu (Drawings by Kihô). This single-volume, wood-block-printed book by Kawamura Kihô (1778–1852) was published by Shôhôdô in Kyoto in 1824, according to the introduction. Kerlen (p. 357), however, notes an 1827 version, published by Yoshida Shinbei in Kyoto. Kihô is the son and pupil of Kawamura Bumpô. The book consists of thirty drawings of landscapes, figures, birds, and flowers. According to the epilogue by the artist, the work was made for the elucidation of his students.

161

Kijin hyakunin isshu (A Hundred Eccentrics). This work has the alternate title of *Kijin hyakushu* (A Hundred Eccentrics). This wood-block-printed book is by Katsushika Isai and six other artists. The work was compiled by

Ryokutei Sen'ryû and was published in Edo in 1852 by Yamaguchiya Tôbei. The work contains a hundred portraits that are accompanied by each person's poetry. They include the Forty-seven Ronin and scholars, samurai, priests, and artists from the Middle Ages. For more on Isai, see *Saiga zushiki* (On the Fine Style).

162

Kikuchi Yôsai gafu (Paintings of Kikuchi Yôsai). The Library owns the complete set of these two wood-block-printed books by Yôsai, that is Kikuchi Takeyasu(1788–1878). They were published in Tokyo by Ôkura Magobei in 1891. The work consists of small-scale reproductions of the works of Yôsai. Each volume contains thirteen pictures that mainly depict incidents from various legends. Laurence P. Roberts informs us that Yôsai was known mostly as a history painter. According to *Nihon gakka daijiten*, he knew a great deal about ancient practices and usages; his work was famous for its accurate portrayals of ancient manners and customs. Between 1836 and 1868, Yôsai brought out his famous *Zenken kojitsu*, a twenty-volume work of historic painting containing five hundred woodcuts. In 1876, Yôsai won an award at the American Centennial Exposition that was held in Philadelphia. He also received the title of *Nihon gashi* (Knight Painter of Japan). Today, however, his work is not highly regarded.

163

Kinpaen gafu (Drawings by Kinpaen). This single-volume, color, wood-block-printed book was published by Hishiya Magobei in Kyoto in 1820. It consists of reproductions of bird and flower paintings by Kawamura Bumpô. Bumpô is not known to have used the name Kinpaen, nor did any of the other artists of the Kishi school of Saeki Masaaki or Ganku (1749/56–1868), to which he belonged.

164

Kôchô gafu (Drawings by Kôchô). These four wood-block-printed books by Ueda Kôchô (fl. 1848–1853) were published by Kawachiya Kihei in Osaka in 1834. The Library has the complete set of four books. The work consists of drawings of people, landscapes, birds, and flowers. Kôchô was an Osaka artist. Roberts regards him as a student of Gekkei or Matsumura Goshun (1752–1811), but he also studied with Keibun or Matsumura Naoji (1779–1843), Goshun's brother.

165

Kôchô ryakuga (Sketches by Kôchô). These two color, wood-block-printed books by Ueda

Kôchô were published by Itamiya Zenbei in Osaka in 1834. They contain simple drawings that were apparently made to teach people how to draw and may be practice books for beginning artists. The Library owns the complete set of two books.

166

Koga shû (Collection of Old Paintings). This work appears to date to the Meiji Period and it is not clear where it was made. It is a scrapbook of small wood-block prints, clippings from newspapers and magazines, paper pilgrimage souvenirs *(junrei fuda)*, and other objects. One print is signed Totoya, that is Uoya Hokkei (1780–1850). He was another famous student of Hokusai.

167

Kogata gajô (A Small Art Book). This wood-block-printed album by some unknown artist contains twenty-eight portraits of poets from the Medieval Period, each of which is accompanied by one of the subject's poems. The poems are paired with others written in the Edo Period. There is no publication information.

168

Kogata nishiki-e harimaze chô (An Album of Mixed Small-scale Color Wood-block Prints). This collection of prints includes eight examples of beauties *(bijin-ga)* by Eizan (1787–1867), seven prints in ink and light colors of the Eight Views of Edo *(Edo hyakkei)*, and theater prints, the last group signed Eishi (1756–1829).

169

Koka Mu-Tamagawa (The Six Tama Rivers in Old Poetry). This small album contains one print of the Twenty-four Japanese Paragons of Filial Piety *(Honchô nijû-shi kô)* by Kuniyoshi. In addition, it contains five of the six prints of the Six Tama Rivers *(Mu-Tamagawa)* by Hiroshige.

170

Kokon azuma nishiki kagami: san no uchi (A Mirror of Ukiyo-e Past and Present: One of Three). This work is another collection of wood-block prints that were originally published separately but are now bound together. Who bound the prints together or when they were bound is not known. The prints include depictions of foreigners, theater prints *(shibai-e)*, and comic pictures. There are twenty-three single-sheet prints, four diptychs, and four triptychs. Artists include Utagawa Yoshikazu (fl. 1850–1870), Utagawa Kunisato (?–1851), and Hiroshige II (1826–1869).

171

Komochi nezumi: hana (no) yamauba (The Mouse with Children: The Flower of Yamauba). This wood-block-printed book by Akatsuki no Kanenari was published in 1827. The publisher and place of publication, however, are not given. The Library owns only the *jô* volume.

172

Konjaku zoku hyakki (A Hundred Ghosts from the Expanded Tales of a Time Now Past). These wood-block-printed books by Toriyama Sekien were published by Naganoya Kankichi in Ise in 1805. The Tales of a Time Now Past *(Konjaku monogatari)* is a collection of more than a thousand stories, traditionally attributed to Minamoto no Takakuni (1004–1077). The Library owns three volumes of Sekien's work, of which volume 3 is bound with *Hyakki yakô shûi*. As is the case for that work, this one depicts monsters, goblins, and similar subjects.

173

Kôrin gashiki (Kôrin's Style of Painting). This single-volume, color, wood-block-printed book was published by Ôkura Magohei in Tokyo in 1889. It consists of miniature wood-block-print reproductions of works done in the style of Ogata Kôrin (1658–1716).

174

Kôrin hyakuzu (A Hundred Paintings by Korin). *Tsunogaki* states *Shinsen* (New Selection). Hosokawa Kaiekidô published this set of two wood-block-printed books in Kyoto. It reproduces a hundred paintings by Ogata Kôrin. In the postscript to the work, Sakai Hôitsu (1761–1828) states: " Since the year 1850 marks the hundredth anniversary of the death of Ogata Kôrin, we publish this work to serve as an aid to those who love Korin's graceful paintings." The Library owns the complete set of two books.

175

Kôrin hyakuzu: kôhen (A Hundred Paintings by Kôrin: Part 2). This wood-block-printed book has an introduction by Tani Bunchô (1763–1840) that is dated 1826. However, the work was actually published in Kyoto by Matsumoto Teizô in 1890. It presents more works by Kôrin. The Library owns the complete set of two books.

176

Kôrin shinsen hyakuzu (A New Selection of a Hundred Paintings by Kôrin). This famous wood-block-printed book was compiled by Ikeda Koson (1801–1866) and was published in

1864. The publisher and place of publication are not given. The work consists of Koson's reduced-size reproductions of the paintings of Ogata Kôrin. The Library owns only the *ge* volume.

177

Kôrin shinsen hyakuzu (A New Selection of a Hundred Drawings by Korin). Matsumoto Teizô published these two wood-block-printed books in 1891. They contain reproductions of a hundred paintings by Ogata Kôrin, printed in miniature in black and white. The Library owns the complete two-book set.

Kotori zukai
See *Ehon kotori zukai*

178

Kotowaza (Proverbs). This work consists of a bag containing thirty-two loose-leaf, wood-block prints. The prints were made in Osaka from blocks owned by Nishikiya Kihei, who is, therefore, identified as the publisher. The work is a collection of proverbs, each accompanied by a cartoonlike illustration. The illustrations are by Eisen, Utagawa Yoshikazu (fl. 1850–1870), and nine other artists. Yoshikazu was the student of Kuniyoshi and is known for his drawings of Westerners in Yokohama.

179

Heso no yadogae (The Navel's Change of Address). Alternate title: *Kotowaza heso no yadogae* (Proverbs: The Navel's Change of Address). *Tsunogaki* states *Kokkei jinbutsu* (Humorous figures). These twelve wood-block-printed books were published in Osaka by Wataya Kihei. The title of the work is a phrase meaning to laugh heartily. The text of the book is by Ikkadô Hansui (?–?), and the illustrations are by one Yoshimune or Hôbai (1819? –1879).

180

Kumanaki kage (Lucid Silhouettes). This single-volume, color, wood-block-printed book by the famous lacquer master Shibata Zeshin (1807–1891) and others was published in 1867. The work has an afterword by Kanagaki Robun, that is Nozaki Bunzô (1829–1884), the journalist and author of the type of farcical works called *gesaku*. *Ukiyio-e jiten* identifies Kôkôsha Baigai (1794–1804) as the compiler. Mitchell (p. 380) identifies Baigai as the copyist of one and possibly all the works shown. See also Kerlen (p. 412). Each page is divided into an upper and lower part. The right side of the lower part consists of a *hokku* poem, to the left of which appears the silhouetted profile of the

poet. The upper part gives a brief biography of the poet.

181

[Kusunoki Masashige Kô, So-ô Kôu]. This album of freehand ink drawings is by some unknown artist. When and where it was made is not clear. The work, which has no title, depicts ancient Chinese and Japanese heroes. It was given the title *Kusunoki Masashige Kô, So-ô Kôu* (Lord Kusunoki Masashige, King of the Sung Dynasty Kôu [Hsiang Yu]) because those are the first two figures that appear in it.

182

[Kyôga]. This work was compiled by Kisai in 1875. It belongs to the same category as *Kyôga awase* (Picture Matching Game). The book has a note written in 1875 stating that: "The pictures in this collection represent each province of Japan by means of pictures of their local products or historical associations."

183

Kyôga awase (Picture Matching Game). This book of 134 freehand drawings by some unknown artist is dated 1867. The *kyô* from *Kyôga* in the title of this book is not in common use. It does appear in Yamada Katsumi's dictionary of specially difficult characters, *Nanji taikan*, p. 286, where we learn it means interesting or fun.

184

Kyôgaen (Garden of Crazy Sketches). This wood-block-printed book contains a number of caricatures drawn in color by Gekkôtei Bokusen. He was the artist from Nagoya who lived with Hokusai and worked with him on his *manga* (comic book) after 1812. The publisher and place of publication of this book are not known, but it was published in 1809. Kerlen notes the existence of Maki Gekkotei Bokusen's *Kyôgaen shohen* (vol. 1), dated 1809. Mitchell notes a Maki Bokusen *Kyôgaen*, published in Nagoya, but undated. Kerlen says the 1809 *Kyôgaen shôhen* is a reprint. The Library copy is marked *shohen* (vol. 1).

185

Kyôka Fusô meishozue (Pictures of Mad Verse on Japanese Famous Places). The work has an alternate title of *Fusô meisho zue* (Pictures of Famous Places). This wood-block-printed book by the little-known Katsura Seiyô (?–?) was compiled by Hinokien Baimei and had its debut in 1836. See Mitchell (p. 259). The work consists of mad verse or *kyoka* illustrated with drawings of famous places in Japan.

186

Kyoka hyakunin isshu: yamiyo no tsubute (A Hundred Verses by a Hundred Mad-verse Poets: Throwing Stones in the Dark of Night). This manuscript *(shahon)* was compiled by Koshigaya Sanjin and is dated 1832. Each page bears a *kyôka* (mad verse), illustrated in color.

187

Kyoka sodekura-kago (No translation). *Tsunogaki* states *Gojunin isshu* (Fifty People). This wood-block-printed book was compiled by Yamamoto Wadamaru and was privately published by Shikaisai (Jikaisai) in 1812. The place of publication is not given. The work was illustrated by Furuichi Kinga (fl. 1800–1840) and Utsumi Mototaka (fl. 1780–1820). *Nihon gakka jiten* states that Utsumi was from Echizen, moved to Kyoto, abd studied with Maruyama Ôkyo and Nagasawa Rosetsu (1755–1799). Nothing is known of Furuichi, *Nihon gakka jiten*, for example, giving only his dates. The work shows fifty *kyoka* poets and their poems. The Library owns three volumes bound into one book. The work is complete.

188

Kyôsai gafu (Drawings by Kyôsai). This wood-block book by Kawanabe Kyosai, printed on colored paper, is a compilation of the kind of short humorous poems called *senryû*. The introduction bears the date 1860 and is by Rokudaime Senryû (Senryû IV), the fourth generation from Karai Senryû (1718–1790), who is credited with creating and popularizing the *senryû* verse form. The original book was published by Suwaraya Sasuke in Edo in 1860 but this book probably dates to the Meiji Period since it is on pulp paper. The Library owns only one book from part 1 of the work.

189

Kyôsai gafu (Drawings by Kyôsai). This work has the same title as that cited above, but is not similar. It is close to *Kyôsai hyakuzu* (A Hundred Pictures by Kyôsai), though it includes one more picture, for a total of fifty.

190

Kyôsai hanshita (Underdrawings by Kyôsai). This book of drawings by Kyôsai consists of nineteen leaves, containing forty-five freehand sketches in ink, with some blue and red color added. The drawings resemble Kyôsai's prints of the *Gyôsai hyakki gadan* (A Hundred Demons) so closely as to suggest that they are the preliminary sketches for those prints. The drawings are on the thin, nearly transparent paper called *gampi* that is commonly used for *hanshita-e*.

191

Kyôsai hyakuzu (A Hundred Pictures by Kyôsai). The Library owns three versions of this wood-block-printed work which consists of forty-nine loose-leaf pages in six envelopes. Each sheet bears a proverb, a saying, or an epigram. These include such things as "Praying in a Horse's Ear" *(uma no mimi ni kaze)* or "Trying to balance a hanging bell on the end of a paper lantern" *(chochin ni tsurigane)*. Each proverb, saying, or epigram is accompanied by an illustration in a comic-book *(manga)*-like style. The work was printed from blocks owned by Wakasaya Yoichi of Edo. The publication date is not known.

192

Kyôsai hyakuzu (A Hundred Pictures by Kyôsai). This work is the same as the one cited in the previous entry. It is in an accordion-book format *(orihon)*, and the printing is not as good as in the previous work. An additional statement notes that the work by Kawanabe Kyôsai was based on an idea by Mantei Ôga.

193

Kyûrô gafu (The Art of Kyûrô). This wood-block-printed, black-and-white book of *haiga* is by Ki Baitei, also known as Kyûrô (1734–1810), and it was published by Yoshida Shinbei in Kyoto in 1797. Baitei was Buson's student; he moved to Otsu and came to be known as Otsu Buson. The Library owns only one book from volume 2.

194

Manga hyakujo (Humorous Drawings of a Hundred Women). This single-volume, wood-block-printed book by the Osaka Ukiyo-e master Aikawa Minwa (?–1821), also known as Aikawatei, was published in 1814 by Maekawa Rokuzaeimon in Edo, Yanahara (Yanagibara) Kihei in Kyoto, and Yoshidaya Shinbei in Osaka. It shows the everyday life of women in simple cartoonlike ink drawings with some light brown color added.

Manga zuko gunchô gaei
See *Gunchô gaei*

195

Masukagami (Clear Mirror). *Tsunogaki* states *Santo haiyû*. This wood-block-printed book by Shôkôsai Hanbei, that is Shôkô (fl. 1795–1809), was published in 1806. There is no other publication information on the work. Shôkôsai Hanbei was another of the teachers of Hokuju and one of the founders of Kamigata-e. This work consists of portraits *(nigao)* of Kabuki actors active in Osaka. The Library has only the *jô* volume.

196

Matsukawa hanzan ehon (Sketchbook of Matsukawa Hanzan). This set of six books of freehand drawings is by the Osaka Ukiyo-e artist Matsukawa Yasunobu, called Hanzan (fl. 1850–1882). It is an example of a humorous book or *kokei bon*. The Library owns the complete set of six books.

197

Meihitsu gafu (Drawings by Famous Artists). This color, wood-block-printed book by the unknown artist Ôko Sanenobu was published by Wataya Kihei in Osaka in 1859. It contains miniature drawings of figures and scenery. The Library owns only volume 2.

198

Meihitsu gafu (Art book of Famous Paintings). There is no artist or publication information for these four wood-block-printed books. This work is not the one that Kerlen (p. 1038) cites as *Toba meihitsu gafu* by Tani Bunchô, published in 1869. The illustrations are by twenty-one artists from the late Edo Period to the Meiji Period. They include work by the little-known *haiku* illustrator Harada Keigaku (fl. 1850s), the lacquer master Shibata Zeshin, and Onishi Chinen (1797–1851). Onishi, who became the student of Tani Bunchô, was a samurai in charge of government granaries. The color illustrations show mostly scenery, people, and flowers.

199

Meika gajô (A Sketchbook of Eminent Artists). This book of eighteen freehand drawings in color with thirteen *haikai, waka* and *nihon kanshi* is by fourteen different artists. When it was made is not known. The illustrations do not always correspond to the poems. Furthermore, although the title states that the artists included are eminent, many of them are unknown.

200

[*Meishô keichi*] [Famous Beautiful Places]. This single-volume, wood-block-printed book is an album of twenty-seven three-color prints *(san-shoku zuri)* depicting such famous places as Mt. Fuji, the paired rocks at Futamigaura, the "floating hall" at Katata (*Katata no ukimido*), the island near Kamakura called Enoshima, and the Nachi Falls. The work was published in Edo. It is signed Kôkunsai Bairin, but it is not certain who he was. The book is dated 1826 in the introduction.

201

Meizan zufu (Pictures of Famous Mountains). This set of wood-block-printed books by

Bunchô was compiled by Kawamura Motoyoshi and published in 1804. The place of publication and publisher are not known. However, Kerlen (p. 448) notes that Shôhakudô owned the blocks from which the book was made. The work shows a hundred drawings of famous mountains in black and white by Bunchô. The Library owns the complete set of three books.

202

Mikuwa sairei no e (Pictures of the Festivals of the Mikuwa Shrine). This book of freehand drawings by an unknown artist dates to the Meiji Period. There is no publication information. The work contains color pictures of the floats that appear in the festivals of the Mikuwa shrine.

203

Miyako meisho gafu (Art book of Famous Places in Kyoto). Aoki Tsunesaburô published these two wood-block-printed books in Osaka in 1894 . The work consists of sixty-three pictures, the majority of which are the same as those in *Yamashiro meishô fûgetsu shû* (Collection of Famous Places of Yamashiro Province). That work appeared in 1885, nine years before this one, has a different publisher, and contains fifty-nine illustrations. This book has four more illustrations and includes compositions by Maruyama Ôkyo, Matsumura Keibun, Yamaguchi Soken, and other artists not included in the other book. The Library owns the complete two-book set. See Mitchell (p. 421).

204

Miyo no hana (Flowers of the Era). Fujii Magobei published this wood-block-printed book in Kyoto in 1892. It consists of Nakamura Busuke's reduced-size, color, wood-block reproductions of the work of various great Kyoto artists. These artists are the flowers of the title. They include mostly late-nineteenth and early-twentieth-century masters, such as Imao Keinen (1845–1924), Suzuki Shônen (1849–1918), and Yamamoto Shunkyô (1871–1933). The Library has volume 6 from this edition.

205

Miyo no hana (Flowers of the Era). Fujii Magobei published this wood-block-printed book in Kyoto in 1893, a year after the previous title. Like that work, this one consists of Nakamura Busuke's reduced-size, color, wood-block-print reproductions of the work of the various great late-nineteenth and early-twentieth-century Kyoto artists. These include Miyake Gogyô (1864–1919) and Tamura Soryû (1846–1918). The Library has volume 11 of this edition.

206

Mono yû hana (Talking Flowers). This wood-block-printed book by some unknown artist was published in 1791. There is no other publication information, and there is nothing on the compiler, who is named Chintei. The work is a book of *haikai* poems, one to a page, accompanied by illustrations.

207

Musashino (Musashino). This book of twelve prints by the unknown artist Tanaka Oseki (?–?) shows the scenery of Musashino in color. The work was published by Kokadô in 1894.

208

Nangaku gahon (Art Book of Nangaku). This book of twenty-six freehand genre sketches is by Nangaku. There are a number of artists who used this name. *Nihon gakka jiten* lists eight. One was Watanabe Nangaku (1767–1813), who is discussed in the entry on *Nangaku-Bumpô tekurabe gafu* (Comparison of the Art of Nangaku and Bumpô). However, it is not clear if he is the author of this work.

209

Nangaku-Bumpô tekurabe gafu (Comparison of the Art of Nangaku and Bumpô). This single- volume, wood-block-printed book is by Watanabe Nangaku and Kawamura Bumpô. There is no publication information on the Library work, but an imprint statement establishes that the blocks were made in 1811. The book in the Library, however, was produced later, possibly in the Meiji Period. It comprises comparisons of genre drawings by Bumpô, who worked in the Kishi style, and Nangaku who, though influenced by Kôrin and Ukiyo-e, is best known for introducing the Maruyama manner of Maruyama Ôkyo (1733–1795) into Edo. The book's preface is translated into English.

210

Nanshû-ryû (The Nanshû Style). This book of freehand drawings of birds and flowers in ink is by an unknown artist. The publication date is not given. The title of the work suggests that the drawings are in the manner of the little-known artist Nanshû or Nansô (?–1714). Honda notes that this name appears in the *Dainihon shoga meika taikan denki: ge hen* (The Great Compendium of Famous Japanese Painting and Calligraphy: vol. 3, p. 1606). There, it states that he was a priest of the Tofuku-ji, Kyoto, skillful in drawing. It is also stated that his common name was Nanshû and his priest name was Soshin. The name Soshin was also used by Watanabe Shiko (1683–1775) and various other

painters. Honda also notes that there is a biography of a priest Nanshû, the *Nanshû Oshô den* (Biography of Priest Nanshû), in the *Tofuku-ji monjo* (Records of the Tofuku-ji, p. 941) but that this source makes no mention of his artistic activities.

211

Nihon hyakushô den isseki-wa (Stories of a Hundred Warriors of Japan Told One Night). This set of wood-block-printed books was written by Shôtei Kinsui, also known as Nakamura Tsunetoshi (1795–1862), and illustrated by Yanagawa Shigenobu (act. 1802–1860). It was published in Edo by Yamashiroya Sahei and in Osaka by Kawachiya Moheii in 1854. Kerlen (p. 481) notes that a later version appeared in 1857. The work consists of a hundred stories about a hundred Japanese warriors. The Library has only volume 5, which contains the stories of Minamoto no Yoshimitsu (?–1127) and seven others.

212

Nippon sankai meisan zue (Products of the Japanese Land and Sea). This set of five wood-block-printed books by Shitomi Kangetsu was published in Osaka by Shioya Uhei and three other houses in 1799. It introduces the *meisan* or famous products of Japan, giving their history and production methods. Illustrations show workers making these products. The Library has the complete set of five books.

213

[Nikuhitsu fûzokuga] [Genre Scene Paintings]. There is no artist or publication information on this single-volume book of drawings. It consists of simple line drawings of persons, such as craftsmen, in a soft brush on paper coated with resist.

214

[Nikuhitsu fûzokuga] [Genre Paintings]. There is no publication information on this single-volume book of genre paintings. These works by an unknown artist are in ink with some color.

215

[Nikuhitsu mokuhanga kirinuki chô] [A Scrapbook of Freehand Drawings and Prints]. There is no publication information. The work consists of a number of miniature freehand drawings in the *nanga* style, most in ink, though some are colored. The drawings are pasted onto what appears to be *shibugami* (paper that is tanned with persimmon juice). The work also contains three wood-block prints and fifteen rubbings of Japanese mirror designs.

216

Nishiki-e aratamein nendai kôshô (A Collection of Censor's Seals from Brocade Prints). There is no publication information on this book of full-color, wood-block prints of censors' seals that were copied by the unknown Kanagawa Shinba.

217

Nishin sensô emaki (Hand Scroll of the Sino-Japanese War). This color, wood-block-printed book by an unknown artist was published by Shun'yôdô in Tokyo in 1895. Although entitled Hand Scroll, this work is not in that format. Rather, it is a collection of individual illustrations of the land and sea battles of the Sino-Japanese War (1894 -1895). The book's table of contents is in English. The Library owns only numbers 2, 3, and 5. A note attached to the book attributes it to Suzuki Kason or Suzuki Sôtarô (1860–1919), a Maruyama-style painter. There is, however, no other evidence to support this attribution.

218

[Nôgaku] [Noh]. The title of this single-volume, color, wood-block-printed book is uncertain. The work is by the famous artist Kawabata Gyokushô (1824–1913) and was published in Tokyo in 1882 by Fukuendô. Gyokushô is the Shijô painter, influenced by Charles Wirgman, who became a leading figure in Tokyo art circles. This book consists of images of *Noh* dancers.

219

O-atsurae mihonchô (A Sample Book from which Customers Order). This three-volume scrapbook is made up of bits of wood-block prints and freehand drawings. One drawing is signed Toyohiko, possibly a reference to Okamoto Toyohiko (1773–1845). He was a Shijô painter, the teacher of Shibata Zeshin. On the other side of the cover page of this book, there is the attribution *Koyama Shokkô-jô* (Koyama Textile Manufacture). The scrapbook is the sort often used as sample books from which customers can choose designs for the textiles that they order.

220

[Oban nishiki-e, ichi] [Large-format, Full-color, Wood-block Prints: Volume 1]. We do not know when, where, or by whom this album was made, but it contains seven single-sheet actor prints, four diptychs, and twenty triptychs, totaling thirty-one prints. The prints are by such artists as Utagawa Kuniyoshi and Kunisada.

221

[Oban nishiki-e, ni] [Large-format, Full-color, Wood-block Prints: Volume 2]. Again, we do not know when, where, or by whom this album was made, but it consists of seven single sheets, two diptychs, eight triptychs, and one four-part work, for a total of eighteen prints. All the works are by Kunisada.

222

Ôgata surimono harimaze-jô (A Collection of Large-format *Surimono*). This collection of *surimono* by various poets and artists dates from about 1848 to 1853. Each sheet contains an illustration and a number of poems relating to the New Years, suggesting that these works were made as New Years' greetings.

223

Ôgata surimono harimazechô (A Collection of Large-format *Surimono*) . This work is the same in form and content as the preceding one, except that it dates to the period around 1853 to 1857.

224

[Okumura Masanobu gajô] [An Album by Okumura Masanobu]. There is no publication information on this black-and-white, wood-block-printed book. However, Okumura Masanobu (1686–1764) was the influential Ukiyo-e painter, printmaker, and publisher who is credited with inventing pillar prints *(hashira-e)* and perspective pictures *(uki-e)*, among other things. The book shows life in the Yoshiwara, or brothel district of Edo, as it existed in Masanobu's Kyôhô Era (1716–1735). The original from which this work was taken may date back to that time.

225

Ôkyo gafu-ge (Art of Ôkyo: Ge Volume). This single-volume, wood-block-printed book was published from blocks owned by Sasada Yahei in Kyoto. Its date of publication is not known. The work is a drawing primer that shows birds, flowers, figures, and animals in color. It purports to be meant for children.

226

Ôkyo gafu: jô (Art of Ôkyo: Jô Volume). This wood-block-printed book was reissued by Fujii Magobei in Kyoto in 1893. An imprint statement indicates that the work is a recarving of another book originally published in 1873. Mitchell notes that the work was published in 1850 by Ishiya Magobei of Kyoto and reissued in 1891 by Tanaka Jihei of Kyoto. The Library work is an even later issue. The book in the Li-

brary shows flowers, birds, scenery, and other subjects in color. The imprint statement also cites the original painter as Maruyama Ôkyo. Since Ôkyo died in 1795, it is clear that he only inspired these works.

227
Ômisoka akebono zôshi (The Novel: New Year's Eve). This novel was written by Santô Kyôzan and illustrated by Utagawa Toyokuni, Kunisada, Kunimasa (1773–1810), and others. Who Yoshiami might be is not clear. The book was published by Tsutaya Kichizô in Edo. The Library owns eight volumes bound together into one fascicle.

228
[Omocha-e, kodomo-e: harimaze jô] [A Collection of Toy Pictures and Children's Pictures]. There is no artist or publishing information for this collection of large-format, full-color, wood-block prints of the sort that are called *omocha-e* or toy prints and *kodomo-e* or children pictures. The work includes prints by such artists as Kuniyoshi, Kunisada, and Yoshitora.

229
Osaka komisemono banzuke (Programs for Small Spectacles in Osaka). This work is a collection of advertisements and programs for sideshows that featured such things as a two-headed, three-eyed horse or a thirty-five-foot-tall Dutch clock. The illustrations are by artists such as Yoshinobu, Yoshiharu and Kunitsuru. The work dates from about 1830 to 1859.

230
Oshi-e shû (Collection of *Oshi-e*). This work is an album of *oshi-e*. It shows twenty Kabuki actors on stage. The work is in the Harunobu style, but the artist and publication information are not given. For more on *oshi-e*, see *Oshi-e hayageiko* (A Quick Exercise [for Learning to Draw] *Oshi-e*).

231
Oshi-e hayageiko (A Quick Exercise [for Learning to Draw] *Oshi-e*). *Tsunogaki* of *Kinubari saiku* (Techniques for Pasting up Silk). This single-volume, wood-block-printed book was written by Kusseiken, another name for Inoue Keitan. It was published in 1825 in Kyoto by Zeniya Shôbei and in Osaka by Kashiwaraya Shôbei. *Oshi-e* are a type of collage. An image is cut out of thick paper and covered with the fabric or paper, leaving an opening which can be stuffed with cotton. The resulting rounded form is pasted down onto a board or paper support to compose the final image. The technique is espe-

cially popular for decorating battledores (*hago-ita*). This book gives instructions on making *oshi-e*, showing techniques for creating the underdrawing, the right thicknesses of papers to use, the way to make the paste, and techniques for gluing things together. Kerlen (p.534) lists the work as *Kinubari saiko, oshi-e hayageiko*.

232
Otehon (Handbook). This single-volume book of nine freehand color drawings of flowers, birds, fish, and landscape is by the Kyoto painter Seiryûsai, also known as Morikawa Sôbun (1847–1902). The last page bears his seal.

233
[Rekishijô jinbutsu] [Historical Figures]. There is no publication or author information on this single-volume, wood-block-printed album of eighty-six miniatures of persons from Chinese and Japanese history and lore. The title is also uncertain.

234
Retsujo hyakkunin isshu (A Hundred Poems Matched to a Hundred Heroic Women). This single- volume, wood-block-printed book by Katsushika Manji Rôjin, that is Hokusai, and Utagawa Toyokuni (1769–1825) was published in Edo by Yamaguchiya Tôbei in 1847. It consisted of two parts: The Thirty-six Poems Matched to Images of Thirty-six Artisans, and The Hundred Poems Matched to a Hundred Heroic Women. Both parts are included in the work in the Library. Hokusai did the illustrations for the first, and Toyokuni did them for the second. The images of the women are each accompanied by an appropriate poem.

235
Ruisei sôga (No translation). The meaning of the word *ruisei* in the title is not clear. This wood-block-printed book by some unknown artist was published in Osaka in 1724 by Terada Joryû (Bunkidô). It depicts people from the Edo Period. The work in the Library consists of three volumes bound together as one fascicle.

236
[Ryakuga-fuku] [Sketchbook]. The work itself consists of fifteen freehand sketches of dolls, personal belongings, and animals in red ink. There is no artist or publication information. It is possible that this is an artist's source book.

237
Saiga zushiki (On the Fine Style). *Tsunogaki* states *Kacho sansui* (Birds and Flowers: Landscapes). This wood-block-printed book by Katsushika

Isai (1821–1880) was published in 1864. Lionel Katzoff notes that this is the fourth edition of *Kachô sansui zushiki*, first published in 1849. See Kerlen (pp. 301–303). There is no publication information on the Library work. Katsushika Isai was the student of Hokusai who lived with him and later designed prints to sell to Westerners. This book comprises designs for combs, sword guards, ornaments, and similar objects. The designs include images of people, animals, birds, flowers, and scenery. The Library owns volume 4.

238
[Sairei zu] [Pictures of Festivals]. This black-and-white, wood-block-printed album by Kitagawa Utamaro was published in Edo. The publisher and date of publication are not given. The work depicts events and customs practiced yearly from January to June. The cover is in black brocade and states: "Painted by Utamaro." Gold dust has been sprinkled on some pages. The January festival is the *Eho mairi*; for February, the *Hatsu-uma mairi*; for March, the *Mokubo-ji mairi*; for April, *Shaka mairi*; for May, *Meguro mairi, Fudo myo-o*; and for June, the *Gion mairi*.

239
Saitan Fusô meisho zu (Famous Places of Japan on New Year's Day). This single-volume, wood-block-printed book by some unknown artist was published in 1799. There is no publication information. The compiler of the work was Issuian. It consists of simply illustrated *hakai* poems about the various Japanese New Year's Day customs.

240
Sanjû rokkasen (Thirty-six Poets). This book of freehand drawings has an *okugaki* that dates it 1822. The work consists of thirty-six poems by sixteenth- to eighteenth-century *hakai* poets including Sokan, Matsuo Bashô (1644–1694), and the little-known Onitsura (1661–1738). Sokan was a *renga* poet whose dates are not certain. Records at the Shinjuan of the Daitoku-ji suggest he died around 1539 or 1540. Each poem is accompanied by a portrait by Suzuki Nankai (fl. 1820s), simply drawn in color. Who Suzuki Nankai might be is not clear, but he should not be confused with the better-known Gion Nankai (1677–1751).

241
Sansui ryakuga-shiki (Landscape Sketches). This single-volume, color, wood-block-printed book by Kuwagata Keisai was published in Osaka in 1812 by an unknown publisher. The work shows

Wakanoura, the Eight Views of Omi, and other equally famous places. The printing is of poor quality.

242

Santai gafu (Three Styles of Drawing). This single-volume, wood-block-printed book by Hokusai, with proofs corrected by Totoya Hokkei (1780–1850) and others, was published in Edo by Kadomaruya (Kakomaruya) Jinsuke and in Nagoya by Eirakuya Tôshirô and one other house in 1816. The book shows the Three Styles of Drawing *(santai gafu)*, about which Shokusanjin (1749–1823) says in the introduction: "Just as there are three styles of calligraphy, the *shin* (Formal), the *gyo* (Running or Semiformal) and the *so* (Grass or Informal), so there are three styles of painting." The work gives examples of the three styles of painting from the work of Hokusai.

243

Seichû gishi meimei gaden (Paintings of Famous Loyal Samurai). This single-volume, wood-block-printed book by Utagawa Yoshitoshi was published in 1869. There is no other publication information on the work. It contains portraits of the Forty-seven Ronin and short descriptions of their lives.

244

Sensai Eitaku gafu (The Art of Sensai Etaku). This black-and-white, wood-block-printed book by Eitaku or Sensai was published by Okura Magobei in Tokyo in 1884. It concerns incidents from ancient Chinese and Japanese legends.

245

[Shaseichô] [Freehand Sketchbook]. This book of freehand drawings in ink by an unknown artist was made during the Tempô Period (1830–1843).

246

Shashingaku hitsu (A Primer for True Drawing). *Tsunogaki* states *Bokusen soga* (Sketches by Bokusen). This single-volume, wood-block-printed book is by Gekkôtei or Maki Bokusen (1736–1824). The publisher and place of publication were not given in the Library work; the introduction is dated 1814. Kerlen (pp. 32–33) cites the publisher as Hishiya Kinbei, the place of publication as Nagoya, and the publication date as 1815. It consists of quick, simple sketches *(ryakuga)* in color. The sketches show people's customs and manners *(fuzoku)*. Many different kinds of artisans are shown.

247

Shi no kô (A Poetry Manuscript). The compiler of this manuscript is not known. The work is a miscellany, consisting of Chinese poems, *waka*, and other subjects illustrated with freehand drawings.

248

Shin bijin (True Beauties). This set of thirty-six portraits of beauties by Toyohara Chikanobu (1838–1912) is reputed to be the last great masterpiece of the final flowering of Ukiyo-e. These colored, wood-block prints feature many special techniques of printmaking, including shading *(bokashi)*, shining ink *(tsuyazumi)*, and gauffrage *(karazuri)*. The prints are mounted as a book that was published in Tokyo in 1898 by Matsumoto Heikichi.

249

Shin bijutsukai (A New Sea of Art). This wood-block-printed book by some unknown artist was published by Yamada Geisôdô in Kyoto in 1903. The Library has only volume 10.

250

Shinji andon (Decorations for Festival Lanterns). This set of five wood-block-printed books was published in 1829 in Nagoya by Eirakuya Tôshirô and in Edo and Osaka by twelve other publishers. The first volume of the work is by Matora (Shinko) or Ôishi Jumpei (1794–1833). Jimpei was a Tosa-style painter of Nagoya who claimed descent from Ôishi Yoshio of the Forty-seven Ronin. The second volume is by Utagawa Kuniyoshi. The third and fifth volumes are by Eisen or Ikeda Yoshinobu (1790–1848). Eisen was the pupil of Kikugawa Eizan (1787–1868) and author of the revised version of the famous history of Ukiyo-e: *Zoku Ukiyo-e ruiko*. Volume 4 is by Utagawa Kuninao (1793–1854), the Chinese-style painter who became the student of Hokusai and Toyokuni. The work consists of illustrations of the type of comic poetry called *senryû*. The original advertisement for the book was still attached to the copy in the Library. It states: "This book is a manual of funny and humorous pictures for drawing on hanging paper lanterns to be used on festive occasions. Its merit lies in the fact that even children who are only beginning to draw can draw these pictures without an art teacher." The Library owns the complete five-book set.

251

Shinji gafu (Festival Pictures). This wood-block-printed book by an unknown artist was published by Eirakuya Tôshirô in Nagoya. The date

of publication is not known. According to the book's introduction, this work presents one-line jokes *(hitokuchi monku)* and puns *(jikuchi)*, appropriately illustrated, and purports to teach children to draw.

252

Shintoku nara miyage (Shintoku's Nara Souvenirs). The author and artist who created this work are not given and neither is the publication date. The publisher was Nakajima Matabei and the work was published in Kyoto. The Library owns only the *ge* volume which consists of sixteen leaves and two illustrations. The work shows old legends from the Nara area which mostly concern the mercy of Buddha and various miracles performed by the gods. The year of publication is printed at the end of the book, but it is so damaged that it is impossible to read with any assurance; it is possible that the date is 1654.

253

[Shôdô gafu] [Shôdô's Sketchbook]. This *oribon* consists of twenty-two freehand drawings of flowers and birds in beautiful color. The freshness of the colors and the very modern style suggest that the work dates to the Meiji Period. The book bears two seals of the artist Shôdô and his signature on the back side of the cover. Comparing the signature on this book to that of Murakami Shôdô (1776–1841) as it appears in *Nihon gakka jiten, ryakkan hen* (p. 307), it is hard to believe that this is the same person. Honda notes that there are at least ten artists known by the same name. The Library owns only volume 2 of this work.

254

Shôkiken bokuchiku fu (A Text on How to Draw Bamboo in Ink). This black-and-white, wood-block-printed book on how to draw bamboo was published in 1759. It is by some unknown artist and it is unclear who did the Library volume, which has no publication information.

255

Shônen sansui gafu (Landscape Paintings by Shônen). This wood-block-printed book by the Kyoto artist Suzuki Shônen (1849–1918) was published by Aoki Sûzandô in Osaka in 1893. It shows twelve landscapes in color and is produced on modern pulp paper.

256

Shoshoku gatsû (Drawings of Various Manufactured Objects). This wood-block-printed book by Utagawa Hiroshige was published in Edo from blocks owned by Fujiiokaya Keijiro. The Library owns only one book from part 2. That

work consists of simple sketches in blue and brown of such varied subjects as arms and armor, people, birds, and animals.

257
Shoshoku jinbutsu gafu (A Sketchbook of Various Artisans). This color, wood-block-printed book depicting artisans by Ichijusai Kishun (?–?) was published in 1823 in Edo from blocks owned by Yoshidaya Bunzaburô. A number of Utagawa artists used the name Ichijusai, though written differently, but who this might be is not clear.

258
Shukuzu (Miniature Drawings). This book by an unknown artist contains fourteen miniature freehand ink drawings of birds, flowers, and animals . The work may be an art student's practice book since the brushwork is rather clumsy. An inscription on the cover of the book states: "Belonged to Bakusen." It is unclear who he is.

259
[Shukuzu gajo] [A Sketchbook of Miniature Drawings]. There is no publication or author information on this book of miniature freehand drawings. Most of them are in ink, but a few are in color. The Library owns only volumes 4 and 5.

260
[Shûsaku shukuzu] [A Sketchbook of Miniature Pictures]. This single-volume book consists of reproductions in pale color of paintings by Ogata Kôrin and Kuwagata Keisai. It bears the comment that it was owned by Shûsai. It is not certain who he is but he may be the person who produced the work.

261
Shûzô suiko meimei den (Stories of the Lives of Each of the Characters of the Suikoden). This wood-block-printed book by Tsukioka Yoshitoshi (1839–1892) was published by Odawaraya Matashichi (Ôhashidô) in the Meiji Period, possibly in Tokyo. Kerlen (p. 683) notes that the original 1867 Edo publication was by Odawara Yashichi. It contains portraits of the heroes of the *Suikoden*, each accompanied by a brief biography. The Library owns only one book from part 3.

262
Soga hyakubutsu (Rough Sketches of a Hundred Things). This wood-block-printed book was published by Tsurugaya Kyûbei in Osaka in 1832. Its contents are the same as in *Harikae andon*. The character *so* in the title is an unusual one not normally used. The character means

rough, in the sense of simple and quick. The Library has one volume. Mitchell (p. 496) notes a complete two-volume example.

263
Sôgajô (An Album of Informal Drawings). This set of four books of freehand drawings in ink with some color cannot be attributed to any particular artist. However, a separate note attached to the work states that it is by Keigaku. There is an artist named Harada Keigaku (fl. 1850–1860) from Kawagoe who might be the Keigaku cited. The books are not numbered and so their sequence is not known. They show scenery, people, fruits, fish, birds, and flowers, all drawn in a simple, rough style.

264
Sôhitsu gafu (Informal Drawings). This wood-block-printed book by Ichiryûsai or Utagawa Hiroshige is dated 1850 in the introduction. The Library work has no other publication information, but Toda notes that the place of publication was Edo and the publisher was Shôrindo. It shows various miniature works of art, including small figures, birds, and landscapes. The Library owns only one book from part 2.

265
Sôka koromo no ka (Flower Arrangement: Scent of Clothing). *Tsunogaki* of *Shikigaen* (Elegant Four Seasons). This set of wood-block-printed books by Tawaraya Sôri III (fl. eighteenth to nineteenth centuries) was compiled by Teishôsai Ichiba, Teishôsai Bei Ichiba, and Keiryû Hiroatsu (1764–1838). The Library's work states that it was published in 1801 in Edo by Ashikagaya and Kobayashi Shinbei and in Osaka by Kashiwaraya Seueimon and Suwaraya Zengorô. The work is a flower arrangement manual. The Library owns the complete set of four books. Kerlen (pp. 685–686) notes a *Sôka koromo no ka kohen* (second edition) as *shohen* (first edition), published in 1812 with Tawaraya Sori III as illustrator.

266
Soka ryakuga shiki (Sketches of Flowering Grasses in Color). This single-volume, wood-block-printed book by Kuwagata Keisai was published by Suwaraya Ichibei and four others in Edo in 1813. It consists of simple color drawings of flowering grasses. The title can also be read *Soga ryakuga shiki.*

267
Sôkajô (A Sketchbook of Flowering Grasses). This book of eight freehand, color drawings of people, birds, flowers, and animals bears this

statement on its first page: "Copied by Eimin on the 21st day of the second month of 1866." Eimin is unknown. The style of the painting on the first page, however, seems to differ from that of the works in the rest of the book.

268
Soken gafu sôka no bu (The Flower and Grasses Section of the Album of Soken). This wood-block-printed book has a date of 1804 in the introduction, though it was published in 1806. The name of the publisher and place of publication are not given, but Mitchell notes that the work was published in Kyoto and that it was illustrated by Yamaguchi Soken. Kerlen (pp. 498–499 and 692) notes that the publisher was Noda Kasuke. The work is an album of prints that reproduce the paintings of Yamaguchi Soken in black and white or in light colors. The Library owns only the *jô* and *chû* volumes.

269
Soken sansui gafu (Landscape Paintings by Soken). There is no publication information on the Library's copy of this wood-block-printed book by Yamaguchi Soken. It shows his landscapes, printed in black and white. The Library owns the *jô* volume.

270
Tama hiroi: Koshi no bu (Selected Jewels: Koshi Section). *Tsunogaki* states *haikai*. The work has an alternate title of *Tama hiroi: Koshi no bu* (Selected Jewels: Koshi Section) that is written with different characters. According to the introduction, these two lightly colored, wood-block-printed books by Moriyoshi, Bairi, and others were compiled by Bakusenjô Ukô, supported by the Kôryôshachû group in Toyama in 1856. The work was published by Kôryôshachû in Toyama in 1856. Who Moriyoshi, Bairi, and Bakusenjô Ukô might be is unclear. Mitchell (pp. 512–514) gives the date of publication as 1861 and the publisher of one issue as Omiya Matashichi of Kyoto and the other as Kameya Hanbei, Fushimi. The old provinces of Etchû, Echizen, and Echigo used to be called generically Koshi no kuni. Thus, this work contains *haikai* poems by poets from those areas. The poems are illustrated. The Library owns the complete set of two books.

271
Tani Bunchô honchô gasan taizen (Tani Bunchô's Complete Compendium of Japanese Art). *Tsunogaki* states *Zôho* (Additional). This wood-block-printed book contains fifty drawings by Tani Bunchô of fifty famous paintings by fifty different artists. Short, simple biographies ac-

company the pictures. The publisher and place of publication are not known, but the work was published in 1890. The Library has only the *jô* volume.

272

Tani Bunchô Honchô gasan taizen: maki no ge (Tani Bunchô's Complete Book of Japanese Art: Volume 2). *Tsunogaki* of *Zôho* (Additional). This work was edited and illustrated by Tani Bunchô, and was supplemented by Haneda Shiun. It can be placed between 1891 and 1892, but there is no other publication information on the Library copy. However, it appears in Mitchell as *(Zoho) Tani Bunchô Honchô gasan taizen.* Mitchell notes a second issue of 1894. The work contains miniature, color, wood-block-print reproductions of paintings by Sesshû Tôyô, Maruyama Ôkyo, and forty-eight other famous artists. Short biographies of the artists accompany the images. The Library owns the *ge* volume of the set.

273

Tategu hinagata: ken (Furniture Designs: The *Ken* Volume). *Tsunogaki* states *eyo* (Art Method). There is no publishing information on this wood-block-printed book. It is also unclear who created the work, which is an introduction to furniture and interior design.

274

Toba meihitsu gafu (Famous Toba Drawings). There is no publication or artist information on this single-volume, wood-block-printed book. However, Mitchell (p. 527) gives the date of publication as 1869 and notes that the work was compiled by Bunchô's followers. See also Kerlen (p. 439). The work is an example of the genre of comic drawing called *Toba-e.* It portrays persons and events from history. The people are exaggerated—drawn with particularly long legs, small eyes, and big mouths. When people speak, their dialogue appears in the picture

275

Toba sangokushi (*Toba* of the Three Capitals). There is no publication or author information on this one-volume, wood-block-printed book. It consists of depictions of festivals: the Daimon-ji, Kiyomizu, Kamo, Sumiyoshi, Taikobashi, Nishinomiya, and Ikutama festivals. The first three are Kyoto festivals, the last three, Osaka. No distinctly Edo festival could be identified. One would expect to see an Edo festival, since the title of this book refers to the Three Capitals, meaning Kyoto, Osaka, and Edo.

276

Toba-e fudebyôshi (*Toba-e* Brushstrokes). The imprint statement on this single-volume, black-and-white book gives the publisher as Kajita Kanesuke in Nagoya. It is a revision of *Toba meihitsu gafu* and was originally published as three separately bound books. However, the work in the Library has all three books bound as one. Hasegawa Mitsunobu is given as the artist of this work in Library set. That name is associated with Eishun, the artist who was also known as Nagaharu (fl. 1704–1763). He was one of the Kaigetsudo masters who worked in Edo. However, it is not certain that he is the man referred to here.

277

[Toba-e jô] [A Book of *Toba-e*]. This single-volume, black-and-white, wood-block-printed book by some unknown artist contains fourteen examples of the humorous pictures called *Toba-e.* There is no publication information.

278

Toba-e ôgi no mato (A *Toba-e:* The Target Fan). There is no artist or publication information on these three wood-block-printed books. However, Kerlen (p. 728) notes a later reprint, *Toba-e ôgi no moto* by Ôoka Shunboku, published by Kawachiya Kihei in Osaka in 1720. Volume 1 is entitled The Clownish Doll *(Odoke ningyô)*, volume 2 is Illustrations of Kyôgen *(Kyôgen ga)*, and volume 3 is To the End of the Twelve Months *(Junigatsu kiwami)*.

279

Toba-e sangokushi (*Toba-e* of the Three Countries). These two wood-block-printed books by an unknown artist were published in Osaka in 1720 from the blocks owned by Terada Yoeimon. The term *sangoku* in the title of this work means three countries and refers to the cities of Osaka, Kyoto, and Edo. However, given that the work in the Library is incomplete, it is not certain whether or not it showed *toba-e* from all three cities.

280

Tôga hitori keiko (Practicing Drawing by Oneself). This one-volume, wood-block-printed book by an unknown artist was published by Kashiwaraya Gihei in Osaka in 1848. It is a primer on how to draw in the Shijô style. It shows mainly vegetables.

281

Tôkaidô shokoku chôbô (Views of Various Places on the Eastern Sea Road). There is no artist or publishing information on this *surimono* book.

However, it appears to date to the nineteenth century. It consists of two parts. Part 1 shows various views of Mt. Fuji as seen from the *Tôkaidô* (Eastern Sea Road). Part 2 consists of more images of Mt. Fuji, this time in different weather conditions and in various seasons. The work is printed in pale colors. Each view is accompanied by a *hakai* poem. The Library has the *ge* volume.

282

[Tokyo meisho] [Famous Places in Tokyo]. This single-volume, wood-block-printed book by Utagawa Hiroshige was published by Amejima Kamekichi in Tokyo in 1881. It provides an introduction to the temples, shrines, and other famous places in not just Tokyo, but Japan as a whole. The title is uncertain.

Tôto meisho zue
See *Edo meisho zue*

283

Tôto saijiki (Annual Festivals of Edo). Alternate title of *Edo saijiki* (Annual Festivals of Edo). This famous, black-and-white, wood-block-printed book was compiled by Saitô Yukinari and illustrated by Hasegawa Settan, with additional illustrations by his son, the Osaka painter and bookmaker Shôsai, also known as Settei (1710–1786). It was published by Suwaraya Mohei and Suwaraya Ihachi in Edo in 1838 and depicts festivals in early-nineteenth-century Edo, organized according to season. The Library has volume 1, spring: parts 1 and 2; volume 2, summer; and volume 4, winter. These are bound together into two fascicles.

284

Tôto shokei ichiran (Views of Famous Places in Edo). These two wood-block-printed *surimono* by Tatsumasa, another name for Katsushika Hokusai, were published in Edo by Tsutaya Jûzaburô and Suwaraya Moheii and one other house in 1800. They contain comic verse or *kyoka* about the festivals and the yearly events in Edo. The poems appear at the top of the page with Hokusai's colorful illustrations below them.

285

[Tsunenobu gajô] [Art Book of Tsunenobu]. There is no publication information on this sketchbook of seventeen freehand drawings of people, scenery, and other things in ink and thirteen in color. The work is unsigned; however, it bears three seals of Kanô Tsunenobu. One of these seals appears in the seal section of Sawada Akira, *Nihon gakka jiten, rakkan hen*, p. 499.

286

Ukiyo gafu (Pictures of the Everyday World). Alternate title of *Keisai ukiyo gafu* (Keisai's Pictures of the Everyday World). These wood-block-printed books are by Keisai Yoshinobu, also called Eisen. Eirakuya Tôshirô published the work in Nagoya and twelve other publishers published it in three other cities, but the date of publication is not clear. The book is not a work of Ukiyo-e. Rather it consists of miniature pictures of people, birds, flowers, insects, landscapes, and other things. The work is probably a Meiji-Period reprint. The Library owns two books of the set, parts 1 and 2. For more on Eisen, see *Keisai ukiyo gafu* (Ukiyo Drawings by Keisai).

287

Ukiyozukushi-e (Pictures of All Worldly Matters). This manuscript consists of drawings of fish and shells and bears the name of the little-known Osaka artist Makino Fukumatsu (?–?). It appears to date to from the Meiji Period.

288

Umi no sachi (Ocean Treasures). This famous, color, wood-block-printed book was edited by Sekijukan Shukoku and has illustrations by Katsuma Ryûsui (1711–1796). It bears a date of 1762 for the preface, but Kerlen notes that the work was published in 1772. There is no other publication information on the work in the Library. The work depicts fifty different kinds of fish, shells, and other sea creatures, each accompanied by a *haikai* poem. Ryûsui, the Edo artist, calligrapher, and sealmaker worked in the circle of Suzuki Harunobu (1724–1770). He published a companion volume to this piece called *Yama no sachi* (Mountain Treasures) in 1765. The two works are reputed to be one of the finest early examples of color printing.

289

Un'en seihitsu (Lively Drawings of Clouds and Fog). There is no artist or publication information on this sketchbook of freehand drawings and calligraphy. However, it appears to date to the Meiji Period. Some of the calligraphy is by the little-known Keizan (?–1924), who should not be confused with the earlier Ohara Keizan (?–1733) or with Koshiba Keizan (fl. 1780). The work also contains eight brush paintings of mountains in a *nanga* style by the unknown artist Shun'nô. The works are in ink with light brown and blue colors added.

290

[Unpitsu soga] [Rough Brushwork Sketches].

This wood-block-printed book by Tachibana Morikuni (1679–1748) was published by Nishimura Genroku in Edo and by Shibukawa Seiemon and one other in Osaka in 1749. The work shows the rudiments of drawing figures, animals, and birds. It is particularly interesting because its author and artist, Tachibana Morikuni, was a student of the Kano painter Tsuruzawa Tanzan (1655–1729), who was famous for being disowned by his school for publishing their secrets. The word *un* in the title of the book means destiny, fate, or luck. *Pitsu* or *hitsu* is brush. What a fateful or lucky brush might be is a moot point. Therefore, no attempt was made to render the title literally and a title descriptive of the work's content is given. The Library owns the *ge* volume.

291

Utagawa Toyohiro kyôga jô (A Notebook of *Kyôga* by Utagawa Toyohiro). This work consists of eighteen black-and-white, wood-block prints by Utagawa Toyohiro (1773–1828) pasted into a notebook. Toyohiro is the student of Toyokuni, who was one of the teachers of Hiroshige.

292

Utagawa Yoshiharu gajô (A Sketchbook by Utagawa Yoshiharu). This album of fourteen color, free-hand drawings purports to be by Utagawa Yoshiharu (1828–1888). Yoshiharu is one of the lesser pupils of Kuniyoshi. Thus, one would not expect much from him, but even so, one wonders if this work is really his.

Wakan ehon sakigake
See *Ehon sakigake*

Wakan koji bokuo shinga
See *Boku-ô shinga*

293

Wa-kan meihitsu gaei (Paintings by Famous Japanese and Chinese Painters). The Library has volumes 5 and 6 of this set of originally six black-and-white, wood-block-printed books. The works are collections of reduced-size copies of various masterpieces by artists of the Kanô school. These include Kanô Tan'yû (1602–1674), Tôun (1625–1694), and Tsunenobu (1636–1713). Tan'yû is the Kanô painter who moved from Kyoto to Edo in 1614 and founded the Kajibashi branch of the school. He became the official painter of the shogunate. Tôun (Dôun) is Kanô Masanobu (1625–1694), Tan'yû's son-in-law. He founded the Surugadai branch of the family. He should not be confused with the Kanô Masanobu (1434–1530) who founded the main branch of the school. Tsunenobu is yet a

third Kanô painter. He brought the Kobikichô branch of the school to prominence. There is no publication data on the Library work, but Kerlen (p. 765) gives the illustrator of *Wa-kan meihitsu gaei* as Yoshimura Shûzan (?–1776) and the date of publication as 1750, with a reprint around 1771.

294

[Wakashû] [Collection of Waka]. This color, wood-block-printed book contains thirteen poems that celebrate the New Year. There is no publication information. The work is a *mame hon* (literally, a pea book, that is a miniature book). It is signed Utamasa, the pseudonym of Maki Bokusen, who is known for his collaboration with Hokusai; he also worked with Utamaro. It was during his time with Utamaro that he used the name Utamasa. His students Gessai (1787–1864) and Gessai II (fl. midnineteenth c.) also used that name.

295

Yakusha fûzoku sangokushi (Customs of Actors from the Three Kingdoms). The work has an alternate title of *Yakusha sangokushi* (Actors of the Three Kingdoms). This wood-block-printed book by Ryûsai Shigeharu (1803–1853) was compiled by Hanagasa Bunkyô and published by Kawachiya Tasuke in Osaka in 1831. It consists of six detailed depictions of the early nineteenth-century theatrical world of Edo, Kyoto, and Osaka. These three cities are the Three Kingdoms mentioned in the title. Shigeharu was a student of Yanagawa Shigenobu. He started using the name Ryûsai around 1826, a period in which he was almost the only full-time, professional actor-print designer in Osaka. This work is in the Osaka or *kamigata* style and is particularly notable for its fine printing. The Library owns the *jô* volume.

296

Yakusha nigao kagami (A Mirror of Likenesses of Kabuki Actors). This famous, color, wood-block-printed book written by Asakusa Ichindo and illustrated by Utagawa Toyokuni I (1769–1825) was published in Edo by Yamadaya Sanshirô in 1804. It consists of thirty-three portraits of Kabuki actors, who appear one to a page. Each is accompanied by a *kyôka* (mad verse) poem.

Yakusha sangokushi
See *Yakusha fûzoku sangokushi*

297

Yamashiro meishô fûgetsu shû (Collection of Famous Places of Yamashiro Province). This work was published in Kyoto in 1885 and consists of color, wood-block prints of Kyoto's famous places by fifty-nine artists. These include such little known Meiji masters as Tamazaki Gyokusho (1886–?), Takahashi Mannen (1896–?) and Suzuki Kayô (1888–?). The Library has two sets of this work, for a total of four books. The pictures are the same in both, but only one has *haikai* poetry on each page. The version in Mitchell (p. 551–552), which he dates 1885, has the poems.

298

Yamato jimbutsu gafu (A Picture Book of Japanese Figures). This black-and-white, wood-block-printed book by Yamaguchi Soken (1759–1818) was published by Fujii Magobei in Kyoto in 1804. Soken originally brought out *Yamato jinbutsu gafu* in 1800 and then followed it with a second edition called *Yamato jinbutsu gafu kohen* in 1804. The Library's work was published in 1804 but it is not marked *kohen*. It is, however, marked *ge kan*, which is the last volume in a *jô, chû, ge* or *jô, ge* sequence. Soken or Sojun was a Kyoto painter, one of the students of Maruyama Ôkyo. The Library work shows various kinds of physical labor being performed by Japanese farmers.

299

Yamato jinbutsu gafu (An Art Book of Japanese Figures). These two wood-block-printed books by Yamaguchi Soken depict daily life, legendary stories, and other Japanese things. There is no publication information on the Library work. However, Mitchell (pp. 552–553) notes a *Yamato jinbutsu gafu* published in 1800 and a *Yamato jinbutsu gafu, kohen* (second series) published in 1804. See also Kerlen, p. 784, for the 1804 edition.

300

Yamato Nishiki (Japanese Brocade). This set of wood-block-printed books has an alternate title of *Yamato Nishiki* (Japanese Brocade), written in Chinese characters rather than *kana*. The work is by the unknown artist Suzuki Manne(?–?). It was published by Tanaka Jihei in Kyoto in 1888. The work consists of five volumes of which the Library has four. It is a picture book, depicting the yearly events and festivals of the court, and it is divided into four parts according to season. The work is printed in light black and red. The table of contents is in romanized Japanese as well as script.

301

Yanagawa gajô (Album of the Art of Yanagawa). This single-volume, wood-block-printed book by Yanagawa Shigenobu (1787–1832) is believed to have been published in the early Tempô Period (1830–1843). It shows flowers, birds, and figures and is in the *beni-zuri* technique of wood-block printing in which only red is used. Yanagawa is the Osaka printmaker, originally a puppetmaker, who studied with Hokusai, married his daughter, and became his adopted son. However, Lionel Katzoff wonders if the work might be by Shigenobu II (fl. ca. 1820).

302

Yodogawa ryôgan shôkei zue (Pictures of the Famous Places on Both Banks of the Yodogawa). The author and artist of this color, wood-block-printed book is the little-known Akatsuki no Kanenari (?–?). The work was published by Kawachiya Heishichi and three others in Osaka and by Honya Sôshichi in Kyoto in 1824. The work shows the scenery on both banks of the Yodo River in Osaka, focusing on the business activity, especially in the areas about famous bridges. There are *waka* poems above the pictures and explanations of each of the scenes shown. The Library owns the *ge* volume.

303

Yûhô bijutsu ôyô (Application of [the Principles] of Yûhô's Art). This wood-block-printed book by Tanaka Shozaburo (ca. 1866–ca. 1910), the little-known artist also called Yûhô, was published by Tanaka Jihei in Kyoto in 1890. The work is a design book of people, animals, landscapes, birds, and flowers. The Library owns volume 2.

304

Yûzen sarasa shinpon (A New Manual of Yûzen Dyeing and Sarasa Printed Cloth). This wood-block-printed album was compiled by Mori Tsunezô. There is no publication information on it. The work is a collection of samples of Yûzen dyeing designs that are cut out of wood-block prints and pasted together in a homemade album.

305

Zaisen shûgajô (A Primer for Learning the Art of Zaisen). This black-and-white, wood-block-printed book is by Hara Zaisen (1849–1916). It was published in Kyoto by Tanaka Jihei in 1889. It contains thirty illustrations of blossoms, vegetables, and other things.

306

Zoku koya bunko (The Sequel to the Koya Library). This famous, five-volume set of woodcut books was compiled by Boukô (Gao), with illustrations by Gesshô, also known as Chô Yukisada (1772–1832). Gesshô was a student of Matsumura Goshun (1752–1811) and Nagasawa Rosetsu (1754–99). Maekawa Rokusaeimon and one other house published this book in Edo in 1798, as did Fûgetsu Magosuke in Nagoya, Fûgetsu Sôzaeimon and one other house in Kyoto, and Kawachiya Kihei and one other publisher in Osaka. The works consists of *haiku* poems, each of which is accompanied by a picture drawn by Gesshô. The Library owns the complete set of five volumes.

307

[Zuan shukuzu gajô] [Album of Small Pictures]. This book of freehand drawings is by an unknown artist. When or where it was made is not known. It was probably meant to be a design book and it contains many small, finely detailed pictures of birds, flowers, insects, animals, figures, and many other subjects. The illustrations are on different sheets of paper of irregular size, pasted together to form the pages of this handmade album.

308

[Zuan shû] [Collection of Designs]. There is no publication or author information on this album of hand-drawn miniature designs. When the work was made is also not known. It consists of small pictures cut and pasted onto the individual pages.

309

[Zuan shû] [Design Book]. There is no publication or author information on this set of three books of freehand drawings in color. They illustrate landscapes and flowers. What these sketches were to be used for is not clear, but they seem perfect for kimono decorations.

井上氏己に月本橋魚一の岸に住む
みのを子びイ
伝弥誓屋弥高衛稽号の草の弥
水月窓
以山人の給る如寄の性の侠情を
土坊ぐろになるこへゞ寺ふ風額に
松井義吉忠史浄る好で和合ん
一個の達人と称る筆に戦場と街ま
にを比で通名五巷に

BOOKS SPEAK BACK

JAMES DOUGLAS FARQUHAR
UNIVERSITY OF MARYLAND

*J*apanese books speak with a resonant voice. But how exactly do they express ideas and how do they convey them to the reader?[1] Not solely through content, for surely Japanese books express themselves with formal elements such as format, presentation of the text, and decoration. Through their form they gain a supplementary voice that converses in an uninterrupted dialogue with readers.

Format, presentation of text, images, and meanings all bespeak modes of communication. Japanese books communicate in rich variety, ranging from focused, highly ordered displays of fixed intentions and conclusions to free, evocative, implicit and contingent exchanges with the reader. Here I will sketch some of this richness using order and form as organizing principles, while exploring the implications of the conceptual framework and presentation of Japanese and European books.

Order

Order is the underlying organizing principle that predetermines the plan or idea of a book. Almost every book is the product of a carefully conceived plan. This plan or design influences how it will be perceived by a reader. It speaks in subtle and obvious ways, and its speech is altered by the experience of every reader and by the continuing dialogue a reader has with each book, insofar as what a book says changes during the process of this interchange.[2]

We often do not have a clear idea of who this planner was and what other contributions he or she made to a manuscript or book. At times the task seems to have been assumed by various people such as the author, translator, illustrator, and publishing house. The decisions affecting page layout and organization of the text were not easy to make or self-evident. Each text contains parts that are related to the subject matter and its division into char-

III

The undifferentiated flow of characters sometimes found in Japanese texts is well illustrated in the vertical title bar in green on this page from *Kumanaki Kage* (Lucid Silhouettes).

acters or words, phrases, sections, and so on. The person who made the ultimate decisions about planning was faced with the task of presenting this text in a way that consistently makes a distinction between its parts yet contributes to the unity of the work. Many techniques or combinations of techniques are used to show textual relationships; for example, the use of scripts and typefaces of different size, style, and quality, or adjustments in spacing to separate one section from another or to give the impression one section belongs with the following rather than with the preceding. In this way the book would speak to the reader, and the reader would be not only aided but also to some extent guided through the book.

Japanese books are frequently conceived in ways that make their message more implicit—inferential rather than stated. Sequence, connections, and progression from one point to another are not rigidly structured in either form or content. Rather, the reader acquires great latitude and responsibility for making connections and understanding significance. Thus, some might say Japanese books put demands on readers; they potentially say more by saying less, by omitting or eliding parts, requiring readers to supply more if they are to get more from the dialogue with the book. In contrast to European books, the essential is often unstated, the various components are provided, but not necessarily in sequential or strictly ordered form, and without reaching a prescribed conclusion, giving the reader more freedom and leaving open possibilities of discovery and interpretation.

European books, on the other hand, tend to be predominantly designed as an explicit guide for the reader, directing the reader towards a specific understanding or conclusion. Stemming from antiquity, modified and reinforced by the Middle Ages and modern periods, the underlying design of Western books reflects a system of logic that depends on ancient rhetorical principles, progressing from exposition and elaboration to conclusion. Sequence, connections, and progression from one point to another usually obey principles that clearly define the relationships and stipulate the direction and the impression of what is intended. Western books speak to the reader in a determinate way, ordering the thinking and impression of the reader to a significant extent. The result is an explicit order that is oriented towards a conclusion.

112 A AND B

Utagawa Yoshitoshi. *Seichu gishgi meimeiden.*
(Paintings of Famous Loyal Samurai).

Form

FORMAT

Simple changes in format greatly affect the presentation of a book, the page layout, and the organization of the text and illustrations. All these components shape the beginning of a dialogue between the book and reader, influencing the process of reading and understanding.

In Japan the book format evolved from that of the hand scroll, but with the noteworthy provision that the hand scroll and book existed comfortably alongside one another into the modern era. Scrolls move easily backwards and forwards between the reader's hands. Rolled and unrolled from one hand to the other, hand scrolls allow their message to flow continuously

before the reader, providing tangible links to that which momentarily preceded the view of the reader and what imminently would follow that view. Japanese books display the variety of shapes and forms one expects to see, but with some extraordinary exceptions, for example the so-called accordion book. Accordion books seem to have an evolutionary place immediately between the scroll and the present-day book. Folded into expandable segments, the paper in an accordion book is folded and unfolded, expanded and contracted, exposing new reading experiences to the reader in the process and having the advantage of the folded compactness of a codex and the forward and backward continuity found in scrolls—a remarkable innovation.

An equally inventive format is the tall, narrow format of many early Japanese books. These proportions allow the books to slip easily into a pocket and to be held open in one hand for reading while riding a horse on a journey—reins in one hand, book open in the other.

Similarly formatted, tall, narrow, prayer books from fifteenth-century England can be identified—for example, the Talbot Book of Hours in Edinburgh National Library—although I am unaware of any attempt to assign a travel purpose to them. The English achieved this format by placing the first fold of a rectangular sheet of parchment or paper along the vertical axis, rather than the horizontal axis favored in France.[3] This procedure yielded a final leaf format that was tall and narrow instead of more square.

European book design also evolved from ancient scrolls and experiments with the emerging form of the modern codex or book in late antiquity and the Middle Ages. Replaced by a new, more compact form—the codex—in the early Christian era, scrolls lost significance as an important format by the Middle Ages, although they were favored for transmitting ancient texts for centuries. Arguments have been made for identifying the emergence of the codex with that of Christianity, providing as it did the capability of containing bulky texts in a durable, relatively small, and above all portable format.[4]

SUPPORT

In Japan, choosing the support of a book is among the most important decisions made by the person who plans a book. This decision determines the life of a book and the structural and visual ground of the contents. As a re-

sult, the qualities of texture, color, transparency, strength, thickness, and evenness of the support add to both the personality and life of a book. All these features contribute to what the book says to the reader.

Japanese scrolls and books use paper made from plants, primarily the *kôzo*, paper mulberry tree, through the early and middle period up to the present day. Of remarkable fineness and strength as well as durability, it often displays translucent properties and conveys tactile qualities of a delicate nature. Yet it is strong with its slightly raised surfaces, saying "special, important, take time, treat with care!"

Both paper and parchment made from animal skins were common supports in the late Medieval-early Renaissance period of Europe, with paper supplanting parchment after the advent of printing circa 1453. Parchment is "that stouffe that we wrytte vpon: and is made of beestis skynnes: is sometyme called parchement [from Pergamon, a city in Asia Minor] / sometyme velem [bycause it is made of a caluys skynne]…sometyme membraan….because it was pulled of by hyldinge fro the beestis lymmes."[5] Made from soaked, stretched, and dried skins that are scraped and polished while they dry, parchment provided a most durable support and conveyed a lasting impression on the reader through the variations in texture, color, and pliability. Although favored in Europe for centuries, parchment was avoided as a support in Japanese books precisely because it was "made of beestis skynnes."

Used predominantly for over one thousand years, until about 1500, parchment yielded to manufactured paper in Europe. "Papyr fyrste was made of certeyne stuffe like the pythe of a bulrusshe in Aegypt: and syth it is made of lynnen clothe soked in water stampte or grunde and smothed."[6] Made from linen cloth, the acid-free durability of paper produced between 1400 and the midnineteenth century rivaled parchment. Durable, robust, with raised texture and bleached surfaces, it provided a flexible, abundant, cheaper support. Less esteemed perhaps than parchment, paper made in this fashion tends to be more substantial and heavier than paper today, providing a tactile effect for the reader.

GATHERINGS

Collecting or gathering the support assembles books into groups of individual leaves. These collections are called gatherings and they not only serve as

a guide to the structure of a book, they dramatically influence its appearance and proportions. Furthermore they indicate how the book was conceived and executed, the subsequent alterations, and the present composition.

Japanese books diverge significantly from the Western model. In one kind of Japanese book production, paper sheets are folded not in long sheets, but individually, and left uncut. When collected for binding, the fold can be found at the outer limit of the page, with Japanese page numbers straddling this folded edge, as if an accordion book were compressed on one side and sewn securely to a binding.[6] This practice has the effect of making the text compact and stable. It also creates a page that not only has a front and back, but also has blank surfaces on the unused inner area of each accordionlike fold, conceptually a space, enhanced by the semitranslucent quality of the paper, to be filled by the reader. This procedure was required because the semitransparent quality of Japanese paper frequently makes it impossible to write directly on the back of a sheet without the text visually bleeding through and hindering reading of the text on the front, and vice versa. Proceeding in this way, with the fold toward the outer edge of the page is, as we shall see below, opposite to the method followed in the West, which did not work with a semitransparent support.

Parchment and paper in the West are collected into groups of folios in two ways: by bifolios and by uncut folded sheets. The bifolio or double-leaf method is the least complicated. It involves assembling piles of sheets cut to a specific size and folding them in the middle. When folded the individual sheet becomes a bifolio, two folios joined together. Gatherings made from bifolios are therefore in multiples of two.

The uncut-folded-sheet method of making gatherings is an extension of the bifolio procedure, the difference being that more folds are made in the sheet and it is cut after folding rather than before. Folded twice, an undivided sheet of parchment or paper yields four leaves; whereas when cut with one more fold it provides eight equal-sized leaves.

In Western books these procedures provide individual leaves with a front and a back. As in Japan, before pagination became widely used, leaves were called folios and were designed by their number and whether they were the front or back, the recto or verso.

RULING

"Parchment leves be wonte to be ruled: that here may be a comly margent: also streyte lynes of equal distaunce be draw withyn: that the writtyng may shew feyre."[7] Before the advent of typesetting, Japanese and European books were often ruled; a grid of lines was placed on each folio to define both the area of the text and the individual lines of text. In Japan, Buddhist texts are commonly provided with ruling, literary texts are not.

Ruling—a guide for the scribe who wrote his text not on the line but suspended about a millimeter within or above—had a significant influence on the appearance of a volume. It provided a visual frame for the text, often

113

The plaque in this book wrapper from *E-zoshi harimaze cho* (An Album of Wrappers) contains an example of square script.

114

The inscription on the fan from this book wrapper from *E-zoshi harimaze cho* (An Album of Wrappers) is in the running style of calligraphy.

in color—magenta, green, mauve, brown, or gray. From it, the proportions of the text were determined, and from the ratio of the ruling to the size of the folio, the size of the margins was delineated, creating a sequence of proportional areas intimately related one to the other: text area, margins, edge of page, and binding create an external rhythm of proportions and relationships that speak to the reader.

Ruling also can say something as an economic index of the book. For scribes, the text area determined the amount of text per folio; for printers, the amount of type, thereby contributing to the length and cost of the book.

SCRIPT

A fifteenth-century advertisement for teaching different scripts in Nantes, France, gives us an idea of how scripts in manuscripts and fonts in printing are essential to the design and function. Script situates and projects the message the book transmits. Its form transmits significant messages to the reader. Consequently, the type and style of the script selected by the planner of the book is important.

> In the name of the Lord, amen. Those who wish to be instructed in the science of calligraphy, which nobody can acquire without the greatest diligence, may make an appointment with Robert de T's, cleric of Nantes and well accomplished in that art.... The kinds of script... are the following: *littera curialis, littera simplex et currens, littera serata seu conclavata, littera rotunda, littera seu textus fractus, littera seu textus semifractus, and littera bastarda,....*He will, with a benevolent heart, try to teach these or any other scripts as they may desire to learn, with many other excellent particulars, once they have cared to pay him well. The end.[8]

From such advertisements, it becomes obvious that a scribe could practice the craft in more than one script, making adaptations as needed. One can imagine how a book designer or planner could choose a script from those mastered by a scribe and make the same type of decision as is made by the modern editor who selects a type font from a book or computer list of available typefaces.

Just as scribes offered different scripts, printers in Japan and Europe

enrich their supply of type fonts to produce books that speak to a different audience, or say something different to the audience. Like digital fonts today, scripts and fonts have been and are chosen for legibility and for what they say through their formal characteristics about the contents. Their use often followed a hierarchy dictated by tradition and influenced by contemporary taste. Messages are conveyed by the choice of script or font, and styles can even be intermixed, for readability, but also to associate different messages with their accompanying text. These messages are contingent on the community that selects and reads them, and the readers provide a continuous and changing context. Thus, the appearance of the text says something about its content, whether using script or font, whether European or Japanese.

Indeed, Japanese scripts and types enjoy quite specific and diverse applications. Moreover, one must consider in Japanese scripts an appreciation of individual accomplishment and identity through connoisseurship of the personalized styles of scribes and authors.[9] Formal, standard, or square scripts commonly are chosen with Buddhist texts such as Sutras; cursive Japanese *hiragana* scripts and cursive and semicursive Chinese scripts are more appropriate with poetic, literary, secular, and personal texts.

Similarly, these distinctions appeared in European books. In two examples of scripts related to those advertised by Robert de T's, cleric of Nantes, *littera gothica formata* is appropriate for religious texts; *littera cursiva formata*, is better suited for literary and poetic texts. In this instance the parallel between Japanese and European choices is quite striking—a square formal script selected for religious texts, a freer cursive script for literary and more personal discourses.

SITUATING THE READER

A reader places a Japanese book with the spine facing the right, the cover is opened toward the right, and the pages are turned to the right.

Reading begins with the upper-right character and continues down a column of characters on the right-hand edge of the page, then moves up to the column of characters immediately to the left of the one just read, reading down and so on, continuing right across the gutter of the book to the facing page. It proceeds in this manner without the interruption of punctuation or capital letters, paragraphs, or other breaks, leaving the divisions,

phrasing, and understanding to the experience of the reader.

Western books, in opposition, are oriented with the spine of the book toward the left of the reader .

The cover is opened by swinging it towards the left and reading begins from the left with the uppermost line, proceeding horizontally towards the right, then returning to the beginning of the next line. Paragraphs, capitals, and various punctuation marks break the flow of reading into set components, organizing and regularizing thoughts and ideas into controllable units.

Capital letters and punctuation are an effective means of ordering the text; however, neither capitals nor punctuation are used in many of the Japanese books on display in this exhibition. For example, spacing within a line of words, such as two spaces after a period and before the beginning of a new sentence that says to the reader, "Stop here. Begin here," is not provided in Japanese books. Captions or rubrics, headings in red, are also not given, and the responsibility of the reader to understand the text is accordingly increased. For the Japanese reader, no stop signs, no start signs; all is internalized and left to the reader's judgment.

Distinctions as to where one idea or expression ends and another begins become a critical element of discernment, placing considerable stress on the experience and discretion of the reader to differentiate and interpret. This characteristic of Japanese books frees the text from a fixed or rigid interpretation. Especially valued ideas and phrases are often included, and they add to the task of the reader.[10] When wood-block type was used these quoted characters were cut in one block. They were inserted where desired, but without punctuation, quotation marks, separation by spacing, and so on. The decision whether these characters were to be understood as a unit or interpreted as belonging in combination with other characters depended on the reader's comprehension. Thus, the meaning of a text remained potentially more open to a variety of interpretations.

In the West, on the other hand, a different approach prevailed, one which simplifies and locks in a fixed interpretation or meaning. Sentences, paragraphs, chapters, and so on set off and presented the order of the text and argument as inherent. Capitals and various forms of punctuation became one of the primary ways of organizing texts into a hierarchy that clearly demonstrated its multiple divisions. Capital initials provided the simplest

manner of indicating this hierarchy and unity. Used as capitals they could be made in different sizes to differentiate the parts of the text. Thus, the first sentence of a paragraph could be planned with an initial one line high, sub-chapters with initials two lines high, chapters by initials three lines high, and large divisions of the book by initials five lines high. A simple visual hierarchy was thereby established to reflect the fundamental organization of the text. None of this could be left to chance; rather it followed a carefully executed plan. There was no latitude in mistaking where one idea ended and another began. The use of punctuation—commas, semicolons, colons, dashes, parentheses, periods, and so on—made these divisions and markers all the more emphatic, defined, and restrictive, as opposed to the Japanese system, which was less prescriptive.

A variation on Japanese practice involves texts written with Chinese characters and syntax. In Japanese books, coded instructions in terms of marks placed beside specific Chinese characters guide the reader to read one character first, another second, and so on throughout the text. These signs visually function like punctuation—a succession of codes steering the reader through the text.

In Western books, decorative elements became signposts of textual hierarchy and a prominent means of negotiating the text. Decorative initials, line-endings, borders, and images expressed the order and structure of the contents. Differences in size and type of initials indicated textual hierarchy and a great variety of types were used, progressing from simpler forms to larger, more elaborate forms as the significance of the textual divisions increased. The two different approaches to organizing the text and decoration in Japan and Europe produced two strikingly different effects on the reader—one internalized the undertaking, leaving the organization and divisions of the text in the domain of the reader; the other externalized the text in a structured, hierarchical way with clear signposts to guide, even control, the reader.

Conclusion

We have seen some ways that Japanese books promise a dialogue with readers through their formal components, yet how they fulfill such a promise depends on their voice, resonant but often understated. Format, supporting

大貌利啻尼亜噯咭唎一名是和蘭佛蘭西等

大貌利啻尼亜噯咭唎。是和蘭佛蘭西等ノ西海ニ有ル二島ノ
総稱ナリ此国北ハスコシア海ヲ限トス東ハ北海ヲ限リ
南ハ。カナールヲ限リ西ハ亜太臈海ニ臨ム全國三部ニ別
又五十二州ニ分ツテ中ニ六十二廈アリテ皆国
王ニ臣服ス大都府中ニ大河アリ繁盛ナル支西洋諸州
ニ比スル者ナシ府中ニ大河アリ龍動ト云名ヲ六十名ツク上ニ奇
巧ノ橋ヲ渡ス長ニ百八十丈ハ八十四丈餘夜中橋上ニ数
基ノ燈火ヲ點ズ是夜中往来ノ便トス人物勇壮ニシテ其
性又寬裕ナラズシテ怨恨ヲ好ム甚喜々深シ土人奇
巧ノ敷品ヲ出ス氣候寒暖共中和ニシテ人ニ宜シ北極地
ヲ出ル支五十度ヨリ五十八度ニ至ル

（England）

歐邏巴 イギリス 噯咭唎

115 A AND B

This two-page spread from Tagawa Harumichi (illustrator), *Gaiban yobo zue* (Portraits of Foreigners) shows an illustration of an English couple and a text concerning them.

116

This section of the text from Tagawa Harumichi, *Gaiban yobo zue* (Portaits of Foreigners) provides the Japanese readings of Chinese characters and other clues as to how to read the difficult parts of this text, such as the tiny open circles between the eighth and ninth characters that give the order in which things are read.

material, gatherings, script type/style, presentation of the text, images, and ordering principles all speak to the reader, but the message is quite different in the Japanese tradition where emphasis is placed on the reader, where reader participation becomes more fluid and subtly required, where more is left unsaid or open, and where less is directed toward a specific result. Thus, the means of organizing and presenting the book differ significantly between Japanese and Western books. Some of the richness of the Japanese approach to the book is indicated here, in a very Western-style essay; nonetheless, the real, unstated significance of the Japanese book is yet to be discovered by the reader in the books shown in this catalog.

Notes

1. I am most grateful to Dr. Sandy Kita, University of Maryland, Dr. Lawrence Marceau, University of Delaware, and the Reverend Honda Shôjô, retired Research Librarian, Li-

brary of Congress, for introducing me to the wonderful world of Japanese books.

2. For different ways, other than those discussed here, that a book may impose order that is to be deciphered and understood, see Roger Chartier, *The Order of Books*, trans. Lydia G. Cochrane (Stanford, 1994), originally published as *L'ordre des livres* (Paris, 1992).

3. For Graham Pollard's discovery of this, see his study, "Notes on the Size of the Sheet," The Library, 4th ser., no. 22 (1941):105–137, esp. 113–114.

4. See Colin H. Roberts, "The Codex," *Proceedings of the British Academy*, 40 (1954), pp. 169–204; Colin H. Roberts and T. C. Skeat, *The Birth of the Codex* (London, 1983); Michael McCormick, "The Birth of the Codex and the Apostolic Life-Style," *Scriptorium*, 39, (1985): 150–58; and Alain Blanchard, ed., *Les débuts du codex, Bibliologia*, 9 (Turnhout, 1989), as cited in Lawrence Nees, "Problems of Form and Function in Early Illustrated Bibles from Northwest Europe," in John Williams, ed., *Imaging the Early Medieval Bible* (University Park, Pennsylvania, 1999), p. 123.

5. William Horman, *Vulgaria* (The English Experience, no. 745; reprint of the London 1519 edition in facsimile) (Amsterdam, 1975), ff. 80v-81. "That stuff we write upon: and is made of beasts' skins: is sometime called parchment.../sometime vellum [because it is made of a calves skin]...sometime membrane...because it was pulled of by hiding [flaying] from the beast's limbs."

6. Horman, folio 80. "Paper first was made of certain stuff like the pith of a bulrush in Egypt: and since it is made of linen cloth soaked in water, stamped or ground, and smoothed."

7. See catalog item 98, where Sandy Kita uses the technique of situating page numbers on both sides of the fold to reconstruct a dismembered book, the sketchbook that is reminiscent of Hokusai and his students.

8. Horman, folio 82. "Parchment leaves be want [need] to be ruled: that there may be a comely margin: also straight lines of equal length be drawn within: that the writing may show fair."

9. (Paris, Bibliothèque nationale), Lat. 8685, ff. 51r-51v, as cited by S. H. Steinberg, "Medieval Writing-Masters," *The Library*, 4th ser., no. 1 (1941): 16–17.

10. See Shen Fu, Glenn D. Lowry, and Ann Yonemura, *From Concept to Context: Approaches to Asian and Islamic Calligraphy* (Washington, D.C., 1986).

11. A similar tradition referencing the past held sway in the West for centuries, see Ann Moss, *Printed Commonplace-Books and the Structuring of Renaissance Thought* (Oxford, 1996).

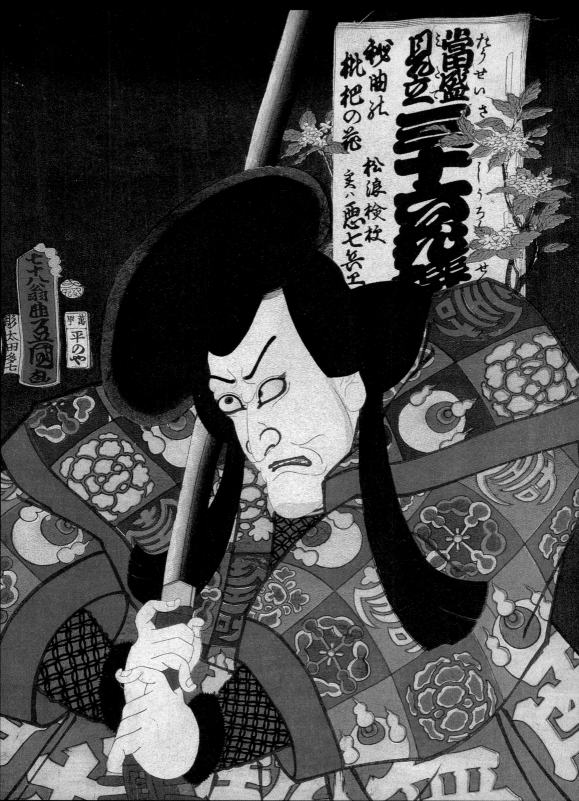

CONTRIBUTORS

KATHERINE BLOOD is fine print curator in the Prints and Photographs Division of the Library of Congress. She oversees the Library's collection of more than a hundred thousand artists' prints from the fifteenth century forward and provides specialized research assistance to those who plumb its depths. Before coming to the Library, she worked with museum collections at the Bishop Museum in Honolulu, Hawaii, and at the Smithsonian Institution's museums of Natural History and American History in Washington, D.C., where she gained a wide knowledge of works on paper, paintings, photographs, and objects. She coauthored *Eyes of the Nation: A Visual History of the United States* (Knopf, 1997) and is author of *Joseph Pennell and the Wonder of Work* (DVD ROM South Peak, 1999). She cocurated *The African American Odyssey: Fine Prints and Photographs by Twentieth-century African American Artists* and contributed to the companion catalog *African American Odyssey: A Quest for Full Citizenship* (Library of Congress, 1998). Recently, she wrote the preface for *David Roberts:*

117

Utagawa Kunisada. *Hikyoku no biwa no hana: Matsunami Kengyô, jitsu wa Aku Hichibei* (Flower of Secret *Biwa* Notes: Matsunami Kengyô, in fact Aku Hichibei) from the series *Tôsei mitate sanjûroku kasen* (Modern Selection of Thirty-six Flowers (Actors). One often hears of *chirimen-e* or crepe prints but it is rare to actually find one. The Library has two. This one, dated 1863, depicts Aku Hichibei in the role of Matsunami Kengyô. Kengyô is a name often used by *biwa* players. Thus the figure holds a sword whose handle is in the form of the head of a *biwa*.

Travels in Egypt and the Holy Land (Pomegranate, 1999). All of these projects have featured the Library's remarkable collections. Ms. Blood earned her M.L.S. from the Catholic University of America in 1998, with a concentration in special collections and visual materials.

JAMES DOUGLAS FARQUHAR, PH.D. University of Chicago and historian of fifteenth-century northern European painting, is especially known for his studies in manuscript art and the archaeology of the book. He is the author of *Creation and Imitation: The Work of a Fifteenth-century Manuscript Illuminator* and, with coauthor Sandra Hindman, of *Pen to Press: Illustrated Manuscripts and Printed Books During the First Century of Printing*, an extensive exhibition catalog that also includes his fundamental essay on methods of codicology, "The Manuscript as a Book." His shorter studies have appeared in *Scriptorium, Quaedrendo, Revue Belge, Revue du Louvre, Gazette des Beaux-Arts, Viator*, and the *Journal of the Walters Art Gallery*. He has held a Younger Humanist Fellowship from the National Endowment for the Humanities and a Samuel H. Kress Fellowship and a Robert and Clarice Smith Fellowship at the National Gallery of Art. He has also been a Fellow at the Institute for Advanced Study, Princeton, and a member of the Équipe de recherche sur l'humanisme française des XIVe et XVe siècles of the Centre National de la Recherche Scientifique, Paris.

SHÔJÔ HONDA was born in Hawaii in 1929. He is a graduate of Ryukoku University (1952), Kyoto, Japan, his special area of study being Buddhism. In 1955, he was ordained a Buddhist priest, and he has served as such for many years in the Washington, D.C., area. For thirty years, from 1961 to 1991, Honda was a reference librarian in the Japanese Section of the Asian Division in the Library of Congress. He has compiled three reference books: *Pre-Meiji Works in the*

Library of Congress: Japanese Mathematics (1982); with Konishi Jin'ichi, *Pre-Meiji Works in the Library of Congress: Japanese Literature, Performing Arts, and Reference Books* (1994); and with Sandy Kita, *Pre-Meiji Works in the Library of Congress: Japanese Art Books.* The Reverend Shôjô Honda also served as the curator for the Library of Congress exhibition, *Words in Motion: Modern Japanese Calligraphy* (June 15 to September 15, 1984).

SANDY KITA, PH.D. University of Chicago, is Assistant Professor of Japanese Art History at the University of Maryland, College Park. He is known for his studies of Ukiyo-e, Yamato-e, and their relationship. His book, *The Last Tosa: Iwasa Katsumochi Matabei, Bridge to Ukiyo-e* (1999), won subventions from the Millard Meiss fund of the College Art Association and from the Japan Foundation. He has published articles in *Monumenta Nipponica, Monumenta Serica, Oriental Art,* and *Orientations,* as well as the journals of the Cleveland, Carnegie, and Elvehjem museums of art. His career as a curator dates back to 1985 and the exhibition at the University of Wisconsin, Madison: *Reality and Reflection: Ukiyo-e and Modern Japanese Prints in the Van Vleck Collection.* His recent traveling exhibition was cataloged in *A Hidden Treasure: Japanese Prints from the Carnegie Museum of Art,* published by the Carnegie Institute of Pittsburgh (1995). He is a dedicated teacher, regularly offering a course on Ukiyo-e at the Rare Book School held at the University of Virginia, Charlottesville. He has won two teaching awards, and four of his students participated in this project.

LAWRENCE E. MARCEAU graduated from Colgate University in 1976, earned his Master's degree in Japanese Language and Literature from Kyôto University in 1983, and his Ph.D. in Japanese Literature from Harvard University in 1989. Currently Associate Professor of Japanese at the University of Delaware, Marceau has published numerous articles on early modern Japanese literature, literary thought, and East Asian comparative culture. His *Takebe Ayatari: A Bunjin Bohemian in Early Modern Japan* is slated for publication by the Center for Japanese Studies, University of Michigan, in the fall of 2001. Marceau is currently working on a study of the transformation of elite culture by middle-class intellectuals in eighteenth-century Japan. He is also committed to promoting the recognition, conservation, and bibliographic study of Japanese wood-block-printed books, albums, and manuscripts in North American collections.

GLOSSARY

atozuri literally "later rubs," reprints, recuts, restrikes, or any other issuing of a print, other than the original

azuma nishiki-e full-color prints

baren a flat circular tool that is used to rub a wood-block image

batsu imprint dates from epilogues

benizuri early prints, using only limited colors

beni-e early prints, using painted colors

bessho variant titles

betsu variant titles

bijin-ga images of beauties

bokashi shading

chirimen-e crepe prints

chitsu a case for storing and protecting multiple volumes

cho an author

chônin the merchant and artisan classes of Edo in the Tokugawa Period

chôshu see *machishu*

chû the middle book in a three-volume set

daisen a title piece

densetsu traditional stories

detchôsô a butterfly-binding style, in which the leaves are folded inward, and the spine edges are pasted together

ebon art or picture books

emaki illustrated hand scrolls

eshi a painter

ezôshi bukuro cases for holding books published in a series

fukeigakka landscape masters

fukuro-e bag pictures, i.e., illustrations on cases that house books in series

fuzoku customs and manners

ga an artist

gahô painting techniques

ganpi-shi translucent paper with vertical fibers, used for making underdrawings

ge the bottom book in a three-volume set

ge kan the last book in a three-volume set

gesaku farcical works

giga-teki playfully done

go an artist's pseudonym

gyo a running or semiformal style of calligraphy or drawing

hago-ita battledores

haiga illustrations of *haiku*

haikai the larger form of poetry, of which a *haiku* is the first line

haiku an unrhymed verse form

hakkô the principal publisher, distributor

han the principal publisher, owner of the blocks

hanashibon collections of humorous stories, popular romances, and action adventures

hanshita / hanshita-e underdrawings

harimaze prints that gather together the various objects that are associated with a particular thing

hashira-e pillar prints

hen a compiler, an editor

hitsu literally, "a brush," means painted by

hokku a type of poetry

hori the cutter in the three-person process by which Ukiyo-e are made

hôsho thick Japanese paper

iboku works left to us by deceased artists

jikuchi puns

jo imprint dates from introductions; foreword or preface

jô the top book in a three-volume set

jôruri puppet plays

junrei fuda paper pilgrims' souvenirs

kaibutsu monsters

kambun a Japanese literary compositional form patterned on classical Chinese

kamigata the Osaka style of drawing

kan a multivolume set of books; the publication date

kana a Japanese syllabary

kanki imprint dates from colophons

kannen fumei an undeterminable publication date

karazuri negative printing, gauffrage, or embossing

| | | | | | | |
|---|---|---|---|---|---|
| *ken* | a two-volume set of books | *renga* | linked verse | *tsuyadashi* | lacquering |
| *ketsu* | an incomplete set of books | *ryakuga* | sketches | *tsuyazumi* | shiny ink |
| *kibyoshi* | "yellow covers," a form of eighteenth- to nineteenth-century popular fiction | | | | |
| | | *saku* | an author | *uki-e* | perspective drawings, bird's-eye-view prints |
| *kô* | an editor or proofreader | *sankin-kôtai* | the shogunate system that required every warlord in Japan to spend every other year in Edo | *ukiyo* | as a proper noun, the brothel and theater district of Edo in the Tokugawa Period; as a common noun, the here and now |
| *kô* | an artisan | | | | |
| *kodomo-e* | pictures of or for children | | | | |
| *kojita-e* | a sketch | | | | |
| *kokei bon* | a humorous book | *sanshoku zuri* | three-color prints | | |
| *kon* | a two-volume set of books | *senryû* | short, humorous poems | *urushi-e* | lacquer prints |
| *kôzo* | paper from the mulberry trees that is used to make Japanese books | *setsuwa* | sermon stories | | |
| | | *shahon* | a manuscript | | |
| | | *shibai-e* | theater prints | *waka* | a type of poetry |
| *kubi-e* | close-up portraits | *shibugami* | paper tanned with persimmon juice | | |
| *kyôka* | comic or mad verse | | | *yago* | a publisher's shop |
| | | *shin* | formal style of calligraphy or drawing | *yakusha-e* | prints of actors |
| *machi* | the modern Japanese word for city but, up to the seventeenth century, autonomous communities within cities | | | *yamazakura* | Japanese wild cherry |
| | | *shin-hanga* | new prints, a type of modern Japanese wood-block prints | *yoga* | Western-style painting |
| | | | | *yoka* | weird creatures |
| | | | | *yurei* | ghosts |
| | | | | *yûsoku* | military practices |
| *machishu* | men of the *machi* or cities | *shinôkôshô* | the four levels of classes during the Tokugawa Period | | |
| *mame-hon* | a miniature book | | | *zôhan* | a principal publisher; the owner of the blocks |
| *manga* | comic or random sketches | *shinwa* | Japanese and Chinese myths | | |
| *meisan* | famous products of a province | *shita-e* | a detailed and exact rendering of a sketch done to the same dimensions as the final painting | *zôho* | additional |
| *mitate* | a parody | | | | |
| *mokuhan* | a wood-block print | | | | |
| | | *shunga* | erotic prints | | |
| *namazu-e* | catfish prints | *so* | grass or an informal style of calligraphy or drawing | | |
| *nigao* | portraits | | | | |
| *nihon* | Japan | *sôsaku-hanga* | "creative prints," a type of modern Japanese prints | | |
| *nihonga* | Japanese-style painting | | | | |
| *nikuhitsu* | Ukiyo-e drawings, as opposed to prints | *sumizuri* | black prints, i.e., prints that are rubbed (*zuri*) in black ink (*sumi*) only | | |
| *nishijin* | high-quality fabric named after the area in Kyoto where it was produced | | | | |
| | | *suri* | the person who rubs or makes the wood-block print | | |
| *nishiki-e* | "brocade prints," that is, full-color prints | *surimono* | literally, printed thing; privately commissioned prints that were made to commemorate special events and were given to a select circle as mementos | | |
| *okubi-e* | close-up portraits | | | | |
| *okugaki* | a statement written at the end of a manuscript book or a scroll; a colophon | | | | |
| | | *tan-e* | early hand-painted Ukiyo-e, done predominantly in red | | |
| *omocha-e* | toy prints | | | | |
| *oraimono* | admonitory writing | *toba-e* | comic drawings or caricatures | | |
| *oribon* | an album; an accordion binding | | | | |
| | | *tobira* | a title page | | |
| *oshi-e* | a type of collage | *tsuno* or *tsunogaki* | an introductory phrase that appears before a book's title | | |

OBJECT LIST AND REPRODUCTION NUMBERS

The following list provides the reproduction numbers for the color copies of the objects reproduced in this book as well as their Library of Congress custodial division. These color transparencies may be ordered from the Library's Photoduplication Service, Washington, DC 20540-5320, telephone: 202 707-5640
or its website address:
http://lcweb.loc.gov/preserv/pds/photo.html

Include both the prefix and suffix listed below for each item you are ordering, and also include a photocopy image with your order if possible. The numbers in bold face preceding the prefixes and suffixes refer to the numbers provided for each image; they do not refer to page numbers.

ABBREVIATIONS FOR CUSTODIAL DIVISIONS
AD/JS Asian Division, Japanese Section
MSS Manuscript Division
P&P Prints and Photographs Division
RBSCD Rare Book and Special Collections Division

1. LC-USZC4-8509, P&P; *2.* LC-USZC4-8439, P&P; *3.* LC-USZC4-8420, P&P; *4.* LC-USZC4-8746, AD/JS; *5.* LC-USZC4-8411, P&P; *6.* LC-USZC4-8407, P&P; *7.* LC-USZC4-8532, P&P; *8.* LC-USZC4-8412, P&P; *9.* LC-USZC4-8408, P&P; *10.* LC-USZC4-8432, P&P; *11.* LC-USZC4-8430, P&P; *12.* LC-USZC4-8437, P&P; *13.* LC-USZC4-8424, P&P; *14.* LC-USZC4-8425, P&P; *15.* (left to right) LC-USZC4-8470, LC-USZC4-8471, LC-USZC4-8472, P&P; *16.* LC-USZC4-8410, P&P; *17.* LC-USZC4-8529, P&P; *18.* LC-USZC4-8528, P&P; *19.* LC-USZC4-8405, P&P; *20.* LC-USZC4-8536, P&P; *21.* LC-USZC4-8530, P&P; *22.* LC-USZC4-8415, P&P; *23.* LC-USZC4-8440, P&P; *24.* (left to right) LC-USZC4-8447, LC-USZC4-8448, LC-USZC4-8449, P&P; *25.* LC-USZC4-8438, P&P; *26.* LC-USZC4-8431, P&P; *27.* LC-USZC4-8485, P&P; *28.* LC-USZC4-8443, P&P; *29.* (left to right) LC-USZC4-8521, LC-USZC4-8522, LC-USZC4-8523, LC-USZC4-8524, P&P; *30.* (left to right) LC-USZC4-8518, LC-USZC4-8519, LC-USZC4-8520, P&P; *31.* LC-USZC4-8421, P&P; *32.* LC-USZC4-8423, P&P; *33.* (left to right) LC-USZC4-8450, LC-USZC4-8451, P&P; *34.* (left to right), LC-USZC4-8458, LC-USZC4-8459, LC-USZC4-8460, P&P; *35.* LC-USZC4-8758, AD/JS; *36.* LC-USZC4-8653, AD/JS; *37.* (left to right) LC-USZC4-8723, LC-USZC4-8724 AD/JS; *38.* (left to right) LC-USZC4-8742, LC-USZC4-8739, LC-USZC4-8741, LC-USZC4-8740, AD/JS; *39.* LC-USZC4-8693, AD/JS; *40.* LC-USZC4-8720, AD/JS; *41.* LC-USZC4-8717, AD/JS; *42.* LC-USZC4-8635, AD/JS; *43.* (left) LC-USZC4-8702, (right) LC-USZC4-8703, AD/JS; *44.* LC-USZC4-8725, AD/JS; *45.* LC-USZC4-8728, AD/JS; *46.* LC-USZC4-8636, AD/JS; *47.* (left) LC-USZC4-8734, (right) LC-USZC4-8733, AD/JS; *48.* LC-USZC4-8651, AD/JS; *49.* LC-USZC4-8719 (only right side of transparency pictured), AD/JS; *50.* 8672, AD/JS; *51.* (left) LC-USZC4-8706, (right) LC-USZC4-8707, AD/JS; *52.* (left) LC-USZC4-8679, (right) LC-USZC4-8678, AD/JS; *53.* (left) LC-USZC4-8681, (right) LC-USZC4-8680, AD/JS; *54.* (left) LC-USZC4-8692, (right) LC-USZC4-8691, AD/JS; *55.* (left) LC-USZC4-8690, (right) LC-USZC4-8689, AD/JS; *56.* (left) LC-USZC4-8682, (right) LC-USZC4-8683, AD/JS; *57.* (left) LC-USZC4-8735, (right) LC-USZC4-8736, AD/JS; *58.* LC-USZC4-8500, P&P; *59.* LC-USZC4-8533, P&P; *60.* LC-USZC4-8534, P&P; *61.* (detail in raking light) LC-USZC4-8641, (left page) LC-USZC4-8715, (right page) LC-USZC4-8716, AD/JS; *62.* (left to right) LC-USZC4-8444, LC-USZC4-8445, LC-USZC4-8446, P&P; *63.* LC-USZC4-8433, P&P; *64.* LC-USZC4-8512, P&P; *65.* LC-USZC4-8413, P&P; *66.* LC-USZC4-8416, P&P; *67.* LC-USZC4-8686, RBSCD; *68.* LC-USZC4-8488, P&P; *69.* LC-USZC4-8538, P&P; *70.* (left to right) LC-USZC4-8473, LC-USZC4-8474, LC-USZC4-8475, P&P; *71.* LC-USZC4-8743, AD/JS; *72.* LC-USZC4-8486, P&P; *73.* LC-USZC4-8492, P&P; *74.* LC-USZC4-8737, AD/JS; *75.* LC-USZC4-8490, P&P; *76.* LC-USZC4-8494, P&P; *77.* LC-USZC4-8493, P&P; *78.* LC-USZC4-8497, P&P; *79.* LC-USZC4-8499, P&P; *80.* LC-USZC4-8501, P&P; *81.* LC-USZC4-8502, P&P; *82.* LC-USZC4-8503, P&P; *83.* LC-USZC4-8505, P&P; *84.* LC-USZC4-8504, P&P; *85.* LC-USZC4-8507, P&P; *86.* LC-USZC4-8540, P&P; *87.* LC-USZC4-8541, P&P; *88.* LC-USZC4-8539, P&P; *89.* LC-USZC4-8511, P&P; *90.* LC-USZC4-8435, P&P; *91.* LC-USZC4-8406, P&P; *92.* LC-USZC4-8748, AD/JS; *93.* LC-USZC4-8750, AD/JS; *94.* LC-USZC4-8747, AD/JS; *95.* LC-USZC4-8749, AD/JS; *96.* LC-USZC4-8542, AD/JS; *97.* LC-USZC4-8640 (transparency shows book cover at a diagonal angle), AD/JS; *98.* LC-USZC4-8417, P&P; *99.* LC-USZC4-8418, P&P; *100.* (left to right) LC-USZC4-8525, LC-USZC4-8526, LC-USZC4-8527, P&P; *101.* LC-USZC4-8535, P&P; *102.* LC-USZC4-8426, P&P; *103.* LC-USZC4-8483, P&P; *104.* LC-USZC4-8487, P&P; *105.* (left to right) LC-USZC4-8476, LC-USZC4-8477, LC-USZC4-8478, P&P; *106.* (left to right) LC-USZC4-8479, LC-USZC4-8480, LC-USZC4-8481, P&P; *107.* LC-USZC4-8675, MSS; *108.* LC-USZC4-8508, P&P; *109.* (left to right) LC-USZC4-8659 (catalog shows image on right only), LC-USZC4-8671, LC-USZC4-8665 (catalog shows image on left only), LC-USZC4-8663 (catalog shows image on left only), P&P; *110.* LC-USZC4-8756, AD/JS; *111.* LC-USZC4-8673, AD/JS; *112.* (left) LC-USZC4-8658, (right) LC-USZC4-8655, AD/JS; *113.* LC-USZC4-8695, AD/JS; *114.* LC-USZC4-8696, AD/JS; *115 A and B.* (left, full page of text is shown in transparency) LC-USZC4-8713, (right, full-page image) LC-USZC4-8714, AD/JS; *116.* (detail taken from LC-USZC4-8713 above); *117.* LC-USZC4-8436, P&P.

INDEX

223

This book was composed in Monotype
Centaur by Blue Heron Typesetting, Lawrence,
Kansas, and printed on 128 gsm Shiraoi matte
coated stock by Toppan Printing Co. Ltd.,
Tokyo, Japan.